Victoria and Albert Museum

Catalogue of
Paintings in the Wellington Museum

C. M. Kauffmann

London: Her Majesty's Stationery Office

© Crown copyright 1982
First published 1982

ISBN 0 11 290373 8 (limp cover)
ISBN 0 11 290380 0* (cased)

Printed in England for Her Majesty's Stationery Office
by Jolly & Barber Ltd, Rugby.
Dd 696405 C40

Cover: detail from Joseph Nash, *Apsley House, The Waterloo Chamber,*
Watercolour 1852 (Wellington Museum)

Contents

Foreword

In 1947 the 7th Duke of Wellington, himself a distinguished architect and antiquarian, gave the nation his London residence, Apsley House, and part of its contents, to be opened as a memorial to his illustrious forebear. It was a truly princely gift, consisting of about 200 paintings, — many of them originally from the Spanish Royal collection; fine works of silver, sculpture and ceramics; and an important display of the Iron Duke's uniforms, medals, orders and personalia.

In cataloguing the paintings which formed a central part of the 7th Duke's gift, the compiler's first debt has been to the 1901 catalogue of the Wellington collection by Evelyn, Duchess of Wellington. This was and remains a work of monumental thoroughness on which the present catalogue leans heavily. The index of the 1901 catalogue is reprinted on p.161 with annotations to show which of the pictures then listed are in the Wellington Museum and which remain in the Duke's private collection. A debt of a similar kind to be acknowledged is to Sir Ellis Waterhouse's exemplary *Catalogue of Eighteen Paintings in the Wellington Gift;* the Arts Council exhibition of 1949.

Grateful thanks for patient help are due to the owners, libraries and curators of archives used in the preparation of this catalogue: the 8th Duke of Wellington and the archivist at Stratfield Saye, Joan Wilson; the Prado and the Instituto Diego Velázquez, Madrid; the Art History Institute at The Hague; and, in London, the archives of the National Gallery and the photographic libraries of the Warburg and Courtauld Institutes and of the National Portrait Gallery. Much individual help is acknowledged in the catalogue entries concerned, but particular mention must be made of assistance generously given by Enriqueta Frankfort, with whom all the entries on the Spanish paintings were discussed, and warm thanks are also due to Diego Angulo Iñiguez, Rocio Arnaez, Allan Braham, Christopher Brown, Mary Cazort, Sir Michael Levey, Juan J. Luna, Hamish Miles, A. E. Perez Sanchez, Ruth Rubinstein, Carl van de Velde, Harold Wethey and Christopher White. Stephen Wood of the National Army Museum gave much helpful advice over problems of uniforms and decorations.

Among colleagues, Graham Reynolds made the original inventory for the Museum, and this catalogue has benefited considerably from discussions with, in particular, Ronald Lightbown, John Murdoch and Lionel Lambourne and from the conservation reports and laboratory examinations of Norman Brommelle, Harry Rogers, Peter Young, Susannah Edmunds and Jo Darrah, present and former members of the Museum's Conservation Department. The help of Michael Holmes was invaluable on matters of heraldry. Victor Percival, curator at Apsley House form 1948 until 1981, has freely shared his detailed knowledge of the collection and of Wellington's campaigns. Finally, thanks are due to Simon Jervis for agreeing to contribute his illuminating note on the frames and to Rosie Sutherland and Tina Huntley for their impeccable typing from a barely legible manuscript.

Introduction: history of the collection

Pictures from Spain

It is usually said that the picture collection of the first Duke of Wellington was founded on the battlefield of Vitoria in Northern Spain in June 1813, but there was a prologue to this romantic beginning. For on 15 August 1812, just after Wellington's victory at Salamanca and triumphant entry into Madrid, the Intendant of Segovia wrote to the Duke:

> Your Excellency,—If a feeling of delicacy on your part will not admit of your accepting the offer I made you, on behalf of the nation, of such trifles in the Royal Palace of San Ildefonso as might have been most agreeable to you, I cannot overlook the deep obligation of my country to the hero of Great Britain, and the Regent would justly resent any indifference on my part in showing the gratitude due to the Liberator of Spain. As I believe that you take a particular interest in pictures, I take the liberty of presenting to you the twelve best and most artistic pictures which I have been able to find.
>
> In the name of the Spanish Nation and the Government I beg that you will deign to accept this very small offering—the chief object of which is to show the gratitude and recognition of the Nation.
>
> I pray the God of Armies to keep you in perfect health, and beg that you will favour me with the expression of your wishes on the subject.
>
> (Signed) The Intendant of the Province,
> SEGOVIA, *August 15, 1812.* RAMON LUIS ESCOVEDO.

The Palace of Ildefonso, built by Philip V in 1739, was at La Granja in the hills north-west of Madrid, on the way to Segovia. Of these twelve pictures, only two were identified in the 1901 Wellington *Catalogue* (nos. 77 and 146 in this catalogue), but this first gift from Spain to the victor of the Peninsular War distinguishes, at the beginning, Wellington's collection from those of any of his contemporaries.

Wellington's army moved north from Madrid in September 1812 to take Valladolid, but at Burgos the French held out against him and forced the army to retreat to winter quarters at Ciudad Rodrigo near the Portuguese border. It was not until the following May that he returned to the offensive and pursued the army of Joseph Bonaparte – who had been placed on the Spanish throne by his brother in 1808 – across northern Spain. The final victory, which put an end to French rule in Spain, came on 21 June 1813 at Vitoria, on the road into France.[2]

After the battle, Wellington's soldiers found Joseph's coach among the masses of captured baggage and equipment. Joseph himself had just managed to escape under the protection of the French cavalry, but the coach was found to contain not only his state papers, some love letters and a silver chamber pot, but also over 200 paintings – the canvases detached from their stretchers and rolled up – as well as drawings and engravings, which Wellington sent to England to the custody of his brother, Lord Maryborough.

Maryborough was fortunate to obtain the services of William Seguier, Keeper of the Royal Picture Galleries and later Keeper of the National Gallery, to draw up a catalogue of the principal pictures, and in a letter of 9 February 1814 he wrote to Wellington explaining their importance: 'A most valuable collection of pictures, one which you could not have conceived'. He goes on:

> I send you a Catalogue of 165 of the most valuable pictures . . .
> I have sent with the Catalogue a memorandum which I made Charles Bagot (a

tolerable judge of pictures) draw, which will give you some idea of the value of the collection. He has, however, I believe very much under-rated it. Owen, the painter, and West, the President of the Academy, have both told me that the Corregio is certainly worth at least 6000 guineas, and many of the others are inestimable. Upon the whole I think I am within the mark if I say the collection is worth £40,000 . . . [3]

It had become clear that Joseph Bonaparte had appropriated these paintings from the Spanish royal collection and had been about to take them to France. But there is no obvious answer to the question why, out of all the magnificent works in the Spanish royal collection, the unparalleled series of paintings by Titian and Rubens, for example, and the very large number of works by Spanish artists, Joseph made the selection of which we see the greater part at Apsley House today. However, a group of about twelve pictures escaped capture and reached Paris safely with Joseph Bonaparte, including five Raphaels (which the Duke later had copied by Bonnemaison), a Titian *Venus* and a Guido Reni *Madonna*, which suggests that he thought he was taking the best.[4]

When the Duke heard that the captured paintings had in fact been stolen by Joseph Bonaparte he at once insisted that they should be returned to the King of Spain. In a letter to his brother, Sir Henry Wellesley, British Minister in Spain, dated 16 March 1814, he wrote:

My dear Henry,
 The baggage of King Joseph after the battle of Vitoria fell into my hands, after having been plundered by the soldiers; and I found among it an Imperial containing prints, drawings and pictures.
 From the cursory view which I took of them the latter did not appear to me to be anything remarkable. There are certainly not among them any of the fine pictures which I saw in Madrid, by Raphael and others; and I thought more of the prints and drawings, all of the Italian school, which induced me to believe that the whole collection was robbed in Italy rather than in Spain. I sent them to England, and having desired that they should be put to rights, and those cleaned which required it, I have found that there are among them much finer pictures than I conceived there were; and as, if the King's palaces have been robbed of pictures, it is not improbable that some of his may be among them, and I am desirous of restoring them to His Majesty, I shall be much obliged to you if you will mention the subject to Mons. Lugando, and tell him that I request that a person may be fixed upon to go to London to see them and to fix upon those belonging to His Majesty.
 This may be done either now or hereafter when I shall return to England, as may be most expedient.
 In the meantime the best of them are in the hands of persons who are putting them to rights, which is an expense necessary for their preservation, whether they belong to His Majesty or not.
 I'll get the catalogue of the pictures which I have got copied and will send it to you. It will probably enable the Spanish Government to form an opinion without inspection which of the pictures belong to the King.

Sir Henry Wellesley duly made representations at the Spanish Court but no reply was received. Consequently the Duke brought the question up again in September 1816 in a letter to Count Fernan Nuñez, Spanish Minister in England. To this letter Count Nuñez replied:

Most Excellent Sir,
 Esteemed Duke and friend,
 I hand you enclosed the official reply which I have received from the Court, and from the same I gather that His Majesty, touched by you delicacy, does not wish to deprive you of that which has come into your possession by means as just as they are honourable. Such is my view of the case, and thus I believe you ought to let the matter rest where it stands and to refer to it no longer. At any rate, whatever may have been your intention, I shall always be ready to act

according to your wishes, not alone in this, but in all other matters in which I can be of asistance to you.

<div style="text-align: right">

Your devoted friend and
Affectionate cousin, who salutes you,
FERNAN NUÑEZ

</div>

Eighty-three of these paintings are now in the Wellington Museum and, thanks to the inventories of the Spanish royal picture collections, we can trace the history of fifty-seven of them. The inventories were regularly compiled at each king's death by the curator of pictures, who was usually the court painter. In February 1794, for example, the royal palace inventory was signed by Francisco Bayeu, Francisco de Goya and Jacinto Gomez. Attribution, sizes, locations and, at times, valuations, are all given.[5]

The earliest painting in the Wellington Museum, the Juan de Flandes *Last Supper,* is also the earliest recorded in the Spanish inventories, for it was in the possession of Queen Isabella (d.1504). Of the small group of sixteenth-century pictures at Apsley House, the *Orpheus enchanting the animals,* then listed as Titian (here under Padovanino), is recorded in the royal collection in 1666 and we know that Philip IV (1621-65) acquired two of the collection's masterpieces: Correggio's *Agony in the Garden* and Elsheimer's *Judith and Holofernes.* Velazquez's *Waterseller* also entered the royal collection in the seventeenth century, and the two canvases by Luca Giordano were painted for the Buen Retiro palace, on the eastern outskirts of Madrid, while he was court painter to Charles II in 1692-1702.

In November 1734 the royal palace in Madrid, the Alcázar, was burnt to the ground. An inventory of surviving paintings made after the fire includes four of the Teniers and three of the Jan Brueghels now at Apsley House. As these are not recorded in the royal palace inventory of 1700, one might conclude that they were acquired between 1700 and 1734, but for the fact that these early inventories were not exhaustive and hence a picture's first appearance in a particular inventory does not necessarily mean that it was acquired in the immediately preceding reign. The Elsheimer, for example, has not been traced in any of the inventories before 1734, though we know it to have been acquired by Philip IV almost a century earlier.

The new Palacio Real in Madrid was built on the site of the Alcázar. In the 1750's and early sixties it was decorated by leading artists from abroad, including Corrado Giaquinto, Mengs and Tiepolo, and by 1764, when it was once again inhabited by the royal family, it contained the largest part of the royal collection, not only of pictures, but also of sculpture, tapestries, armour and all manner of artifacts.

Meanwhile, the picture collection of the first Bourbon king, Philip V (reigned 1700-46), the grandson of Louis XIV of France, and his wife Isabella Farnese, was assembled at their palace at La Granja, outside Madrid. Philip, who had his palace built on the model of Versailles and filled its gardens with French sculpture, collected French pictures, while Isabella preferred those of her native Italy. However, these preferences are only marginally reflected in the representatives of their collections at Apsley House which include, respectively, a Claude and a Guido Reni. Philip's pictures are marked with a cross and Isabella's with a fleur-de-lis, and the two collections were separately catalogued after Philip's death in 1746. Most of the pictures concerned remained at La Granja, but some of them reappear later in the century at Aranjuez, Philip II's palace on the banks of the Tagus, south of Madrid, which was rebuilt by Philip V and Charles III.

Charles III (reigned 1759-88), who had formerly been King of Naples, collected on a considerable scale and his acquisitions included Velazquez's *Two men at a humble table* and *Innocent X,* both from the collection of the Marquis of Ensenada. Meanwhile in 1772 his son, the future Charles IV,

Fig 1. The Apsley House pictures in the Spanish royal collection

Margaret of Austria 1505 and 1516	Palacio Real Alcázar 1666	Palacio Real 1686	Palacio Real 1701	Buen Retiro 1701	Palacio Real (after fire) 1734	La Granja 1746
Juan de Flandes						
	'Titian', Orpheus	×	×			
	Correggio	×	×			
				Giordano (2) Velazquez, Water Seller		
					Teniers, 108 Teniers, 791 Teniers, 864 Teniers, 893 Brueghel, 148 Brueghel, 1025(2) 'Ribera', Carcasse	
						I. *Isabella Farnese* Eglon v. der Neer Wouwerman, 314 After Rubens, 806 Teniers, Bowls de Hondt, 531 Murillo, St Francis Elsheimer Guido Reni
						II *Philip V* Claude, 335 Poelenburgh, Crucifixion

Palacio Real 1772	La Granja 1774	Casita de Principe (Escorial) c.1782	Palacio Real 1794	La Granja 1794	Aranjuez 1794
×					
×			×		
×					
×					
×			×		
×					
×					
×					
×			×		
	×				×
	×				
	×				
×	×				×
	×				
	×				
				×	
					×
					×
Van Dyck			×		
Velazquez, portrait			×		
Velazquez, Two men			×		
Velazquez, Innocent			×		
Brueghel, 956 (2)			×		
Gysels, 956 (2)			×		
Wouwerman(2)			×		
Cignani			×		
Mengs, Holy Family			×		
Murillo, Isaac & Jacob					
'Titian', portrait					
Bril (?)					
Coffermans					
		d'Arpino, Expulsion			
		d'Arpino, St Catherine			
		P.P. Roos			
		Sassoferrato, Madonna			
		Vernet, Bay			
			Mengs, St Anthony		
			Ribera,		
			St John		
			Rubens, Nun		
			Rubens, Man		
			After Rubens(2)		
			Luini, Madonna 453		
			Parmigianino		
			Panini		
			'Raphael', Madonna		
			Gysels		
					Poelenburgh, Nativity

while he was still Prince of Asturias, was building his country house, Casita del Principe, in the grounds of the Escorial on the model of the Petit Trianon. His collection included Italian Old Masters, but he was also known for his patronage of contemporary artists and, in particular, he bought twelve paintings by Claude Joseph Vernet.[7]

The fact that about twenty-five of the pictures captured at Vitoria have not been traced in these inventories may be due to a variety of reasons. Many works, particularly if the artist is unknown or the subject very common, are inherently difficult to identify among the hundreds of paintings listed. Some inventories may be incomplete and others – for example, the 1794 inventory for the Escorial – have not been traced at all. Furthermore, no inventories were compiled between 1794 and 1814, so that any paintings acquired in those years would not have been recorded.

Nevertheless, the question is bound to arise: did Joseph Bonaparte also take with him pictures from other Spanish collections? We know that the French took a large number of works of art from Spain. As early as 1809, Vivant Denon, director of the Musée Napoléon, persuaded Joseph Bonaparte to decree that fifty Spanish masterpieces – of which there were none in the Louvre – should be confiscated from loyalist Spanish nobles. The Spaniards managed to delay the process of selection, but ultimately, in September 1813, 250 confiscated pictures finally reached Paris and in the same year Marshal Soult handed over to the Musée Napoléon three of the numerous Murillos he had appropriated in Seville.[8]

In that connection, Colonel Gurwood, editor of the Wellington dispatches, told an illuminating story concerning the Marshal. When, after the war, he was showing his collection to Gurwood, he stopped before one of them and said: 'I value that picture very much; it saved the lives of two estimable men.' An aide-de-camp whispered in Gurwood's ear, 'He threatened to have them both shot if they did not send him their painting."[9]

In his role as King of Spain, Joseph Bonaparte was de facto owner of the royal collection and had no need for such methods of personal aggrandisement. On the contrary, he planned to use the pictures taken from suppressed religious institutions to found a national museum in Madrid. Yet it remains possible that he took some of these sequestered pictures with him on his flight and that not every picture captured at Vitoria was necessarily from the royal collection.[10]

The Duke's Purchase of Old Masters

It was in 1816, after the end of the war, when he had settled in to his new position of commander of the occupation forces in France, that the Duke bought Apsley House from his brother Richard, Marquess Wellesley. It had been built in the early 1770s by Robert Adam for Henry, Lord Apsley, afterwards 2nd Earl Bathurst (1714-94), whose son had sold it to Lord Wellesley.[11] Wellington's agent in the purchase was Benjamin Dean Wyatt, son of the architect James Wyatt. Benjamin Wyatt, himself an architect, had been Wellington's secretary in India and Ireland and, after the failure of the plan to build a Waterloo Palace,[12] it was he who added the great gallery at Apsley House in 1828-9 in what he called Louis XIV style.[13] Having acquired Apsley House and received Stratfield Saye, his country house in Berkshire, as a gift from the nation in 1817,[14] the Duke bought French eighteenth-century furniture in Paris and patronized the Sèvres factory.[15] It was at this time that he began to extend his picture collection. Paris in the years after 1815 was an ideal place in which to do so. Napoleon's secularization of religious houses and the turmoil of the war years had dislodged works of art from their homes on an unprecedented scale. Wellington used as his agent Féréol Bonnemaison, painter, dealer and picture restorer, and his main purchases were at the La Peyrière sale in April 1817, where he bought nine pictures,[16] and at the Le

Rouge sale in April 1818 where he acquired twelve.[17] La Peyrière was a speculative financier who had acquired his pictures from recent sales of celebrated collections in Holland and Paris; Le Rouge was himself a picture dealer who was selling his stock and withdrawing from commerce after the death of his wife. Wellington's purchases at these sales, which included his great works by Jan Steen and Nicolaes Maes, demonstrate his own personal taste for the realism of Dutch genre painting. The highest prices were paid for Jan Steen's *Wedding Party* (£472) and *Physician's Visit* (£460), Jan van der Heyden's *Town View* (£378) and the large Bakhuizen, *Man of rank embarking at Amsterdam* (£880).[18] In 1818, also, the Duke bought a further group of pictures from Bonnemaison including works by Jan Steen, de Hooch and Duyster.

Dutch pictures had of course always been popular collectors' items in England. The best collections had their Rembrandts and their landscapes by Ruisdael and Cuyp. But the emphasis on narrative genre was a nineteenth-century taste which is reflected in the growth of the national school of such narrative painting at the time. Wellington was not alone in this taste; in 1836 J. D. Passavant recorded several important collections of Dutch pictures including those of Thomas Hope, Sir Robert Peel and Alexander Baring.[19] Above all there was George IV, who acquired some of the best Jan Steens and Teniers in the royal collections from Sir Thomas Baring in 1814[20] and who personified this taste, which is usually described as bourgeois. It would be misleading to suggest that Wellington was in the same class as a collector as Peel; his main buying period was 1817-18 and he bought only about thirty old master paintings then. Equally, he retained an interest in pictures other than Dutch – after all, he had Bonnemaison make copies of four of the Raphaels from Madrid, and bought a large *Ascension* attributed to Tintoretto (Stratfield Saye).[21] But it remains generally true that of the old masters at Apsley House, Wellington himself supplemented the predominantly Spanish, Italian and Flemish pictures from the Spanish royal collection with some of the most splendid Dutch narrative scenes to be seen in London in the early nineteenth century, and their popularity is attested by the constant demand for them to grace the annual exhibitions at the British Institution. The popularity was due to what was seen as the faithful realism of Dutch genre paintings, and this remained the sole critical assessment of them throughout the nineteenth century. It is only in the last fifty years that their symbolic content – often highly complex and sophisticated – has been explored and interpreted with reference to contemporary emblem books.[22] Such interpretation, which adds considerably to our understanding of these paintings, has been taken into account in this catalogue, though it may be that there is a danger of reading too much into them.

At the Congress of Aix-la-Chapelle in October–November 1818, the allied nations agreed to end the occupation of France. This might have signalled the end of Wellington's active career, but in December he accepted the post of Master-General of the Ordnance in Lord Liverpool's Tory cabinet and, at the age of 46, he embarked upon a second career in politics. It was a stormy time for politicians, a period of economic stress and social unrest to which Wellington and his colleagues replied with fierce repression. In 1819 the massacre of Peterloo – when eleven people were killed and nearly five hundred wounded when troops fired into a crowd of demonstrators in a field near Manchester – was followed by the Six Acts directed against press criticism and public meetings. Wellington was Prime Minister in 1828-30, but was defeated over Parliamentary Reform and in 1831 Apsley House itself was stoned by an angry crowd.[23]

His most active years in politics left the Duke little time or inclination to pursue his interest in Old Master paintings, but during the last decade of his life, from about 1840, he bought some fine examples, though not on the scale

of his acquisitions in 1817-18. The biggest single group of paintings acquired at this time was Spanish. The *Unknown Man* ascribed to Murillo was bought in 1838, followed by the portrait of Quevedo from the studio of Velazquez (1841) and by Mazo's *View of Pamplona* (1844). They form a coda to the great works from the Spanish royal collection at Apsley House.

Contemporary paintings
Portraits
Our admiration for the masterpieces by Correggio, Velazquez, Rubens and Jan Steen should not blind us to the fact that sixty-three of the pictures in the Wellington Museum, about a third of the total, are early nineteenth-century portraits. Wellington was very keen to represent not only his own generals and the heads of state of the allied nations but also Napoleon and his family. To this end he commissioned Sir Thomas Lawrence in 1817-18 and subsequently George Dawe to portray his comrades in arms, though the largest number of the portraits of his officers is by the Dutchman Willem Pieneman, from whom Wellington bought the sketches for his *Battle of Waterloo* (Rijksmuseum). These portraits have always hung in the Striped Drawing Room (the 'yellow drawing room' in the Wellington *Catalogue*) where they still are today. Portraits of Napoleon and his family by Lefèvre were bought by the Duke soon after the war and he continued to acquire them to the end of his life: Lefèvre's *Josephine* was one of his last purchases, in 1851. The galaxy of full-length portraits of the crowned heads of Europe, hung then as now in the Dining Room, were largely gifts from the rulers concerned, particularly in the years 1818-26. Taken together, these two rooms at Apsley House formed a parallel in miniature to the Waterloo Chamber at Windsor Castle for which Lawrence was commissioned by George IV to paint over twenty portraits in 1813.[24] In this area also the Duke returned to collecting again towards the end of his life: the portraits of Soult, of the Duke of York, of Pitt and of Spencer Perceval were bought in the years 1843-52.

Contemporary British Paintings
Wellington's most famous act of patronage, and his most expensive purchase of all, was Wilkie's *Chelsea Pensioners*, commissioned in 1816.[25] He was introduced to the artist by Lord Lynedoch and the pictures which he saw in the artist's studio at the time were very much in the manner of the seventeenth-century Dutch painters he so admired. In the same vein, Edwin Landseer's *Illicit Still* was commissioned in 1826 and the Duke returned to Landseer for a version of *Van Amburgh and his animals* over twenty years later. Other acquisitions were made as purchases from the artist rather than as commissions, such as Burnet's *Greenwich Pensioners*, painted and hung as a pendant to Wilkie's *Chelsea Pensioners*, and William Allan's *Battle of Waterloo* which was clearly sufficiently accurate to satisfy the Duke, who was heard to comment 'Good – very good; not too much smoke.' Prices varied very considerably. In 1818 Lawrence received only £210 for his full-length portrait of the Marquess of Anglesey, whereas Wilkie was paid £1,260 for his *Chelsea Pensioners* when it was finally completed in 1825. Sir Francis Grant received 500 guineas for the *Melton Hunt* (formerly at Stratfield Saye)[26] in 1839 and Sir William Allan was paid £600 for his *Battle of Waterloo* when it was exhibited at the Royal Academy in 1843. These were major pictures by some of the leading artists of the time and the prices paid were in line with current levels. Indeed, when, during a dinner party, the Duke was spoken of as avaricious, it was Landseer who sprang to his defence, explaining that he had been free to fix his own price for *Van Amburgh and his animals*. Landseer's story is told by William Powell Frith: 'and when in reply to the Duke's enquiry Landseer told him the price would be six hundred guineas, the Duke wrote out a

cheque for twelve. "I could tell you many more instances of his liberality," said the painter.[27] Concerning the execution of the same picture, one might also quote Richard Ford in 1853: 'Sir Edwin, however, was compelled to obey orders as strictly as if his R.A. had meant Royal Artillery.'[28]

Even so, one should not, from Landseer's touching testimony, overestimate the Duke of Wellington as a patron and collector of contemporary British art. He bought many portraits, a few history pictures and a handful of distinguished genre scenes. It is an important collection as an illustration of British history but it can hardly be seen as embodying trends in British painting of the time. Indeed it was never intended as such, as a comparison with the major collections of the time – Vernon (now Tate Gallery) and Sheepshanks (now V&A) – amply demonstrates. Perhaps the most fitting comment on the extent and limits of Wellington's interest in his collection is contained in the following story told in Frith's *Memoirs:*

> The great Duke, being human, was no doubt the victim of weaknesses, one of which – a very small one – consisted in the conviction that he could name every picture in the Apsley House collection without reference to the catalogue. So long as the pictures followed in regular sequence, and were named one after another in order, the effort of memory was successful; but if the narrator were called back, by the forgetfulness of the visitor, to any special picture, he was at fault; and without beginning again with the first picture in the room, he could not give the information asked for.
>
> 'I beg your pardon, sir; who did you say that was?' said Landseer to the Duke, on the occasion of a visit to Apsley House, at the same time pointing to a half-length portrait of a sour-looking woman in the costume of the time of Elizabeth.
>
> The Duke looked up at the picture, muttered something, and left the room.
>
> While the Duke was absent, Landseer studied other pictures, and had pretty well forgotten all about the sour-looking lady, when a voice close to his ear exclaimed, 'Bloody Mary!'[29]

Postscript

Arthur Wellesley, Lord Douro (1807-84), who succeeded as Duke of Wellington in 1852, had been a disappointment to his father and the two had never been on cordial terms. In 1853 he opened Apsley House to the public for limited periods. To mark the occasion both a guide and a collection of ten lithographs were published, and appreciations appeared in the *Quarterly Review* and the *Athenaeum* in the same year. Meanwhile, the collection continued to grow, both in the 2nd Duke's lifetime and in succeeding generations. Lawrence's portrait of the Iron Duke was bequeathed by the Marchioness Wellesley to the 2nd Duke, who also collected in a minor way himself. Seven pictures in the Wellington Museum were acquired by him, both Old Masters, for example, the small Bakhuizen, and portraits (for example, Reynolds and Leslie).

The 7th Duke's princely gift to the nation in 1947 included nearly all the masterpieces in the Wellington collection, but it should be remembered that in terms of number less than half the pictures collected by the family in the nineteenth century are in the Wellington Museum. Of the 'Spanish' pictures now at Stratfield Saye, two Claudes, three landscapes by Pillement, a Vernet harbour view and a *St Cecilia* by Matthias Stomer are among those worthy of particular mention, and the collection is rich in early nineteenth-century portraits.[30] The paintings at Stratfield Saye can provide further insight into the Duke's taste, highlighting, for example, his love of sporting pictures. Yet it is first and foremost from the paintings in the Wellington Museum that a history and appreciation of the great Duke's collection can be derived.

Notes

1. Evelyn Wellington, *A descriptive and historical catalogue of the collection of Pictures and Sculpture at Apsley House*, 1901, p.68.
2. For a recent account of the battle see Elizabeth Longford, *Wellington. The Years of the Sword*, 1969, p.309ff.
3. The correspondence was published in the introduction to the 1901 Wellington catalogue. For Seguier's list, see below, p.157.
4. Cecil Gould, *Trophy of Conquest. The Musée Napoléon and the creation of the Louvre*, 1965, p.100.
5. There are copies of all the inventories in the Prado and in the Instituto Diego Velázquez, Madrid, and a copy of the 1772 Royal Palace inventory in the National Gallery, London. The inventory of 1686 for the Alcázar was published by Yves Bottineau, *Bulletin Hispanique*, 58, 1956, pp.421-52; the others are in process of publication by G. Fernández Bayton, *Inventarios Reales*, 1975ff.
6. On the Buen Retiro Palace, see Jonathan Brown and J. H. Elliott, *A Palace for a King. The Buen Retiro and the Court of Philip IV*, Yale U. P., 1980.
7. F. Zarco Cuevas, *Cuadros reunidos por Carlos IV siende Principe, en su Casa de Campo de El Escorial*, 1934 (extract from 'Religión y Cultura'), p.37, nos.331-4.
8. I. H. Lipschutz, *Spanish Paintings and the French Romantics*, 1972, pp.40-51; Gould, *op. cit.*, pp.97-9; M. Gómez Imez, *Inventario de los Cuadros Sustraidos par el gobierno intruso en Sevilla el año de 1810*, Seville 1896; Allan Braham, *El Greco to Goya*, exhibition catalogue, N.G. 1981, p.21ff. For an account of Joseph's character and reign see Michael Ross, *The Reluctant King*, 1976.
9. Quoted in the *Quarterly Review*, 92, 1853, p.464.
10. Even the painted inventory numbers can cause confusion. For example, both the Godoy and the Medinaceli collections had white numbers painted on the front of pictures in the same manner as those in the royal collection (I am grateful to A. E. Perez Sanchez for this information).
11. John Hardy, 'The building and decoration of Apsley House,' *Apollo*, 98, 1973, p.170ff.
12. The drawings by Wyatt and others for the project, formerly in the Duke's collection, were sold at Sotheby's 11th December 1980, and reproduced in the catalogue.
13. Hardy, *op. cit.*, p.174.
14. James Lees-Milne, 'Stratfield Saye House', *Apollo*, 102, 1975, p.69ff.
15. Denys Sutton, 'The Great Duke and the Arts', *Apollo*, 98, 1973, p.161ff; R. J. Charleston, 'French porcelain for the Duke', *ibid.*, p.234ff.
16. Eight of the Lapeyrière pictures are in the Wellington Museum: A. Brouwer, *The Smokers* (lot 15); Jan van der Heyden, *View of a Dutch Town* (lot 21); Abraham van Calraet, *Cavalier with grey horse* (lot 29); Willem van Mieris, *Cavalier drinking* (lot 34); Caspar Netscher, *The toilet* (lot 36); Adriaen van Ostade, *Peasants playing shuffleboard* (lot 38); Jan Steen, *The Physician's Visit* (lot 55); Teniers, *A village merrymaking* (lot 58).
17. All twelve of the Le Rouge pictures are in the Wellington Museum: Bakhuizen, *Man of rank embarking at Amsterdam* (lot 37); Jan van der Heyden, *View of the Vecht, near Maasen* (lot 20); Nicolas Maes, *The Eavesdropper* (lot 29) and *The Milkwoman* (lot 30); Pannini, *St Paul at Athens* and *St Paul at Malta* (lot 41); Jan Steen, *The Wedding Party* (lot

53) and *The Egg Dance* (lot 54); Jan van Huysum, *Rape of Proserpine* (lot 67); Jan Victors, *A Village Scene* (lot 68); J. Lingelbach, *Landscape with travellers*, a pair (lots 70, 71).

18. The British Library copies of these sale catalogues are inscribed with prices. The rate of exchange was about 25 fr. to the £.
19. J. D. Passavant, *Tour of a German artist in England*, i, 1836, p.227. For a recent discussion see Christopher Brown's introduction to *Scholars of Nature*, Ferens Art Gallery, Hull, 1981.
20. Oliver Millar, *The Queen's Pictures*, 1977, p.151.
21. Brinsley Ford, 'The Pictures at Stratfield Saye', *Apollo*, 102, 1975, p.28, fig.18.
22. E. de Jongh and his followers have led the way in research in this field; see especially the exhibition catalogue *Tot Lering en Vermaak*, Rijksmuseum, Amsterdam, 1976. For a broad survey of the history of moralizing symbolism in Netherlandish genre painting, see P. C. Sutton, *Pieter de Hooch*, 1980, p.41.
23. Elizabeth Longford, *Wellington. Pillar of State*, 1972, pp.268, 271.
24. Oliver Millar, *Pictures in the Royal Collection. Later Georgian Pictures*, 1969, p.xxxv.
25. See catalogue, no.194.
26. H. Clifford Smith, 'Sir Francis Grant's Quorn Masterpiece,' *Country Life*, 111, 1952, p.152f. The painting is now in the Paul Mellon collection.
27. W. P. Frith, *My Autobiography and Reminiscences*, 1887, i, p.323.
28. *Quarterly Review*, 92, 1853, p. 464. It is likely that Richard Ford was the author of this review of the Apsley House pictures as the text is very similar to his introduction to *Apsley House and Walmer Castle, illustrated by plates and description*, 1853.
29. Frith, *Autobiography*, *loc. cit.*
30. Brinsley Ford, *loc. cit.* (note 21).

Chronology of the Duke of Wellington

Ensign, *7 March 1787*
Lieutenant, *25 December 1787*
Captain, *30 June 1791*
Major, *30 April 1793*
Lieut.-Colonel, *30 September 1793*
Colonel, *3 May 1796 (India)*
Major-General, *29 April 1802*
Knight Companion of the Bath, *1 September 1804*
Colonel of the 33rd Regiment of Foot (later the Duke of Wellington's
 Regiment), *30 January 1806 (to December 1812)*
Irish Secretary, *3 April 1807 (resigned April 1809)*
Privy Councillor, *8 April 1807*
Lieutenant-General, *25 April 1808 (Portugal)*
Marshal-General of the Portuguese Army, *6 July 1809*
Baron Douro of Wellesley and Viscount Wellington of Talavera,
 26 August 1809
Member of the Regency in Portugal, *August 1810*
General, *31 July 1811*
Conde de Vimeiro and Knight Grand Cross of the Tower and Sword,
 (Portugal), *26 October 1811*
A grandee of Spain, with the title of Duque de Ciudad Rodrigo,
 February 1812
Earl of Wellington, *18 February 1812*
Order of the Golden Fleece (Spain), *1 August 1812*
Generalissimo of the Spanish Armies, *August 1812*
Marquess of Wellington, *18 August 1812*
Marquez de Torres Vedras (Portugal), *August 1812*
Duque da Victoria (Portugal), *18 December 1812*
Colonel of the Royal Regiment of Horse Guards, *1 January 1813 (to 1827)*
Knight of the Garter, *4 March 1813*
Field Marshal, *21 June 1813*
Marquess Douro and Duke of Wellington, *3 May 1814*
Ambassador to the Court of France, *5 July 1814 (to November)*
Prince of Waterloo (Netherlands), *18 July 1815*
Commander-in-Chief of the Allied Armies of Occupation in France,
 22 October 1815
Field Marshal in the Austrian, Russian and Prussian Armies, *October 1818*
Master-General of the Ordnance, *26 December 1818*
Governor of Plymouth, *9 December 1819*
Colonel-in-Chief of the Rifle Brigade, *19 February 1820*
Lord High Constable (at the Coronations of George IV, William IV and
 Victoria), *1821, 1831, 1838*
Constable of the Tower of London, *29 December 1826*
Colonel of the Grenadier Guards, *22 January 1827*
Commander-in-Chief, *22 January 1827*
Prime Minister, *15 February 1828 (resigned October 1830)*
Lord Warden of the Cinque Ports, *20 January 1829*
Chancellor of the University of Oxford, *30 January 1834*
Secretary of State for Foreign Affairs, *December 1834 (resigned April 1835)*

Picture frames and picture hanging at Apsley House

by Simon Jervis

On 7 August 1829 Benjamin Dean Wyatt, the 1st Duke of Wellington's architect, wrote to his patron as follows:
'I beg to mention to Your Grace that I have seen three *very fine* old carved oak French Picture Frames, for whole length portraits, suited to the style of decoration intended for the Gallery. Shall I have these things sent to Apsley House for Your Grace to see? One of the Picture frames has the following Inscription upon it, viz. 'Donné par le *Roy* aux Juge et consuls de Paris en 1758'. It strikes me that these Frames would do admirably to hang over the 3 Fire places of the Gallery.'
On 11 September 1829 Wyatt wrote thus:
'With respect to the size of the Picture frames to which Your Grace's letter of today relates, I beg to mention that if Your Grace has any inclination to have the large French frame it would be very possible to increase or diminish its size, so as to suit the size of either of the Pictures described by Your Grace; but of the two it would be much easiest to increase it.' On 18 September the Duke replied: 'I find upon enquiry that my Picture of Charles 1st is 9 feet 9 inches and a half long by seven feet wide. It is ten inches shorter and fifteen Inches narrower than what is required to fill the largest of the three frames. It is 10 inches shorter & one foot narrower than the second size, it is nine inches too long and ten Inches too wide for the 3rd size of frame. The other Pictures that is the Bloody Mary & the Rodolph of Hapsburgh are of the small size of full lengths.'
This exchange is illuminating in several ways. It shows the Duke's close attention to every detail of the planning of his great Gallery at Apsley House, then building. It shows Wyatt, as architect, was concerned that the frames of the paintings to hang in the three principal axial positions above the fireplaces in the Gallery should match its interior decoration in the French style. It shows that even before the Gallery was complete the pictures to hang above the fireplaces had been chosen. Since 1980, when the present Duke of Wellington allowed the Museum to buy the portrait of 'Bloody Mary' (WM5–1980), the three paintings have been restored to their original positions in the Gallery. Their frames are not old French ones, as proposed by Wyatt, but new English ones in the French style, almost certainly designed by Wyatt, so congruous is their ornament with his French interior decoration. Fortunately the 'Bloody Mary' frame bears its maker's lable as follows:

TEMPLE & SON
Carvers, Gilders & Picture Frame Makers
by APPOINTMENT TO
His Royal Highness the Duke of York
No 50 Great Titchfield Street
LONDON

Thomas Temple is first recorded in Pigot's London Directory of 1827 as working as a carver and gilder at 50 Great Titchfield Street. Frederick Augustus, Duke of York, died in 1827 leaving uncomplete his London palace, of which Benjamin Dean Wyatt had been the architect since 1825, in collaboration with his brother Philip Wyatt. York House (now Lancaster House) was the direct prototype for the additions made to Apsley House in the late 1820s, and there seems every probability that Temple owed his involvement at Apsley to his earlier contact with Wellington's architect at

York House. Great Titchfield Street was also the address of another prominent frame maker, Joseph Crouzet, who worked on occasion for Constable.

Two other labels by Temple have been noted at Apsley House, on the Swebach Encampment (WM1643–1948) and on the Gysels Flemish Village (WM1646–1948). However bills and correspondence in the archives at Stratfield Saye make it clear that up to his bankruptcy in 1839 Temple was the Duke's main frame-maker, and that many of the unlabelled frames at Apsley House must be by him. His bill for February to December 1837 amounted to £13.0.0; it included maple frames for engravings and 'Dec. 13 Making a handsome French frame for portrait of the Earl of Maryborough 6.15.0'. His bill for April to December 1838 amounted to £58.11.6 and included 'Regilding a carved french frame enlarging do. repairing the carving back lining &c. 12.0.0 . . . Making 13 Tablets with the name of painters 1.6.0 . . . Rehanging 8 pictures in the Gallery 5.0 . . . Removing 2 Cases from Apsley House to Mr Seguier's and unpacking 7.0 . . . Making a handsome sweep Frame for Picture by Murillo 10.16.0 . . . Regilding a Frame for portrait of the Dke of Marlborough 1.0.0. Among other frames regilded was that of the 'pancake Woman'.

The mention of 'Mr Seguier' introduces the Duke's principal man of business and adviser in artistic matters, William Seguier, whom Constable jocularly described in 1833 as 'a much greater man than the King'. Seguier and his brother John were the Duke's restorers. In 1842, for instance, they charged for 'Cleaning and Varnishing 205 Pictures at Apsley House 51.5.0'. A bill of 1845 from John Seguier for 'Arranging Pictures at Apsley House £1.1.0' seems to imply advice at a professional level, and letters from William Seguier make it clear that he advised the Duke on which paintings were suitable for hanging at Apsley House, where there was a conscious effort to create a great picture gallery, and which were of lesser importance and therefore to be sent to Stratfield Saye. The aftermath of Temple's bankruptcy demonstrates Seguier's role as regards frames. It emerged that before he went bankrupt Temple had finished a number of frames for the Duke and that the rest were 'in a very forward state'. Temple's official assignee, George Lackington, proprietor of the Egyptian Hall in Piccadilly, then ordered the completion of the frames and offered them to the Duke. In December 1839 the Duke wrote to Seguier stating that he had only given minor orders to Temple and that Lackington had acted quite improperly in ordering the completion of the frames after Temple's bankruptcy. From Seguier's reply it is clear, although not unequivocally stated, that he had been in the habit of ordering frames for the Duke's paintings from Temple, without consulting the Duke. In the event the Duke agreed to take the completed frames provided they were suitable.

From at least 1843 Temple's role as the Duke's main frame-maker seems to have been filled by 'Robert Thick, Carver and Gilder, 35 Clipston Street, Gt Portland Street', as he appears on his account for January to September of 1843, totalling £18.8.0 and including items for frames and for hanging paintings. Thick only opened business at Clipston Street in 1843. He remained there until 1854. Also in Clipston Street in 1851 were the cabinet-makers Johnstone & Jeanes, the painter Ford Madox Brown and H F & C Hawkins, carvers and gilders. Thick's account for 1844 amounted to £120.5.0 and included as well as items for hanging and sundries 'Making & Gilding Rich frame to Wouvermans 9.0.0', another similar for the companion painting (these must be WM 1617 1650–1948), 'Making & Gilding Frame to Pan & Syrinx of Brill 5.14.0, Ditto Magdalen in landscape Spanish School 7.16.0, Ditto Jacob receiving the Blessing Murillo 8.0.0'. In 1944 Miss Mary Draper presented to the 7th Duke of Wellington a Thick ledger, from which it is clear that he worked for many great collections. It includes work done for

the 1st Duke from 1848 to 1852, for example 'April 12 1852 Making Gilt Frame to Pt. of Wm. Pitt 10.10.0'.

Temple and Thick were however not the only frame-makers to work for the Duke. The 'Catarina Cornaro' (WM1543-1948) bears the impressed mark 'SQUIRE MANUFACTURER LISLE STREET LONDON', as does the companion frame to Doge Marcantonio Memmo (WM1543–1948). Charles Squire was at 38 Lisle Street, Soho, from at least 1846 to 1850, although not before 1843. Also in Lisle Street in 1850 were Reuben Brooks, carver and gilder, James Parry, picture cleaner, and William Anthony, restorer of paintings. In 1851 Squire moved to 20 Old Fish Street, City and in 1852 the firm became Henry Squire & Co. It is also worth mentioning that in 1853 and 1844 'Henry Graves & Company, Printsellers to the Queen, 60 Pall Mall' submitted accounts for prints and for maple frames for prints.

Such in brief is the information about the frames at Apsley House which has so far come to light. Most seem to have been made for the 1st Duke. However others, particularly those for the Napoleonic portraits and for the portraits of allied sovereigns, may have accompanied these paintings into the Duke's collection. This seems particularly likely in the cases of the frames of the Lefèvre Napoleon (WM1491-1948) decorated with Napoleonic bees and the Gérard Louis XVIII (WM1464–1948) decorated with fleurs-de-lys.

Much more work needs to be done before the stylistic groups which can be more or less clearly discerned are properly disentangled and further conclusions drawn. Nevertheless it is clear that in general neo-classical frames were thought appropriate for the Dutch paintings, and rococo for the Italy and Flemish paintings. No consistent rule seems to apply to the Spanish paintings. Portraits tended to have plain frames with minor neo-classical or rococo embellishments. To prevent confusion it should be put on record that, when in 1980 the present Duke of Wellington generously gave to the Museum the four Bonnemaison Raphael copies which hung in the Portico Room under the 1st Duke, only one, the Madonna della Perla (WM1-1980), had its original frame. This served as a model for modern copies made by Mr Paul Levi for the three Bonnemaisons without frames (WM2,3,4-1980).

Picture hanging at Apsley House is too complex a subject to be treated fully here. Evidence for the 1st Duke's approach to hanging includes the illustrations to Richard Ford, *Apsley House and Walmer Castle* (London, 1853) (the Museum has recently purchased five of the watercolours prepared for this work (WM1-5-1981), and Salter's 1836 view of the Waterloo Banquet. Written descriptions by Ford, Passavant, Waagen and in the 1852 Guide Book are also helpful. The 2nd Duke's complete rehanging of the Gallery is recorded on hanging cards of about 1880 and Evelyn, Duchess of Wellington's 1901 *Catalogue* records the disposition then. Photographs of about that date give a clear idea of the character and the detail of the hanging in several rooms, as does a view of the Gallery published in E. Beresford Chancellor, *Private Palaces of London* (London, 1908). In essentials the scheme of about 1900 seems to have survived until the Second World War, when many of the paintings were removed to the country for safe-keeping.

After the War the 7th Duke's munificent gift to the Nation of Apsley House and its contents included 193 paintings, as compared to the 288 distributed in the rooms comprising the Wellington Museum in 1901. Artistic quality and historic significance seem to have been the criteria for selection, and the reconstruction or preservation of the interiors as they were under the 1st Duke do not seem to have been major considerations. When the Wellington Museum was opened to the public in 1952 the paintings were hung without reference to their original disposition, except in the Dining Room and the Striped Room. Considerations taken into account were school, size, subject and quality. In other words Apsley House was treated essentially

on the same basis as, say, the National Gallery. This approach was following in the various rehangings which took place up to the mid 1970s.

In 1973 John Hardy, of the Department of Furniture and Woodwork, published an article 'The Building and Decoration of Apsley House' in an issue of *Apollo* devoted to the Wellington Museum. The present writer was at that time planning the redisplay of part of the Continental Primary Galleries at the Victoria and Albert Museum which was to include a selection of Mannerist Kunstkammer objects of the late 16th century. Dr Charles Avery, then in the Sculpture Department, who had identified the 'Rodolph of Hapsburgh' at Apsley House as a work by Hans von Aachen, suggested its inclusion in the new gallery alongside the Adriaen De Vries relief of Rudolph (6920–1860) and the Wenzel Maler wax of Rudolph (1208–1864). The painting was at that time in store at the Victoria and Albert Museum sundered from its magnificent original frame by Thomas Temple, in store at Apsley House. John Hardy then drew the present writer's attention to the crucial importance of the painting and its frame to the Gallery at Apsley House, and the proposal to display the painting at the Victoria and Albert Museum was abandoned. This incident gave impetus to the consultations which led in 1976 to the decision of the Director, Dr Roy Strong, to transfer responsibility for Apsley House from an officer-in-charge under the Director to the Department of Furniture and Woodwork, with its experience of administering country-house ensembles at Ham and Osterley.

Thus a picture and its frame played a major role in encouraging a completely new strategy in the display of Apsley House, namely to return the house, insofar as possible, to its appearance under the 1st Duke of Wellington. The application of this strategy, still in progress, has included not only radical redecoration of many rooms but also the rehanging of the paintings on an archaeological basis, using the evidence mentioned above. Recently, for instance, the Dining Room was rehung. It has always contained the same six paintings but until 1981 they were hung at the wrong height and in the wrong positions – wrong, that is, according to the archaeological criteria now adopted. A more complex project was the rehanging in late 1980 of the Gallery, discussed in articles by John Cornforth in *Country Life* (4 and 11 June 1981) and by the present writer in the *Connoisseur* (December, 1981). Clearly there are possible tensions between the former approach to hanging at Apsley House, in which considerations of connoisseurship and art history were paramount, and the new strategy, there are gaps in the evidence, and there are less paintings in the house than there were under the first Duke. Compromises and adjustments are in the circumstances inevitable. But the new strategy has brought with a minor benefit, that no paintings are now relegated to the store or the basement stairs, the major gain that Apsley House is far less institutional in character. It is now shown as the London palace of a great national hero, the paintings and their frames arranged in the original manner to form, as intended, the richest elements in the ensemble.

I am grateful to the Duke of Wellington for allowing me to consult the archive at Stratfield Saye, and to Mrs Joan Wilson, his Curator, for making the relevant documents available. I also thank the Hon. Georgina Stonor for assistance and advice.

Abbreviations

Arts Council, 1949
Eighteen Paintings from the Wellington Gift, Arts Council exhibition 1949.

Bartsch
A. Bartsch, *Le peintre graveur,* Vienna, 1803-21.

B. F. A. C.
Burlington Fine Arts Club.

B. I.
British Institution

Burl. Mag.
Burlington Magazine.

Ceán Bermudez, *Diccionario*
J. A Ceán Bermudez, *Diccionario Histórico de los más ilustres profesores de las Belles Artes en España,* Madrid, 1800.

Cumberland, *Anecdotes*
R. Cumberland, *Anecdotes of Eminent Painters in Spain during the 16th and 17th centuries,* London 1783, reprinted 1787.

Cumberland, *Catalogue*
R. Cumberland, *Supplement* (to the above): *Catalogue of Paintings in the King's Palace, Madrid*

Dictionary of British Portraiture
Dictionary of British Portraiture, 2, Later Georgians and Early Victorians, compiled by E. Kilmurray, 1980.

Fernández Bayton, *Inventarios*
Inventarios Reales Testamentaria del Rey Carlos II 1701-1703, Musel del Prado, Madrid, ed. G. Fernández Bayton, 1975*ff.*

Gaya Nuño, *Pintura Española*
J. A. Gaya Nuño, *La pintura española fuera di Espana,* Madrid, 1958.

Gaya Nuño, *Pintura Europea*
J. A. Gaya Nuño, *La pintura europea perdida por España: de Van Eyck a Tiepolo,* Madrid, 1964.

N. G.
National Gallery.

Not inv.
Not found in the Spanish royal inventories and thus conceivably not from the royal collection (see Introduction, p.7)

G. B-A.
Gazette des Beaux-Arts.

H. de G.
C. Hofstede de Grote, *A Catalogue Raisonné of the works of the most eminent Dutch painters of the seventeenth century*, 1907–27

K. d. K.
Klassiker der Kunst.

N. P. G.
National Portrait Gallery.

Palomino, *El Museo*
Antonio Palomino de Castro y Velasco, *El Museo Pictórico*, 1715–24.

Passavant, *Tour*
J. D. Passavant, *Tour of a German artist in England*, London, 1836.

Perez Sanchez, *Pintura italiana*
A. E. Perez Sanchez, *Pintura italiana del s. xvii in España*, Madrid, 1965.

Ponz, *Viage*
Antonio Ponz, *Viage de España*, Madrid, 1772–94

R. A.
Royal Academy.

Smith, *Cat. Rais.*
J. Smith, *A Catalogue Raisonné of the works of the most eminent Dutch, Flemish and French painters*, London, 1829–42.

Stirling, *Annals*
W. Stirling Maxwell, *Annals of the Artists of Spain*, London, 1848

Thieme Becker
V. Thieme and F. Becker, *Allgemeines Lexikon der Bildenden Künstler*, 1908–50.

Tot Lering en Vermaak
Amsterdam, Rijksmuseum, *Tot Lering en Vermaak*, 1976.

Valdivieso, *Pintura Holandesa*
E. Valdivieso, *Pintura Holandesa del siglo xvii en España*, Valladolid, *1973*.

Waagen, *Art and Artists*
G. F. Waagen, *Works of Art and Artists in England*, London, 1838

Waagen, *Treasures*
G. F. Waagen, *Treasures of Art in Great Britain*, London, 1854. (As this is the more readily available book, reference is usually made to it, though in fact the text on Apsley House is the same in *Art and Artists.)*

Wellesley, Steegmann, *Iconography*
Lord Gerald Wellesley and J. Steegmann, *The Iconography of the first Duke of Wellington*, 1935.

Wellington *Cat.*
Evelyn Wellington, *A descriptive and historical catalogue of the collection of Pictures and Sculpture at Apsley House*, 1901.

Lists and descriptions of the Wellington pictures

1824 William Hazlitt, *Criticisms on Art* (Appendix VII, 'Catalogue of the principal pictures at Apsley House', lists 45 paintings).

1836 J. D. Passavant, *Tour of a German Artist in England*, i, p.166-74 (discusses about twenty pictures in some detail).

1838 G. F. Waagen, *Works of Art and Artists in England*, ii, pp.293-301 (a critical review of the pictures).

1849 Peter Cunningham, *Hand-book for London*, p.27 (a brief description).

1853 'Apsley House,' *The Athenaeum*, 8 Jan. 1853, pp.49-50 (a brief guide to mark the opening of the house to the public).

1853 *Apsley House, Piccadilly, the Town Residence of his Grace the Duke of Wellington.*

1853 Richard Ford, *Apsley House and Walmer Castle*, illustrated by plates and description (including the lithographs of Apsley House).

1853 (Richard Ford), 'Apsley House', *The Athenaeum*, 92, pp.446-86 (a detailed survey of the collection; Ford's authorship is suggested by the similarity of the text with the introduction to the previous publication).

1854 G. F. Waagen, *Treasures of Art in Great Britain*, ii, pp.272-8 (the text is almost identical to that of 1838).

1862 *A Catalogue of the Pictures at Apsley House.*

1901 Evelyn Wellington, *A descriptive and historical catalogue of the collection of Pictures and Sculpture at Apsley House.*

1952 C. H. Gibbs Smith and H. V. T. Percival, *A Guide to the Wellington Museum* (first edition of the standard guide which marked the opening of the Wellington Museum in 1952. The most recent edition is 1977).

1965 C. M. Kauffmann, *Paintings at Apsley House* (54 reproductions).

1973 *Apollo*, September 1973 (whole issue devoted to the Wellington Museum).

Explanation of Terms

Attribution
The following terms are used –

Ascribed to
indicates an element of doubt in the attribution

Follower of
indicates a work painted within a generation of the artist concerned.

After
is used where the precise original is identified.

Manner of
indicates a general stylistic relationship; usually a much later work.

Replica
A copy attributable to the original artist.

Lit
The bibliographical sections omit some of the 19th-century references given in the 1901 Wellington Catalogue where these consist only of lists (see p.23). The references to the Duke of Wellington are to the 1st Duke.
The rubric *red* or *black* after the 1901 Wellington Catalogue number refers to the original division between pictures taken at Vitoria (black) and all the others in the collection (red).

Vara
1 vara = 33.36 in. or 84.7 cm.

Medium
The medium is assumed to be oil unless otherwise stated.

Measurements
These are given in inches followed by centimetres; height precedes width.

Artists' biographies
These have, in the main, been kept very brief. The principal monographs are sometimes listed, in particular where they do not appear in the catalogue entries.

Catalogue

Hans von AACHEN (1552–1615)
German school

Born in Cologne, he bears the name of his father's native town. He was in Italy *c.*1574–87, influenced particularly by Tintoretto in Venice, and returned to Cologne in 1588. After some time at the Bavarian court in Munich, he finally agreed to accept Rudolf II's call to Prague and was made court painter by Rudolf on 1 January 1592. He remained a close associate of the Emperor, who raised him to the peerage in 1594 and sent him abroad on several missions, and is reckoned among the leading representatives of German Mannerism.

Lit. R. A. Peltzer, Der Hofmaler Hans von Aachen', *Jahrbuch der Kunsthistorischen Sammlungen des allerhöchsten Kaiserhauses,* 30, 1911, p.49ff. Rüdiger an der Heiden, 'Die Portraitmalerei des Hans von Aachen,' *Jahrbuch der Kunsthistorischen Sammlungen in Wien,* 66, 1970, pp.135–226; E. Fučikova, *Hans von Aachen* (forthcoming).

1 THE EMPEROR RUDOLF II (1552–1612)
Inscribed lower right *el emperador Rodolfo* and on left, inventory no. *415*
Canvas, $78\frac{1}{2} \times 47\frac{1}{2}$ (200 × 121)

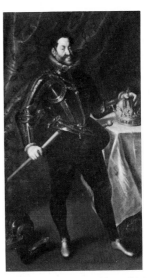

1 WM 1509–1948 Neg. Q1368
Wellington *Cat.*, p.121, no.66 red

He wears a laurel wreath, breastplate of steel and gold, with the order and collar of the Golden Fleece, dark trunks and pantaloons and buff shoes, and holds his crown which is lying on the table on the right.

Rudolf II, the son of Maximilian II, born in Vienna and educated at the Spanish court, became Emperor in 1576. Enormously learned and able, he was an outstanding patron of artists, scientists and mathematicians, and his court at Prague, with its *Kunstkammer* and its festivals, became one of the principal cultural centres of its time. Yet he was politically unworldly and indecisive, and was ultimately forced to abdicate in favour of his brother Matthias in 1611.

Catalogued as 'painter unknown' by Evelyn Wellington, the attribution to Hans von Aachen was suggested by Charles Avery when the picture was shown in the *Baroque in Bohemia* exhibition, V&A Museum, 1969 (ex-catalogue), and it has been supported by Dr. E. Fučikova (oral opinion). Certainly, of the three principal court painters – von Aachen, Spranger and Heintz – it was von Aachen and his workshop who produced most of the portraits of the Emperor. WM 1509 is similar, in particular, to the engraving after a half-length of Hans von Aachen by B. Höfel, in which the Emperor also wears a breastplate and a laurel wreath – a reference to a temporary victory over the Turks in 1598 – and holds a baton. The same head appears also in Egidius Sadeler's more famous engraving after von Aachen of 1603 (Heiden, 1970, fig.135). The soft modelling of the face is paralleled in the oil portraits by von Aachen, and from his workshop (e.g. bust portrait, Vienna Museum, Heiden, fig.132; bust portraits in armour Nürnberg, Germanisches Museum and Donaueschingen, Heiden, figs.133, 136) and is quite different in style from the portrait of Josef Heintz in the Kunsthistorisches Museum, Vienna (Schwarzenfeld, frontispiece). Final support for the attribution is provided by a drawing from the von Aachen workshop which is closely related to WM 1509 (Budapest Museum; Heiden, pp.171, 216, no.B.30, fig.186). Although it is reversed, with the table on the left, and differs somewhat in the Emperor's costume and posture, it serves to link the composition with the von Aachen workshop.

Rudolf's crown, so prominently displayed here, had been described as the finest achievement of imperial design (Evans, 1973, pp.80, 175). Attributed to Hans Vermeyen, it is based on the mitre crown of Maximilian I, which had been melted down by Philip II, but was known from Dürer's depictions, both in his portraits of Maximilian and on the summit of the Triumphal Arch. Rudolf's crown continued to be used as the Imperial Crown of Austria from 1804 until the abolition of the monarchy in 1919 and it is still the centrepiece of the Treasury of the Kunsthistorisches Museum in Vienna (*Katalog*, 1961, p.20, no.55; see also H. Fillitz 'Studien zur Krone Kaiser Rudolfs II,' '*Kunstmuseets Årsskrift*, Copenhagen, 1950, p.79 ff., figs.1–3; *id.*, *Die Österreichische Kaiserkrone*, 1959, p.22 ff., figs1–5). It is dated 1602, which provides a terminus post for this portrait. Although the crown is depicted with reasonable accuracy, its narrative scenes are not shown.

Condition. Paint surface much cracked.
Prov. According to Wellington family tradition, the Duke of Alva; Sir Henry Wellesley (afterwards Lord Cowley), brother of the Duke of Wellington, from whom the Duke bought the picture before 1829.

In a letter of 14 August, 1829 to Seguier, the Duke wrote: 'I bought some pictures some years ago from my brother, Lord Cowley ... There were among them some good ones ... an original of Rodolfe de Hapsburg ... They all came from the collection of the Duke of Alva'.
Lit. For Rudolf II see: G. von Schwarzenfeld, *Rudolf II*, Munich, 1961; R. J. W. Evans, *Rudolf II and his world,* 1973; Thomas da Costa Kaufmann, *Variations on the Imperial theme in the age of Maximilian II and Rudolf II* (Outstanding dissertations in the Fine Arts), 1978.

Sir William ALLAN (1782–1850)
British School
Born in Edinburgh, he was a contemporary of Wilkie at the Trustees Academy and then spent ten years travelling in Russia (1805–14). His early work is dominated by exotic themes derived from his travels, but from the 1820s, under the influence of Walter Scott, he turned increasingly to subjects from Scottish history. He became President of the Royal Scottish Academy in 1838 and was knighted in 1842.

2 WM 1539—1948 Neg. N2590
Wellington *Cat.*, p.293, no.180 red

2 THE BATTLE OF WATERLOO
Signed lower right *William Allan Pinxt, 1843*
Panel., $46\frac{1}{2} \times 122$ (118×310)

The artist's own description of the picture is pasted on the back of the panel:

WATERLOO.
18th June 1815. *Half-past seven o'clock p.m.*
The picture represents the last desperate effort of Napoleon to force the left centre of the allied army and turn their position. In the centre of the picture are several battalions of the Imperial Guard, formed into one massive column, led on by Marshal Ney, who, in endeavouring to ascend the rising ground occupied by the British, is received in front by Captain Bolton's Battery, while General Maitland's Brigade of Guards attack the French on their right, and General Adams' Brigade assail their left. This combined attack throws the head of the French column into irreparable confusion, perceiving which, the Duke of Wellington, who, with his staff, is immediately behind Captain Bolton's Battery, orders the general advance of the allied army, covered by a range of batteries seen on the right and left of the Duke's position. To the left of the Duke is the village of Mont St. Jean and that of Waterloo, of which the church spire is alone visible. In the distance is the forest of Soignies. The farm of La Haye Sainte is seen at the bottom of the slope, close to the road from Brussels to Genappe; a little above the farm-house is the cross road to Wavres, and the hedge-row, where, during the early part of the day, the battle raged furiously, and where Picton fell. In the neighbourhood of the farm, and along the line

towards Planchenoit, the French are seen in full retreat. On the extreme left of the spectator, the 23rd Light Dragoons are driving back the French Cuirassiers from their final attempt to silence the guns at the north-east angle of Hougoumont, from whence the smoke is issuing, the Chateau being then in flames. Beyond the smoke is the 71st Regiment, above which is seen the Nivelles road and the Church of 'Braine La Leude' in the extreme distance. Napoleon and his staff form the principal group in the foreground, comprising Soult, Bertrand, Drouet, Labédoyère, etc.

(Signed) William Allan,
72 Great King Street, Edinburgh, and 34 King Street, Covent Garden.

In terms of Allan's history paintings, of which many dealt with early Scottish or oriental themes, this was a near contemporary subject and he took the trouble to obtain copies of the engraved plans of Waterloo before beginning (Irwin, 1975). It remains a reconstruction, painted in the tradition of panoramic battle scenes under dramatic skies which can be traced back at least to Altdorfer's *Battle of Issus* in Munich, and it differs from more directly observed military scenes such as Swebach's *Wagram* (see below, no.169). However, the picture's accuracy is attested by Wellington himself, who bought it at the R.A. in 1843 and was said to have commented, 'Good – very good; not too much smoke'. *Athenaeum*, 2 March 1850).

As WM 1539 represents the battle from the French side, Allan painted a companion, seen from the British side, which was his entry for the Westminster Hall competition in 1846 (now Royal Military Academy, Sandhurst). There are preparatory drawings for WM 1539 in the National Gallery of Scotland, including studies of hands (D.4343) and of the fallen horse in the left foreground (D.3414A).

A rather different view of the battle by Felix Philippoteaux, dated 1874, in the V&A collection, is also on display at Apsley House (VAM, *Catalogue of Foreign Paintings*, ii, 1973, no.176).

Condition. The large and comparatively thin panel is badly warped, but the paint surface is in reasonably good condition.
Prov. Bought by the Duke of Wellington from the artist for £600 in 1843.
Exh. R.A., 1843 (287; reviewed *Times*, 9 May 1843); Mr Hill's Galleries, Edinburgh, 1851.
Lit. Quarterly Review, 92, 1853, p.468; Thieme, Becker i, 1908, p.300; V. Percival, *The Duke of Wellington: A pictorial survey of his life*, 1969, p.47; D. and F. Irwin, *Scottish Painters at Home and Abroad 1700–1900*, 1975, p.213.

Giuseppe Cesari, called Il Cavaliere d'ARPINO (1568–1640)
Roman School
He enjoyed the patronage of Gregory XIII and Clement VIII, by whom he was created Cavaliere di Cristo in 1600, and painted extensive series of frescoes in Roman churches and palaces in a late mannerist style. His small cabinet pictures, executed in sharp detail and somewhat similar to those of Jacopo Zucchi and Alessandro Allori, were also highly popular in the early seventeenth century.

Lit. Exhibition catalogue, *Il Cavalier d'Arpino*, Rome, Palazzo Venezia, 1973.

3 THE EXPULSION FROM PARADISE
Copper, 20¼ × 13⅞ (51·5 × 35·3)

This is one of several versions of a composition by d'Arpino of which the original is in the Louvre (*copper, 50.5 × 37.2;* Rome exh. cat. 1973, no.19, repr., dated *c.*1597). It was used again in the vault fresco in the Villa Aldobrandini, Frascati (*c.*1602-3) and there is an autograph version, with variations in the landscape, at Christ Church, Oxford (*copper, 46.5 × 35.5;* Rome exh. 1973, no.39, repr., dated *c.* 1606; Byam Shaw, 1967, no.135).

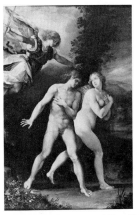

3 WM 1633–1948 Neg. J937
Wellington *Cat.*, p.129, no.125 black

d'Arpino 27

Another version was in the collection of E. V. Hyde *(copper, 48×35, sold Christie's, 7 July 78., lot 219; exh. Trafalgar Galleries, June 1977, no.4, repr. in colour)* and other versions have been recorded (Rome exh. cat. p.92f.). A drawing in the Pierpont Morgan Library *(J. Pierpont Morgan collection . . formed by Fairfax Murray,* iv, 1912, p.161) shows considerable variations and has the composition of the figures reversed.

The quality of the Wellington picture and the fact that it contains pentimenti (below the angel's knee and at Adam and Eve's legs) suggest that it may well be autograph, but Herwarth Röttgen (Rome exh., 1973) tentatively ascribed it to Bernardino Cesari (1571–1622), Giuseppe's younger brother. It is closer to the Christ Church version than to the one in the Louvre in that it includes a fuller landscape, with flowers in the foreground, and a fig leaf for Adam, but it differs from both in the position of Eve's hands, leaving one breast uncovered, and in the gesture of Adam's left hand. The composition is ultimately based on Michelangelo's *Expulsion* on the Sistine ceiling, but the mannered, ballet-like postures are characteristic of d'Arpino.

Condition. Areas of retouching on the angel's dress and Adam's face, right, but good on the whole.
Prov. Charles IV when Prince of Asturias in the Casa de Campo de El Escorial *(c.* 1782 inventory). Captured at Vitoria, 1813.
Exh. Il Cavalier d'Arpino, Rome, Palazzo Venezia, 1973, no.152, repr.
Lit. Antonio Conca, *Descrizione odeporica della Spagna,* ii, Parma, 1793, p.164; J. Zarco Cuevas, *Cuadros reunidos por Carlos IV seinde Principe, en su Casa de Campo de El Escorial,* extract from 'Religion y Cultura', 1934, p.12, no.56; Gaya Nuño, *Pintura Europea,* p.86, no.279; Perez Sanchez, *Pintura Italiana,* p.221; J. Byam Shaw, *Paintings by Old Masters at Christ Church, Oxford,* 1967, p.85.

Follower of Giueseppe Cesari, Cavaliere d'ARPINO

4 THE MYSTIC MARRIAGE OF ST CATHERINE
Inscribed on back on fragment of old paper *Joseph . . . Arp . . . as / fecit*
Walnut panel, 25⅛ × 18 (64 × 45·8)

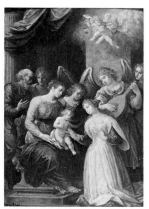
4 WM 1607–1948 Neg. H1524
Wellington *Cat.,* p.136, no.74 black

Attributed to Rottenhammer in the Wellington Heirloom catalogue, the old attribution to d'Arpino was readopted when the inscription on the back was discovered (Evelyn Wellington). The painting was listed as by d'Arpino in the inventory of the Casita del Principe, Casa del Campo del Escorial and it is close to his style but its weaknesses and lack of crispness in detail endorse Herwarth Röttgen's judgement (oral opinion) that it is the work of a follower. There is another, smaller version with half-length figures in the Prado (no.555).

The mystic marriage of St Catherine occurs in hymns from the 13th century (see under Parmigianino no. 125). After refusing to marry in her native Alexandria, St Catherine followed a hermit into the Sinai desert and there, in a church, she was baptized and spiritually married to Christ. The scene was frequently depicted from the 14th century and the iconography became standard, only the numbers of attending angels and saints remaining variable (e.g. see repr. in H. Bremond, *Sainte Catherine,* 1926, pp.10-32). Nearly always represented is the moment when ' . . . our Lord espoused her in joining himself to her by spiritual marriage . . . and in token of this set a ring on her finger' (Golden Legend). Among the immediate forerunners of this particular composition are two by Veronese: one in the Galleria Corsini, Rome, which shows St Catherine in identical posture, another in the Dulwich Gallery (no.239) in which the hovering angel appears. An engraving dated 1595 by Vespasiano Strada (Bartsch, xvii, 309, 16) also has a closely comparable composition.

Condition. Damaged area on left of St Catherine's head; smaller retouched areas on her dress.

Prov. Charles IV when Prince of Asturias in the Casa del Campo de El Escorial, *c.* 1782 inventory, no.57).
Lit. Zarco Cuevas, *op. cit.* p.12; Gaya-Nuño, *Pintura Europea*, p.86, no.280; Perez Sanchez, *Pintura Italiana*, p.221.

Ludolf BAKHUIZEN (1631-1708)
Dutch School
Born in Emden, East Friesland, he came to Amsterdam in 1649-50 and remained there for the rest of his life. He was a pupil of Allart van Everdingen and Hendrick Dubbels, but he was most influenced by the seascapes of Willem van de Velde the younger. After the two van de Veldes went to England in 1672 he was the leading marine painter in Holland.

5 A MAN OF RANK EMBARKING AT AMSTERDAM
Signed on side of barge on right *L. BAKHUYZEN F. 1685*
Canvas $42\frac{3}{4} \times 62\frac{3}{4}$ (109 × 159)

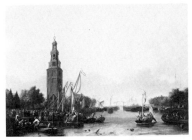

5 WM 1504–1948 Neg. GD588
Wellington *Cat.*, p.5, no.61 red

The view is of the Oude Schans canal, looking north, with the Montelbaans tower on the left and the docks in the distance. At the foot of the tower, a crowd has gathered to see off the man concerned who is bowing in acknowledgement of their salutations. Traditionally, he was identified as Admiral de Ruyter, but as the Admiral died in 1676, nine years before the picture was painted, this is unlikely. Evelyn Wellington quoted the archivist of Amsterdam, Veder, as suggesting that the subject is the embarkation of Henry Casimir II, Stadholder of Friesland in October 1684, but this has been rejected on the grounds that his wife, who accompanied him, is not represented here.

A closely related pen and wash drawing, apparently preparatory for the painting, was in the Klein sale, Frankfurt Kunstverein (7 Dec. 1910, lot 1, repr.); another, showing the same view of the Montelbaans tower and the canal, but without the figures, is in the Rijksmuseum, Amsterdam.

Condition. Slight tendency to flaking; otherwise good. Cleaned by Vallance in 1951.
Prov. Le Rouge sale, Paris, 18 April 1818, lot 3; bought by Bonnemaison for the Duke of Wellington for 21,990 fr. (£880).
Exh. B.I. *Old Masters*, 1821, (105) (as 'Embarkation of van Tromp'), 1856 (90) (reviewed, *Athenaeum*, 14 June 1856); R.A., *Winter Exhibition*, 1888, (77).
Lit. Smith, *Cat. Rais.*, vi, p.419, no.54; H. de G. vii, no.77.

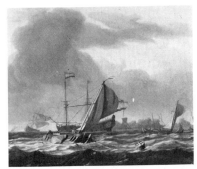

6 WM 1559–1948 Neg. K715
Wellington *Cat.*, p.17, no.223 red

6 A WARSHIP AT ANCHOR IN A ROUGH SEA
Canvas, $16\frac{1}{2} \times 20\frac{1}{2}$ (42 × 52)

Prov. Bought by the 2nd Duke of Wellington from Gambardella in 1859.
Lit. H. de G., vii, no.243.

Leandro BASSANO (1557–1622)
Italian (Venetian) School
Son of the painter Jacopo dal Ponte, called Bassano from his home city of that name. Leandro had settled in Venice by 1588 and enjoyed a successful career as a portrait painter. He also painted subject pictures in the style of his father.

Lit. W. Arslan, *I Bassano*, 1960.

Ascribed to Leandro BASSANO

7 DOGE MARCANTONIO MEMMO (1536–1615)
Canvas $39\frac{7}{8} \times 40\frac{3}{8}$ (101·4 × 102·6)

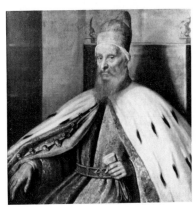

7 WM 1544–1948 Neg. H880
Wellington *Cat.*, p.155, no.185 red

Formerly catalogued as Doge Pasquala Cicogna by Tintoretto, the identity of the sitter was established upon comparison with an almost identical painting by Leandro Bassano in the Museo Civico at Padua (no.643). This is inscribed in the upper left corner:

MARCUS ANTO.S / MĒMO DUX VENET. / OBIIT. 29 OCTOB. 1615 / AET. SUAE AÑO 78. ME XI / DIE 18. DUCATUS VERO / AÑO III. MEN. III DIE. VI.

(Marco Antonio Memmo, Doge of Venice, died 29 Oct. 1615 aged 78 on (the previous) 18 Nov. He was Doge for 3 years, 3 months and 6 days).

This is generally accepted as the original painting of the Doge by Leandro Bassano (Arslan, 1960, p.266, pl.335) which was mentioned by Ridolfi in the 17th century (C. Ridolfi, *Le Maraviglie dell' arte*, Venezia, 1648, ii, p.168). The Wellington picture is identical in composition except that it shows less at the bottom – it may have been cut down – and a little less on the left. It is also somewhat smaller than the painting in Padua (101×102.5cm. as against 125×109cm.), but this is accounted for by the reduction in the amount of costume shown rather than by any difference in scale. It lacks the sharpness and precision, particularly in the facial features, of the Padua picture and it may well be a contemporary copy rather than a replica by the artist.

There are several other such copies/replicas:
[1]Venice, Accademia (no.229, 114×87cm. from S. Giacomo alla Giudecca. Arslan, 1960, p.270, 'original copy by (?) Leandro of the version in Padua').
[2]Frankfurt, Staedelsches Kunstinstitut. Formerly called Palma Giovane (111×99cm.; bought in 1847 from the Galleria Barbini Breganze, Venice. Arslan, 1960, p.343 'contemporary replica of the painting in Padua').
[3]Ex. coll. Albert Deberghe (sale Fievez, Brussels, 26 July 1930, lot 113, p.26 as Titian, portrait of a Doge, 119×96 cm.).

Marcantonio Memmo belonged to a distinguished Venetian family recorded in public documents since 960. He earned a high reputation during his career in public administration on the Venetian mainland and was elected Doge on 24 July 1612 at the age of 75. He died at the end of October 1615. His monument is in S. Giorgio Maggiore; there is a portrait of him in the Palazzo Ducale by Palma Giovane and various other portraits have been recorded (Andrea da Moste, *I Dogi di Venezia*, 1960, pp.331–6).

Because of the inscription which gives the death date, Venturi, *(Storia dell' Arte Italiana*, ix, 4, 1929, p.1321), Berenson (*Venetian Painters*, 1958, p.24) and Arslan (1960, p.266) took the Paduan picture to be later than 1615. However, there is no reason to suppose that it was a posthumous portrait; it is more likely that the inscription was added to an extant painting after Memmo's death. Certainly the inference from Ridolfi (1648) is that Leandro painted the portrait while Memmo was Doge, which would place it in the period 1612–15.

Condition. Somewhat worn and retouched. Considerable retouching along upper edge, on face, beard and sitter's right hand. Retouching along whole of lower edge may be an indication that it was cut down at the bottom (see above).
Prov. Bought by Henry Graves & Co. in 1844 from Peter Norton, a dealer of Soho Square, for £30; sold by them in 1845 to E. N. Dennys for £210; bought back by Graves for the same price a few months later and sold to the 1st Duke of Wellington, still for the same price.
Lit. The original in Padua and the versions in Venice and Frankfurt (but not WM 1544) are discussed by W. Arslan, *I Bassano*, 2nd ed. 1960, pp. 266, 270, 343, pl.335.

Sir William BEECHEY, R.A. (1753–1839)
British School
Portrait painter. Studied at the R.A. Schools under Zoffany and copied Reynolds' portraits. He became portrait painter to the Queen in 1793 and was knighted in 1798.

8 LT. GENERAL SIR THOMAS PICTON G.C.B. (1758–1815)
Canvas, 29¾×24¼ (75.6×62)
He wears the sashes and stars of the Order of the Bath and of the Portugese

8 WM 1485–1948 Neg. N1406
Wellington *Cat.*, p.290, no.30 red

Order of the Tower and Sword and from his neck hangs the badge of the Tower and Sword and the Peninsular gold cross.

Picton became a lieutenant in 1777 and thereafter spent many years on inactive service. From 1794 he served in the West Indies and, because of his knowledge of Spanish, was made governor of Trinidad, newly captured from Spain in 1797. Replaced in 1803, he was tried in England for excesses of cruelty in his administration of justice and found guilty in 1806. At a retrial in 1808 his name was cleared on the grounds that the use of torture was permissible under Spanish law, current in Trinidad when he became governor. In the same year he was promoted major-general and he served with distinction in the Peninsular War 1809–13 and at Waterloo, where he was killed. The story of his rule in Trinidad is dramatically recounted in V. S. Naipaul's *The Loss of Eldorado*, 1969.

There is another portrait of Picton, by Martin Archer Shee, in the N.P.G. (no.126). His two roles in British life, colonial villain and military hero, are neatly contrasted in two representations of him: C. Doyle's caricature entitled *Gen. Thomas Picton cruelly inflicting Torture on Louisa Calderon in the Island of Trinidad* (published in 1807) and Sebastian Graham's marble bust surmounting Picton's monument in St Paul's Cathedral. The date of WM 1485 is indicated by a label on the back, apparently copied from an inscription on the canvas before relining: *Sir Thomas Picton painted a fortnight bef. his death by / Sir WB RA.*

Condition. Pronounced bituminous cracking of paint surface.
Prov. Bought by the Duke of Wellington in 1839 from Colnaghi for £21. According to a letter from Colonel Gurwood to the Duke of Wellington dated 16 Oct. 1839: 'I have secured the portrait of Sir Thomas Picton by Sir William Beechey. I could not get a bargain in proportion to what Mr Colnaghi gave for it. I gave him 20 guineas for it. Several artists have seen it who think it a good portrait. Sir F. Stovin thinks the likeness excellent.'
Exh. South Kensington, *National Portrait Exhibition*, 1868 (200).
Lit. Dictionary of British Portraiture, 2, 1979, p.170.

After BEECHEY

9 HORATIO, VISCOUNT NELSON (1758–1805)
Canvas, $53\frac{1}{2} \times 43\frac{1}{2}$ (136 × 111)

9 WM 1530–1948 Neg. Q1365
Wellington *Cat.*, p.292, no.102 red

Three-quarter length, life-size, age about 44. He wears the blue, gold-embroidered coat with gold epaulettes and white waistcoat and breeches of an admiral. From his neck hangs the gold medal of St Vincent and that of the Nile. On his chest are the stars of the Bath, of St Ferdinand and of the Ottoman order of the Turkish Empire. He wears the red sash of the Bath and beneath it that of St Ferdinand of the Two Sicilies with the cross of the order at the lower end.

Nelson entered the navy in his twelfth year, under his uncle Captain Suckling. He was given his first command in 1778 and spent the following years, until the outbreak of war with France in 1793, largely on missions to the West Indies. After his victory against the Spanish fleet at Cape St Vincent in 1797 he was made K.B. and promoted to rear-admiral. In July 1797 he lost his right arm at Santa Cruz, Tenerife, but only a year later he won his most overwhelming victory at Aboukir against the French fleet on the Nile. He defeated the Danish fleet at Copenhagen in 1801, was appointed Commander-in-chief in 1803 and was killed at Trafalgar in October 1805.

Beechey's original full-length portrait of Nelson is at St Andrew's Hall, Norwich, and the bust-length sketch for it, which was exhibited at the R.A. in 1801 (125), is on loan at the N.P.G. A three-quarter length version, very similar to WM 1530, formerly in the collection of Commander E. Culme Seymour, R.N., was bought for the Admiralty in 1970 ($49\frac{1}{2} \times 38\frac{3}{4}$ in.). The

canvas of WM 1530, before relining, bore what appeared to be a manufacturer's or importer's stamp that included the date 1806, which indicates that this replica was painted after Nelson's state funeral in January of that year.

Hoppner's full-length portrait of *c*.1801 in the royal collection is closely comparable in posture and type (W. McKay and W. Roberts, *John Hoppner*, R.A., 1909, p.182 repr.).

Condition. Surface badly cracked through paint shrinkage; relined *c*.1950.
Prov. Bought by or presented to the Duke of Wellington.

Féréol BONNEMAISON (active 1796; d.1827)
French School

Educated at Montpelier, he exhibited portraits at the Paris Salon from 1796. After Waterloo, when the Duke of Wellington was concerned with the return of the art treasures looted by Napoleon, he commissioned Bonnemaison to restore the Raphaels taken from Madrid and to make lithographic reproductions of them. These were published in 1822 with a text by Eméric David. Bonnemaison continued to be active as a lithographer and as director of restoration of pictures at the Louvre, but by 1817 he had also become an art dealer, acquiring control of the Talleyrand collection of Dutch masters in that year and bidding for Wellington at the Le Rouge sale.

Lit. Denys Sutton, 'The Great Duke and the Arts', *Apollo*, 1973, p.166f.

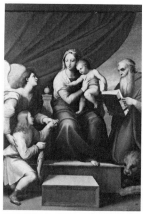

10 WM 3–1980 Neg. GK4751
Wellington *Cat.*, p.213, no.75 red

10 COPY OF RAPHAEL'S 'MADONNA WITH THE FISH'
Canvas, 85×63 (216×160)

The Archangel Raphael presents Tobias, holding the fish, to the Virgin, while St Jerome reads from his translation of the Bible, thereby upholding the canonical nature of the Book of Tobit. The original painting by Raphael is in the Prado, Madrid *(Catálago de las Pinturas,* 1972, no.297; transferred onto canvas, 215×158 cm.). It was painted in 1513–14 for S. Domenico, Naples, and acquired by Philip IV of Spain in 1645.

This is one of four life-size copies made by Bonnemaison for the Duke of Wellington of the Raphaels in the Spanish royal collection which had been taken from the Escorial to Paris by Joseph Bonaparte in 1813 and exhibited at the Musée Napoléon. While in Paris, in about 1816, they were restored and transferred from panel onto canvas under the direction of Bonnemaison.

The process was described by Passavant: 'There is little doubt but what (*sic*) these pictures required being cleaned and transferred from wood to canvas; but I have as little hesitation in saying, that they were much injured in the process, and not treated with that care they deserved. In confirmation of this, I remember an anecdote which David, under whose instruction I studied in Paris, always used to relate. On visiting Bonnemaison one day, at his studio, David found him, to his great consternation, with a sponge full of spirits of turpentine in his hand, with which he was most unmercifully rubbing the injured parts; and that to all his remonstrations on the danger of such a proceeding he could elicit no answer beyond, 'That's of no consequence, turpentine is good for them.'

The copies were delivered to the Duke in 1818 and by November of that year the originals were back in Madrid. A fifth painting, *The Holy Family under the Oak* (Prado, no.303), which suffered the same fate as the other four, was not, apparently, copied by Bonnemaison.

Prov. Bought by the Duke of Wellington from Féréol Bonnemaison, 1818; presented to the Museum by the 8th Duke of Wellington in 1980.
Exh. B.I., *Old Masters*, 1822 (161–4).
Lit. Passavant, *Tour*, i, 1836, p. 173; *Quarterly Review*, 92, 1853, p. 456 ('hard and

unsatisfactory copies – libels in truth'); Waagen, *Treasures*, ii, 1854, p.274. For the original painting see: P. de Madrazo, *Catálogo descriptivo é Historico del Museo del Prado*, i, 1872, p.184 ff.; O. Fischel, *Raphael*, 1964 ed., p.139, pl.149; L. Dussler, *Raffael*, 1966, p.45, no.74, with further lit.

11 COPY OF RAPHAEL'S 'VISITATION, WITH THE BAPTISM IN THE DISTANCE'
Canvas, $79 \times 57\frac{1}{2}$ (200 × 146)

The original painting is in the Prado, Madrid *(Catálogo de las Pinturas*, 1972, no.300; transferred on to canvas, 200 × 145cm.). Painted for the church of San Silvestro, Aquila, in the Abruzzi, in about 1519, it was acquired by Philip IV of Spain in 1655. It is now considered to be a workshop product, possibly in part by Giulio Romano.

This is one of four such life-size copies made by Bonnemaison for the Duke of Wellington (see above, no.10).

Prov.
Exh. } As above, no.10.
Lit.
 For the original see Rosenberg, *Raffael*, K.d.K., pl.165; Dussler, p.46, no.77.

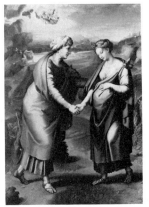

11 WM 4–1980 Neg. GK4750
Wellington *Cat.*, p.64, no.76 red

12 COPY OF RAPHAEL'S 'HOLY FAMILY', CALLED 'LA PERLA'
Canvas, $58\frac{1}{4} \times 46$ (148 × 117)

The original painting is in the Prado, Madrid *(Catálago de las Pinturas*, 1972, no.301, panel, 144 × 115 cm.). It is no longer accepted as by Raphael but seen as the work of his pupils, conceivably Giulio Romano.

This is one of four such life-size copies made by Bonnemaison for the Duke of Wellington (see above, no.10).

Prov.
Exh. } As above, no.10.
Lit.
 For the original see Rosenberg, *Raffael*, K. d. K., pl.160; Dussler, p.46, no.78.

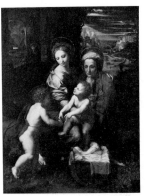

12 WM 1–1980 Neg. GK.4752
Wellington *Cat.*, p.321, no. 77 red

13 COPY OF RAPHAEL'S 'CHRIST CARRYING THE CROSS'
Canvas, $122\frac{1}{4} \times 87\frac{3}{4}$ (311 × 223)

The original painting is in the Prado, Madrid, *(Catálogo de las Pinturas*, 1972, no.298; transferred onto canvas, 318 × 229cm.). It was painted in 1516–17 for the monastery of S. Maria del Spasimo in Palermo and became popularly known as 'Lo Spasimo di Sicilia'. It is in Raphael's late, dramatic style of the period of the tapestry cartoons and is generally considered to have been partly or wholly painted by pupils.

This is one of four such life-size copies made by Bonnemaison for the Duke of Wellington (see above, no.10).

Condition. Detached from its stretcher and in a much damaged condition.
Prov.
Exh. } See above, no.10.
Lit.
 For the original see O. Fischel, *Raphael*, 1964 ed., p. 276, repr.; A. Rosenberg *Raffael*, K.d.K., 1909, p.146; Dussler, p.45 no.75.

(not reproduced)
13 WM 2–1980
Wellington *Cat.*, p.152 no.74 red

Bartholomeus BREENBERGH (1598/1600–1657)
Dutch School
Born in Deventer, he was in Rome from 1620 where he came under the influence of Elsheimer, Bril and Poelenburgh. In 1629 he returned to Holland and settled in Amsterdam. Together with Poelenburgh he was the most Italianate of Dutch painters, specialising in landscapes, with figures and

ruins bathed in a warm orange light. From the late 1630s he turned to painting biblical subjects which betray the influence of Rembrandt.

Lit. M. Roethlisberger, *Bartholomäus Breenbergh, The Paintings,* 1980.

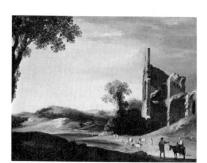
14 ;WM 1647–1948 Neg. Y897
Wellington *Cat.,* p.24, no.209 black

14 LANDSCAPE WITH CLASSICAL RUINS AND FIGURES
Inscribed with inventory no.82
Copper, 12½ × 17 (31.8 × 43.2)

Typical of Breenbergh's Italianate landscapes, this painting may be placed *c.*1630, in the latter part of his stay in Rome or not long afterwards. (Compare for example no.28 in the exh. *Italianisirende Landschapschilders,* Utrecht, 1965; dated 1631). The fact that it is on copper supports an early date; the works painted in Holland tend to be on panel or canvas rather than copper, though this is by no means invariable. Roethlisberger's (1980) attribution to Poelenburgh appeared too late to be taken into account in this catalogue.

Condition. Some small areas of damage above hills in left background, otherwise good.
Prov. Spanish royal collection (not inv.); captured at Vitoria, 1813.
Lit. Gaya Nuño, *Pintura Europea,* no.172; Roethlisberger, 1980, p.36 no.42

Paul BRIL (1554–1626)
Flemish School, worked in Rome
He was born in Antwerp, but after a brief stay in Lyon from 1574 he settled in Rome. From 1600 he was strongly influenced by Elsheimer and his landscapes mark the transition between the detailed treatment of the 16th century and the broader, more naturalistic concept of the 17th century.

Lit. Anton Mayer, *Das Leben und die Werke der Brüder Mattheus und Paul Brill,* 1910.

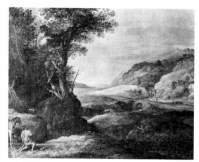
15 WM 1623–1948 Neg. H871
Wellington *Cat.,* p.37, no.101 black

15 LANDSCAPE WITH ST HUBERT AND THE STAG
Signed on stone, centre foreground *PA-- BRIL*
Canvas, 14⅛ × 18 (36 × 45.7)

St Hubert was out hunting when he saw Christ on the cross between the antlers of a stag. As a result of his vision he became converted to Christianity and subsequently became Biship of Liège, where he died in 727. The scene of his vision is commonly depicted from the 15th century onwards. However, St Eustace had the same vision and it is often difficult to distinguish between them. In this case St Hubert is the likelier alternative as St Eustace's stag usually stands on rocks which do not appear here, and also Hubert, Bishop of Liège, is the more popular of the two in Netherlandish painting.

Another version of the scene by Bril was in the Wetzlar collection, Amsterdam, but it is not similar in composition. He frequently placed saints in the corners of his landscapes: St Jerome, for example, in a painting in the Galleria Borghese, Rome, and St John in the Louvre. The relatively broad treatment indicates a date in the latter part of Bril's career, after *c.*1615.

Condition. Pronounced craquelure; retouched upper edge, but condition good on the whole.
Prov. Spanish royal collection, possibly to be identified with a *Vision of St Eustace,* 'Flemish school', of similar size listed in the Royal Palace inventory of 1772 (Gabineto colgado de verde); captured at Vitoria, 1813.
Lit. Gaya Nuño, *Pintura Europea,* no.135, pl.56; G. T. Faggin, 'Per Paolo Bril', *Paragone,* 16, 1965, p.32, no.43.

BRITISH School

British School, *c.*1805

16 WILLIAM HENRY WEST BETTY, THE 'YOUNG ROSCIUS.' (1791–1874)
Canvas, with painted arched top, 22¾ × 19¼ (58 × 49)

The appearance of Master Betty, an infant prodigy capable of arousing mass

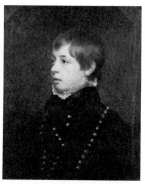
16 WM 1552–1948 Neg. M241
Wellington *Cat.,* p.235, no.206 red

adulation, was the main event of the London theatre season of 1804–5. From the time of his debut, as Selim in *Barbarossa*, at Covent Garden on 1 December 1804, through his roles as Romeo, Hamlet, Richard III and Young Norval in Home's *Douglas* in 1805-6, he had London at his feet. But his prominence declined almost as quickly as it had risen. In 1808 he retired from the stage to enter Christ's College, Cambridge, and his attempt to make a comeback in 1812 was unsuccessful.

During the period of his fame, at the age of 13-15, he was portrayed by the leading portrait painters of the time, including Harlow (N.P.G) Northcote (Shakespeare memorial theatre, and Petworth) and Opie (Garrick Club and N.P.G.) as well as by theatrical illustrators and caricaturists. WM 1552 is not very similar to any of the principal images. It was catalogued as 'attributed to Lawrence' in the Wellington Catalogue, but the link with Lawrence is too tenuous for such a description and the very cursory execution defies attribution to any of the better known artists.

Condition. Tendency to flaking in the background, particularly round the face.
Prov. Bought by the 2nd Duke of Wellington in 1871 from W. Gardner, Conduit Street, for £25.
Lit. For the sitter, see Giles Playfair, *The Prodigy; The Strange Life of Master Betty*, 1967; there is also a Theatre Museum Card: J. Roose-Evans, *Master Betty – The Infant Phenomenon*, 1978.

British School, *c.*1850

17 GENERAL SIR FRANCIS PATRICK NAPEIR, K.C.B. (1785–1860)
Canvas, $49\frac{1}{2} \times 39\frac{1}{2}$ (126 × 100)

(not reproduced)
17 WM 1563–1948
Wellington *Cat.*, p.399, no.271 red

The sitter was the younger brother of Sir Charles James Napier, commander of the army in Bengal. He served with distinction in the Peninsular War, of which he wrote a history, and was made general in 1859. His white hair and beard suggest an age over sixty and hence a date *c.*1850. A comparable portrait of him by Spiridione Gambardella is in the private collection of the Duke of Wellington, and a marble bust by G. G. Adams, 1855, in the N.P.G. (1197).

Condition. The canvas is much damaged and in need of extensive repair and relining.
Prov. Bought by or presented to the 2nd Duke of Wellington.
Lit. Dictionary of British Portraiture, 2, 1979, p.155.

Adriaen BROUWER (1606(?)–1638)
Flemish School
Born in Oudenaarde, he moved to Holland in 1621 and spent the next decade in Amsterdam and in Haarlem where he was a pupil of Frans Hals. In 1631 he became a master of the Antwerp Guild of St Luke, but two years later he was in prison, probably for debt. He painted scenes of peasant life and, in particular, the interiors of taverns, of which he was said to have been an *habitué*.

Lit. G. Knuttel, *Adriaen Brouwer, the Master and his Work*, The Hague, 1962.

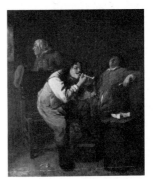

18 THE SMOKERS
Signed on bench-end on right *Braw . . .*
Oak panel, $16\frac{1}{8} \times 14\frac{3}{4}$ (41 × 37.4)

Three men are seated, two of them smoking pipes; a woman holding a tankard is speaking to another who is looking in at the window. The broad and fluid manner and the elimination of superflous detail indicate a late work: Bode (1924) and Knuttel (1962) agree in dating it *c.*1635–38. There is a replica in Budapest (K. Garas, *Paintings in the Budapest Museum of Fine Arts*, 1977, pl. p.263).

18 WM 1522–1948 Neg. L395
Wellington *Cat.*, p.7, no.86 red

Smokers appear frequently in Brouwer's tavern scenes, though at this time smoking was still a relatively new occupation. It was seen as a popular pastime, becoming current first among the lower classes, and consequently smokers were linked with drunkards in tavern scenes at an early date. Furthermore, the elusive quality of the smoke itself was interpreted as an allegory of the transitory nature of human life and earthly vanities. This is underlined in a painting by Brouwer's follower, Joos van Craesbeek, in which a man holds a skull in one hand and a pipe in the other, and also in an engraving by Hendrick Bary of a smoker inscribed (in Dutch) 'While I diligently smoke . . . so flies the world away' (*Tot Lering en Vermaak*, figs. 7c, 7d).

Condition. Panel warped upper right; small paint loss on right of central head.
Prov. Braamcamp sale, Amsterdam, 31 July 1771, lot 37; Randon de Boisset sale, Paris, 27 Feb. 1777, lot 53; C.J. Clos sale, Paris, 18 Nov. 1812, lot 1; Lapeyrière sale, Paris, April 1817, lot 15, bought by Bonnemaison for the Duke of Wellington for 2,401fr. – about £96.
Exh. B.I., *Old Masters*, 1818, (25); Guildhall, *Loan Collection*, 1903 (152); B.F.A.C., *Winter Exhibition*, 1927–8 (28).
Lit. Waagen, *Treasures*, ii, p.277; Paul Mantz 'Adriaen Brouwer', *G. B-A* 21, 1880, p.43; H. de G., iii, no.117; W. von Bode, *Adriaen Brouwer*, 1924, p.164, pl.114; G. Knuttel, *Adriaen Brouwer, the Master and his Work*, 1962, p.120 ff., figs. 75–6.

Jan BRUEGHEL I (1568–1625)
Flemish (Antwerp) School
Born in Brussels, the sone of Pieter Brueghel the Elder, he worked mainly in Antwerp. From 1590 he was in Italy, in Rome *c.*1592–4, returning to settle in Antwerp in 1596, where he became Dean of the Guild of St Luke in 1602. He painted mainly small-scale landscapes, originally under the influence of Paul Bril and Gillis van Coninxloo, and flower pieces.

There were six paintings by Brueghel from the Spanish royal collection in the Duke of Wellington's possession, of which five are in the Wellington Museum (no. 64 remaining in the ducal collection) as well as three by his follower Peeter Gysels.

Lit. Klaus Ertz, *Jan Brueghel der Ältere: Die Gemälde*, Cologne, 1979.

19 River Scene with boats and figures
Signed lower left *BRVEGHEL 16(?06)*
Copper, $11\frac{1}{4} \times 16\frac{1}{2}$ (28.6×42)
River scenes with a village and figures standing on the river bank are frequent in Brueghel's work. Klaus Ertz (1979) has classified this as his fifth main landscape type (out of seven), under the heading 'wedge shaped, recessioned landscapes'. Dated examples of this type cover the period 1603–16 and Ertz cites in particular two autograph variants of WM 1574 in the Galleria Sabuada, Turin and in the Toledo Museum of Art (Ertz, Catalogue nos. 95, 106, pl.23) as well as other variants. WM 1574 itself appears to have served as a model for several nearly identical versions attributed to Brueghel, for example (1) L. Koetser (spring exh. 1965, no.12); (2) Sotheby's 10 Dec. 1975, lot 63).

The deep recession shows Brueghel's precociously naturalistic treatment of landscape. On the other hand, the fairyland atmosphere engendered by the bright green tonality is emphasised by the presence of a huge church in the small village on the left.

Condition. Small areas of damage upper right and left, otherwise good.
Prov. Spanish royal collection; probably one of a group of four paintings by Jan Brueghel listed under no.1025 in the 1734 inventory of pictures saved from the fire in the Alcazar. Some of these are described individually in the Royal Palace inventory of 1772 and WM 1574 may perhaps be identified with '1025; River landscape with

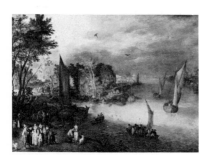

19 WM 1574–1948 Neg. H874
Wellington *Cat.*, p.241, no.18 black

ships; in the foreground a child being handed to a gentleman' which was hanging in the Infanta's dining room. Captured at Vitoria, 1813.

Lit. Gaya Nuño, *Pintura Europea,* no.91; G. Winkelmann-Rhein, *Jan 'Flower' Brueghel,* 1968, p.56, fig.15, col. pl. 15; F. Baumgart, *Blumen-Brueghel, Leben und Werk,* Dumont, Cologne, 1978, p.51, col. pl. 3; Ertz, *op. cit.,* 1979, Cat. no.135, p.580, and pp.52, 54 pls 24, 211a.

20 ROAD SCENE WITH TRAVELLERS AND CATTLE
Oak panel, $9\frac{5}{8} \times 15$ (24.5 × 38)

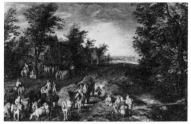

20 WM 1639–1948 Neg. H870
Wellington *Cat.,* p.212, no.136 black

This is a recurrent theme in Brueghel's *oeuvre.* Ertz described the group to which WM 1639 belongs under the rubric 'woodland roads', in a subsection of the 'recessioned road scenes' which is his third basic landscape type. This particular composition is based on a drawing in the Berlin-Dahlem Print Room (Inv. no.763, Ertz pl.166; Winner, 1961, p.215 fig.22) which contains the basic features of road, houses and trees, but hardly any figures. WM 1639 is an autograph replica of a painting in Zurich (David Koetser, formerly J. C. Morris coll., Ertz, Cat. no.232, pl.165), which is dated 1611, and it may probably be placed in the same period. Another autograph replica is in the Hermitage, Leningrad (Ertz, Cat. no. 242, pl.168).

Prov. Spanish royal collection; probably to be identified with no.148 in the 1734 inventory of pictures saved from the fire in the Alcazar, and the 1772 Royal Palace inventory (hanging in the room of the Infanta Xavier) . . . 'landscape with a cart with figures'. Captured at Vitoria, 1813.
Lit. Gaya Nuño, *Pintura Europea,* no. 93; M. Winner, 'Zeichnungen des älteren Jan Brueghel', *Jahrbuch der Berliner Museen,* iii, 1961, p.213; Ertz, *op. cit.,* 1979, Cat. no.242, p.598 and p.153, pl.168.

21 ENTERING THE ARK
Signed lower right *BRVEGHEL 1615.* Inscribed centre foreground in white (oxydized) with inventory no.956.
Copper, $10\frac{3}{8} \times 14\frac{3}{4}$ (26.3 × 37.5)

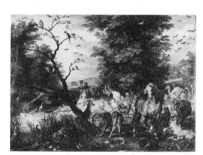

21 WM 1637–1948 Neg. L392
Wellington *Cat.,* p.236, no.134 black

Brueghel used two biblical scenes of Paradise to provide a *raison d'être* for what are essentially pictures of animals in landscape: *The Garden of Eden* and *Entering the Ark,* and the two are very similar in his work. There is a version of the *Garden of Eden* in the V.&A. *(Catalogue of Foreign Paintings,* i, 1973, no.51; attributed by Ertz to Isaac van Oosten; 1979, pl. 321). As to *Entering the Ark,* WM 1637 belongs to a compositional type of which the earliest secure example, dated 1613, is in a private collection (Ertz, 1979, Cat. no.273, pl.307). It became an extremely popular composition and there are numerous versions, of which only WM 1637 and the picture in the Museum of Fine Art, Budapest are accepted by Ertz as autograph (Ertz, 1979, Cat. no.274, pl.311). Among the other versions, attributed by Ertz to Brueghel's followers, are: (1) Dessau, Gemäldegalerie (1929 guide, p.39, no.266); (2) Walters Art Gallery, Baltimore (Ertz, pl. 319); (3) Earl of Verulam coll. (exh. *Flemish Art,* R.A., 1953–4, no. 398); (4) Madrid, Prado, Cat. no. 1407; (5) Madrid, Lazaro Galdiano coll., no.819; (6) Pau, Musée des Beaux Arts, Cat. no. 39; (7) Utrecht, Centraal Museum, Cat. no.1366; (8) Sale Martin and Martin, Versailles, Feb. 1976 *(Connoisseur,* May 1976, p.86, fig.19). WM 1637 differs from all of these and from the original painting of 1613 in showing the horse standing on the right and facing left, rather than in the centre facing right, and in the disposition of some of the animals.

Several of Brueghel's animals were inspired by Rubens: the horse, which also appears in the *Garden of Eden* pictures, is derived from Rubens' *Riding School* in Berlin, where it faces right (G. Glück, *Rubens, van Dyck und Ihr Kreis,* 1933, p.37, cf. figs. 21 and 25), and the two lions were adapted from his *Daniel in the Lions' Den* of which there are drawings in the Albertina, Vienna (Ertz, fig. 312) and in the British Musuem (Jaffé, 1955, fig.4) and a painting

formerly in the Hamilton Collection (M. Rooses, *L'Oeuvre de P. P. Rubens*, i, 1886, no.130 pl.40).

There is no reason to accept the suggestion made in the Wellington *Catalogue* that Hieronymus van Kessel (1578 – after 1638) collaborated on WM 1637 – even though he was Jan Brueghel's son-in-law. He was essentially a portrait and figure painter and in any case is documented as being in Cologne in 1615 when WM 1637 was painted, presumably at Antwerp.

Prov. Spanish royal collection; Royal Palace inventory of 1772, one of eight paintings by Jan Brueghel described under no.956 as hanging in the Infanta's dining room. Captured at Vitoria, 1813.
Exh. R.A., *Exhibition of Belgian and Flemish Art*, 1927 (241); Brod Gallery, London, *Jan Brueghel*, 1979 (32.)
Lit. M. Jaffé, 'Rubens en de leeuwenkuil', *Bulletin van het Rijksmuseum*, iii, 1955, p.59. fig.5; Gaya Nuño, *Pintura Europea*, no.94, pl. 39; Winkelmann-Reihn, *op. cit.*, p.64, col. pl.17; K. Müllenmeister, *Meer und Land im Licht des 17 Jahrhunderts*, ii, *Tierdarsstellungen in Werken niederländischer Künstler*, Bremen, 1978, p.42f, no. & fig.74; Ertz, *op. cit.*, p.603, Cat. no.287, pp.236, 246, pl.311A.

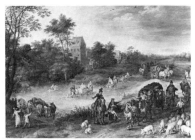
22 WM 1634-1948 Neg. H873
Wellington *Cat.*, p.228, no.127 black

22 TRAVELLERS ON A COUNTRY ROAD, WITH CATTLE AND PIGS
Signed lower left *BRVEGHEL. 1616.* Inscribed in white (oxidised) with inventory no.*956.*
Copper, $10\frac{1}{8} \times 14\frac{5}{8}$ (25.7 × 37)
This is a common type of composition in Brueghel's work; WM 1639, *Road scene with travellers*, has several of the same ingredients. However, as Klaus Ertz points out, the country road in this instance is wider than reality would allow, so much so that the composition is in many ways closer to the flat landscape compositions. Ertz places it in a separate compositional group of 'country roads', together with *Flooded country road* of 1614 in the Alte Pinakothek, Munich (Ertz, Cat.279, pl.42) though this differs in having a windmill as the focal point. A version or copy of WM 1634 was in a sale at Lepke, Berlin (16–17 May 1933, lot 312). Ertz (p.81) discusses the realism of Jan's treatment of cows and pigs and suggests that the image of the trotting horse in the foreground is derived from Rubens or Caspar de Crayer in *c.*1613.

Prov. Spanish royal collection; Royal Palace inventory of 1772, one of eight paintings by Jan Brueghel or his followers described in general terms under no. 956. Captured at Vitoria, 1813.
Lit. Winkelmann-Rhein, *op. cit.*, fig.19, col. pl.13; Baumgart, *op. cit.*, p.53, col. pl.4; Müllenmeister, *op. cit.*, p.42 f., no. and pl.75; Ertz, *op. cit.*, p.608, Cat no.306, pp.69f., 81f., 89, pl.43, colour.

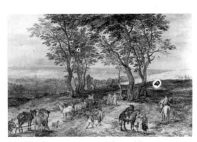
23 WM 1640-1948 Neg. H875
Wellington *Cat.*, p.123, no.138 black

23 COUNTRY ROAD SCENE WITH FIGURES: A MAN PRAYING AT A SHRINE
Copper, $8\frac{1}{2} \times 12\frac{3}{4}$ (21.5 × 32.3)
There is a pen drawing for this composition, with variations in the dispositions of the figures, in the Musée des Beaux Arts, Brussels (no. 484, 16.9 × 28.5 cm.; Winner, 1961, p.210, fig.19; Ertz, 1979, p.146, pl.152; another version, ex-Rudolf collection, Alfred Brod Gallery, *Old Master Drawings,* Jan. 1964, no.59 repr.). A variant of the painting is in the Wachtmeister Collection, Wanas, Sweden (Ertz, no.152, pl.151) and another is in the possession of David Koetser, Zürich (Ertz, no.223, pl.150). A variant with St Martin dividing his cloak in the foreground was at Christie's (14 May, 1965, lot 84 repr.). Winner tentatively dated the drawing *c.*1619 but Ertz places it and the oil paintings *c.*1610 on the grounds of their compositional similarity with the *Country road with wagons* in Munich, which is dated 1610 (Ertz, pl.18).

Although its surface is rubbed, it remains clear that WM 1640 differs from the other landscapes by Jan Brueghel in the Wellington Museum in its brown tonality and, in particular, in the greenish-brown colour of the grass. These are the colours of late summer, as opposed to the deep blue-greens usual in Brueghel's paintings.

Condition. Dent top right corner; surface rubbed.
Prov. Spanish royal collection; 1734 inventory of pictures saved from the fire in the Alcazar; 1772 Royal Palace inventory, probably one of a small group of paintings by Brueghel described in general terms under no.1025. Captured at Vitoria, 1813.
Lit. Gaya Nuño, *Pintura Europea*, no.96; Ertz, *op. cit.*, p.595, no.224, p.149, pl. 153; for the drawing: M. Winner, 'Zeichnungen des älteren Jan Brueghel', *Jahrbuch der Berliner Museen*, iii, 1961, p.210.

John BURNET F.R.S. (1784–1868)
British School
Born in Musselburgh, he studied at the Trustees Academy in Edinburgh before coming to London in 1806. He began his career as engraver for Britton and Brayley's *England and Wales* and, apart from the fame of the Apsley House *Greenwich Pensioners*, his reputation rests on his engravings and his writings on art.

24 THE GREENWICH PENSIONERS COMMEMORATING TRAFALGAR
Signed on the lower left *Jno. B/Oct.21/18 (sic)*.
Panel, 38¼ × 60 (97 × 153)

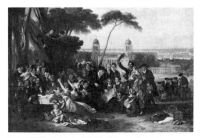

24 WM 1556–1948 Neg. L1406
Wellington *Cat.*, p.75, no.217 red

A group of Greenwich Pensioners and others are assembled on the hill overlooking Greenwich Hospital in the direction of the Thames, on the anniversary of Nelson's victory at Trafalgar.

Burnet had engraved several of Wilkie's paintings, including the *Chelsea Pensioners* (see no.194), and decided to paint a companion to it, apparently without a comission. He 'set up his easel at Greenwich itself amid the living models of the Hospital' (*Quarterly*, 92, 1853, p.455) but the composition is clearly based on Wilkie's. By June 1835 the painting was sufficiently far advanced for Burnet to write to the Duke of Wellington, apparently at the suggestion of William IV, asking if he would like to see it, and adding that the engraving was also nearing completion (Wellington *Cat.*). The Duke finally bought the picture in 1841 and on 29 March Burnet wrote to thank him for the honour: 'I beg to assure Your Grace that nothing could be more gratifying to my feelings; and by it now being placed in the same collection as Sir David Wilkie's inimitable picture of the Chelsea pensioners, you have stamped a value and consequence on the work, which no other collection could confer.'

Burnet made oil studies of the heads of nine Greenwich Pensioners (National Maritime Museum), several of whom may be tentatively identified with the figures in the finished picture. These are, from left to right: Hanlayson (extreme left), Tom Allen (between the women's arms), Joe Brown (carrying the child), Joe Miller (centre, under the raised hat) and Sam Wilks (extreme right of central group). There are also two water-colour sketches related to the group on the right in the National Maritime Museum, an oil sketch of the whole composition in the National Gallery of Ireland, Dublin (no.378; 43 × 73cm.) and a water-colour copy by S. P. Denning, in the National Maritime Museum (44.5 × 71cm.) Burnet also planned a composition of 'A Tale of Trafalgar', showing pensioners examining Turner's painting, but only water-colour studies remain (National Maritime Museum).

Condition. There are two horizontal cracks in the panel but the condition of the paint surface is good.
Prov. Bought for the Duke of Wellington in 1841 by Messrs Hodgson and Graves, to whom he paid £525.

Exh. B.I., 1837 (112); Japan-British Exhibition, London, 1910.
Lit. Athenaeum, 4 June 1836, p.402; *Quarterly Review,* 92, 1853, p.455; D. and F. Irwin, *Scottish Painters,* 1975, p.195; Patsy Campbell, 'Pictures of the Waterloo Era: Wilkie and Burnet at Apsley House,' *Country Life,* 25 Feb. 1971, p.418, repr.

Abraham van CALRAET (1642–1722)

Dutch School

Born in Dordrecht, where he spent most of his life, he was probably a pupil of Aelbert Cuyp.

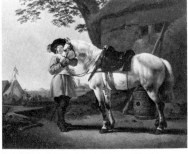

25 WM 1490–1948 Neg. H827
Wellington *Cat.,* p.230, no.42 red

25 A CAVALIER WITH A GREY HORSE

Signed top right *AC*

Canvas, $13\frac{1}{2} \times 15\frac{1}{4}$ (32 × 38.7)

The A C signature both on paintings of this kind and on still lifes was generally accepted as being Cuyp's, and it was as Cuyp that this picture was catalogued by Evelyn Wellington and by Hofstede de Groot (ii, 1909, no.555). In 1916, Bredius ascribed the still-life paintings with the A C signature to Calraet; a propositin which led to a lively controversy with Hofstde de Groot in the pages of *Oud Holland* (i, 1915–16, pp.90 143, 186, 241, 293, 314, 386; also Bredius in *Burl. Mag.,* 30, 1917, p.172). For the group of A C pictures of horses a further stage was reached when the *Horses in a stall* in the Boymans Museum, Rotterdam, was found to bear the signature of AP v K, which was read as Abraham Pietersz van Kalraet. Hofstede de Groot (Thieme Becker, 1926) accepted that if this was indeed the correct reading, it followed that a whole series of related paintings with the A C signature – including the one in the Wellington Collection – would have to be given to Calraet. This argument was endorsed by J. G. van Gelder, who singled out a painting identical to WM 1490 in the Alte Pinakothek, Munich (Cat. no. 879), as definitely by Calraet on the grounds of its similarity to a painting in Leningrad which in turn could be firmly linked with the Rotterdam Calraet *(Kunsthistorische Mededelingen,* i, 1946, p.7 f. repr.). The Munich version remains identified as by Calraet and the Wellington picture must be given to the same artist. His indebtedness to his master can be demonstrated by the similarity with Cuyp's *Trooper and horse* in the royal collection (S. Reiss, *Aelbert Cuyp,* 1975, pl.114).

Condition. Wavy lines of wrinkling in foreground; otherwise good. Cleaned by Horace Buttery, 1949.
Prov. Lapeyrière sale, Paris, April 1817, lot 29, bought for the Duke of Wellington by Bonnemaison for 794frs. (£32).
Exh. B.I., *Old Masters,* 1818 (96); R. A., *Old Masters,* 1890 (114) (reviewed in *Athenaeum,* 1 Feb. 1890)
Lit. H. de G. ii, 1909, no.555 (Cuyp); Hofstede de Groot in Thieme Becker, 19, 1926, p.483 (as 'returned to Calraet').

Cecco del CARAVAGGIO (active *c.*1600–20)

? French or Flemish; worked in Italy

Little is known of him except that he was listed by Mancini *(Considerazioni sulla pittura, c.*1620, ed. 1956–7, i, p.108) as 'Francesco del Caravaggio' among the followers of Caravaggio. 'Cecco' is a nickname for Francesco; 'del Caravaggio' implies a close follower of that artist. In a contemporary document he is recorded as having lodged with Tassi at Bagnaia in 1613, together with numerous Frenchmen (Salerno, 1960). His stylistic links with northern Caravaggisti such as Finson and Ducamps suggest a Flemish or French nationality.

26 A MUSICIAN

Canvas, $49\frac{1}{4} \times 39\frac{1}{4}$ (125×100)

The traditional title of *Conjurer* for this picture was based on the opinion that the man has a ball in his mouth and a coin in his hand. Recently, however, Richard Spear (1971) has suggested it is a whistle he has in his mouth and a clacker in his hand, which, together with the tambourine in his right hand and the prominence of the violin on the table, can be taken as evidence that he was more probably a musician. A version of this painting with variations in the figure in the National Gallery, Athens (no.133, $45\frac{3}{4} \times 38\frac{3}{4}$ in., repr. R. Longhi, *Opere Complete*, 1961, i, p.387, ii, pl.169) is entitled *The Musical Instrument Maker*. This seems unlikely for want of any tools and for the man's elaborate dress, but even without a firm identification of all the objects on the table – some of them may be cases for instruments – *Musician* is a more plausible title than *Conjurer*.

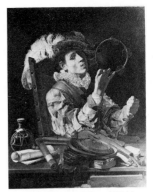

26 1547–1948 Neg. H881
Wellington *Cat.,* p.181, no.190 red

Caravaggio was the generic name for all such genre scenes with strong chiaroscuro and it was as Caravaggio that WM 1547 was described in the Wellington Catalogue. Subsequently various Caravaggio followers were suggested, including Louis Finson, to whom a similar painting of a young man playing a recorder in the Ashmolean Museum was attributed *(Catalogue of Paintings,* 1961, p.55, pl.49). The Ashmolean picture was ascribed to Cecco del Caravaggio by Longhi *(Proporzioni,* i, 1943, p.27) and WM 1547 was given to Cecco by Luigi Salerno (1969) on the grounds of its similarity with the *Expulsion of the money changers from the Temple* (East Berlin), which was described as by Cecco in an epigram by Silos as early as 1673 (J. M. Silos, *Pinacotheca,* 1673). The case for a firm attribution to Cecco has been argued by Richard Spear (1971), who compared it with the *Money changers* in Berlin, with a *Narcissus* (private coll., Rome), and with a *St Lawrence* in the Oratory of the Filippini, Rome. Apart from demonstrating close similarities in the detailed treatment of the dress and the still life, Spear pointed to the characteristic feature that some element in the composition, in this case the open drawer, extends to the lower edge of the composition. The attribution to Cecco has been accepted by Carlo Volpe (1972) and Benedict Nicolson (1974) and a further comparison can be made with two paintings of a man and a woman in the Prado given to Cecco by Perez Sanchez (exh. *Pintura italiana del Siglo xvii,* Prado, Madrid, 1970, nos 52–3. Spear has suggested a date *c.*1610.

Condition. There are several *pentimenti,* particularly round the tambourine which was originally further to the left. There is an added strip about 10cm. wide at the top, perhaps original. Good condition generally, some signs of wear, particularly in the light costume.
Prov. Burland, Liverpool (as Velazquez); bought by the Duke of Wellington for £367.10 from Messrs Henry Graves & Co. in 1845.
Exh. Caravaggio and his followers, Cleveland Museum of Art, 1971, (23), repr. (Richard E. Spear).
Lit. L. Salerno, 'Cavaliere d'Arpino, Tassi, Gentileschi and their assistants' *Connoisseur,* 146, 1960, p. 162; Carlo Volpe, 'Annotazione sulla Mostra Caravaggesca di Cleveland', *Paragona (Arte)* 23 (i), 1972, p.62; B. Nicolson, 'Provisional list of Caravaggasque pictures in . . . collections in Great Britain and Northern Ireland', *Burl. Mag., 116, 1974, p.560*

Carlo CIGNANI
Italian (Bolognese) School
Born in Bologna, he was a pupil of Francesca Albani and subsequently came under the influence of Guido Reni and Guercino. His first important commission was in 1658 for frescoes in the Sala Farnese of the Palazzo Pubblico in Bologna. In 1662 he accompanied Cardinal Girolamo Farnese to

Rome where he painted frescoes in Sant' Andrea della Valle. He returned to Bologna in 1665 to take his place as one of the leading artists of the later Bolognese school.

Lit. S. Vitelli Buscaroli, *Carlo Cignani*, Bologna 1953; Renato Roli, *Pittura Bolognese 1650–1800*, Bologna 1977.

Ascribed to CIGNANI

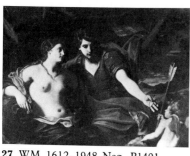

27 WM 1612–1948 Neg. P1401
Wellington *Cat.*, p.96, no. 80 black

27 VENUS AND ADONIS
Inscribed with inventory no. in white, lower right, *213*
Canvas, 49½ × 74 (126 × 188)
Adonis, who was out hunting when he met Venus, holds the lead of his dog, while his right arm encircles Venus.

This painting was described as by Cignani in the Spanish royal palace inventories of 1772 and 1789. The attribution was presumably not known to Lord Maryborough, to whom the Duke of Wellington had sent the pictures captured at Vitoria for safe keeping, for in a letter dated 9 February 1814 he speaks of it as by Domenichino. This appears to have been the attribution suggested by Benjamin West and the other connoisseurs to whom Lord Maryborough had shown the collection. Subsequently, Cignani's name was again given (Wellington *Cat.*) and the attribution was more recently accepted by Perez Sanchez (1965) and Mary Cazort Taylor (oral opinion). However, it must be admitted that precise parallels in Cignani's documented work are hard to find and the picture has not been included in the lists of either Buscaroli (1953) or Roli (1977). Nevertheless, there are close stylistic links with Cignani; the figure of Cupid, for example, is paralleled in the angels in his Sant' Andrea della Valle frescoes (Roli, pl. 6A), and it remains reasonable to retain the traditional attribution. The composition, including Cupid and the dog, is standard in Italian painting from the time of Veronese (Vienna, Kunsthistorisches Museum).

Condition. Prominent area of damage running vertically down the centre.
Prov. Marquis of Ensenada, bought for the Spanish royal collection before 1772; Royal Palace Madrid 1772 inventory (hanging in the passage to the Infante Don Luis's apartment), 1794 inventory (in the 'Green Room with fireplace'). Captured at Vitoria, 1813.
Lit. Gaya Nuño, *Pintura Europea*, p.88, no.295 pl.97; Perez Sanchez, *Pintura Italiana* p.121.

CLAUDE Gellée, called Le Lorrain (1600–82)
French school; worked in Rome
Born in Chamagne (Vosges), he went to Rome in *c.*1613, where he worked under Agostino Tassi. He went to Naples *c.*1618–20 and revisited his home country in 1625, thereafter settling in Rome. His fame as the greatest exponent of pastoral landscape was still further spread by his *Liber Veritatis*, a series of drawings he made of his paintings as a safeguard against forgery and imitation.

Lit. M. Röthlisberger, *Claude Lorrain. The Paintings*, 1961.

Ascribed to CLAUDE

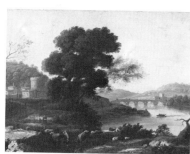

28 WM 1599–1948 Neg. L1399
Wellington *Cat.*, p.95, no.58 black

28 PASTORAL LANDSCAPE WITH THE PONTE MOLLE, ROME
Inscribed in white, lower left, with inventory number *335* and, on right, with cross of Philip V.
Canvas, 18½ × 26½ (47 × 67)

The Ponte Molle (Ponte Milvio) across the Tiber, north of Rome, was built in 109 B.C. and remodelled in the 15th century by Nicholas V, who added the

42 *Cignani*

watch towers. It is shown here in an 'idealized but fairly accurate' setting (M. Kitson, *The Art of Claude Lorrain,* exhibition, Arts Council, 1969, no. 19).

This is a version of the painting once in the Ashburnham collection, now in the City Art Gallery, Birmingham (Röthlisberger, 1961, fig. 170), which is dated 1645 and recorded as no.90 in Claude's *Liber Veritatis* (ed. M. Kitson, 1978, p.109 f., pl. 90). In the Wellington picture the round tower on the left has become crenellated, as opposed to roofed, the houses are different, a wooded hill has been added behind the buildings on the left and the two figures, which form the focus of attention in the foreground of the Birmingham painting, have been omitted. In each of these details, both the Wellington version and another in a Norwegian private collection (74.5×99 cm., formerly Earl of Normanton; Röthlisberger, fig. 405) are more closely similar to a preparatory drawing in the Louvre (M. Röthlisberger, *Claude Lorrain, the Drawings,* 1968, no.578; cf. also the other preparatory drawings, nos.579, 581), and it would appear that both paintings are derived from the Louvre drawing rather than from the Birmingham picture. The two versions are not, however, sufficiently close to indicate that they were copied from each other. A third painting also based on the Birmingham picture, but without the bridge, is in an English private collection (Claude exhibition, 1969, no.20). In general terms, the composition is related to those of the *Pastoral Landscape* in the royal collection and another in the Prado, Madrid (both of 1644–5, Röthlisberger, 1961, figs.157, 162, LV 83, 85), but this is the clearest rendering in Claude's work of the Ponte Molle.

WM 1599 was accepted as autograph by early authorities, but Röthlisberger (1961) described it as an 'old, small and simplified version' of the Birmingham picture, and Cecchi (1975) lists it as a copy.

Condition. Large areas of retouching in the sky and centre foreground; slight wearing on thinner foliage over sky, otherwise good.
Prov. Spanish royal collection. The cross of St Andrew on the right was the mark of Philip V (1731–46) and the painting is recorded in the La Granja inventory of 1746 (no.335) and in the Aranjuez inventory of 1794. Captured at Vitoria, 1813.
Exh. Birmingham Society of Arts, 1831.
Lit. Passavant, *Tour,* 1836, i, p.171; O. J. Dullea, *Claude Gellée, Le Lorrain,* 1887, p. 127; M. Röthlisberger, *Claude Lorrain, The Paintings,* i, *Critical Catalogue,* 1961, p.247, fig.404; M. Röthlisberger and D. Cecchi, *L'Opera Completa di Claude Lorrain,* 1975, p.105, no. 153.

Claudio COELLO (1642–93)
Spanish School
Born in Madrid, he was a pupil of Francisco Rizi and, apparently, also of Carreño. After copying pictures in the royal collection, he remained influenced in particular by Titian, Rubens and Van Dyck. He was made *pintor del rey* in 1684.

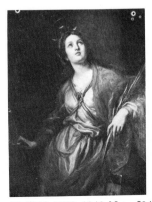

29 SAINT CATHERINE OF ALEXANDRIA
Inscribed on wheel, lower right, *CLAUD. COELL. FA. PICT. REG. ANNO 1683* (last number indistinct)
Canvas, 48×37¼ (122×94.6)

St Catherine is shown three-quarter length, crowned, holding in her left hand the martyr's palm and in her right a sword, the instrument of the martyrdom. A small part of the spiked wheel on which she was tortured is visible on the right.

This is generally considered to be one of Coello's finest paintings of saints and, indeed, Gaya Nuño (1957) went so far as to describe it as 'the most perfect of the thousand and one saints painted in Spain at this period'. Although the depiction of female saints in ecstasy is a commonplace in baroque art, the Wellington St Catherine has been seen as reflecting the

29 WM 1578–1948 Neg. J947
Wellington *Cat.,* p.106, no.30 black

influence of Van Dyck. In particular there is a version of Van Dyck's *St Rosalie* in the Prado which Coello could have seen in the Escorial where it hung in the 17th century (Trapier, 1957; Sullivan, 1979).

Palomino described a painting of St Hyacinth hanging as a pendant to the St Catherine in the Church of El Rosario, but this is no longer extant. Coello painted one earlier version of the St Catherine in the 1660s; it is now in the museum at Dallas (Sullivan, 1979). The posture of the head and the ecstatic glance may be compared with the Santa Rosa de Lima (Prado) which was also formerly in the Church of El Rosario (Gaya Nuño, pl.20), but the Wellington picture is a much more sensuous representation of a female saint.

Condition: Good. Cleaned by S. Isepp, 1950; strip lined 1955.
Prov. Spanish royal collection, Chapel of San Domingo in the church of El Rosario, Madrid (Palomino 1724; Ponz 1772). Captured at Vitoria, 1813.
Exh. Grafton Galleries, *Spanish Old Masters*, 1913-14 (158); R.A., *Spanish Painting*, 1920 (12); N.G., *El Greco to Goya*, 1981 (38).
Lit. Palomino, *El Museo*, iii, p.655 (wrongly referred to as 'Santa Catalina de Siena'); Ponz, *Viage*, v, p.187; A. L. Mayer, in Thieme Becker, vii, 1912, p.166; J. A. Gaya Nuño, *Claudio Coello*, Madrid, 1957, pp. 19, 27, 35, pl. 19; Gaya Nuño, *Pintura Española*, p. 135, no. 610; E. du Gué Trapier, 'The School of Madrid and Van Dyck, *Burl. Mag.*, 99, 1957, p.271f., fig.31; H. Vey, X. de Salas, *German and Spanish Art*, 1965, p.173 repr.; Crombie 'Legacy of Vitoria', p.214, fig. 10; A. E. Perez Sanchez, 'Presencia de Tiziano en la España del Siglo d'Oro', *Goya*, 135, 1976, p.140; Edward J. Sullivan, *Claudio Coello and Late Baroque Painting in Madrid*, unpublished Ph.D. diss., New York University 1979, pp. 142-4, 327-9; *id.*, *Studies in late Baroque painting in Madrid*, forthcoming.

Marcellus COFFERMANS (active 1549–78)
Flemish (Antwerp) School

Coffermans became a master in the Antwerp painters' guild in 1549. He painted small panels, mostly for export to Spain, in an extremely archaic manner. In the period of Brueghel and Frans Floris, he continued to work in the style of Rogier van der Weyden and Memling; many of his compositions are based on the prints of Dürer and Schongauer.

30 TWO WINGS OF A TRIPTYCH: THE VIRGIN AND THE ANGEL OF THE ANNUNCIATION
Oak panels, each $12\frac{1}{8} \times 3\frac{7}{8}$ (30·7×9·8)

The inscription on the vase containing lilies – a symbol of the Virgin – reads \overline{M} (Mater) *Jhs* (Jesus) \overline{A} (Angelus).

These panels can reasonably be related to an entry in the 1772 Royal Palace inventory or, more precisely, in the appendix to this inventory dated September 1773, describing the pictures stored in a vault of the palace: 'An ancient painting on panel, originally a portable altar-piece, containing on the principal panel the Nativity and the two panels forming the doors the Annunciation'. The size given (more than one-third vara high, one vara wide) is about 30×21 cm., which fits well with that of the two wings, which, in turn must have been equal in size to the centre panel. Evelyn Wellington also identified these panels with an 'Annunciation, school of Dürer' listed as being in the King's private oratory in the 1794 inventory. This would indicate that the wings had already been detached from the *Nativity* before that date.

There are several similar compositions of the *Annunciation* by Coffermans or his workshop, including one in the Burrell Collection, Glasgow Museum, and another in the Prado (no. 2723). Both of these show the scene on a single panel. The *Annunciation* on two panels, nearly identical in composition to WM 1649, forms the wings of a triptych of which the centre panel is a *Nativity, with the Adoration of the Shepherds* (sale, Galliera, Paris, 11 June 1971, lot 54 repr.; 20.5 cm. high). As the wings are so nearly

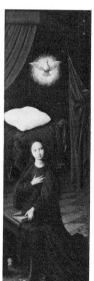
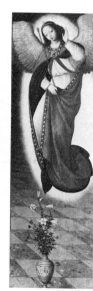

30 WM 1649-1948 Neg. L1405
Wellington *Cat.*, p.194, no.238 black

identical, the centre panels were probably also related, and it is likely that the Paris *Nativity* reflects the appearance of the lost centrepiece of the Apsley panels.

Much of the composition, including the bed behind the Virgin, is derived from Rogier van der Weyden's St Columba altar-piece in Munich (Alte Pinakothek). However, Coffermans has reversed the positions of the Virgin and the angel; it is most unusual to have the angel approaching from the right. Other examples of this reversed composition are those by Dieric Bouts (Richmond, Virginia, Musuem; M. J. Friedländer, *Early Netherlandish Painting*, iii, 1968, no.78. pl.88) and by the Master of Liesborn (National Gallery, no.256).

The style, like the iconography, is wholly archaic, based on the period of Rogier van der Weyden and Memling a full century earlier. Only the dragon bedpost adds a mannerist feature to what is, in character, a fifteenth-century painting.

Condition. Some vertical cracks in the Virgin panel; otherwise good.
Prov. Royal Palace, Madrid, 1772 and 1794 inventories; captured at Vitoria, 1813.
Lit. Gaya Nuño, *Pintura Europea*, no. 67-8 (ascribed to Gerard Horenbout).

John Singleton COPLEY, R.A. (1737–1815)
American School
Born probably in Boston, he became the leading painter in the American colonies. He came to England in 1774 at the invitation of Benjamin West and settled here in the following year. His considerable popularity was due to his depictions of contemporary history, such as the *Death of Chatham* (Tate Gallery).

Lit. J. D. Prown *John Singleton Copley,* 1966.

31 WILLIAM II, KING OF HOLLAND (1792–1849), WHEN PRINCE OF ORANGE
Canvas, $36\frac{3}{8} \times 27\frac{1}{8}$ (100 × 69)

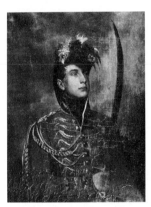

31 WM 1542–1948 Neg. Q1358
Wellington *Cat.,* p.313, no.183 red

Half-length, life-size. He wears a red embroidered uniform with blue stand-up collar and gold siguillettes, and a cocked hat. The Peninsula Gold Medal hangs on his chest.

The son of William I, William spent his youth in England owing to the French invasion of the Netherlands. From the age of 19 he served as aide-de-camp to Wellington in Spain, 1811-14, and during the campaign of 1815 he commanded the Dutch and Flemish contingents and was wounded at Waterloo. He succeeded to the throne of Holland on the abdication of his father in 1840 (see below, no.115),.

There is another version of this portrait, three-quarter length, in the royal collection, Buckingham Palace (50×40 in., Prown, 1966, fig.671; Millar, 1969, p.20 no.713, as 'after Copley') and the figure reappears, mounted but in comparable posture, next to the Duke of Wellington in Copley's *Battle of the Pyrenees* (Musuem of Fine Art, Boston; Prown, fig.673). The portraits have been dated *c.*1812–13 and a terminus ante is provided by Charles Turner's engraving of WM 1542 which is dated 4 December 1813. They are therefore among Copley's last works before his death in 1815, painted at a time when he was old and infirm.

According to tradition (Wellington *Cat.* p.313), WM 1542 was painted for Princess Charlotte, daughter of George IV, who was considering marrying William at this period; she was, however, dissatisfied with it. The couple became engaged in December 1813, but the engagement was broken off in the following year when it became clear that William was returning to live in Holland. It is not known when or how the Duke of Wellington acquired the portrait. There is an oil sketch of William by Thomas Heaphy in the N.P.G. (1914/20).

Condition. Paint surface badly wrinkled and buckled.
Prov. Bought by or presented to the 1st or 2nd Duke of Wellington.
Exh. Orange-Nassau Exhibition, Rijksmuseum, Amsterdam, 1898.
Lit. J. D. Prown, *John Singleton Copley*, Cambridge, Mass., ii, 1966, pp.381, 428, fig.672; Oliver Millar, *The Later Georgian Pictures in the collection of H.M. the Queen*, 1969, p.20; H. Lachouque, *Napoleon's Battles*, 1966, fig.23.

Antonio Allegri, called CORREGGIO (c.1494–1534)
North Italian School

Born in Correggio in Emilia, he came to maturity under the formative influence of Montegna and Costa, successive court painters at Mantua, and then under that of Leonardo and Giulio Romano. He worked mainly at Correggio and Parma, where the frescoes in the cupola of the Cathedral are his most famous work. He enjoyed an enormous reputation both in the 16th century and subsequently and has been seen as the precursor of Baroque church decoration.

Lit. Cecil Gould, *Correggio*, 1976.

32 WM 1585-1948 Neg. H1
Wellington *Cat.*, p.162 no.38 black

32 THE AGONY IN THE GARDEN (Luke xxii, 39–46).
The angel appears to Christ while the Apostles Peter, James the Greater and John are asleep on the right.
Panel, $14\frac{1}{2} \times 15\frac{3}{4}$ (37 × 40)

This picture has been described as 'one of the most famous high Renaissance paintings in the country' (Gould, 1950) and it was certainly one of the most highly prized treasures of the Duke of Wellington's collection. Its highly honoured place in art literature may be traced back as far as Vasari (2nd ed. 1568): 'And in the same city (Reggio Emilia) a small picture about a foot in size; the rarest and most beautiful of his productions with small figures; in which is Christ in the Garden, a picture with an effect of night, where the angel, appearing to him, illumines Christ with his splendour – the whole thing so true to life that it is impossible to imagine or express it better. Down at the foot of the mount we see the sleeping apostles, on whom the shadow of the mount falls where Christ prays, and this gives unheard-of force to the figures. And further on, in the distant landscape, the dawn is breaking and we see soldiers coming in from the side with Judas; and within its limited dimension this scene is so well realized that it would be impossible to equal the patience and application displayed'.

Not long after Vasari, the picture was described by Lomazzo (1590) as having been given by Correggio in payment of a paltry debt of 4 or 5 scudi to an apothecary, while a few years later it was sold for 400–500 scudi to Count Pirro Visconti of Milan. The history of the picture can then be followed in the description of Francesco Scannelli (1657), from whom we learn that it was recently sold by Count Pirro Visconti (a descendent of the earlier Count Pirro) to the Marquis of Caracena, Governor of Milan, for 750 doppie. Caracena was acting for Philip IV of Spain and the painting is regularly recorded in the inventories of the Royal Palace, Madrid, from 1666 until 1794. The provenance for the time from Pirro Visconti to Philip IV and his successors is therefore fully documented. For the period before 1590, the picture may be tentatively identified with the *Agony in the Garden* by Correggio mentioned in a letter of 1584 from Fulvio Rangoni to Alfonso II d'Este of Ferrara, who referred to the owner at that time as Francesco Maria Signoretti of Reggio, which would fit with Vasari's description of it as being in that city. The fact that Signoretti was a member of the College of Medicine may perhaps be relevant to Lomazzo's story that Correggio sold the picture to an apothecary, even though this sounds more like a legend.

After its entry into the Spanish royal collection, the picture was singled out for particular praise by many writers and in particular there is a lengthy

analysis by Mengs (see Ponz, 1782). When it reached England after Vitoria, it at once took up its pre-eminent position in the Wellington collection. Lord Maryborough wrote to the Duke on 9 February 1814: 'Owen, the painter, and West, the President of the Royal Academy, both told me that the Corregio is certainly worth at least £6,000 guineas (sic) . . . West said that the Corregio and the Julio Romano ought to be framed in diamonds, and that it was worth fighting the battle for them.' (Wellington *Cat.*, p.164).

From Benjamin Robert Haydon we know that it was one of the Duke's personal favourites: 'He (Colonel Gurwood), told me that the Duke keeps the key of the glass of his Correggio, and when the glass is foul, dusts it himself with his handkerchief. He asked him once for this key, and he replied 'No I won't'.

In 1949–50, the picture was cleaned with unexpected results. Before cleaning, it was so blackened that the right-hand side was indecipherable. The removal of the overpaint in this area led to the reappearance of a fully lit apostle on the extreme right, apparently cut down at the edge, and another in the middle ground to the left of him, as well as the partial body of a third almost hidden by the one on the extreme right. At the same time the tiny figures of Judas and the soldiers on the right were shown to be later additions and removed. Thus the picture differs both from the engravings by Bernardino Curti (1640) and Giovanni Volpato (1773) and from the old copy, probably 17th century, in the National Gallery, all of which show tiny figures of Judas and the soldiers in the right background. This also fits with Vasari's description quoted above, and it is probable that these figures disappeared when the picture was cut down on the right. There is evidence that it had already suffered damage by the 17th century, for Sebastiano Resta (d.1714) stated that he had learnt from the painter Tanga that the picture has been 'ruined by a lamp standing in front of it' ('*La pittura sia rovinata affatto da una lampada che la sta davanti'*). An engraving by P. E. Moitte (1722–80) of the copy of the painting in the Hermitage (Gould, 1950, fig.B) shows it as an upright, with Christ and the angel only, which supports the view that the original was damaged on the right by the time these early copies were made. Cecil Gould, who has put forward these arguments in detail (1950), suggested that the alteration of the figures in the restoration – particularly the painting in of Judas and the soldiers in an area where they had not been before – indicated a time lag between damage and restoration which led the restorer to replace damaged figures without a precise knowledge of their original position.

The painting is close in style to another of Correggio's chiaroscuro compositions, the Nativity *(La Notte)* in Dresden (Gould, 1976, pl.107–8). Both were painted in Reggio in the 1520s. The *Notte* was commissioned in 1522, but as the chapel in St Prospero, Reggio, for which it was intended was not in use until 1530, it may not have been delivered until that date. The *Agony in the Garden* was dated *c.*1526–28 by Gronau (1907) and Bevilacqua (1970) and slightly earlier in the mid 1520s by Gould. There is a drawing of the figure of Christ in the British Museum (Popham, pl.96; Gould, pl.79) which has on the verso a study for the *School of Love* in the National Gallery which Gould also places in the mid 1520s.

The composition represents a synthesis of the accounts given in the different Gospels. Only Luke (xxii, 39-46) mentions the angel, while the number and names of the Apostles are given only in Matthew (xxvi, 36-47) and Mark (xiv, 32-42). All three stress the fact that the action takes place at night. The angel is nearly always shown in illustrations of the scene; in the Middle Ages he appears in a cloud (e.g. Prayer Book of St Hildegard, Regensburg, 12th century, Munich Nat. Libr., Clm.935) but from the 15th century he is shown in a more realistic fashion, hovering above Christ's head. The scene was frequently illustrated both with and without the approach of

Judas and the soldiers; in either case it was, from the 16th century, commonly shown as a night scene. A near contemporary sketch by Parmigianino at Holkham Hall is close to the Correggio in the frontal posture of Christ, but the closest comparison may be drawn with Titian's composition in the Escorial (H. Tietze, *Titian*, 1950, pl.262) probably influenced by Correggio, which in turn influenced the El Greco in the National Gallery (no. 3476, c.1580).

Of the numerous copies referred to only those in the National Gallery and in the Hermitage, Leningrad, can now be readily traced.

Condition. Cleaned by S. Isepp in 1949 when the sleeping apostles were again revealed (see above).

Prov. Probably F. M. Signoretti, Reggio; before 1590, Pirro Visconti, Milan; before 1657, sold by another Pirro Visconti to Marchese di Caracena, Governor of Milan, acting for Philip IV of Spain. Royal Palace, Madrid (Alcazar) inventories, 1666 (no.640), 1686 (no.190), 1701 (no.41); new Royal Palace, inventories 1772 (passage to the King's pew) and 1794 (first room of the new wing). Captured at Vitoria, 1813.

Exh. B. I., *Old Masters*, 1854 (12); R.A., *Old Masters*, 1887 (131); R.A., *Italian Art*, 1930 (183)

Lit. Vasari, *Vite*, 1568 (ed. Milanesi, iv, 1889, p.117); Giov. Paolo Lomazzo, *Idea del Tempio della Pittura*, Milan, 1590 (1785 ed., p.101); Francesco Scannelli, *Microcosmo della Pittura*, 1657, p.81., Sebastiano Resta, letter 'ad signor N.N.' in G. Bottari, *Raccolta di lettere sulla Pittura . . .* iii, 1759, p.328 f.; Ponz, *Viage*, vi, pp.44, 210 (incl. Mengs's letter to Ponz); Cumberland, *Catalogue*, 1787, p.88 (with detailed description); Luigi Pungileoni, *Memorie istoriche di . . . Correggio*, 1817–18, i, p.100f, ii, p.153f.; Passavant, *Tour*, i, p.169; B. R. Haydon, *Life*, iii, 1853, p.143; Waagen, *Art and Artistes*, ii, p.295; *id., Treasures*, ii, p.275; A. Venturi, 'Della provenienza di due quadri di Correggio, *Arte e Storia*, iii, 1884, p.26 f.; Corrado Ricci, *Antonio Allegri da Correggio*, Eng. ed. 1896, p.231ff; G. Gronau, *Correggio* (K. d. K.), 1907, pl.120 p.164; A. E. Popham, *Correggio's Drawings*, 1957, p.89 ff., pl. 95; Cecil Gould, 'A Correggio Discovery', *Burl. Mag.* 92, 1950, pp.136–40; *id., The Paintings of Correggio*, 1976, pp. 88–92, 212f., col. pl. F, pl.96; A. Bevilacqua and A. C. Quintavalle, *L'Opera Completa del Coreggio*, Milan, 1970, p.63, no.67. (Fuller 19th-cent. lit. in Wellington *Cat.* p.164ff.).

Laurent DABOS (1761–1835)
French School
Born in Toulouse, he exhibited at the Salon from 1791, principally genre scenes, historical subjects and portraits.

33 WM 1517-1948 Neg. H1518
Wellington *Cat.*, p.261, no.80 red

33 NAPOLEON BONAPARTE (1769–1821) as First Consul
Canvas, $23\frac{1}{4} \times 18\frac{1}{4}$ (59 × 46·4)

Bust portrait, life-size, age about 35. He wears the double-breasted, gold-embroidered scarlet uniform of the First Consul (1799-1804). The face and costume are similar to Ingres' full-length portrait of the First Consul (colour repr. in A. Gonzalez-Palacios, *David e la Pittura Napoleonica*, 1967, pl. iv; the dress in Gros' portrait of the First Consul, 1802, Musée de la Légion d'Honneur, is different, cf. G. Delestre, *Antoine-Jean Gros*, 1951, pl.28).

The charming story of the Duke's acquisition of this picture is set out by Evelyn Wellington (Wellington *Cat.*, p.262):

> *Mr. Martin* in his MS notes respecting the Apsley House pictures, says: '. . . (A) Mr Fleming . . . received by mistake an invitation to dinner, intended by the Duke for another gentleman of the same name. The messenger, discovering his error, requested the return of the card, but the receiver declared that, mistake or no mistake, he had accepted the invitation, and meant to avail himself of it. He came at the time appointed, was received by the Duke, and on the following day sent the picture of the 'First Consul' as an *amende honorable.*'
>
> *Mr Fleming* (the unbidden guest above referred to) writes to the first Duke of Wellington as follows:—'104 Gloucester Place, May 17, 1824. Mr Fleming presents his respectful compliments to the Duke of Wellington, and sends for

His Grace's inspection the picture of Buonaparte which he had the honour of mentioning to him yesterday. As Mr F has been assured by some who have had an opportunity of seeing the *Chief Consul* about the time when this portrait was taken, that it is an exceeding good likeness, he hopes His Grace will do him the honour of accepting it and giving it a place in his Collection. The enclosed certificate was sent to Sir G. A. Robinson by the painter along with the picture.'

Je certifie que le portrait qui fut remis a Monsieur Robinson, étoit original et d'une telle Ressemblance qu'à l'epoque ou je le fis, le Gouvernement me chargea d'en faire une copie en pied, pour etre placée dans la Salle du Conseil de l'Hotel de Ville de Paris. — DABOS.

Another of Dabos' portraits of Napoleon was engraved by A. Aubert.

Condition. Paint surface worn, particularly on the costume. Cleaned in 1950.
Prov. Sir G. A. Robinson; Mr Fleming, who gave it to the Duke of Wellington in 1824.

George DAWE, R.A. (1781–1829)
British School
He trained at the Royal Academy Schools, 1796, as an engraver, took up painting in 1801, at first mainly historical and mythological subjects and from 1813 almost entirely portraits, which he exhibited at the R.A. 1813–18. In 1818 he visited the Continent with the Duke of Kent, painting portraits at Brussels, Cambrai and Aachen – at the Congress of the Holy Alliance. From 1819 until 1828 he was court painter in St Petersburg, having been called there by Alexander I, for whom he painted a series of Russian notables for the 'War gallery of 1812' in the Winter Palace.

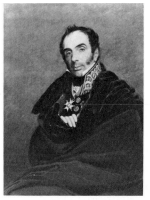

34 GENERAL MIGUEL RICARDO DE ALAVA (1771–1843)
Signed lower left *Geo. Dawe RA Pinxt Brussels 1818*
Canvas, $35\frac{1}{4} \times 27\frac{3}{8}$ ($90 \times 69 \cdot 5$)

Waist-length, life-size, aged about 47. He wears the uniform of a Spanish officer; dark with gold buttons and a gold-embroidered collar, enveloped in a brown cloak. From his neck hangs the cross of the Bath; on his chest he wears the red cross of Santiago.

As a naval officer, Alava joined the patriots when Napoleon placed his brother Joseph on the Spanish throne. In 1811, when the Cortes decided to give the chief command of the Spanish army to Wellington, Alava was attached to his staff and served with distinction in that capacity until the end of the war and again attended Wellington at Waterloo. His liberal politics brought him into conflict with Ferdinand VII and, at Wellington's invitation, he lived in London *c.*1824–34. On the accession of Isabella to the Spanish throne in 1834, Alava returned home, but he was soon afterwards appointed ambassador to England.

34 WM 1477–1948 Neg. K2762
Wellington *Cat.,* p.284, no.19 red

Dawe was in Brussels in 1818 to paint Prince Wiliam Frederick of Orange before going on to Cambrai for the memorial review of the allied armies. There is a replica of WM 1477 in the Hermitage, Leningrad, also dated 1818 (91×71.5cm.; 1958 catalogue of paintings, no. 4832, fig. 368). Alava is also the subject of a portrait by Pieneman at Apsley House (see below, no.138).

Prov. Bought by the Duke of Wellington.

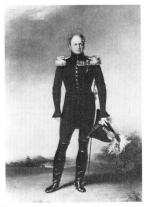

35 ALEXANDER I, EMPEROR OF RUSSIA (1777–1825)
Signed lower right *Geo. Dawe RA 1825 pinxt*
Canvas, $31\frac{1}{2} \times 23\frac{1}{4}$ (80×56.5)

Full-length, frontal, aged 48. Alexander wears the undress uniform of a Russian field-marshal. He wears the star of St Andrew and beneath it the

35 WM 1528–1948 Neg. Q1366
Wellington *Cat.,* p.402, no.93 red

Sword of Sweden, the crosses of St George of Russia, Maria Theresa of Austria, and the Iron Cross of Prussia, and the 1812 War medal.

For Alexander I see under Gérard.

The pose and the landscape setting are based on Gérard's portrait, of which there is a version at Apsley House. Painted in Russia, this is a reduced version of Dawe's portrait in the royal collection; there are replicas at Londonderry House (110×60in.) and in the Ranfurly sale, Christie's, 21 June 1929, lot 23 (bought by Stanley Baldwin). A three-quarter-length version of the composition was engraved by Thomas Wright.

Prov. Bought by or presented to the Duke of Wellington.

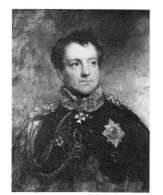

36 WM 1535–1948 Neg. Q1367
Wellington *Cat.,* p.281, no.176 red.

36 FIELD–MARSHAL AUGUST NEIDHARDT, COUNT OF GNEISENAU (1760–1831)
Canvas, $28\frac{5}{8} \times 22\frac{3}{4}$

Head and shoulders; life-size; aged about 55. He wears the dark double-breasted uniform with red-gold embroidered collar, gold aiguillettes and gold buttons, of a Prussian general. Round his neck he wears the crosses of St John of Prussia and Maria Theresa of Austria. He also wears the Vladimir of Russia, the Iron Cross, and, on the left breast, the star of the Black Eagle and beneath it a second Iron Cross.

Gneisenau was in the Austrian army 1780–86 and joined the Prussian army in 1786. He took an active part, under Blücher, in the campaigns against Napoleon 1812–15 and is famed as a military reformer, championing the virtues of a conscript army fired by patriotism. He was created a field-marshal in 1825. This portrait was presumably painted in 1818 when Dawe attended the memorial review of the allied armies at Cambrai. There is a comparable half–length, frontal, portrait of Gneisenau by F. Kruger, litho-graphed by Schall.

Prov. Bought by the Duke of Wellington from Colnaghi in 1843, together with the portraits of Blücher (WM 1536) and Barnes (WM 1537), for £78.15s. 0d.

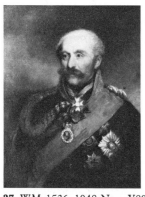

37 WM 1536–1948 Neg. Y894
Wellington *Cat.,* p.285, no.177 red

37 FIELD MARSHAL PRINCE VON BLÜCHER (1742–1819)
Canvas, $28\frac{1}{2} \times 22\frac{7}{8}$ (72·5×58)

Head and shoulders, life-size, aged about 75. He wears the dark double-breasted uniform of a Prussian general, with heavy gold aiguillettes and gold buttons. The cross hanging from his neck is probably that of St John of Prussia; beneath it is the Iron Cross and the Prussian medal for 1813–14. On his left breast he wears the stars of the Bath, the Iron Cross and two other orders. Over his shoulder he wears the ribbon of the Black Eagle and over the ribbon hangs a miniature of George IV.

Gebhard Lebrecht von Blücher, born in Rostock, joined the Swedish army and fought with the Swedes in the Seven Years' War. Taken prisoner by the Prussians, he subsequently joined their army and rose to the rank of captain. He commanded the centre of the allied army when Prussia entered the coalition against Napoleon, distinguished himself at Lutzen and Leipzig and entered Paris in 1814. In 1815 Blücher, at the head of the Prussian army, was defeated by Napoleon at Ligny on 16 June, but by a masterly flank-march joined Wellington at 5p.m. on 18 June, in time to participate in the final defeat of the French at Waterloo.

There is a full length portrait of Blücher dated 1814, very similar to WM 1536, by Lawrence in the royal collection (O. Millar, *Later Georgian Pictures,* 1969, no.886, pl.192) and a marble bust by C. Rauch (1815) in the Wellington collection, Stratfield Saye.

Prov. Bought by the Duke of Wellington from Colnaghi in 1843, together with the portraits of Gneisenau (WM 1535) and Barnes (WM 1537), for £78 15s 0d.

38 LT.-GENERAL SIR EDWARD BARNES G.C.B. (1776–1838)
Canvas, $28\frac{1}{2} \times 22\frac{5}{8}$ (72·5 × 57·5)

A sketch, unfinished in the costume. Head and shoulders, life-size, aged about 40. He wears a black stock and round his neck the ribbon of the Bath with cross attached. Below it is the large Peninsular gold medal. He wears the scarlet uniform and gold aiguillettes of a general.

Sir Edward Barnes joined the army in 1792 and commanded a brigade at the battles of Vitoria, Pyrenees, Nivelle, Nive and Orthes. He served as adjutant general in 1815 and was severely wounded at Waterloo. He became a lieutenant–general in 1825 and Governor and Commander-in-Chief East Indies in 1831. This portrait was probably painted in 1818 when Dawe portrayed a whole series of generals (see nos. 34, 36-7), as well as Wellington himself. There are two water-colour sketches of 1813–14 by Heaphy in the N.P.G. (1914 (2) and (3)) and a full-length painting by John Wood in the Army and Navy Club. He is portrayed in Salter's *Waterloo Banquet* (Stratfield Saye), for which there is an oil sketch in the N.P.G.

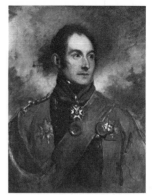
38 WM 1537- 1948 Neg. L1400
Wellington *Cat.,* p.283, no.178 red.

Prov. Bought by the Duke of Wellington from Colnaghi in 1843, together with the portraits of Blücher, (WM 1536) and Gneisenau (WM 1535), for £78 15s 0d.
Lit. Dictionary of British Portraiture, 2, 1979, p.13.

Karel DU JARDIN (1621/2–78)
Dutch School
Probably born in Amsterdam, he was, according to Houbraken, a pupil of Berchem and also went to study in Rome. From 1650 he lived mostly in Amsterdam. He painted mainly idealized Italian views in the manner of Berchem.

39 THE RIVER BANK: LANDSCAPE WITH FIGURES AND CATTLE
Signed indistinctly lower left (?) *K.D.*
Canvas, $13 \times 9\frac{5}{8}$ (33 × 24·5)

The number 181, recorded in the Wellington *Catalogue* as painted in white in the lower right, is no longer visible.

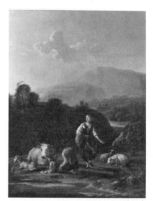

Condition. Paint surface very worn, especially on the rocks in the middle ground.
Prov. Spanish royal collection (not inv.); captured at Vitoria, 1813.
Lit. H. de G. (German edition) ix, 1926, p.343, no.187 (as by Du Jardin); Gaya Nuño *Pintura Europea,* no.189; Valdivieso, *Pintura Holandesa,* p.252.

Gainsborough DUPONT (1754–97)
British School
A portrait painter and mezzotint engraver, he was the nephew and pupil of Thomas Gainsborough, in whose style he worked.

39 WM 1573–1948 Neg. J933
Wellington *Cat.,* p.20, no.15 black

40 WILLIAM PITT (1759–1806)
Canvas, rectangular in oval frame, painted in simulation of stone, 30 × 25 (76 × 63·5)

William Pitt, second son of the Earl of Chatham, precocious from childhood though dogged by ill-health, was called to the bar in 1780 but left it when he was elected to Parliament in the same year. He soon became Chancellor of the Exchequer in the administration of Lord Shelburne which was displaced by the Fox-North coalition in 1782. In the following year, when Pitt was still only 24, George III appointed him First Lord of the Treasury (Prime Minister) and Chancellor of the Exchequer. Except for a short interval in 1801-4, at the time of the Peace of Amiens, he remained Prime Minister until his death in 1806, and he is best remembered as a war leader against revolutionary France and Napoleon.

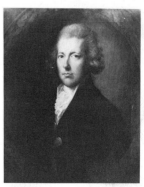
40 WM 1557–1948 Neg. P1408
Wellington *Cat.,* p.84, no.219 red

The ascription to Gainsborough Dupont is authenticated by the labels on the back of the stretcher: (1) *An Original Portrait of the Right Honble Wm Pitt and for which he sat at Walmer Castle Sepr. 1792 Gainsborough Dupont.*, and at the side: *Left by Will of Sir James Sanderson Bart to his friend Brook Watson June 1798.* (2) *This picture of the Rt Honble Wm Pitt by Gainsborough Dupont Mr Pitt sat for at Walmer in the year 1792 to oblige Sir James Sanderson Bart who by his Will bequeathed it to me, Brook Watson.*

There is no reason to doubt the statement that the picture was painted in 1792. We know that Pitt was a patron of Dupont, and it may conceivably have been painted from the life. However, it does not differ perceptibly from the standard portrait of Pitt established by Gainsborough in 1787. This picture – one of two that Gainsborough painted of Pitt – was a three–quarter length, painted for the Marquess of Buckingham (W. T. Whitley, *Thomas Gainsborough*, 1915, pp.271, 290, 339f.), possibly completed by Gainsborough Dupont and engraved by J. K. Sherwin in 1789. It can no longer be identified with certainty among the thirty versions that exist. Most of these are now attributed to Gainsborough Dupont, others are still labelled Gainsborough.

Waterhouse (1953) lists ten versions of the three-quarter length (50×40in.) of which those in the Iveagh Bequest, Kenwood and the Burrell Collection, Glasgow City Art Gallery are the most readily accessible, and a further twenty of the bust-length type akin to WM 1557, measuring 30×25 in. Of these, the one formerly belonging to Earl Amherst (Sotheby, 27 June 1962, lot 3) is now in the Paul Mellon Collection and there is another in the Fitzwilliam Museum, Cambridge.

Gainsborough Dupont also painted a portrait of Sir James Sanderson, Lord Mayor of London, the first owner of WM 1557, which was exhibited at the R.A. in 1793.

Prov. Sir James Sanderson, 1792; Sir Brook Watson, 1798; bequeathed to Thomas Aston Coffin, Robert Coffin; 1842. Bought in 1843 by the Duke of Wellington, at the suggestion of Lord Fitzroy Somerset (Wellington *Cat.*, p. 85), from Robert Coffin, for £105.
Lit. E. K. Waterhouse, 'Preliminary check list of portraits by Thomas Gainsborough' *Walpole Society*, 33, 1948–50 (1953), p.85. For the original painting by Gainsborough see also E. K. Waterhouse *Gainsborough*, 1958, p.85, no.545.

Willem Cornelisz DUYSTER *(c.*1599–1635)
Dutch (Amsterdam) School
He is recorded in Amsterdam in 1625, 1631 and 1632. His surviving works, which are relatively rare, are mainly genre scenes similar to those of Pieter Codde (1599–1678).

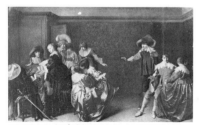

41 WM 1524–1948 Neg. Q1379
Wellington *Cat.*, p.141, no.88 red

41 A MUSICAL PARTY
Oak panel, $19\frac{1}{8} \times 31\frac{7}{8}$ (48·6×80·7)

Elegantly dressed couples are disporting themselves in a room decorated with green embossed leather wall covering. The man on the right is holding up his hands in astonishment at the love-making of the couple in the foreground. Two musical instruments, a lute and a violin, are shown, but in fact no one is actually playing them.

Duyster's is the earliest of several Dutch pictures in the Wellington Museum which illustrate the close connection between love and music; there are others by de Hooch and Jan Steen. It is an ancient link which became popular in the visual arts in the 15th century when, for example, the natives of the planet Venus were depicted as lovers and musicians, and musicians peopled the garden of love (A.P. de Mirimonde, 'La Musique dans les allegories de l'Amour; i, Venus', *G. B.-A.*, 68, 1966, pp. 265–90, ii, 'Eros',

ibid, 69, 1967, pp.319–46; R. van Marle, *Iconographie de l'art profane, allégories et symboles*, 1932, e.g. p.428, fig. 456). In the 16th century Venus frequently appears as an allegory of music (e.g. Cranach, Munich, Alte Pinakothek), and at the same time musical instruments take up a more prominent place in scenes of *fête champêtre* (e.g. ascr. to Giorgione, Louvre). The symbolism of music as the food of love was adapted for interior genre scenes by the 17th century Dutch school; indeed, it became one of the most popular of all themes. Duyster himself returned to this subject on more than one occasion; a smaller picture with only two figures is in Berlin (Jagdschloss Grünewald, see *Tot Lering en Vermaak*, no.21, with iconographical parallels). To judge from the costume, the date of WM 1524 is *c.*1630. The former attribution to Le Duc was corrected by C. Hofstede de Groot before 1900. There is a copy of the two figures on the left in a private collection (Christie's, 15.12.78, lot111, as Pieter Codde).

Condition. Vertical crack where two panels joined together 4 in. from right. Damage at woman's eye on left.
Prov. Bought for the Duke of Wellington by Féréol Bonnemaison in Paris, 1818.
Exh. B.I., *Old Masters*, 1821 (141, as Le Duc); R.A., *Dutch Art*, 1929, (73).

Sir Anthony van DYCK (1599–1641)
Flemish School
Painter of portraits and figure subjects, he was, after Rubens, the most important artist of the seventeenth-century Flemish School. Born and trained in Antwerp, he worked with Rubens in about 1618–21 and lived in Italy 1621–27. He again left Antwerp in 1632 for London where he became court painter to Charles I and where he remained for most of the rest of his life.

42 ST ROSALIE CROWNED WITH ROSES BY TWO ANGELS
Canvas, $46\frac{1}{8} \times 34\frac{5}{8}$ (117·2 × 88)

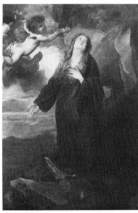

42 WM 1651–1948 Neg. GG4134
Wallington *Cat.*, p.107, No.246 black

In April 1624, Van Dyck sailed from Genoa to Sicily at the invitation of Philiberto Emmanuele of Savoy (M. Vaes, 'Le Séjour de Van Dyck en Italie . . . 1621–1627', *Bulletin de l'Institut historique belge de Rome*, iv, 1924, pp. 163–230, esp. p.214ff.). In the summer of that year Palermo was swept by the plague and on 14 July in a cave on Monte Pellegrino, above the city, fragments of a skeleton were discovered which were identified as the remains of St Rosalie. She had lived as a recluse on Monte Pellegrino – where she had been guided by two angels – in the mid-12th century until her death in about 1160. In 1292 an altar was dedicated to her in Palermo Cathedral and there are early representations of her by Francesco Traini and Antonello da Messina (Collura, figs 2, 5). Her popularity as the patron saint of Palermo dates from the Counter-Reformation. The discovery of her remains at the height of the plague in July 1624 was seen as God's intervention; they were translated to Palermo cathedral and the saint's protection was invoked by the hard-pressed population of the city.

Between July and September, when he left Palermo, Van Dyck painted six different compositions of St Rosalie, each represented by several extant versions. The Wellington picture, characterized by its broad, free treatment from which its expressiveness derives, appears to be a preparatory version of a larger painting formerly in Paris, now in the University of St Thomas, Houston (166 × 136 cm.; Sterling, pl.I; *Art Journal*, winter 1968-9, p.194, fig.8). In composition, the two are identical except for minor details: the book and the skull have been moved to the right in the Houston picture; only in the Wellington version does the saint have the transparent veil, and there is a difference in the posture of the second angel. A third version in the Palermo Museum appears to be a copy of the Houston picture (Collura, pl.14) and a half-length copy was formerly in the collection of Harry Axelson Johnson,

Stockholm. Another half-length version without the angels, attributed to Van Dyck, is in the Prado (106×81cm.; E. du Gué Trapier, 'The school of Madrid and van Dyck', *Burl. Mag.*, 1957, p.271, fig.30). This is the picture which is recorded in the Alcázar and the Escorial in the 17th and 18th centuries (Bottineau, 'Alcázar', *Bulletin Hispanique,* 58, 1956, p.478, no.1507).

Van Dyck's *St Rosalie crowned by angels* is related to his composition of *St Rosalie interceding for the city of Palermo* (Sterling, pls, II, IIIc) which also shows the saint standing on Monte Pellegrino. The former, at any rate is barely distinguishable from scenes of Mary Magdalen's life as a hermit and, indeed, the Wellington picture was at times taken to represent the Magdalen (1794 inventory).

Condition. Pentimenti visible above the head; considerable areas of paint loss and retouching along edges and in dark area lower right. Cleaned, 1977.
Prov. Royal Palace, Madrid, 1772 inventory, 'St Rosalie, in passage to king's pew;'; 1794 inventory, 'Magdalen crowned with roses, in the king's dressing room'. Captured at Vitoria, 1813.
Lit. Ponz, *Viage,* vi, 1782, p.46; Cumberland, *Catalogue,* 1787, p.85 (passage room in Royal Palace); G. Glück, *Van Dyck* (K. d. K.), 1931, pl.156; G. Sterling, 'Van Dyck's paintings of St Rosalie', *Burl. Mag.,* 74, 1939, esp. p.59, pl.IIIb; Gaya Nuño, *Pintura Europea,* no.138; P. Collura, *Santa Rosalia nella storia e nell' arte,* Palermo, 1977, p.100, fig.33; Erik Larsen, *L'Opera Completa di van Dyck 1613-26,* Milano 1980, no.454.

After van DYCK

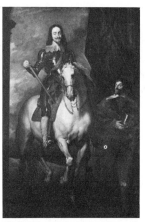

43 WM 1498–1948 Neg. Q1353
Wellington *Cat.* p.103, no.54 red

43 CHARLES I (1600–49) ON HORSEBACK WITH M. DE ST ANTOINE
Canvas, 116×83¾ (295×213)

The King, wearing armour with the sash of the Garter and holding a baton, rides on a white horse; M. de St Antoine, his equerry, is in attendance. This is an old, probably 17th-century, copy of the equestrian portrait painted by van Dyck for Charles I in 1633, now in Buckingham Palace (Millar, 1963, no.143). It has been reduced at the top and on the left – the original is 368×270 cm – and is without the top of the arch and the shield with the royal coat of arms on the left which are prominent features of the original picture. The original was probably designed for the end of the gallery at St James's Palace, where it made a considerable impression, and hence it is noteworthy that the Duke placed his copy over the mantelpiece of the Waterloo Gallery rather than at either end.

The composition originated with Rubens' *Duke of Lerma* (R. Oldenbourg, *Rubens,* K.d.K. 1921, pl.5) and it was commonly used by van Dyck with different backgrounds, for example, for Cornelius de Wael (Antwerp Museum, 892) and Antonio Giulio Brignole Sale (Genoa Museum, Glück, 1931, no.200). There are many copies. Millar (1963) lists seventeen large copies, including two in the royal collection (nos. 173, 174) and others formerly at Hamilton House, and at Warwick Castle, Petworth and Corsham Court. Several of these are simplified, reduced or without the equerry. The portrait was engraved by Baron in 1741.

Pierre Antoine Bourdin, Seigneur de St Antoine, had been sent by Henri IV of France to James I in 1603 with a present of six horses for Henry Prince of Wales. He remained in the service of Henry and later of Charles I as riding master and equerry. The identification of the equerry as the Duc d'Epernon, accepted in the Wellington *Catalogue,* was according to Millar, due to an error made in the 18th century.

Condition. Painted on three pieces of canvas joined by seams running (a) across centre,

(b) 40 cm. from lower edge; folding line below (a). Some wearing, especially in sky and dark areas; retouched damage on horse's nose. Retouched tear about 50 cm. long from horse's left flank to equerry's red robe.

Prov. Sir Henry Wellesley, G.C.B., afterwards Lord Cowley (according to family tradition originally from the Duke of Alva's collection); bought by the Duke of Wellington from his brother, some years before 1829.

Lit. Passavant, *Tour,* i, p.171 (repetition at Apsley House); Waagen, *Art and Artists,* ii, 298 (an old copy of the van Dyck at Windsor); Waagen, *Treasures,* ii, p.277; Jules Guiffrey, *Antoine van Dyck,* 1882, p.261; G. Glück, *van Dyck,* K. d. K., 1931, p.559, no.372; Oliver Millar, *The Tudor, Stuart and Early Georgian Pictures in the Collections of H.M. The Queen,* 1963, p.94.

Anton EINSLE (1801-71)
Austrian School

Born in Vienna, he was a portrait painter in Prague and Budapest before returning to Vienna in about 1838 and becoming court painter there. He became very popular in the reign of Franz Joseph, of whom he painted innumerable portraits.

44 Francis II, Emperor of Austria (1768-1835)
Signed at foot of pedestal *Anton Einsle K.K.* (Kaiserlich Königlicher)
Hofmaler in Wien 1841.
Canvas, $91\frac{3}{4} \times 62\frac{3}{8}$ (232×158)

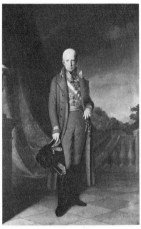

44 WM 1541–1948 Neg. P1411
Wellington *Cat.,* p.305, no.182 red

Full-length, life-size, aged about 65. He wears the uniform of an Austrian field marshal: a long grey greatcoat, with red and gold collar and cuffs, a white coatee embroidered with gold, a gold and red sash round his waist, red breeches and high black boots. The Golden Fleece hangs from his neck and he wears the star of Maria Theresa. The rather stiff neo-classical setting is reinforced by the pedestal and vase on the right and the stone balustrade in the background.

Francis II succeeded his father Leopold II as Emperor in 1792, but in 1806 he renounced the titles of Roman Emperor and King of Germany to become Francis I of Austria. He fought the French from 1792 until the peace of Campo Formio in 1797 and again from 1799 until the peace of Lunéville, 1801. War started again in 1805 and was intermittent until the defeat at Wagram in 1809, when a marriage between Napoleon and the Emperor's daughter Marie Louise was arranged as part of the peace treaty. In 1813 Francis joined Russia and Prussia against France and was present with the allied armies until the end of the war.

As this portrait dates from 1841, six years after Francis's death, there can be no question that it was painted from life; indeed Frances never sat to Einsle, who did not return from Budapest to Vienna until about 1838. In fact the features and posture are derived from Friedrich von Amerling's half-length of 1832-3 (painted for the gallery in Laxenburg Castle; engraved by Benedetti). In 1841, however, Amerling left Vienna for Italy and Einsle became the natural choice to paint the portrait of Francis desired by the Duke of Wellington.

The origin of the commission is explained in the Emperor Ferdinand's letter, dated 12 January 1842, to the Duke of Wellington:

> Mon Cher Duc de Wellington,–Mon Ambassadeur en Angleterre m'ayant fait connaître votre désir de posséder un portrait de feu mon Père de glorieuse mémoire, j'éprouve une véritable satisfaction en Vous l'envoyant par le Prince Esterhazy. Il ne saurait être mieux placé que dans l'habitation paisible de l'homme de guerre qui voue maintenant ses conseils et son expérience à Sa Souveraine et à son pays après avoir rendu de si grands services militaires à la cause de l'ordre et de la paix en génerale, but constant du règne de l'Empereur François: il ne saurait être mieux gardé que par Votre famille, qui contera parmi tant de glorieux souvenirs celui de l'estime et de l'amitié particulière

dont Vous a toujours honoré feu Mon Père. Héritier de ces mêmes sentimens, je forme les meilleurs voeux pour votre conservation, et je suis,

Mon Cher Maréchal,

Votre bien affectioné,

VIENNE, *le* 12 *Janivier*, 1842. (Signed) FERDINAND.

Prov. Given to the Duke of Wellington by Ferdinand, Emperor of Austria, in 1842.
Lit. Waagen, *Treasures*, ii, p.278 ('a specimen of the most prosaic and tasteless conception possible'); Thieme Becker, x, 1913, p.425.

Adam ELSHEIMER (1578–1610)
German School; worked in Rome

Born in Frankfurt, where he was a pupil of Philip Uffenbach, he travelled in 1598 to Venice, where he was associated with Hans Rottenhammer, and settled in Rome in 1600. His landscapes show the influence of Altdorfer and the Danube School, and of Paul Bril whom he knew well in Rome. He painted mainly small cabinet pictures with dramatic figure subjects in idyllic landscapes which were much admired already at the time of his early death.

Lit. Keith Andrews, *Adam Elsheimer*, 1977.

45 WM 1604–1948 Neg. FJ3055
Wellington *Cat.*, p.217 no.67 black

45 JUDITH SLAYING HOLOFERNES (Judith, xiii, 7–9)
Painted fleur-de-lys lower right
Tinned copper, $9\frac{1}{2} \times 7\frac{3}{8}$ ($24 \cdot 2 \times 18 \cdot 7$)

The action takes place in a tent lit by two candles. Above the entrance there is a hanging frieze with putti and a leopard. The object above the meticulously painted still-life on the left is difficult to identify in its present state; it is presumably a piece of costume or armour.

This is one of four paintings by Elsheimer owned by Rubens; it was apparently acquired by him after 1610 and sold after his death to Francisco de Rochas who bought it for Philip IV of Spain (Andrews, 1973; documents in Weizsäcker, ii, p.219). Keith Andrews compared the half-naked figure of Holofernes to that of Aeneas in the *Burning of Troy* (Munich, Alte Pinakothek; Andrews, pl.31) and suggested a date *c.*1601–3, early in the artist's Roman period. It is one of Elsheimers's few interior scenes and, like the somewhat later *Philemon and Baucis* in the Dresden Gallery, it derives dramatic impact from its closed-in atmosphere and confined space. The violence and drama of the event is enhanced by the strongly localized flickering candlelight and is contrasted with the domesticity of the interior.

Judith is a popular figure in the history of art, but she is usually shown holding Holofernes' head or placing it in the sack. Nevertheless, the beheading scene itself does occur occasionally from Carolingian times and becomes quite common in baroque art (e.g. Artemisia Gentileschi, Pitti Palace, Florence; Jan de Bray, 1659, Rijksmuseum, Amsterdam). It has been argued that Elsheimer's composition derives from a lost original by Caravaggio (Oldenbourg, 1922; Grossmann, 1949), but there is little evidence for this, and in fact the surviving picture by Caravaggio (*c.*1599, Galleria Nazionale d'Arte Antica, Rome, Andrews, 1973, fig.2) is different in composition and conceived on more blatantly violent lines. Elsheimer's depiction of Holofernes raising his leg in his death agony is a dramatic ingredient often used by subsequent artists, including Rubens (engraving after Rubens by Ph Galle, *c.*1608, Oldenbourg; Bauch; Andrews, 1973, figs. 3, 4). A copy with variations by an unknown artist was in the collection of William Haecht II (Andrews, 1973, fig.1).

Condition. Generally good; area of retouching lower right corner and perhaps on the face of the servant in the background and on the object above the jug.
Prov. Peter Paul Rubens (inventory at his death, 1640); bought from his estate by Don

Francisco de Rochas for Philip IV of Spain; 1746 La Granja inventory of Isabella Farnese; 1774 La Granja inventory; captured at Vitoria, 1813.
Exh. Between Rennaissance and Baroque, Manchester City Art Gallery, 1965, no.84; *Adam Elsheimer Ausstellung*, Staedelsches Kunstinstitut, Frankfurt, 1966–7, no.3.
Lit. R. Oldenbourg, *Peter Paul Rubens*, 1922, p.75; H. Weizsäcker, *Adam Elsheimer*, i, 1936, pp.7, 98–101; ii, 1952, pp10f., 219f., pl.33; H. Möhle, *Elsheimer*, 1940, p.14; Fritz Grossmann, exhibition review in *Phoebus*, ii, 1949, p.125; K. Bauch, *Der Frühe Rembrandt und seine Zeit*, 1960, p.131, fig.94; J. S. Held, 'Artis Pictoriae Amator', *G.B.-A.*, 50, July 1957, p.67, n.30a. Keith Andrews, 'Judith and Holofernes by Elsheimer', *Apollo*, 98, Sept. 1973, pp.49–51 (col. repr.); *id.*, *Adam Elsheimer*, 1977, pp.27, 30, 35, 144, cat.12, pl.36.

Spiridone GAMBARDELLA (?1815–1886)
British School
He exhibited genre scenes and portraits at the R.A. and B.I. 1842–68. During this period he is recorded as living in London and in Liverpool. There were seven of his portraits in the Wellington collection.

46 The Rt Hon Charles Arbuthnot, m.p. (1767–1850)
Inscribed on the back *The Right Honble. Charles Arbuthnot in the 83rd year of his age 1849 by S. Gambardella*
Canvas, oval painted surface, 28×36¼ (71×92)
Charles Arbuthnot, diplomat and politician, was ambassador extraordinary in Constantinople 1804–7 and joint under-secretary at the Treasury 1809–23. Both he and his wife Harriett were close friends of the Duke of Wellington, and Arbuthnot lived at Apsley House after the death of his wife in 1834 until his own death in 1850.

Prov. Given by Miss Joan Harrild, great-granddaughter of the sitter, in 1971;
Lit. Elizabeth Longford, *Wellington; Pillar of State*, 1972, fig.36.

46 WM 1-1971 Neg. GA3081

47 The Duke of Wellington (1769–1852). (After Lawrence)
Canvas, 94½×59 (240×150)
He wears a long cloak over a blue uniform and holds a telescope in his right hand. This is a copy of the portrait painted by Lawrence for Sir Robert Peel, exhibited at the R.A. in 1825 (71) and now in Wellington College, Crowthorne, Berks. (99×55; Garlick, 1964, p.194, no.6; repr. Longford, 1972, fig.14; mezzotint by Samuel Cousins, 1847). The copy was made at the request of the 2nd Duke of Wellington. In a letter to the Duke (1860) Gambardella suggested that by means of slight alterations he could make an excellent original picture of it. In the event, however, he painted a very faithful copy, though it differs slightly in size.

Prov. Bought by the second Duke of Wellington from the artist in about 1860.

Baron François-Pascal-Simon GÉRARD (1770–1837)
French School
Born in Rome, he returned with his family to Paris at the age of 12. In 1786 he entered the studio of David and became his favourite pupil. He made his reputation with a series of large-scale history paintings (Versailles Museum) but it is as a portrait painter that he remains best known. In spite of his work for the Bonaparte family, he was made *premier peintre du roi* by Louis XVIII after the restoration in 1814. His early portraits are characterized as much by their psychological insight as by their technical assurance, but from about 1818 there is a marked decline in quality as studio assistants undertook an increasing amount of the work. Gérard's portraits were engraved and published as a series by Pierre Adam in 1826 under the title *Collection des Portraits . . . de M. le Baron Gérard* (2nd ed. by H. Gérard, 1852–7).

47 WM 1534-1948 Neg. Q1352
Wellington *Cat.*, p.272 no.175 red

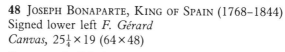

48 JOSEPH BONAPARTE, KING OF SPAIN (1768–1844)
Signed lower left *F. Gérard*
Canvas, 25¼ × 19 (64 × 48)

Bust, nearly life-size. He wears a green uniform with an orange plastron (probably of the Chasseurs Napolitains à cheval). Round his neck hangs the order of the Golden Fleece; on his chest, the badge and sash of the Legion of Honour and the new Royal Order of Spain.

Joseph was the eldest son of Charles Bonaparte and the eldest brother of Napoleon. After taking a legal degree at Pisa in 1787, he became a lawyer and then a judge at Ajaccio at the time of the Revolution. In 1794 he married Julie Clary at Marseilles. Elected deputy in 1797, he was then made ambassador to Rome by Napoleon and in 1800 he negotiated peace with the United States and with Austria. Installed by Napoleon as King of Naples 1806–8, he carried through financial reforms and earned a reputation for good government, but his period as King of Spain, 1808–1813, was marred by the success of Wellington's campaigns. He was forced to leave Madrid in 1812 and lost the whole kingdom at the battle of Vitoria in 1813. After Waterloo, he retired to the U.S. under the name of Comte de Survilliers and later lived in England (1832–7) and Florence (1841–4) where he died in 1844.

This picture is based on the official full-length portrait painted by Gérard in 1810 when Joseph was 42. A closely related bust portrait is in the Museo Napoleonico in Rome, where it is attributed to Lefèvre. A second full-length, with the palace of Aranjuez in the background, attributed to François-Joseph Kinson, is in the museum at Cassel (*Napoléon,* exhibition, Grand Palais, Paris, 1969, no.353, repr.). For another portrait of him in the Wellington Museum see under Lefèvre (WM 1520).

Prov. Joseph Bonaparte, in Spain; captured at Vitoria, 1813.
Lit. Michael Ross, *The Reluctant King,* 1976, repr. on jacket; A Braham, 'Goya's Equestrian Portrait of the Duke of Wellington', *Burl. Mag.,* 108, 1966, p.621.

Caption (under image 48):
48 WM 1630–1948 Neg. J939
Wellington *Cat.,* p.279 no.119 black

49 ALEXANDER I, EMPEROR OF RUSSIA (1777–1825)
Canvas, 95 × 63¼ (241 × 160)

Full-length, life-size, aged about 40. He stands in a landscape, wearing the undress uniform of a Russian field-marshal. He wears the sash and star of St Andrew (the star interlaced with the Garter of Great Britain), beneath which is the star of the Sword of Sweden, and above it are the cross of St George, the Iron Cross, the Cross of Maria Theresa of Austria, the silver 1812 medal and the badge of the Order of William.

Alexander I became Tsar after the murder of his father Paul I, in 1801. He joined the allied coalition against France in 1805, but two years later made peace with Napoleon, which lasted until the invasion of Russia in 1812. After the war, Alexander was instrumental in the formation of the Holy Alliance with the Emperor of Austria and King of Prussia, which became a symbol of monarchical despotism. The letter from Count Nesselrode (see below) shows this portrait to have been made in 1817 'by or under the immediate supervision' of Gérard himself. Closely related versions, with minor variations in the landscape background, are at Versailles, Helsinki University and Malmaison (repr. *History Today,* Feb. 1969). Gérard's portrait served as a model for George Dawe's, also in the Wellington Museum (see no.35), and for Lawrence's full-length of 1818 in the royal collection (*Sir Thomas Lawrence,* exh., N.P.G., 1979, no.35, repr.)

The correspondence concerning this picture is described by Evelyn Wellington:

'In a letter dated Paris, May 15, 1817, General Pozzo di Borgo, Russian Ambassador in Paris, encloses to the Duke of Wellington the following

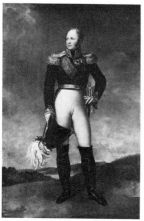

Caption (under image 49):
49 WM 1462–1948 Neg. N2589
Wellington *Cat.,* p.309, no.4 red

communication received by him from Count Nesselrode, Chancellor of the Russian Empire:

St. Petersbourg, le 5/17 Avril, 1817.

Monsieur le general,–L'Empereur a été informé du desir que Mr. le Maréchal Duc de Wellington vient de manifester à Votre Excellence à l'effet d'obtenir l'autorisation necessaire pour fair tirer une copie du portrait de S.M. Impériale peint par Gérard. Une demande semblable ne pouvait qu'être agréée par Notre Auguste Maître qui se plaît à y trouver une preuve de la justice que Mr. le Maréchal rend à ses sentimens. S. M. Impériale vous confie, Monsieur le Général, le soin de faire cette copie par l'artiste habile, auteur du tableau original, ou du moins sous ses auspices immédiats, l'intention de S.M. Impériale étant, que ce don ait une valeur analogue à la spontanéité qui le motive.

L'Empereur y met une condition, celle de recevoir en retour le portrait de Mr. le Duc de Wellington, et Votre Excellence est chargée de lui en faire la demande au nom de Sa Majesté.

J'ai l'honneur d'être,
Le Cte. de Nesselrode.

Prov. Presented to the Duke of Wellington by Alexander I of Russia and sent over from Paris in 1817.
Lit. Passavant, *Tour,* i, p.173; Waagen, *Treasures,* ii, p.277.

50 Louis XVIII, King of France (1755–1824)
Canvas, $102\frac{1}{2} \times 76\frac{3}{4}$ (260×195)

Full-length, life-size, aged about sixty-eight. In full regal robes. He wears a short ermine cape over which are the collars of the St Esprit and another order. Under the cape he wears a purple velvet cloak lined with ermine and embroidered with gold fleurs-de-lis. He wears the Garter below his left knee. He holds his sceptre, the other end of which rests on a book which lies on a table to the left, together with another sceptre and a crown.

Louis XVIII, brother of Louis XVI, fled from Paris during the Revolution and ultimately settled in England. He was placed on the throne by the allies in 1814 and finally, after Waterloo, in 1815.

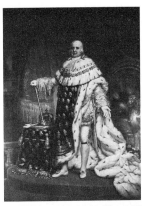

50 WM 1464–1948 Neg. P1412
Wellington *Cat.,* p.311, no.6 red

Gérard painted several portraits of him in full regal robes: the more common composition shows him seated, in three-quarter profile (Museums of Toulouse and Bremen, catalogue of 19th–20th-century paintings, 1973, fig. 528). The costume and posture of the Wellington picture are standard for French royal portraits; closely comparable in nearly every detail, for example, with Antoine Callet's *Louis XVI* of 1779 in the Versailles Museum (exh. *Les Grandes Heures de la diplomatie française,* Versailles, 1963, no.233, repr.), and in general terms the concept does not differ from Rigaud's portrait of Louis XIV in the Louvre.

The date of the picture, unfinished at Louis XVIII's death in 1824, and the details of Charles X's gift to the Duke of Wellington are recorded in the correspondence between the Prince de Polignac, the French ambassador in London, later Charles X's prime minister, and the Duke:

Portland Place, *ce 16 Novembre,* 1824.

Monsieur le Duc,—N'ayant pas eu l'honneur de vous rencontrer à votre Hotel je m'empresse de m'acquitter d'une commission que j'eusse préféré faire verbalement auprés de vous. Le Roi, mon auguste maître, ayant appris que j'avais fait prendre quelques informations dans le but de savoir si le Portrait qui vous avait été destiné par le feu Roi, Monsieur le Duc, était bientôt achevé, m'a chargé par l'intermédiaire de son Ministre des Affaires Etrangères de faire savoir à votre Excellence qu'il en faisait presser l'execution, et que de plus il avait donné l'ordre de faire faire son propre portrait, que Sa Majesté compte vous offrir comme un témoignage de son amitié. Je me félicite, Monsieur le Duc, d'avoir à vous faire connaître cette nouvelle preuve des sentiments que

vous porte Mon Souverain, et qui s'accordent si bien avec les souvenirs glorieux qui se rattachent a votre personne.

Recevez, etc.,

(Signed) Le Prince de Polignac.

In a letter dated Stratfield Saye, November 17, 1824, the Duke thanks the Prince for the trouble he has taken with regard to the picture promised him by the late King, Louis XVIII, and begs him to thank the present King, Charles X, for his promise of a picture of himself.

Then follows a second letter from the Ambassador:

> Portland Place, *ce 4 Juillet*, 1826
>
> Monsieur le Duc,— Je m'empresse de transmettre à votre Grace le Portrait du feu Roi que Sa Majesté Charles X m'a envoyé pour vous être remis; j'attends sous peu celui du Roi actuel et je ne perdrai pas un moment à vous le faire savoir aussitôt qu'il sera arrivé. J'éprouve une vraie satisfaction à être en cette occasion, Monsieur le Duc, l'organe des sentimens d'estime et d'amitié de mon Souverain à votre égard.
>
> J'ai l'honneur, etc.
>
> (Signed) Le Prince de Polignac.

Prov. Presented to the Duke of Wellington by Charles X in 1826 in accordance with the wishes of Louis XVIII, who died before the completion of the work.

Lit. Passavant, *Tour*, i, p.173 (erroneously attributed to Lefèvre); Waagen, *Treasures*, ii, p.277.

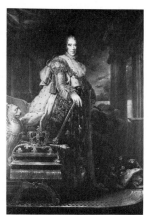

51 WM 1465–1948 Neg. P1402
Wellington *Cat.*, p.389, no.7 red

51 Charles X, King of France (1757–1836)
Canvas, $100 \times 70\frac{1}{2}$ (254 × 179)

Full-length, life-size, aged about sixty-seven. He wears an ermine cape which reaches to the waist in front and to the ground at the back and sides. From the waist down he wears a red velvet skirt trimmed with ermine at the bottom and embroidered with gold fleurs-de-lis. Over his shoulder are the collar and cross of the St Esprit. In his right hand he holds his sceptre, the other end of which rests on a cushion, together with another sceptre and a crown.

Charles X, brother of Louis XVI and Louis XVIII, fled from Paris during the Revolution and settled in England in 1795. Already in his brother's reign he was the leader of the Ultra royalists, the party of extreme reaction, and when he came to the throne in 1824 he assumed an autocratic rule upheld by his belief in the divine right of kings: 'I would rather hew wood than be a King under the conditions of the King of England.' His reactionary policies led to the convening of the Assembly and ultimately to the Revolution of 1830, when he abdicated in favour of his grandson Louis Philippe and fled to England.

Gérard painted several versions of this portrait; the most closely related, at the Bowes Museum, Barnard Castle, is identical except for minor differences in the building in the background. The one at Versailles is similar but does not have the view on to the exterior, while the Louvre portrait is of head and shoulders only (1960 catalogue, no.925). Charles X offered both the portrait of Louis XVIII and this one of himself to the Duke of Wellington in November 1824 (see previous entry) and Gérard's letter of November 1825 to the Duke fixes its date reasonably firmly. Evelyn Wellington's summary of the correspondence is as follows:

> On the 24th of the following November, M. Gérard writes to the Duke from Paris, saying that he has not forgotten that it was the Duke's wish that the picture of Charles X should be painted by him, and that he has tried to make the picture worthy of its destination, adding that it will soon arrive at the French Embassy, if it is not already there. He then says: 'Je serai très heureux, Monseigneur, que votre Grâce fût satisfaite de cet ouvrage; ne pouvant en changer la figure puisque c'est celle agréée par le Roi pour la manufacture des

Gobelins, et pour la gravure en taille douce, que le Gouvernement fait exécuter, j'ai cherché du moins à jeter quelque variété dans l'effet et dans la disposition du fond, ce qu'on pourrait reconnaître en comparant ce tableau avec les deux autres dont j'ai été également chargé pour l'Ambassade et pour Lord Salisbury.'

On December 5, 1826 the Duke writes to M. Gérard and thanks him for the pains he has taken with the picture. He tells him that he has already received an excellent picture of the King from the Ambassador, which had been sent by mistake to Lord Salisbury, but that as in his letter of the 24th of November M. Gerard mentioned his efforts to alter the effect and disposition of the background, and that as it was the Duke's desire to possess the picture intended for him by the King, he had sent M. Gérard's letter on to the Ambassador. He now begs M. Gérard to explain to the Secretary of the French Embassy (M. de Flavigny) the changes that had been made in the picture, with a view to ascertaining whether or not he possessed the portrait the King intended him to have. To this M. Gérard replies, expressing regret that the picture intended for the Duke should have, in the first instance, been sent to the wrong person, adding that he has written to inform M. de Flavigny that the picture in question has a sky background, and that it should have arrived first.

Prov. Presented to the Duke of Wellington by Charles X in 1826.

After GÉRARD

52 NAPOLEON BONAPARTE (1769–1821)
Canvas, rectangular, framed to oval, $28\frac{3}{4} \times 23\frac{1}{8}$ (73 × 59)

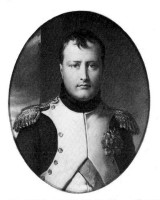

Bust portrait, life-size; Napoleon wears the uniform of a colonel of the foot grenadiers with a white 'plastron' showing a white waistcoat and a portion of the red sash of the Legion of Honour. He wears gold epaulettes and the Grand Cross of the Legion of Honour. The 'croix d'officier' of the same order and the Italian Iron Crown hang from one of the button holes of his coatee.

Acquired and catalogued in the Wellington collection as by Lefèvre, this is in fact a somewhat lifeless copy, identical in all details, except for the background, of Gérard's oval portrait (private collection, Zurich, 73 × 59, see *Napoleon,* exh. Grand Palais, Paris 1969, no.489, repr.)

Prov. Bought by or presented to the Duke of Wellington before 1830.

52 WM 1515–1948 Neg. Q1377
Wellington *Cat.,* p.253 no.78 red

GERMAN School

German School, *c.*1810–15

53 FREDERICK WILLIAM, DUKE OF BRUNSWICK (1771–1815)
Canvas, rectangular, framed as oval, 29 × 23$\frac{1}{2}$ (73.7 × 59.7)

He wears a deep-collared coat with bars of black braid and, on his chest, the star of the Black Eagle.

Frederick William was the son of Charles William Ferdinand of Brunswick and brother of the persecuted Queen Caroline of England. He fought in the Prussian army against revolutionary France and became a bitter opponent of Napoleonic domination in Germany. In 1809, after Wagram, he fled to England and fought in the Peninsular campaign. He returned to Brunswick to raise fresh troops in 1813 and died fighting at Quatre Bras in June 1815.

This picture was bought by the Duke of Wellington from a Mr Henry Hayter and the Wellington Catalogue enshrined the tradition that this was probably the name of the painter('Henry Hayter (?)'). However, there is no mention of such an artist in any of the reference books and perhaps the time has come to abandon this attribution. Indeed, to judge from the picture's style, characterized by a hardness and detailed treatment of the face which is silhouetted against a plain background, it is more likely to be Continental

53 WM 1553–1948 Neg. Q1359
Wellington *Cat.,* p.383, no.213 red

than English. It is interesting to note that this was the assumption of the writer on the Apsley House collection in the *Quarterly Review* in 1853, where the portrait was described among a group of 'foreign pictures', without further attribution. The likelihood is that the picture is by a German painter working under French influence, and that it dates from the period 1813–15 when Frederick William was back in Brunswick. In posture, facial features and hairstyle it is close to the engraving by F. Müller after J. F. Schmidt (repr. in Hemming's *Deutscher Ehren Tempel*, Gotha, 1824).

Prov. Bought by the Duke of Wellington 1851 from Henry Hayter for £26. 5s. 0d.
Lit. *Quarterly Review*, 92, 1853, p.459.

German School, *c.*1830

54 FREDERICK WILLIAM III, KING OF PRUSSIA (1770–1840)
Illegible signature, centre foreground.
Canvas, 105 × 69 (267 × 175)

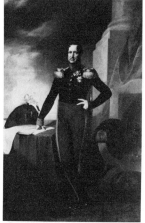

54 WM 1565–1948 Neg. P1413
Wellington *Cat.,* p.401, no.279 red

Frederick William wears the star of the Black Eagle and above it the Iron Cross, the cross of Maria Theresa of Austria, the cross of St George of Russia and two war medals, partially hidden. He is considerably older than in the portrait by Herbig at Apsley House (see below, no.68) and a date *c.*1830 may be proposed for this painting.

Prov. Bought by the Duke of Wellington from Colnaghi's in 1847 for £84.

Luca GIORDANO (1634–1705)
Italian (Neopolitan) School
Son and pupil of Antonio Giordano, he was also greatly influenced by Ribera. He worked mainly in Naples but also in Rome and Florence, as well as Madrid. Known as *fa presto* from the speed at which he worked, his output was enormous even allowing for the fact that he must have employed assistants for his major decorative schemes.

Lit. O. Ferrari, G. Scavizzi, *Luca Giordano*, Naples, 1966.

55 WM 1638–1948 Neg. GD589
Wellington *Cat.,* p.318, no.135 black

55 HAGAR AND ISHMAEL IN THE DESERT (Genesis xvi, 7)
Inscribed in white with inventory no. *897.*
Canvas, 26⅜ × 61⅛ (67 × 156)

Luca Giordano was invited to Madrid by Charles II in 1692 and remained as court painter until his return to Naples in 1702. Among his official commissions was a group of paintings of biblical subjects for the Buen Retiro palace and, in particular, a series of Old Testament scenes for the Hermitage of St John in that palace. Both the *Hagar and Ishmael* and the *Samson and Delilah* (see next entry) are described in the Buen Retiro inventory of 1701: . . . 'The slave of Abraham with her son Ishmael in the desert and the angel pointing out where she will find water', and 'Another picture over the window . . . of Samson asleep and Delilah cutting off his hair'. (Fernández Bayton, *Inventarios*, II p.348 nos.895, 898, valued at 1,200 reales each).

Both pictures were painted to hang over windows, as were five others in the series: *Abraham showing God the twelve tribes* (whereabouts unknown), *God and Abraham* (Prado; inscribed no. 894), *Abraham and the three angels* (Prado; inscribed no.895), *(Samson and the Philistine)* Burgos Museum) and *Lot and his daughters* (Prado). The series is reproduced by Ferrari and Scavizzi, ii, p.195ff., figs 388–90. Three other scenes of Samson – *Samson burning the Philistines' harvest* (Madrid, Palacio Real, inscribed no.890), *Samson fighting the lion* (Prado), and *Samson in the Temple* (Escorial) (Ferrari-Scavizzi, figs 381–2) were hanging as overdoors in the same room. The two Apsley House pictures are, however, painted in a broader, more sketchy style than the others and this led Ferrari-Scavizzi to argue that they

never belonged to the Buen Retiro series. Works in this broader style do not occur earlier in Giordano's *oeuvre* than the frescoes of the Cason del Retiro (1697) and Ferrari placed the Wellington pictures *c*.1700 rather than *c*.1696 when the biblical paintings for Buen Retiro were produced. Yet the descriptions and sizes in the Buen Retiro inventory of 1701 fit the Wellington pictures precisely and the admitted difference in style could readily be explained by the time lag of a year taken to complete the decorative scheme.

The importance of Buen Retiro as a royal residence declined in the 18th-century and these paintings, among others, were transferred to the Palacio Real in Madrid which was built 1738–64.

The composition follows the standard 17th-century iconography – compare, for example, the painting by P. F. Mola at Dulwich – but it has had to be squeezed into a narrower horizontal shape.

Condition. Paint loss upper left; worn irregularly.
Prov. Hermitage of St John, Buen Retiro, (1701 inventory no.895); Royal Palace, Madrid, Infanta's antechamber (1772 and 1794 inventories). Captured at Vitoria, 1813.
Lit. S. L. Ares Espada, *Il Soggiorno spagnolo di Luca Giordano*, diss. Bologna 1954–5; p.151; A. Griseri, 'Luca Giordano alla maniera di . . .,'*Arte Antica e Moderna*, 13–16, 1961, p.436, n.25 (wrongly identified with a picture of the same subject sold at Christie's, 25 Feb. 1949, lot 86); Gaya Nuño, *Pintura Europea*, 1964, p.88; O. Ferrari, G. Scavizzi, *Luca Giordano*, 1966, ii, p.222, fig.490.

56 SAMSON AND DELILAH (Judges xvi, 19)
Inscribed in white with inventory no. *900*
Canvas, $23\frac{3}{8} \times 57\frac{7}{8}$ (56 × 147)

See previous entry.

56 WM 1631–1948 Neg. GD590
Wellington *Cat.*, p.323, no.120 black

The composition, showing Delilah cutting Samson's hair while he lies in her lap and the soldiers approach with ropes, is fairly standard in the 17th century (cf. Guercino, Christie's, 21 April 1967, lot 74). Another version of the subject attributed to Luca Giordano (advertised in *Burl. Mag.*, Nov. 1970) is different in shape.

Condition. Signs of wearing in background, upper centre; darkened retouches on figure of Samson.
Prov. See previous entry.
Exh. First Magnasco Society Exhibition, Agnews, Oct–Nov. 1924, no.33 (see Osbert Sitwell, 'The Magnasco Society' *Apollo*, 79, 1964, p.382).
Lit. Ares Espada, *loc.cit.;* Gaya Nuño, *loc.cit.;* Ferrari, Scavizzi, ii, p.222, fig.491.

James W. GLASS (1825–57)
American School
Born and trained in New York, he settled in London in 1847 and exhibited at the R.A. and B.I. 1848–55. Having gained a considerable reputation as a painter of horses and military life, he returned to New York shortly before his death.

57 HIS LAST RETURN FROM DUTY
Signed lower right *JW* (monogram) *Glass 1853*
Canvas, 32 × 48¼ (81·3 × 123)

The Duke of Wellington is shown riding from his office at the Horse Guards for the last time as commander-in-chief, not long before his death in September 1852. He has just emerged on to the Horse Guards' Parade. His horse, known as 'the Brown Mare', was led in the procession at his funeral.

There are two oil sketches, one formerly in the Duke of Wellington's collection inscribed: '26 July 1852 – The Duke saw this sketch at Apsley House on the above date and seemed pleased' (Wellesley-Steegmann, p.12),

57 WM 1562–1948 Neg. Q1383
Wellington *Cat.*, p.255, no.263 red

and another belonging to the Duke of Sutherland ($7\frac{3}{4}$ × 12in.; photo in Witt library). According to the Wellington *Cat.*, the first finished oil was in the collection of the Earl of Lonsdale and another replica was painted for Queen Victoria, but there is now no record of such a painting in the royal collection.

It appears that the Duke was persuaded to sit to Glass through the mediation of Abbot Lawrence, American Minister in London (*Athenaeum,* 23 October 1852). The last sitting was on 23 July and it was reported that the Duke said to the artist: 'You had better take all your sittings now, I may not be here in the spring' (*Athenaeum,* 20 November 1852). Glass also painted a portrait of Wellington, seated, with his secretary Algernon Greville (exh. R.A. 1853; Wellesley-Steegmann, p.12). There is an engraving by James Faed.

Prov. Bought by the 2nd Duke of Wellington from Messrs Colnaghi.
Exh. National Exhibition of Works of Art, Leeds, 1868; New Gallery, *Victorian Exhibition,* 1891–2 (31).
Lit. Thieme, Becker, 14, 1921, p.240. Wellesley, Steegmann, *Iconography,* 1935, p.12.

Francisco de GOYA (1746–1828)
Spanish School

Born in Fuendetodos, near Saragossa, he was a pupil of Francisco Bayeu in Madrid in 1766. He visited Rome in 1771, settled in Madrid by 1775 and, at the instigation of Mengs, began to paint cartoons for the royal tapestry works. He was appointed court painter in 1789 and first court painter (primer pintor de cámara) in 1799. A severe illness left him totally deaf at the age of 47 and from that period the mood and subject matter of his pictures became more sombre. In 1824 he fled from the autocratic regime of Ferdinand VII and settled in Bordeaux. His fame rests on his etchings as much as on his paintings and he exerted considerable influence on French painting from Delacroix to Manet.

Lit. P. Gassier & J. Wilson, *Vie et Oeuvre de Francisco Goya,* 1970.

58 WM 1566–1948 Neg. F942
Not in Wellington *Cat.*

58 EQUESTRIAN PORTRAIT OF THE DUKE OF WELLINGTON (1769–1852)
Canvas, 116 × 95 (294 × 241)

Wellington is wearing civilian dress; the sabre and sash are of a Spanish type and are probably fanciful additions by Goya. The execution is very sketchy; considerable areas have been laid on with a palette knife and numerous alterations are visible. It is now generally accepted that this portrait was painted in the three weeks between 12 August 1812, when Wellington entered Madrid, and 2 September when it was exhibited at the Academia di San Fernando (MacLaren, 1947). An announcement in the *Diario de Madrid* of 1 September 1812 refers to it as 'the equestrian portrait . . . of Lord Wellington . . . which has just been executed by . . . D. Francisco Goya'. In a letter Goya himself writes: 'Yesterday His Excellency Sr. Willington (sic), Duke of Ciudad Rodrigo, was here. A plan to exhibit his portrait in the Royal Academy (of San Fernando) was discussed, about which he showed much pleasure' (letter in Lazaro Galdiano coll., Madrid; Spanish text in Wellesley, Steegman, 1935; translations in MacLaren, 1947; Braham, 1966).

Clearly the speed with which the picture was produced would account for its sketchiness, while an X-ray photograph published by Allan Braham (1966, fig.28) shows conclusively that Goya painted the Duke's head over that of an earlier sitter. The X-ray reveals that this sitter wore a large curved hat, a circular star on his chest and a sash over his right shoulder. Goya painted Wellington's face over the hat, hence giving him a taller and broader body than the original figure. As Braham points out, this change accounts for the faulty anatomy of the shoulders, right arm and back, and also perhaps for the

fact that a victorious general was painted as a civilian. The alternative explanation, that Goya merely painted over an earlier version of the Duke's head, is unlikely; the face looks different and a change of sitter is also indicated by the over-painting of the star and sash. Braham suggests that the original sitter was perhaps Joseph Bonaparte, whose portrait was painted over when Wellington entered Madrid, thereby providing 'a perfect symbol of the altered political situation in Madrid.' On the other hand, Xavier de Salas suggests that the original sitter was Manuel Godoy, Prince of La Paz (Salas, 1969). His argument is based on a comparison of the facial features and the overpainted decoration, as well as on a consideration of the position of the horse, which is closer to Goya's equestrian portraits of the 1790s and based on Velazquez's portrait of Philip IV (Lopez-Rey, *Velazquez,* 1963, no.209) than to the later equestrian portraits painted during the war, in which the horse is usually placed diagonally to the picture plane. Unfortunately the face in the X-ray photograph is unsufficiently clear to provide evidence that would clinch the argument either way.

There are two other portraits of Wellington by Goya: (*1*) a bust portrait in the National Gallery (64·3×52·4cm.; formerly Duke of Leeds, see especially A. Braham, 'Goya's portrait of the Duke of Wellington in the National Gallery', *Burl. Mag.,* 108, Feb. 1966, p.78ff., fig.28). Braham suggests that although the portrait was begun in 1812 it was not finished until 1814, when the depiction of the decorations was brought up to date. (*2*) Half-length, wearing cloak and hat, in the National Gallery, Washington (105×88cm.; Beruete, 1922, pl.47). The face is more closely based on the drawing in the British Museum (see below) than either of the other two paintings.

There are also two preparatory drawings, both bust length: (*1*) British Museum, red chalk (Braham, *Burl. Mag.,* Feb. 1966, fig.30; Goya exhibition, R.A., 1963–4, no.145, pl.45). This differs from WM 1566 and the N.G. painting in details of the face, particularly in the prominence of the front teeth, and was probably drawn from life. The suggestion first put forward by MacLaren, (1947) that it was made for a projected etching that was never executed has not been widely accepted, (Goya exhibition, R.A., 1963–4; MacLaren-Braham, 1970, p.22, no.19; cf. the portraits discussed by de Salas, *Burl. Mag.,* 106, 1964, p.14ff.). (*2*) Hamburg, Kunsthalle, black chalk (Braham, *Burl. Mag.,* Feb. 1966, fig. 29). Closer in facial features to the oil portraits, it has been suggested that this is perhaps a copy (MacLaren-Braham, 1970, p.21).

According to an anecdote of doubtful veracity current in the early 19th century, the portrait led to a dispute between artist and sitter mainly because Wellington insisted that he had been made to look too heavy (MacLaren-Braham, 1970, p.22, no.16), and certainly the Duke kept it rolled up at Stratfield Saye. The fact remains that Wellington was the only Englishman – and one of only a few foreigners – ever to sit to Goya.

Condition. Retouches on centre part of sky at top right corner and on horse, next to the sitter's knee; some cracking of paint on the Duke's jacket.

Prov. Painted by Goya for the Duke of Wellington; at Stratfield Saye until 1948 and not, therefore, included in the Wellington Catalogue.

Exh. Academia di San Fernando, Madrid, 2–4 September 1812; *Spanish Paintings,* Arts Council/N.G., 1947 (2) (catalogue by Neil MacLaren); *Goya and his times,* R.A., 1963–4, (105).

Lit. V. von Loga, *Francisco de Goya,* Berlin 1903, p.206; A. de Beruete, *Goya as Portrait Painter,* 1922, p.147–8; Wellesley, Steegmann, *Iconography,* 1935, p.14; X. Desparmet Fitz-Gerald, *L'Oeuvre peint de Goya,* Paris, 1950, ii, p.189, no.476; F. J. Sanchez Canton, *Vida y Obras de Goya,* Madrid, 1951, pp.95, 171, fig.33; *Paintings at Apsley House,* 1965, pl.21; Allan Braham, 'Goya's Equestrian Portrait of the Duke of Wellington', *Burl. Mag.,* 108, Dec. 1966, pp.618—21; Xavier de Salas, 'Sobre un retrato ecuestre de Godoy', *Archivo Español de Arte,* 42, 1969, pp.217—33; Gassier, Wilson, *Goya* no.896; N. MacLaren, A. Braham, N.G. Catalogue, *The Spanish*

School, 1970, p.17; T. Crombie, *Apollo*, 1973, p.215, fig.15; R. de Angelis, *L'Opera Pittorica Completa di Goya*, Milan, 1974, no. 537.

Antiveduto GRAM(M)ATICA (*c*.1571–1626)
Italian School; worked in Rome.
Born in Siena, he lived in Rome from 1578 when he was the pupil of Giov. Dom. Angelini. He was patronized by Cardinal Francesco del Monte and became a member of the Academy of St Luke in 1593. In the mid–1590s he was associated with Caravaggio, but from the little that is known of his work it appears that he only adopted a Caravaggesque style in the following decade.

Ascribed to GRAMMATICA

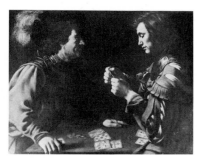

59 WM 1635–1948 Neg. H877
Wellington *Cat.*, p.325, no.131 black

59 CARD PLAYERS
Canvas, 34¼ × 45¾ (87 × 116)

This painting was catalogued as Caravaggio in the Wellington collection and was included as such in the first exhibition of the Magnasco Society in 1924. It therefore has an honourable place in the baroque revival in England, though the attribution to Caravaggio himself has not found acceptance. In the Wellington Museum it was labelled 'follower of Caravaggio' and no more precise attribution was forthcoming until Carlo Volpe's recent suggestion that it is by Grammatica (1972). This attribution found favour with Benedict Nicolson (1974; and written communication). No very similar compositions by this artist are known but some of his stylistic peculiarities, in particular the fleshy noses and lips, recur in the Wellington picture. The costume suggests a date *c*.1620, which would fit with Grammatica's chronology, for it is only in his mature work that he fully exploits Caravaggesque naturalism and chiaroscuro (see R. Longhi, *Quesiti Caraveggeschi* in *Opere Complete*, iv, 1968, p.138f., pls 193-207).

The subject of *card players* reached Rome, along with the *fortune tellers, money changers* and kindred scenes, from earlier 16th-century Flemish genre painting and was taken up by Caravaggio in the 1590s (see W. Friedlaender, *Caravaggio Studies*, 1955, p.81). Caravaggio's *Cardsharps* of *c*.1594 (Friedlaender, *op. cit.*, pl.12) was widely popular at the time and set the fashion for such paintings in Italy. Indeed, it was painted for Cardinal del Monte, who was also Grammatica's patron (Friedlaender, p.153; on del Monte see the articles by C. L. Frommel and others in *Storia dell'Arte*, 9–10, 1971, p.5ff.).

Condition. Irregular surface; some general wearing, but on the whole in good condition.
Prov. Spanish royal collection (not inv.); captured at Vitoria, 1813.
Exh. First Magnasco Society Exh., Agnew's, Oct-Nov. 1924, no.31 (as Caravaggio. See Osbert Sitwell, 'The Magnasco Society', *Apollo*, 79, 1964, p.382).
Lit. Athenaeum, 8 January 1853 ('fine in expression and marvellous in point of colour and light and shade'); Gaya Nuño, *Pintura Europea*, no.278 (Caravaggio); Carlo Volpe, 'Sulla Mostra Caravaggesca in Cleveland', *Paragone* (Arte), 23, (1), 1972, p.69; B. Nicolson, 'Provisional list of Caravaggesque pictures in collections in Great Britain and N. Ireland', *Burl. Mag.*, 116, 1974, p.560.

GUERCINO (1591–1666)
Italian (Bolognese) School
Giovanni Francesco Barbieri, called Guercino ('squint eyed') was born in Cento, near Bologna. Largely self-taught, though influenced by Ludovico Carracci, he was active from 1613 in Cento and Bologna. He was called to Rome in 1621 when his patron Cardinal Alessandro Ludovisi became Pope Gregory XV, but after Gregory's death in 1623 Guercino returned to Cento. Upon Guido Reni's death in 1642, he moved to Bologna and became head of a large workshop.

Lit. D. Mahon, *Il Guercino*, exhibition catalogue, Bologna, 1968; N. B. Grimaldi, *Il Guercino*, Bologna, 1968.

60 MARS AS A WARRIOR
Canvas, oval painted surface on rectangular canvas, $44\frac{3}{8} \times 33\frac{3}{8}$ (112·7×85)

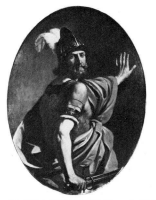

On 23 Feb and 17 and 26 March 1630 Guercino received sums amounting to 125 scudi from Lorenzo Fioravanti for a painting of *Mars* together with its companion *Venus and Cupid* which can probably be identified with these two Wellington pictures (the account book is printed in Malvasia and excerpted by Grimaldi). There is a very similar composition showing the three figures on one canvas, with Mars appearing frontal and Venus reclining full length, in the Galleria Estense, Modena (Horton, fig.2; Grimaldi, 1968, pl.99). This painting dates from 1634 when Guercino sold it for 126 scudi. As Anne Horton has pointed out, the Wellington pictures are in a more baroque style, with a fuller use of chiaroscuro and diagonals, than the painting at Modena, and she compares them with the *Guardian Angel* of 1628 in the Galleria Colonna, Rome (Grimaldi, pl.91). The warrior recurs in the *Martyrdom of St Lawrence* of 1629 in Ferrara Cathedral (Grimaldi, pl.92). There is a preparatory drawing of Mars in the Oberlin Museum and two related drawings of warriors in the Witt Collection, Courtauld Institute (Horton, figs. 1, 5, 6) and another in the Kunsthalle, Hamburg (Gernsheim photo. no. 16859).

Concerning the warrior's armour: the helmet and sword are both characteristic of the early 17th century, but the body armour, presumably intended to appear Roman, is purely imaginary (information supplied by Claude Blair).

Condition. Some retouching in background; otherwise good. The original shape appears to have been oval.
Prov. Probably from the Mora collection (Wellington *Cat.*); certainly in France in the early 19th century, label on back formerly read as 'Mars quittant Venus. Deux figures de grandeur naturelle. Oval par Gio. Francesco Barbieri dit le Guercin né à Cento en 1590 mort en 1666.' Bought by or presented to the Duke of Wellington.
Lit. C. C. Malvasia, *Felsina Pittrici*, Bologna, 1841, ii, p.308; Anna K. Horton, 'A Drawing by Guercino', Allen Memorial Art Museum; Oberlin, *Bulletin*, 18, 1960, p.5ff., esp. pp. 7-13, fig.3; Grimaldi, *Guercino*, 1968, p.94 (summary of 1630 documents; no mention of the Wellington pictures).

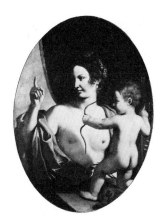

61 VENUS AND CUPID
Canvas, oval painted surface on rectangular canvas, $44\frac{3}{8} \times 33\frac{3}{8}$ (112·7×85)

Companion piece to *Mars as a Warrior* (see previous entry).

Condition. Some wearing, e.g. hair and shadow near Venus's right breast, otherwise good. The original shape appears to have been oval.
Prov. See previous entry.
Lit. Malvasia, *loc.cit.*; Horton, *loc.cit.* and fig.4.

Peeter GYSELS (1621-1690/1)
Netherlands (Antwerp) School
Born in Antwerp, where he was a pupil of Jan Boots and, according to Houbraken, of Jan Brueghel, he became an independent master in 1649. Many of his small landscapes and village views are indistinguishable from those of Brueghel. He also painted still life in the manner of Jan Weenix.

62 A FLEMISH VILLAGE: THE RIVER LANDING STAGE
Signed lower centre *p. gijsels*. Inscribed in white with inventory no. 956
Copper, $11\frac{1}{8} \times 14\frac{1}{8}$ (28×35·8)

This and the following two paintings are typical of Gysels' work in the style

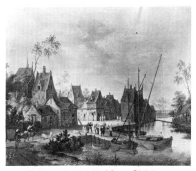

of Jan Brueghel. A very similar village scene with landing stage by Gysels is in the Dresden Gallery (no.1154); it combines the features of this painting and of no. WM 1636. Another similar scene, with a wider river, was in the Vanderkar Gallery, London (advertised in *Apollo*, June 1972).

Prov. Royal Palace, Madrid, 1772 inventory, one of eight paintings by Brueghel or his school inscribed with the number 956; others now in the Wellington Museum are nos. WM 1636, Gysels, and WM 1634 and 1637, Brueghel.
Lit. Gaya Nuño; *Pintura Europea*, no.161.

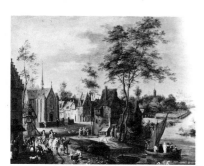

63 A FLEMISH VILLAGE WITH RIVER VIEW
Signed right centre foreground *Petrus Geysels*. Inscribed in white with inventory no.956.
Copper, $11\frac{3}{8} \times 14\frac{1}{4}$ (29×36)

See previous entry.

Prov. Royal Palace, Madrid, 1772 inventory, one of eight paintings by Brueghel or his school inscribed with the number 956; others now in the Wellington Museum are WM 1646, Gysels, and WM 1634 and 1637, Brueghel. 1794 inventory, apparently one of a pair hanging with WM 1646 in the King's first cabinet, entered as '956 and 957 . . . 'Passing a River' and a 'Waterside piece with buildings: Men on horses etc.,' style of Brueghel.' The size is given as a half by a third vara, i.e. 28×42cm. Captured at Vitoria, 1813.

Lit. Gaya Nuño, *Pintura Europea*, no.159.

63 WM 1636–1948 Neg. J934
Wellington *Cat.*, p.124, no.132 black

64 LANDSCAPE WITH FIGURES CROSSING A BROOK
Signed indistinctly lower right, *p. gijsels*
Copper, $11 \times 14\frac{1}{4}$ (28×36)

An almost identical version was in the Tollemache collection, (Christie's, 26 Nov. 1971, lot 75; panel, $15\frac{1}{2} \times 22\frac{1}{2}$ins.)

Prov. Royal Palace, Madrid, 1794 inventory, apparently one of three hanging with WM 1636 and 1646 in the King's first cabinet, entered as '956 and 957 . . . 'Passing a River' and 'Waterside piece with buildings, men on horses etc., style of Brueghel.' The size is given as a half by a third vara, i.e. 28×42cm. Captured at Vitoria, 1813.

Lit. Gaya Nuño, *Pintura Europea*, no 160.

64 WM 1572–1948, Neg. J932
Wellington *Cat.*, p.146, no.10 black

James HALL (1797–1854)
British School
A Scottish advocate as well as an amateur painter, he was a student at the Royal Academy and a friend of Wilkie. He exhibited portraits – including one of the Duke of Wellington – and landscapes at the R.A., 1835–54.

65 COLONEL JOHN GURWOOD C.B. (1790–1845)
Dated on the back, 1837
Canvas, $49\frac{1}{2} \times 39\frac{1}{4}$ ($126 \times 89 \cdot 6$)

Three-quarter length, life-size, aged 47. He wears the uniform of esquire to the Duke of Wellington, as Knight of the Bath. This consists of a round, soft black hat, a round frill collar and a white sleeveless coat over a red silk undercoat. In his right hand he holds the Duke's banner, and he is wearing the Waterloo medal on his chest.

John Gurwood joined the army in 1808 and subsequently served as a lieutenant in the 52nd Light Infantry throughout the Peninsular War, receiving a severe wound in the head at Ciudad Rodrigo in 1812. He also fought in France and was again wounded at Waterloo. After the war he was for many years private secretary to the Duke of Wellington, and edited the Duke's orders and a selection from his dispatches under the title of the *Wellington Despatches,* in 1837–44.

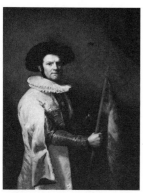

65 WM 1467–1948 Neg. Y893
Wellington *Cat.*, p.291, no.9 red

A preparatory pencil drawing for this portrait, showing the head and shoulders only, in identical posture and inscribed *Col. Gurwood / 1837 / 6 January / 7 Jan.y* is in the collection of the Duke of Wellington (66×54cm.). There is also a marble bust of Gurwood by Samuel Joseph at Apsley House dated 1840. He was included in William Salter's *Waterloo Banquet at Apsley House*, 1836 (Duke of Wellington), and there is a sketch of him for this painting in the N.P.G. (3719).

Prov. Bought by the Duke of Wellington.
Exh. South Kensington *National Portrait Exhibition*, 1868 (411).

John HAYTER (1800–c.1891)
British School
Younger brother of Sir George Hayter, he exhibited mainly portraits and historical scenes at the R.A. and B.I. from 1815 until 1879.

66 STAPLETON COTTON, FIELD-MARSHAL VISCOUNT COMBERMERE G.C.B., K.S.T., (1773–1865)
Signed at the back *John Hayter pinxit, 1839*
Canvas, 55×43¼ (141×110)

66 WM 1531–1948
Wellington *Cat.,* p.292, no.103 red

He is represented in the uniform of Colonel of the 1st Life Guards – red coatee, cuirass, white breeches and jackboots – standing in front of his charger which is being held by a trooper of the same regiment. From his neck hangs the large Peninsular gold cross and he also wears the small one.

Combermere, the second son of Sir Robert Salusbury Cotton, Bt, entered the army as a second lieutenant in the Royal Welsh Fusiliers in 1790. He took part in the Netherlands campaign of 1793–4, becoming a lieutenant–colonel at the age of 21 in 1794, and served with distinction in India, 1795–1800, and in the Peninsular War, 1808–14. At Salamanca he was second in command under Wellington. He was raised to the peerage in 1814 and was governor of Barbados 1817–20, and then successively commander-in-chief in Ireland and in India, where he attained the rank of general and successfully besieged the fortress of Bhurtpore in 1826. He returned to England in 1830.

Combermere obtained the honorary appointment of Colonel of the 1st Life Guards, with its attendant duties at court (see Mary, Viscountess Combermere, *Memoirs and correspondence of Field-Marshal Viscount Combermere*, 1866, II, p.227) in September 1829 when he was 55 and it is likely that this portrait refers to that date, even though it is itself dated 1839. Certainly the sitter appears to be nearer 55 than 65, and a preparatory pencil drawing, showing the trooper holding the horse, bears the watermark 1831 (Christie's, 19 Dec. 1978, lot 140, inscribed *for Lord Combermere picture)* which suggests that the portrait originated in the early 1830's, even if it was not completed until 1839. It was engraved by Samuel Reynolds in 1841. Among the other portraits of Combermere is a half-length by Lawrence of *c.*1815 (Horse Guards coll., K. Garlick, *Walpole Society*, 1964, p.58) and another by J. P. Knight, *c.*1845 at Plas Newydd.

Condition. Cleaned at the National Army Museum (where it was on loan 1966-81) in 1966.
Prov. Bought by or presented to the Duke of Wellington.
Exh. South Kensington, *National Portraits Exhibition*, 1868 (195); New Gallery, *Victorian Exhibition*, 1891-2 (299).

George Peter Alexander HEALY (1808-94)
American School
The son of an Irish ship's captain, Healy was born in Boston where he established himself as a largely self-taught portrait painter at the age of 18. He came to Europe and settled in London, 1838-43, and then in Paris, where he

was a pupil of Gros and Couture. In 1855 he returned to the U.S., and settled in Chicago until 1866 when he went back to Paris and to Rome. He was very popular for both his portraits and his history paintings.

Lit. Marie de Mare, *G. P. A. Healy, American Artist,* 1954.

67 WM 1555–1948 Neg. L1403
Wellington *Cat.,* p.247, no.215 red

67 MARSHAL NICOLAS JEAN DE DIEU SOULT, DUC DE DALMATIE (1769-1852)
Inscribed on the back of the canvas: *Maréchal Soult, Duc de Dalmatie, by G.P.A. Healy, to his Friend J.S. Lucet aîné.*
Canvas, 29½ × 24½ (75 × 62)

Head and shoulders, life-size, aged about 70. The sitter wears a dark, gold-embroidered uniform of a French field-marshal with gold epaulettes. He wears the star, the small cross and the sash of the Legion of Honour.

Soult joined the army in 1785, served with conspicuous skill in the campaigns of the 1790s and was made marshal in 1804. He took part in the campaigns of Napoleon and commanded the French armies in Spain 1808–13. After the war he was at first a supporter of Louis XVIII, who made him Minister of War, but then declared for Napoleon and was his chief of staff at Waterloo. Subsequently exiled, he returned to France in 1819 and was ultimately restored to the peerage and made Minister of War by Louis Philippe. He represented France at the coronation of Queen Victoria in 1838.

The picture was painted from life in 1840 at the suggestion of General Lewis Cass, American Minister in Paris, and the artist was awarded a gold medal for it at the Paris Salon of that year. Soult himself considered it so good that he regretted it was not full length, whereupon Healy painted a full-length version and gave the original to Lucet, a professor of literature. Correspondence in the Wellington archive (see Wellington *Cat.,* p.248) concerns Lucet's offer of the painting to the Duke of Wellington in 1841 and the Duke's repeated refusal to accept the gift. When Lucet sent the Duke the picture in spite of this refusal, Wellington replied:

> 'However desirous of possessing permanently the portrait in question of Marshal Soult, I feel great repugnance to receive a present of an article of value from a gentleman with whom I have not the honour of being acquainted. There I leave the matter, and I request that you will send for the portrait or leave it where it is, as you may think proper. I will have marked upon it if you should leave it – "Sent to Field-Marshal the Duke of Wellington in the year 1841 by Mons. J. S. Lucet, then residing No.39, Foley Place, Portland Place, London".'

Wellington ultimately bought the picture for 50 guineas in 1849.

Prov. Bought by the Duke of Wellington in 1849 from J. S. Lucet for £52. 10s. 0d.
Lit. Marie de Mare, *G. P. A. Healy, American Artist,* 1954, p.81ff.

Wilhelm HERBIG (1787–1861)
German School
Born in Berlin, where he studied at the Academy of which he became a member in 1829 and deputy director in 1845. He painted battle scenes based on his own experiences in the Napoleonic wars, as well as portraits and figure subjects.

68 FREDERICK WILLIAM III, KING OF PRUSSIA (1770–1840)
Signed at foot of balustrade, lower left, *Herbig pint.*
Canvas, 91¾ × 62¼ (233 × 158)

Frederick wears the uniform of a Prussian field-marshal; dark double-breasted coatee with silver buttons, red facings embroidered with silver, a silver sash with tassels round his waist, silver epaulettes, dark breeches and high black boots. On his chest is the star of the Black Eagle, and from a button hang the

68 WM 1461–1948 Neg. P1405
Wellington *Cat.,* p.306, no.3 red

Iron Cross, the cross of Maria Theresa and that of St. George of Austria.

Frederick William III succeeded to the Prussian throne in 1779. In 1805 he declared war on France and was forced to flee from Berlin during the French occupation 1806–9. The country suffered further during the campaign of 1812–14, but under his rule, after the war, Prussia took a leading place in German affairs.

This portrait may be compared with the full-length by Lawrence painted in 1814–18 for the Waterloo Chamber at Windsor Castle (K. Garlick, *Walpole Society*, 1964, p.83). There is a similar composition in the Examination Schools at Oxford; for a portrait of the King at a later age, see above under German school (no.54).

The Duke of Wellington's desire for a portrait of Frederick William and the King's reply is set out in a letter from him to the Duke dated 18 August 1818:

> MONSIEUR LE MARÉCHAL,– J'ai appris que vous aviez temoigné le désir de posséder mon portrait en pied. J'ai vu dans ce désir flatteur un moyen de vous donner une nouvelle preuve de tous les sentimens que je vous porte, et qui vous sont dus .a juste titre. Je saisirai toujours avec le plus grand empressement toutes les occasions de vous exprimer mon attachment sincère et ma reconnaissance pour les grands et immortels services que vous avez rendus et que vous rendez tous les jours á la cause de l'humanité. Je souhaite, Monsieur le Duc, que mon portrait que je vous envoye, vous rappèle quelque fois celui qui ne cessera jamais d'être avec une parfaite considération et une véritable estime,

<div align="right">

Monsieur le Maréchal,
Votre très affectionné,
FREDERIC GUILLAUME.
</div>

Au Maréchal Duc de Wellington,
BERLIN, ce 18 Août, 1818.

Prov. Given to the Duke of Wellington by the King of Prussia in 1818.
Lit. Passavant, *Tour*, i, p.173; Waagen, *Treasures*, ii, p.277 (wrongly attributed to Gérard); Thieme, Becker, 16, 1923, p.449, (wrongly identified with the portrait exhibited in Berlin in 1828).

Jan van der HEYDEN (1637–1712)
Dutch School
He lived mainly in Amsterdam where he was one of the leading specialists in town views. From the end of the 1660's he was also engaged in projects to improve street-lighting and fire-fighting.

Lit. Helga Wagner, *Jan van der Heyden*, 1971.

69 ARCHITECTURAL FANTASY, WITH THE OLD TOWN HALL, AMSTERDAM
Signed on wall, lower centre *V. Heyde f* (with ? trace of a date).
Oak panel, $18\frac{3}{4} \times 23\frac{1}{4}$ (47·7×59)

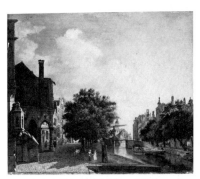

69 WM 1500–1948 Neg. F949
Wellington *Cat.*, p.13 no.56 red

This is an architectural fantasy containing buildings from different parts of Amsterdam. The house in the left foreground with the small gothic balcony is the St Elisabethgasthuis; behind it is the old town hall which burnt down in 1652. In the background, the dome of the new town hall, which was built to replace the one destroyed, is visible behind the bridge. Such architectural fantasies of eclectically derived buildings placed in invented settings form a distinct group in van der Heyden's work; thirty-seven are catalogued by Helga Wagner.

Stylistically, this painting is broader in treatment than the early works and Helga Wagner links it with a number of pictures of the period *c.*1667–72, including the *Westkerk* in the Wallace Collection and the *Oude Kerk* in the Mauritshuis, The Hague (Wagner, nos.7 and 6 respectively). She does not accept the tradition that the figures are by Adriaen van de Velde (Hofstede Groot; Wellington *Cat.*). There is contemporary evidence to confirm that Adriaen van de Velde painted figures for Van der Heyden, but this is not to say that each figure on all his paintings are by him. Van der Heyden's

drawings for his *Brandspuytenboek* show that he could draw figures, though their style is derived from Adriaen van de Velde. His own figures in his paintings are also in the style of van de Velde, but they are plumper and more squat.

Condition. Slight paint loss in sky top left; otherwise good.
Prov. Lapeyrière sale, Paris 14 April 1917 (lot 21); bt. by Bonnemaison for the Duke of Wellington for 9450 fr. about £378.
Exh. B.I., *Old Master* exhibitions 1818, (64), 1835 (6); 1843, (78; reviewed *Athenaeum*, 10 June 1843), 1847 (4); 1856; R.A. *Old Masters,* 1886, (52; reviewed, *Athenaeum,* 30 Jan, 1886); *Arts Council*, 1949, (2).
Lit. Smith, *Cat. Rais.* ix, p.672; H. de G., viii, no.207; Helga Wagner, *Jan van der Heyden,* Amsterdam 1971, pp.32, 61, 85, no.79.

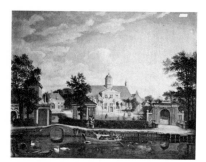

70 WM 1501–1948 Neg. F946
Wellington *Cat.,* p.16, no.58 red

70 The Château of Goudestein, on the River Vecht, near Maarsen
Signed on river bank, mid right *J V D Heyde/1674.*
Canvas, $21\frac{7}{8} \times 28\frac{1}{4}$ ($55 \cdot 6 \times 71 \cdot 8$)

As well as town views, van der Heyden painted pictures of country houses and these are among the earliest examples of precise topographical accuracy in this field. The banks of the Amstel and the Maarsen provided the most popular sites for the country houses of the richer citizens of Amsterdam. Goudestein, the residence of the Huydecoper family, was pulled down and rebuilt in 1754. Van der Heyden painted several different aspects of the house (Wagner nos.125–30) of which the dated compositions cover the years 1666 to 1675.

The tradition that Adriaen van de Velde painted the figures in this picture (Waagen; Hofstede de Groot) was laid to rest when the date 1674 was revealed, for van de Velde died two years earlier.

From the end of the 1660s van der Heyden was also engaged on projects to improve street-lighting and fire-fighting and an engraving of this view of Goudestein was used as an advertisement *voor de Tuinspuitjes,* i.e. for a small fire-hose invented by the artist.

Prov. Jan Tak, Leyden, 1781; van Leyden, 1804; Le Rouge; bought for the Duke of Wellington at the Le Rouge sale, Paris, April 1818 (lot 20) by Féréol Bonnemaison for 5410 fr., about £216 (not 3400 as in Wellington *Cat.*).
Exh. B.I., *Old Masters,* 1821 (117), 1829 (50); R.A., *Old Masters,* 1887, (63); V.&A., 1947, (4); Arts Council, 1949, (1); Paris, Musée des Arts Décoratifs, *La Vie en Hollande au XVIIe siècle,* 1967 (46, pl.13).
Lit. C. J. Nieuwenhuys, *A review of the lives and works of some of the most eminent painters . . .* London 1834, p.136; Smith, *Cat. Rais.,* v, p.381, par. 33; Waagen, *Treasures,* ii, p.274; *Athenaeum,,* 14 June, 1856; H. de G., viii, no.69; Helga Wagner, *op. cit.,* pp.45, 61, 95, no.124.

Lambert de HONDT (d. before 1665)
Flemish School
He worked in Malines, where his widow remarried on 10 Feb., 1665; but little is known about him. He was probably responsible for the camp and battle scenes, with figures in the manner of Teniers, signed L. D. HONDT, but there is some confusion with the work of another L. de Hondt who made designs for tapestries in *c.*1700.

71 WM 1632–1948 Neg. GG1717
Wellington *Cat.,* p.209, no.122, black

71 An Encampment with soldiers playing cards
Signed left of centre *L.D. HONDT. F*
Inscribed in white with fleur-de-lis and inventory no. – *31.*
Canvas, $12 \times 17\frac{1}{4}$ ($30 \cdot 5 \times 43 \cdot 8$)

Both the style and the subject are very similar in two battle scenes in the Gallery at Schleissheim and in the *Surprise Attack* in the Staedel Institute, Frankfurt (signed L. D. HONNT F; repr. Bernt, *Netherlandish Painters,* II

fig.540, as Lambert de Hondt). The same sketchy technique reappears in these paintings and it is most probable that they are by the same hand. This artist is usually identified as the Lambert de Hondt who died before 1665. To judge from the costume, this picture can be dated c.1660.

The white fleur-de-lis, and the coat of arms formerly on the back, indicate that the painting was in the collection of Isabella Farnese, wife of Philip IV, and in the 1746 inventory of the palace at La Granja it is listed as one of a pair by de Hondt.

The whereabouts of the companion picture, which showed a battle scene with a Moor on horseback, is unknown.

Condition. Good; cleaned and relined in *c.*1950.
Prov. Isabella Farnese (the coat of arms originally stamped on the back, repr. Wellington *Cat.*, p.210, was obliterated when the picture was relined). La Granja inventory 1746, no.531. Captured at Vitoria 1813.
Lit. Gaya Nuño, *Pintura Europea*, no.180 (mistakenly as Abraham de Hondt).

Pieter de HOOCH (1629–after 1684)
Dutch (Delft, Amsterdam) School
Born in Rotterdam, he is recorded in Delft from 1653 and in Amsterdam from 1661, where he remained until his death in 1684. In the 1650s he was one of the pioneers of the new style of realistic genre painting with which Carel Fabritius, Nicolaes Maes and, above all, Jan Vermeer are also associated.

Lit. W. R. Valentiner, *Pieter de Hooch* (English ed.1930); Peter C. Sutton, *Pieter de Hooch*, 1980.

72 THE INTRUDER: A LADY AT HER TOILET, SURPRISED BY HER LOVER
Signed lower left on rail of table *P. D. Hooch*
Canvas, $21\frac{1}{2} \times 24\frac{3}{4}$ (54·5×63)

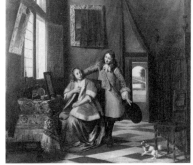

72 WM 1571–1948 Neg. J944
Wellington *Cat.*, p.31, no.9 black

This is one of several scenes of couples in interiors painted by de Hooch in the 1660s and seventies. Both Valentiner (1930) and Sutton (1980) compared it with a painting of *c.*1663 in the Germanisches Museum, Nürnberg, which fits well in style and costume, (Sutton, cat.55; pl.38). But, as Sutton points out, the composition is more closely comparable with the *Morning Toilet* in Lord Barnard's collection (Sutton, cat. 69, pl. 72), in which the view through the open door, the bed on the right and the picture, partially covered by a curtain, all recur. In the Barnard painting the picture on the wall is less fully curtained and clearly shows a recumbent nude woman, probably Venus, which is doubtless also the subject of the one in WM 1571, and which occurs frequently to underline the meaning of scenes of this kind (e.g. Valentiner, pp.91, 103, 107–9; the last also half-curtained). *The Morning Toilet* in Lord Barnard's collection is dated 1665 and such a date also seems reasonable for WM 1571. At this time de Hooch's pictures had become more anecdotal in subject and more elegant in setting than the earlier work of his Delft period: a reflection of the great prosperity of Amsterdam at this time.

Condition: Cleaned in 1950–51; paint surface worn at the woman's right hand and bodice.
Prov. H. Muilman sale, Amsterdam, 12 April 1813 (201 florins, Ryers); W. Ryers sale, Amsterdam, 21 Sept. 1814 (205 florins, Nieuwenhuys); Le Rouge sale, Paris, 16 Jan. 1816, lot 7; bought by Duke of Wellington before 1821 (and not, as in the Wellington *Cat.*, and elsewhere, captured at Vitoria).
Exh. B.I., *Old Masters*, 1821 (138), 1852 (reviewed, *Athenaeum*, 26 June 1852); Guildhall, Loan Exhibition, 1892 (77).
Lit. R. Gower, *The Figure Painters of Holland*, 1880, p.112; H. de G. i, no.73; A. de Rudder, *Pieter de Hooch*, Brussels, 1914, p.100; C. H. Collins Baker, *Pieter de Hooch*, 1925, p.6, pl.12; C. Brière-Misme, 'Tableaux inédits ou peu connus de Pieter de Hooch', *G. B-A.*, xvi, 1927, p.267; Valentiner, 1930, pp.73, 276; Gaya Nuño, *Pintura*

Europea, no.191, pl.69; *Paintings at Apsley House*, 1965, pl.39; Valdivieso, *Pintura Holandesa*, p.289; Sutton, *de Hooch*, p.98, no.70, pl.73.

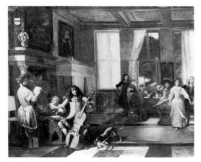

73 WM 1487–1948 Neg. H1512
Wellington *Cat.*, p.323, no.36 red

73 A MUSICAL PARTY
Signed indistinctly above chair on left *P. D. HOO(GE)*
Canvas, $41\frac{3}{4} \times 54$ (106×137)

This is a late work usually dated *c.*1675 (Valentiner, 1675–80; Sutton, *c.*1675–7). The room and its occupants are typical of de Hooch's patrician interiors and mirror his clientele in Amsterdam, so different from the more homely genre scenes of his Delft period in the 1650s. There is in fact only one musician in an interior with twelve figures and the emphasis is on love rather than music. (For a discussion of the link between the two see under Duyster, above.) Above the fireplace, the painting – based on Rembrandt's etching of the *Small Lion Hunt* – was one which de Hooch introduced into several of his compositions (Sutton, p.44; pls 95, 113). The coats of arms to the left (or, a fess gules; azure, 3 mullets argent), too simple to convey the complexity of 17th–century armorial bearings, are probably fanciful but nevertheless convey the patrician character of the household.

De Hooch painted several musical parties of this kind in his mannered, refined style of the 1670s, but this is the fullest and most elaborate composition. His later paintings are often criticized for their weak execution, but in the use of light emanating from the open window and from a point on the spectator's left to model the figures, de Hooch has here recaptured some of the subtlety and monumentality of his earlier work. Among the comparable scenes are those in the Academy of Arts, Honolulu (Sutton 108); in the Royal Museum of Fine Arts, Copenhagen (Sutton 109); the Deder collection (Sutton 112); Philadelphia Museum, Wilstach collection (Sutton 114) and the Indianapolis Museum of Art (Sutton 117). Sutton rejects Pelinck's suggestion that WM 1487 could have been the companion piece to the Jacott-Hoppesack family portrait in Berlin (Sutton, no.107, pl.113).

Condition. Good. Cleaned by Horace Buttery, 1951.
Prov. Probably J. van der Linden van Slingeland sale, Dordrecht, 22 Aug. 1785, no.189 (bought by Beekman, 70 fl.); M-M sale, Paris, 16 Jan. 1816, lot 7. Bought by Féréol Bonnemaison, Paris 1818, for the Duke of Wellington.
Exh. B.I., *Old Masters*, 1821 (86); 1829 (181); 1847 (118); 1856 (reviewed, *Athenaeum*, 14 June 1856); R. A., *Winter Exhibition*, 1888 (53; reviewed *Athenaeum*, 11 Feb. 1888); R.A., *Dutch Art*, 1929 (328).
Lit. N.G. *Catalogue*, 1889, p.203; H. de G., i, no.128; C. Brière-Misme, 'Tableaux inédits ou peu connus de Pieter de Hooch', *G.B-A.*, xvi, 1927, p.277; Valentiner, 1930, pp.143, 285; E. Pelinck, 'Een portretgroep van de familie Jacott Hoppesack', *De Nederlandsche Leeuw*, 75, 1958, col. 308ff., nos.3 and 7; *Paintings at Apsley House*, 1965, pl.38; H. Gerson, 'Pieter de Hooch', in *Kindlers Malerlexikon*, iii, Zurich, 1966, p.310; Sutton, *de Hooch*, pp.44, 109, cat.117, pl.120.

John HOPPNER R.A. (1758–1810)
British School
Hoppner's father came from Germany to act as physician to George II, and he grew up in St James's Palace. He entered the R.A. school in 1775 and obtained a gold medal in 1782 for an illustration to King Lear. He achieved considerable success as a portrait painter and was appointed court painter to the Prince of Wales in 1793.

Lit. William McKay and W. Roberts, *John Hoppner R.A.*, 1909.

74 MAJOR-GENERAL SIR HENRY WILLOUGHBY ROOKE, C.B., K.C.H. (1782–1869)
Canvas, $29\frac{1}{2} \times 24\frac{1}{2}$ (75×62)
Sketch, waist-length, life-size. He wears a black stock, white frill and the

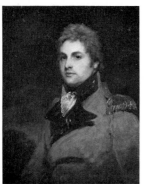

74 WM 1471–1948 Neg. L1404
Wellington *Cat.*, p.289, no.13 red

74 *de Hooch*

uniform of the 3rd Guards: scarlet with blue facings, and epaulettes.

Rooke joined the 3rd Guards in 1798, served in Holland in 1799 and 1813 and was Assistant Adjutant-General at Quatre Bras and Waterloo.

WM 1471 was catalogued as 'Painter Unknown' by Evelyn Wellington and attributed to Hoppner by Graham Reynolds. The attribution has been generally accepted. A date c.1805–10 is likely; in the sketch by William Salter for the *Waterloo Banquet at Apsley House* of 1836 (N.P.G. 3747) the sitter looks considerably older.

Prov. Bought by or presented to the Duke of Wellington.

75 WILLIAM PITT, M.P. (1759–1806)
Canvas, $55\frac{1}{2} \times 43\frac{3}{4}$ (141 × 111)

This is one of over twenty recorded versions of Hoppner's three-quarter-length portrait of Pitt painted in 1805 and exhibited at the R.A. in 1806 (108; Lord Cowdray coll.). Others are at the N.P.G. (no.697), Trinity College, Cambridge, and the Inner Temple, and there are full-length versions in the Landesgalerie, Hanover (von der Osten, fig.215; engr. T. Bragg., 1810) and Grocers' Hall. The original was engraved in mezzotint by G. Clint in 1806, in stipple by H. Meyer, 1809, and on numerous occasions subsequently (McKay and Roberts, 1909, p.206).

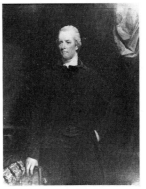

75 WM 1554–1948 Neg. P1472
Wellington *Cat.,* p.71, no.214 red

An illuminating comparison can be drawn between Hoppner's portrait and that of Lawrence, his great rival, which was painted after Pitt's death and exhibited at the R.A. in 1809 (Lord Rosebery, and royal coll., Windsor Castle; see K. Garlick, *Lawrence,* 1954, pl.63). The two are very similar in composition; Lawrence's is more fully modelled and expressive, whereas Hoppner's is coolly classical and linear.

For another portrait of Pitt at Apsley House and a note on his career see above under Gainsborough Dupont, no.40.

Condition. Retouch in background below curtain upper right; otherwise good.
Prov. Earl of Liverpool, sold Christie's 5 April 1852, lot 49; bought by the Duke of Wellington for 130 guineas.
Lit. *Athenaeum,* 10 April 1852, p.410 ('a fine three quarter length portrait of Mr Pitt . . .' sold at Christie's); McKay and Roberts, *Hoppner,* p.208 (listed under 'replicas'); Gert von der Osten, 'Kleine Gemäldestudien,' *Niederdeutsche Beiträge zur Kunstgeschichte,* i, 1961, p.274, fig.217.

Jan van HUYSUM (1682-1749)
Dutch School

He was born in Amsterdam and spent most of his life there. Although he painted some idealized landscapes, the bulk of his work consists of paintings of flowers and fruit, for which he achieved considerable fame.

76 THE RAPE OF PROSERPINA
Oak Panel, $31\frac{1}{4} \times 24\frac{3}{4}$ (80·7 × 62·8)

Proserpina (in Greek, Persephone), daughter of Jupiter and Ceres, was gathering flowers in her native Sicily when Pluto appeared in his chariot and, struck by her beauty, carried her off to the nether regions.

At one time attributed to Gerard Lairesse (Le Rouge catalogue, 1818), this painting was catalogued as by Nicolaes Verkolje and Jan van Huysum by Evelyn Wellington. The implication, not stated in the catalogue, was that Verkolje had painted the figures and Huysum the landscape. However, there is no evidence that these two artists ever collaborated in this way. The landscape is clearly by Jan van Huysum and the figures are also, in all likelihood, by him. Similar figures occur in his relatively rare mythological scenes, such as the *Worship of Bacchus* at Longleat (Marquess of Bath; exh. R.A., *Dutch Pictures,* 1952–3, no.383).

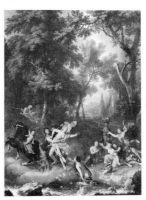

76 WM 1492–1948 Neg. R1378
Wellington *Cat.,* p.18, no.44 red

The treatment of the subject, showing Proserpina struggling in the chariot, is traditional in classical and renaissance art. Both for the vigorous gestures of the women and in the forest setting, Huysum has followed a pattern known in Netherlandish paintings from the 16th century, without any attempt at the more lifelike rendering of Rembrandt (Berlin–Dahlem; K. d. K., *Rembrandt*, pl.109) or Rubens (Prado, Madrid). A very close comparison can be drawn with the composition by Jan Soens in the Museum at Valenciennes (S. Beguin, in *Oud Holland*, 71, 1956, p.217f., fig.1).

Condition. Slight split in panel upper edge, 15cm. long; otherwise good.
Prov. Le Rouge sale, Paris, April 1818, lot 67; bought for the Duke of Wellington by Féréol Bonnemaison for 1267 fr., about £500.
Lit. Paintings at Apsley House, 1965, pl.43.

ITALIAN School

Italian School, 16th century

77 A SAINTED NUN
Inscribed in white, lower right, with inventory no.448
Poplar panel, 20¾ × 16¾ (52·7 × 42·5)

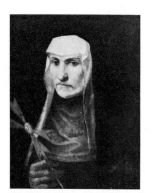

77 WM 1529–1948 Neg. Q1357
Wellington *Cat.*, p.60, no.95 red

The attribution to Andrea del Sarto in the Wellington *Catalogue* is clearly unacceptable on grounds of both style and quality. Indeed, the hard outlines against a plain background are more reminiscent of Bronzino and his imitators. A date in the mid-16th century remains likely.

The hand and the cross are executed in a different, broader technique and could conceivably have been added later. The Maltese cross, which has an image of the crucifixion at its centre, could signify that the sitter was a member of the Hospitaller Sisters of St John of Jerusalem, who were linked to the Order of the Knights of Malta, but this form of cross was also used as the insignia of several other orders (see Filippo Bonanni, *Catalogo degli Ordini Religiosi della Chiesa militante*, Rome, 1707, ii, nos.75, 94, 96).

Condition. General wear of paint surface, particularly in the flesh and light areas; the halo has been much rubbed. Paint losses round cracks in panel, particularly on right side.
Prov. Spanish royal collection, La Granja; presented to the Duke of Wellington, with eleven other pictures, on behalf of the Spanish nation, by the Intendant of Segovia, August 1812 (see p.5).

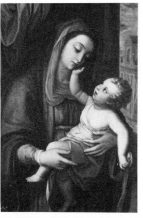

78 WM 1622–1948 Neg. M1972
Wellington *Cat.*, p.119, no.100 black

Italian School, *c*.1600

78 VIRGIN AND CHILD
Inscribed lower left with inventory no.394
Copper, 19¼ × 13½ (49 × 34·3)

The church in the background appears to be a 16th-century building and in general terms the composition is Correggesque (cf. the Campori Madonna in Modena; C. Gould, *Correggio*, 1976, pl.26A). The attribution to Lavinia Fontana (1552–1602) in the Wellington *Catalogue* is difficult to justify, though a date *c*.1600 – when the use of copper as a support had become widespread – is conceivable.

Condition: Small areas of damage *passim*, e.g. at Virgin's sleeve.
Prov. Spanish royal collection (not inv.); captured at Vitoria, 1813.

Italian School

79 PORTRAIT OF A MAN
Poplar panel, 16½ × 13¼ (42 × 33·5)

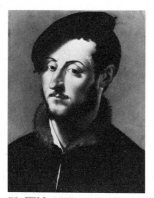

79 WM 1551–1948 Neg. N1340
Wellington *Cat.*, p.391, no.202 red

The sitter wears a black cap and a brown coat with a fur collar; the

76 *van Huysum*

background is green. 'Painter unknown' was the verdict of the Wellington *Catalogue*, though the frame bore the inscription *Par Gaspard Becerra*. Becerra (*c.*1520–70) was a Spanish artist who studied in Rome and painted religious and mythological subjects in the manner of Michelangelo, and it is difficult to see why his name ever became attached to this portrait (C. R. Post, *A History of Spanish Painting*, 14, 1966, pp.148–80). A possible French origin was suggested by Graham Reynolds (V&A files) but the costume militates against this view (information from Mdme. A. Dubois), even allowing for the fact that the picture may well be a copy. The poplar panel strongly indicates an Italian origin and there are faint reminiscences of Bronzino (see, for example, the Bronzino imitations reproduced by E. Bacceschi, *L'Opera Completa del Bronzino*, 1973, pl.107), though the fur collar is more common in northern Italy (see *G. B. Moroni*, exhibition catalogue, Bergamo, 1979, e.g. no.81). In any case, it appears to be a copy of the 17th or 18th century.

Condition. Several cracks running vertically down the face; small areas of damage.
Prov. Bought for the Duke of Wellington by Féréol Bonnemaison, Paris, 1818.

George Francis JOSEPH, A.R.A. (1764–1846)
British School
A painter of historical and literary subjects and genre as well as portraits, he first exhibited at the R.A. in 1784. From 1813 he concentrated on portraiture.

80 Spencer Perceval (1762–1812)
Canvas, $29\frac{1}{2} \times 24\frac{5}{8}$ (75×62·5)

Spencer Perceval, second son of the Earl of Egmont, was known as a successful barrister when he entered Parliament in 1796. He became Solicitor General in 1801, Attorney General a year later, Chancellor of the Exchequer in 1807 and Prime Minister in 1809. On 11 May 1812 he was assassinated in the House of Commons by John Bellingham, a man of disordered mind.

80 WM 1558–1948 Neg. GX4230
Wellington *Cat.*, p.85, no.220 red

Joseph made both frontal and three-quarter profile portraits of Spencer Perceval. Both were painted from a mask taken after his death by Joseph Nollekens who himself made a marble bust in 1813, which is also in the Wellington Museum. The frontal type is represented in the N.P.G. (1031). A version almost identical with WM 1558 but inscribed with the sitter's name and the date 1812 is also in the N.P.G. (no.4; 29×24in.), and there are several others (e.g. Christie's, 12 Dec. 1930, lot 73, catalogued as Beechey; C. Austin coll., Cobham, Surrey).

Prov. Bought by the Duke of Wellington at Christie's, 5 April 1852, lot 29, for £43 1s.
Lit. *Athenaeum*, 10 April 1852, p.410 ('This portrait confirmed the popular notion that the mild Mr Perceval was in look extremely like the *un*mild Mr Robespierre').

JUAN de Flandes (active 1496; d.before 1519).
Netherlandish School; worked in Spain
As the name implies, Juan was a Flemish artist; he was in the service of Queen Isabella of Castille from 1496 until her death in 1504. He is then recorded in Salamanca in 1505 and, from 1509, in Palencia. The altarpieces in Salamanca and Palencia cathedrals and the panels discussed below are his main surviving works. His style was influenced by the miniaturists of Ghent and Bruges of the last quarter of the 15th century. In particular, his figures are close to those of the Master of Mary of Burgundy.

Lit. E. Bermejo, *Juan de Flandes*, Madrid, 1962.

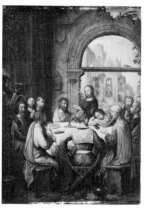

81 WM 1603–1948 Neg. F963
Wellington *Cat.*, p.219 no.65 black

81 THE LAST SUPPER, WITH THE INSTITUTION OF THE EUCHARIST AND CHRIST
WASHING THE DISCIPLES' FEET
Oak panel, $8\frac{1}{4} \times 6\frac{1}{4}$ (21 × 15·8). Thin gold framing line on all sides except the
top; nail holes at the corners and in the middle of each side.

This is one of a series of 47 small panels painted with subjects of the New
Testament and the life of the Virgin, recorded as having been the property of
Queen Isabella of Spain (d.1504) in the castle of Toro, Zamora, in a list of 23
Feb.1505. 32 of them, including the *Last Supper,* were acquired for Margaret
of Austria (inventories of March 1505 and 1506 at Malines, printed by
Davies, 1970) and on her death, in 1530, 24 of these passed to Charles V, who
sent most of them back to Spain. Fifteen have remained in the Royal Palace,
Madrid, and a further thirteen have been identified in other collections as
probably originating from the same series. One of these, *Christ appearing to
the Virgin,* is in the N.G., two are in the National Gallery, Washington, two
in the Louvre, one in the Bode Museum, Berlin, one in the Detroit Institute
of Art. The full list of the 28 surviving panels is given in the Maclaren-
Braham N.G. Catalogue (1970, p.45) and most of them are reproduced by
Bermejo (1962, pls.1-18).

It has usually been accepted that these panels originally formed an
altarpiece of many compartments. They are recorded in the earliest document
(Feb.1505) as 'en un armario' which could be an altarpiece with doors but is
now generally interpreted as meaning that they were literally in a cupboard
(Davies; Braham, 1970). They were sold separately in 1505 and it is likely
that they were part of a series not then completed. Martin Davies also points
out that the *Christ appearing to the Virgin* in the N.G. (the only one painted on
chestnut) practically duplicates the subject of the Berlin picture, which
suggests that more than one series may have been involved.

Two of the panels, the *Ascension of Christ* and the *Assumption of the
Virgin* are documented in the inventory of 1516 as the work of Master
Michiel, that is, Michel Sittow (1469–1529), who was in the service of Queen
Isabella, 1492–1502. *The Coronation of the Virgin* is obviously by the same
hand. The author of the rest of the panels, which are in a style distinct from
Sittow's three paintings, is not mentioned in any of the documents, but they
have been attributed to Juan de Flandes from the time of Crowe and
Cavalcaselle (*The Early Flemish Primitives,* 1857, p.284ff.) on a basis of
comparison with the altarpiece at Palencia. The attribution of the whole
series to Juan de Flandes was accepted by most authorities, including Carl
Justi (in *Jahrbuch der Königlich Preussischen Kunstsammlungen,* 1887,
pp.157-67), Friedrich Winkler (1926), Hulin de Loo (*Trésor de l'art flamand,
Memorial de l'Exposition de l'art flamand à Anvers,* 1930, 1937, i, p.49ff.) and,
more recently, Elisa Bermejo (1962, p.11). But in his publication of 1930
Sanchez Canton distinguished between a larger group of superior quality
which he gave to Juan, and a smaller, inferior one by an assistant. This
division was, to a large extent, accepted by MacLaren, who went on to
distinguish two further hands. Allan Braham (MacLaren and Braham, 1970,
p.46, no.26) lists six panels as belonging to a weaker group, coarser in
handling, including *Christ on Galilee, Christ in the house of Simon, The
Betrayal, Christ before Pilate* and *The Mocking* (all in Madrid) and the Apsley
House *Last Supper.* The question of attribution to the hands of assistants
cannot be settled until the surviving pictures can be reassembled. The *Last
Supper* is of better quality than the photograph suggests – in particular the
faces are expressive and finely individualized – but it is true that the
highlights are more sketchily rendered than in the rest of the panels.

The *Last Supper* is here depicted at the moment when Christ blessed the

bread and wine and gave it to the disciples (Matthew xxvi, 26). This scene appears occasionally in the Early Medieval period, e.g., Codex Aureus Escorialensis, but is relatively rare in the high Middle Ages. Its renewed popularity in the second half of the 15th century – perhaps due to the influence of the Speculum Humanae Salvationis – is splendidly exemplified by Dirk Bouts' altarpiece of 1468 at Louvain, though this shows only Christ's blessing and not the actual communion of the Apostles. A closer comparison can be made with the *Last Supper* in the Breviary of Queen Isabella (British Library, Add.18851, fol.100) in which the *Washing of the Feet* – here seen in a chamber in the background – is also shown occurring at the same time in a side room. Indeed the composition is very similar, except that it shows Judas receiving the sop (John xiii, 21–30) and not, as here, Peter receiving the sacrament. There are other, even closer, compositional similarities between the Juan de Flandes panels and the Breviary – in particular the *Temptation of Christ* and the *Entry into Jerusalem* are almost identical – and it is possible that Juan actually knew this manuscript. This is not unlikely; it was produced in about 1490–5 in Bruges for the Spanish diplomat Francisco de Rojas, who gave it to Isabella probably in 1497, at the very time when Juan was working for the Queen.

Condition. Surface deeply pitted in several places.
Prov. Isabella of Spain (d.1504); 1505, Margaret of Austria; 1530, Charles V, Spanish royal collection, Royal Palace, Madrid; captured at Vitoria, 1813 (then listed as Dürer).
Exh. B.F.A.C., *Winter Exhibition*, 1927-8 (12); Malines, Palais de Justice, *Margareta van Oosterijk en Haar Hof*, 1958 (37).
Lit. W.H.J. Weale, quoted in Wellington *Cat.*, p.219 (as belonging to the series); C. Justi, *Miscellaneen*, 1908, i, p.318 (listed as the *Ascension*); F. Winkler in Thieme Becker, 19, 1926, p.279; F.J. Sanchez Canton, 'El Retablo de la Reina Católica', *Archivo Español de Arte*, vi, 1930, esp. p.28; Gaya Nuño, *Pintura Española*, no.754; N.G., *Spanish School*, 1952, no.1280, second ed. revised by A. Braham, 1970, p.45, n.3, p.46, n.26; E. Bermejo, *Juan de Flandes*, 1962, p.15, pl.8; Martin Davies, *Les Primitifs Flamands: The National Gallery, London*, iii, 1970 (fullest treatment of the whole series).

François van KNIBBERGEN (1597 – after 1665)
Dutch School
Landscape painter in the Hague. His relatively rare paintings show the influence of Salomon Ruisdael and of the Italianizing artists, in particular Breenbergh.

82 LANDSCAPE WITH DEER
Signed in white, lower right, *F. KNIBBERGEN:* inscribed in white with inventory no.107.
Oak panel, cradled, $17\frac{1}{2} \times 23\frac{1}{2}$ (44·5 × 60)
This is one of the very few signed paintings by Knibbergen. Comparable wooded river views occur occasionally in his work (Basel Museum) but more often he painted flat landscapes (Rijksmuseum, no.A.2361) or views of castles or towns (Pommersfelden, Schönborn Coll.). The rather humanized deer in WM 1577 have been attributed by H. Gerson and S. Gudlaugsson to Paulus Potter (1625-54) (letter of Jan.1965 in departmental files).

82 WM 1577–1948 Neg. H1521
Wellington *Cat.*, p.24, no.23 black

Condition. Some discoloured retouching in sky; otherwise good.
Prov. Spanish royal collection (not inv.); captured at Vitoria, 1813.
Lit. C. Hofstede de Groot in Thieme, Becker, 20, 1927, p.583.

John Prescott KNIGHT (1803-81)
British School
Born in Stafford, he came to London and studied with Henry Sass and

George Clint 1823–4. He became one of the most popular portrait painters of his time, best known for his group portrait of the *Heroes of Waterloo assembled at Apsley House,* 1842 (coll. Marquess of Londonderry).

83 GENERAL SIR GEORGE MURRAY, G.C.B. (1772–1846)
Canvas, 35⅛ × 27¼ (89 × 69)

83 WM 1538–1948 Neg. P1020
Wellington *Cat.,* p.289, no.179 red

Three-quarter length, seated, life-size. The sitter wears a black frock coat and waistcoat, over which is a red sash of the Grand Cross of the Bath. The star of the Bath is on his coat.

Born in Perthshire, Murray joined the army in 1789, served in Flanders 1793–5 and subsequently in the West Indies, Ireland and Egypt. In 1809 he was promoted colonel and appointed quartermaster general to the forces in Spain and Portugal. At the end of the war he was made Governor-General of Canada and returned to Flanders just too late to be present at Waterloo. In 1828–30 he was Secretary of State for the Colonies in Wellington's administration and then Master-General of the Ordnance from 1834–46. He was the editor of *The Letters and Despatches of John Churchill, first Duke of Marlborough, 1702–1712,* (1845).

In a letter dated 11 April 1842 (in the possession of Mr S.G.P. Ward) Murray wrote to General Sir Robert Gardiner to say that he could not sit for Knight at any particular time, but perhaps Knight might care to make a copy of a portrait by Lawrence. However, none of the three portraits of Murray by Lawrence (listed by K. Garlick in *Walpole Society,* 1962–4, p.148) appears to have served as the basis for Knight's portrait, which clearly shows the sitter in old age, at any rate some years after 1830, when Lawrence died. It therefore seems likely that Murray relented and agreed to sit for Knight after all. There is also a whole-length portrait of him by William Pickersgill in the Scottish N.P.G. (*c.*1832) and drawings by Linnell and Heaphy (*c.*1814) in the N.P.G. (respectively nos.1818, 4319; all reproduced by Ward, 1980).

Prov. Bought by the Duke of Wellington from the artist in 1847 for £63.
Exh. South Kensington, *National Portraits Exhibition,* 1868 (532).
Lit. Dictionary of British Portraiture, 2, p.154; S.G.P. Ward, 'General Sir George Murray', *Journal of the Society for Army Historical Research,* 58, 1980, p.207, pl.IV.

Sir Edwin LANDSEER, R.A. (1802–73)
British School
Born in London, the son of the engraver John Landseer, he was a pupil of B.R. Haydon before entering the Royal Academy Schools in 1816. From the first his animal paintings were widely acclaimed, and he received the praise of leading Romantic artists including Fuseli and Géricault. His first visit to Scotland in 1824 expanded his range of subjects; he was elected A.R.A. in 1826, at the earliest age of 24, and R.A. five years later. In 1855 he was awarded the Gold Medal of the Universal Exposition in Paris, but bouts of mental illness from 1858 clouded his later years. There are 21 paintings by him in the V&A.

84 WM 1532–1948 Neg. Q1384
Wellington *Cat.,* p.243, no.104 red

84 THE ILLICIT HIGHLAND WHISKY STILL
Panel, 31½ × 40 (80 × 101·5)

The distiller is seen working in his hovel. The tools of his trade, a still and tub, are visible behind him; on the right is a second still, used to bring the liquid to the necessary stage of refinement, while the raw material, a tub of malted barley, is at his feet. In the foreground an old woman talks to a customer, a huntsman seated on a dead stag, while a young boy – holding a snared black grouse behind his back – and girl, presumably the distiller's children, stand and watch.

In a letter dated 4 April 1829 to the Duke of Wellington, Landseer

informs the Duke of the picture's completion and points out that, as three years had elapsed since it was commissioned, '...Your Grace may possibly not immediately recollect the circumstances or the subject of the Picture. I therefore take the liberty of reminding Your Grace that it represents the 'Illicit Highland Whiskey Still'.' (Wellington archive, Stratfield Saye). Landseer's first visit to Scotland, in the company of C.R. Leslie, had made a deep impression on him and, indeed, provided a turning point in his career. In general terms the vogue for romantic Highland scenes was fuelled by Walter Scott, whom Landseer visited at Abbotsford on more than one occasion, but whisky distilling in particular was much under discussion at this period. Illicit distilling had been on the increase and had become widely accepted with the steep rise in excise imposed at the end of the 18th century. Consequently, in 1823, Parliament repealed all the old legislation, abolished the high rate of duty and replaced it by a flat licence fee and low duty. This encouraged distillers to take out a licence and to trade within the sytem, with the immediate result that the consumption of tax-paid whisky rose rapidly, preparing the ground for the introduction in 1831 of the continuous operating still, the basis of modern distilling. (See David Daiches, *Scotch Whisky*, 1969; M. Brander, *A Guide to Scotch Whisky*, 1975, p.19.) The subject of the illicit still was therefore very topical in the years 1826–9 when Landseer was planning and painting this picture. Doubtless he intended it to be situated in the time before the reform of 1823, but there is no apparent reason why it should be 'set fifty years back', as has been suggested (I.B. Hill, 1973, p.24).

In his choice of this subject Landseer followed David Wilkie, who had painted a *Scottish Whiskey Still* for Sir Willoughby Gordon in 1819 (private coll., Scotland). However, Wilkie's was a legal still, well swept and orderly, quite different to the picturesque disorder of Landseer's composition, which emphasizes the illicit nature of the still in a remote rural setting far from the prying eyes of excisemen. Yet a decade later Wilkie produced his *Irish Whiskey Still* (R.A., 1840; now N.G. of Scotland; see 1975 exhibition) which in turn shows the influence of Landseer's ideas.

Numerous sketches, drawings and other versions of the subject are recorded in the sale of Landseer's studio in 1874 (Christie's, May 8, 9, 11–15, 1874, lots 14, 74, 103, 372, 396), but they are not described in any detail in the catalogue. Among the oil sketches still extant, one is freer, more sketchy in technique (private collection, Scotland, 43×53cm., photograph in N.G. of Scotland); another is very close to the finished picture (Mrs Maud Robinson coll., exh. Belfast Art Gallery, *Pictures from Ulster Houses*, 1961, no.159, 63·5×76cm.). The composition was engraved by Robert Graves, 1842, and by James Stephenson; the girl alone by W.H. Simmons under the title *Rustic Beauty*, 1849.

Prov. Bought by the Duke of Wellington from the artist in 1829 for £350.
Exh. R.A., 1829 (20; reviewed *Times*, 5 May 1829; *Athenaeum*, 27 May 1829, quoted in Wellington *Cat.*); Birmingham Institution, 1829–30; R.A., *Old Masters*, 1890 (12; reviewed *Times*, 6 Jan. 1890); *Victorian Era Exhibition*, Earls Court, 1897 (Fine Art Section 31); R.A., *Edwin Landseer*, 1961 (93); Mappin Gallery, Sheffield, *Landseer and his world*, 1972 (32); Philadelphia Museum of Art and Tate Gallery, *Sir Edwin Landseer*, 1981 (28; catalogue by R. Ormond with a rather different interpretation).
Lit. Passavant, *Tour*, i, p.172; Waagen, *Treasures*, ii, p.274; James Dafforne, *Pictures by Sir Edwin Landseer*, 1873, p.9f; A Graves, *Catalogue of the Works of the late Sir Edwin Landseer, R.A.*, 1874, p.13, no.151; F.G. Stephens, *Sir Edwin Landseer*, 3rd ed., 1881, p.62; J.A. Mason, *Sir Edwin Landseer, R.A.*, 1902, p.69; Ian Barras Hill, *Landseer* (Lifelines 20), 1973, p.22; N.G. Scotland, exhibition catalogue, *Sir David Wilkie: Drawings into Paintings*, 1975, p.22, fig.6; Campbell Lennie, *Landseer, the Victorian Paragon*, 1976, p.52.

Sir Thomas LAWRENCE, P.R.A. (1769–1830)
British School

Born in Bristol, he was an infant prodigy, drawing portraits at the age of ten which were much admired. He entered the R.A. schools in 1787, but was almost entirely self-taught. Lawrence enjoyed a rapid success as a portrait painter, becoming A.R.A. in 1791, R.A. in 1794, and P.R.A. in 1820. He became King's Painter in Ordinary on the death of Reynolds in 1792 and was knighted in 1815.

Lit. Kenneth Garlick, *Sir Thomas Lawrence*, 1954; *id*, 'A Catalogue of the drawings, paintings and pastels of Sir Thomas Lawrence', *Walpole Society*, 39, 1964.

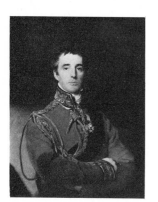

85 WM 1567–1948 Neg. F591
Not in Wellington *Cat.*

85 ARTHUR WELLESLEY, 1ST DUKE OF WELLINGTON (1769–1852)
Canvas, 36×28 (91·5×71)

Standing, half-length. He is wearing field-marshal's uniform, with the Garter sash, the Golden Fleece and the Grand Cross of the Bath. For a note on Wellington's life, see 'Chronology of the Duke of Wellington', p.16

Garlick (1964) records seven portraits in oil by Lawrence of Wellington. The two men were exactly the same age and Lawrence's devotion to the Duke is borne out by his ownership both of the sword Wellington carried at Waterloo and of 'A Spanish portrait of the Duke of Wellington' (Garlick, 1964, Appendix IV, no.354; Levey 1979). Lawrence's two earliest portraits of the Duke, both full-length, were painted in 1814; one belongs to the Marquess of Londonderry, the other, exhibited at the R.A. in 1815 (109), belongs to H.M. the Queen and is in the Waterloo Chamber at Windsor Castle (Millar, *Later Georgian Pictures*, no.917, pl.195). WM 1567 clearly shows the sitter wearing the Grand Cross of the Bath, and as Wellington was not made G.C.B. until 1815 the picture must have been painted after that date. Its quality suggests that it was painted from life, and if this was the case it was presumably painted after Waterloo, as Wellington left England early in 1815 for Vienna and Brussels. Accordingly, the picture's date may be given as *c.*1815 (Garlick, 1964) or 1815–16 (Levey, 1979). There is a copy, said to be by Rembrandt Peale, in the Museum of Fine Arts, Boston, and an enamel copy by William Essex was in the collection of the Duke of Beaufort (see Arts Council, 1949). For a copy of the 1822 portrait by Lawrence, see no.89.

Prov. Bequeathed by the Marchioness Wellesley to the 2nd Duke of Wellington, 1853, it hung at Stratfield Saye and was therefore not included in the Wellington *Cat.*
Exh. South Kensington, *National Portraits*, 1868 (199); *Royal Jubilee Exhibition*, Manchester, 1887 (496); Arts Council, 1949 (3); *Sir Thomas Lawrance* (catalogue by Michael Levey), N.P.G., 1979 (30).
Lit. Lord Ronald Sutherland Gower, *Sir Thomas Lawrence*, 1900, p.165; Sir Walter Armstrong, *Lawrence*, 1913, p.169; Wellesley, Steegmann, 1935, p.25, pl.19; Garlick, 1954, p.62, pl.7; Garlick, 1964, p.193; *Paintings at Apsley House*, pl.54.

86 THOMAS GRAHAM, LORD LYNEDOCH, G.C.B., G.C.M.G. (1748–1843)
Canvas, 93×57¾ (236×146)

Full-length, life-size, against a landscape background. In uniform, with drawn sword, he wears the badge, star and sash of the Grand Cross of the Bath and inside his collar is the gold Peninsular cross.

Thomas Graham, M.P. for Perthshire in the Whig interest, 1794–1806, joined the army in 1794 and served at Mantua, 1796, Minorca, 1798, and Messina, 1799. He became a major-general in 1809, commanded a brigade at the Walcheren expedition, and served with distinction throughout the Peninsular war. Created Baron Lynedoch in 1814 and promoted to full general in 1821.

Lawrence painted four portraits of Lynedoch (see Garlick, 1964, p.134):

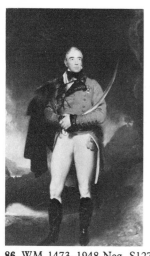

86 WM 1473–1948 Neg. S1274
Wellington *Cat.*, p.288, no.15 red

(1) Standing, whereabouts unknown: engraved by T. Blood for *European Magazine*, 1811.
(2) Standing, looking left, 50×40in., probably exhibited in R.A., 1813 (7), Lord Monsell coll.
(3) WM 1473.
(4) Standing, 93×58in., *c*.1820, formerly United Services Club (c/o The Crown Commissioners).

There are also oil paintings of him by Pompeo Batoni, 1772 (Yale Center for British Art, New Haven), and by Sir George Hayter (N.P.G. 1037).

WM 1473 was engraved in mezzotint by Thomas Hodgetts in 1829.

Condition. Good; cleaned by Vallance in 1959.
Prov. Commissioned by the Duke of Wellington from the artist in 1817 for £210 and delivered by Lawrence's executors in 1830 (see Garlick, 1964, Appendix IV, no.376).
Exh. R.A., 1817 (68); South Kensington, *National Portraits*, 1868 (199).
Lit. Gower, *Lawrence*, p.147; Armstrong, *Lawrence*, p.149; Garlick, 1954, p.48; Garlick, 1964, p.134; *Dictionary of British Portraiture*, 2, p.137.

87 HENRY WILLIAM PAGET, 1ST MARQUESS OF ANGLESEY, K.G. (1768–1854)
Canvas, 93×58 (236×147)

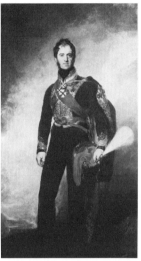

87 WM 1474–1948 Neg. P1461
Wellington *Cat.*, p.272, no.16A red

Full-length, life-size, against a cloudy sky background. He wears the uniform of the Hussars, the sashes of the Royal Hanoverian Guelphic Order and the Bath Cross on his chest. From his neck hang the Orders of Maria Theresa of Austria, St George of Russia and William of Holland, and he also wears the Peninsular and Waterloo medals. The stars of the R.H.G.O. and of the Bath are on his slung jacket.

Henry William Paget, eldest son of the Earl of Uxbridge, was M.P. for Carnarvon 1790–96 and afterwards for Milborne Park. He joined the army of the Duke of York in Flanders in 1794, was promoted lieut.-colonel in 1796 and served in the expedition to Holland as commander of the cavalry brigade in 1799. Obtaining the rank of lieut.-general in 1808, he served with distinction at Coruña and again at Waterloo where he commanded the whole of the cavalry and horse artillery, and lost a leg in the battle. He was created Marquess of Anglesey in July 1815 and became Master General of the Ordnance in 1827–8 and Lord Lieutenant of Ireland 1828–9 and 1830–3, during which period his relations with the Duke of Wellington became strained. He was made field marshal in 1846.

WM 1474 is a replica commissioned by the Duke of Wellington from Lawrence in 1818 of a portrait exhibited at the R.A. in 1817 (Marquess of Anglesey, Plas Newydd; 93×58in.). It was engraved in mezzotint by C. Turner, 1828, S. Mason, 1831, J.R. Jackson, 1845, and there was a copy by Sir William Ross in the United Services Club. Wellington described the origin of his commission to Lawrence in a letter dated 15 December 1832 to the Hon. Berkeley Paget: 'I was making a collection of the pictures of the principal officers whom I had the honour of commanding during the War, and I asked Lord Anglesey to allow Sir Thomas Lawrence to paint a picture of him for me. My plan has been but imperfectly carried into execution, principally on account of the difficulty of getting Sir Thomas Lawrence to finish his pictures. But he did finish some pictures, among others that of Lord Anglesey.'

Anglesey had originally hoped that Lawrence would let him have a version of his portrait of the Duke, but this never materialized (for the full correspondence see Wellington *Cat.*, p.273f.).

For another portrait of Anglesey at Apsley House see under Pieneman (no.133). He is also portrayed in William Salter's *Waterloo Banquet at Apsley House* (1836; Duke of Wellington coll.) and there is a sketch of him for this picture at the N.P.G. (3693). At Plas Newydd there are also portraits of him

by John Hoppner and Sawrey Gilpin, 1798, R.B. Davis, 1829–30, and F.X. Winterhalter, c.1840, and there are drawings of him by Sir Francis Chantrey and by James Stephanoff in the V&A.

Condition. Some wearing in background; otherwise good.
Prov. Commissioned by the Duke of Wellington from the artist for £210 in 1818, and delivered by Lawrence's executors in 1830 (see Garlick, 1964, Appendix IV, no.377).
Exh. South Kensington, *National Portraits*, 1868 (205).
Lit. Gower, *Lawrence*, p.110; Armstrong, *Lawrence*, p.109; Garlick, 1954, p.25; Garlick, 1964, p.20; *Paintings at Apsley House*, pl.50.

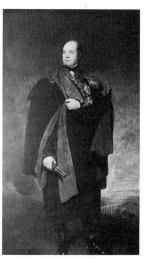

88 WM 1480–1948 Neg. HA3465
Wellington *Cat.*, p.280, no.23 red

88 WILLIAM CARR, VISCOUNT BERESFORD, G.C.B. (1768–1854)
Canvas, 93×57¾ (236×146)

Full-length, life-size, standing on high ground traversed by a viaduct. He wears the uniform of a Portuguese field marshal with the sashes and stars of the Bath and the Portuguese Order of the Tower and Sword.

Although he lost the sight of an eye in a shooting accident, Beresford, who entered the army in 1785, obtained rapid promotion, becoming a captain in 1791. He took part in the British expedition to Corsica in 1793–4 and in the Indian Campaigns of 1799–1803, where he commanded a brigade. After serving with distinction at Coruña he was made commander of the Portuguese army, which he reorganised and led throughout the Peninsular War. He was raised to the peerage in 1814 and subsequently resumed his command in Lisbon until 1819. A strong supporter of the Duke of Wellington, he was made a general in 1825 and Master of the Ordnance, 1828–30.

Commissioned by Wellington in 1818, this is one of two portraits painted by Lawrence of Beresford; the other is in the British Embassy at Lisbon (Garlick, 1964, p.34). There are also portraits of him by Sir William Beechey, c.1814, and Richard Rothwell, c.1831, in the N.P.G. (1180; 300) as well as a caricature drawing, *A Political Riddle*, 1829, in the B.M.

Condition. Tendency to flake on lining of cloak, minor marks on forehead, otherwise good.
Prov. Commissioned by the Duke of Wellington from the artist in 1818 and delivered by Lawrence's executors in 1830 (see Garlick, 1964, Appendix IV, no.375).
Lit. Gower, *Lawrence*, 1900, p.110; Armstrong, *Lawrence*, p.114; Garlick, 1954, p.27; Garlick, 1964, p.33; *Dictionary of British Portraiture*, 2, p.19.

After LAWRENCE

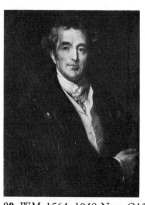

89 WM 1564–1948 Neg. Q1370
Wellington *Cat.*, p.253, no.272 red

89 ARTHUR WELLESLEY, 1ST DUKE OF WELLINGTON (1769–1852)
Canvas, 35½×27½ (79×61)

Half-length, wearing a dark cloak over a black coat, white neckcloth and yellow waistcoat.

This is a slightly enlarged copy of the portrait painted by Lawrence for Charles Arbuthnot, M.P., and exhibited at the R.A. in 1822 (29×24in.; Garlick, 1964, p.194; Wellesley and Steegmann, pl.25). It was subsequently in the collections of the Earl of Rosebery and Mrs. W.V. Goodbody. A studio variant is also recorded by Garlick (Christie's, 13 June 1913, lot 123).

Although it is only a mediocre copy, some interest attaches to this picture on account of its provenance, for it was given to the second Duke of Wellington by Charles Patrick Mahon, better known as the O'Gorman Mahon (1800–91), an Irish politician of note. At the back of the stretcher is the inscription: 'Aguinaldo al Ill^mo. Princepe Snr. Don Arturo Ricardo Duque de Wellington V.C./de la parte de su Amigo Milesiano Snr. Coronel – The O'Gorman Mahon/Dia de Año Nuevo 1862.' (New Year's present to the

most illustrious Prince Arthur Richard Duke of Wellington from his Irish friend, Colonel The O'Gorman Mahon, New Year's Day 1862).

Mahon was both an active politician, M.P. for Clare, 1830, and for Ennis, 1847–52, and a colourful character, widely travelled, who was on friendly terms with Louis Philippe in the 1830s and with Bismarck in the 1860s. He fought for the Union in the American Civil War and in various revolutions in South America, not to mention countless duels.

Prov. Given to the 2nd Duke of Wellington by The O'Gorman Mahon in 1862.

See also under Gambardella.

Hippolyte LECOMTE (1781–1857)
French School
A pupil of Regnault in Paris, and son-in-law of Carle Vernet, he specialized in genre, history and, above all, battle-scenes. There are about thirty of his paintings at Versailles.

90 THE DUKE OF WELLINGTON VISITING THE OUTPOSTS AT SOIGNIES
Signed lower right *H^(te.) Lecomte.*
Canvas, $14\frac{3}{4} \times 18\frac{1}{4}$ $(37 \cdot 5 \times 46 \cdot 5)$

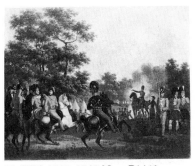

Soignies, between Waterloo and Brussels, was the site of the British camp in June 1815 and the event depicted was presumably shortly before the battle. The Duke is shown riding a white charger, pardonable artistic licence to mark the central figure, for in fact he rode Copenhagen, a chestnut charger, at Waterloo. Lecomte specialized in such romanticized, slightly naive, views of contemporary history (e.g. *Josephine at Lake Garda*, Malmaison, repr. *De David à Delacroix* (see below), 1974–5, pl.116).

90 WM 1568–1948 Neg. P1463
Wellington *Cat.*, p.400, no.388 red

Prov. Bought by the 3rd Duke of Wellington, 1887, for £8 from Henry Samuel, Oxford Street.
Exh. Vienna, Congress Exhibition, 1896–7.
Lit. Grand Palais, Paris, *De David à Delacroix*, 1974–5, p.520 (listed only).

Robert LEFÈVRE (1755–1830)
French School
He was a pupil of Regnault in 1784 and exhibited at the Salon from 1791. In his early years he painted allegorical and mythological subjects but concentrated increasingly on portraiture and was employed as a portrait painter by both Napoleon and his family and by Louis XVIII. Although he is still highly regarded for his attention to detail of costume and setting, his posthumous reputation has not been maintained at the height fixed by his contemporaries, who placed him on the same level as David and Gérard.

Lit. Gaston Lavalley, *Le Peintre Robert Lefèvre,* 1902.

91 NAPOLEON BONAPARTE, EMPEROR (1769–1821)
Signed lower left corner of pedestal supporting the column *Robert Lefèvre ft.1812*
Canvas, $85 \times 61\frac{1}{2}$ (216×156)

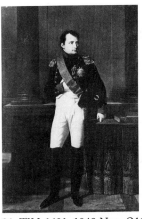

Full-length, life-size, aged about 44. Wearing the blue uniform with red facings, gold epaulettes, white waistcoat and white breeches of a French general, and black Napoleon boots. He wears the sash and star of the Grand Cross of the Legion of Honour and the 'croix d'officier' of the same order, together with the Italian Iron Crown, which hangs from his buttonhole.

This type of full-length portrait of Napoleon with neoclassical accoutrements was fixed by Ingres' portrait of the first Consul in 1804 (Liège Museum), but perhaps the best-known image is David's painting of 1810

91 WM 1491–1948 Neg. Q1376
Wellington *Cat.*, p.257 no.43 red

(National Gallery Washington, see A. Gonzalez-Palacios, *David e la Pittura Napoleonica*, 1967, pls.IV and V respectively).

Lefèvre's first version of this composition, dated 1809, is in the Musée Carnavalet, Paris. Another, identical with the Apsley picture but with a sculpture gallery in the left background, was engraved by Thomas Lupton (repr. J.T. Herbert Baily, *Napoleon*, 1908, p.113). A half-length version, dated 1814, was in a sale at the Hôtel Drouot (27 May 1960, lot 13).

Prov. Bought by the Duke of Wellington before 1820.

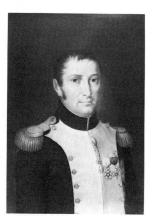

92 WM 1629–1948 Neg. F951
Wellington *Cat.*, p.277, no.118 black

92 JOSEPH BONAPARTE, KING OF SPAIN (1768–1844)
Canvas, $26\frac{1}{2} \times 19\frac{1}{2}$ ($67 \cdot 3 \times 49 \cdot 5$)

Bust, life-size. He wears a green uniform with a yellow plastron and gold epaulettes. From his neck hangs the Golden Fleece; on his chest are the badge of the Légion d'Honneur and the badge and star of the Order of the Two Sicilies.

On Joseph Bonaparte see above, no.48, under Gérard. Another portrait of Joseph by Lefèvre is in the collection of Lord Rosebery at Dalmeny and there is a copy of WM 1629 at Stratfield Saye.

Prov. Joseph Bonaparte in Spain; captured at Vitoria, 1813.

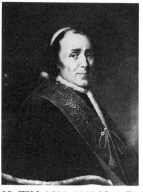

93 WM 1520–1948 Neg. P1407
Wellington *Cat.*, p.72 no.83 red

93 POPE PIUS VII (1742–1823)
Signed and dated on right *Robert Lefèvre ft.1805 à Paris*
Canvas, $28\frac{3}{4} \times 23\frac{1}{2}$ ($73 \times 57 \cdot 7$)

Head and shoulders, life-size, aged 63. The Pope wears a small white skull-cap and a gold-embroidered red velvet ermine-fringed cape.

Gregorio Barnaba Chiaramonti, Pope Pius VII, was born at Cesena in 1742 and succeeded Pius VI in 1800. He saw his main task as the restoration of the position of the Church after the events of the French Revolution, and in 1801 he succeeded in negotiating a concordat with Napoleon which re-established the Church in France. He was in Paris to meet Napoleon and to negotiate a modus vivendi for the Papal states in 1804–5. Nevertheless, in 1809 Napoleon proclaimed the end of the temporal power of the papacy; Pius VII was arrested and spent the next five years in exile, only to return to Rome in triumph in 1814.

It was during his diplomatic mission to Paris in 1805 that he sat to David and Lefèvre. David's frontal portrait is in the Louvre and there is an identical version of WM 1520 in the Detroit Institute of Arts ($29 \times 23\frac{1}{2}$in., see F.W. Robinson in *Bulletin of the Detroit Institute of Arts*, 24, 1945, p.70 repr.).

Prov. Bought by or presented to the Duke of Wellington.

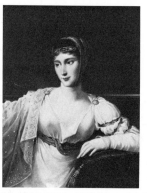

94 WM 1519–1948 Neg. L1402
Wellington *Cat.*, p.242, no.82 red

94 PAULINE BONAPARTE, PRINCESS BORGHESE (1780–1825)
Signed right centre above sofa *Robert Lefèvre ft.1806*
Canvas, $31\frac{3}{4} \times 25\frac{1}{2}$ ($80 \cdot 6 \times 63$)

Nearly life-size, half-length, seated on a bluish-green sofa, she wears a white semi-transparent gown and a white and gold headdress fastened by two gold bands passing over the head and under the chin. A jewelled fillet crosses the forehead and her dress is fastened by opal plaques at the shoulders.

Pauline, celebrated for her beauty, was the second sister of Napoleon. She married General Leclerc in 1801 and went with him to Saint Domingo where he died in 1802. Returning to France she married, in the same year, Prince Borghese, who had supported the French cause in Italy. They were soon separated and Pauline lived most of her life apart from her husband in Paris and Rome. She remained loyal to Napoleon and helped him during his exile on Elba.

There are several portraits of her by Lefèvre. A bust-length version of WM 1519 is in the Museum at Versailles (H. Vever, *La Bijouterie Française au XIX siècle*, I, 1906, p.49 repr.); another was in a New York sale in 1936 (Bonaventura sale, American Art Association, 8–9 May 1936, lot 334 repr.). A half-length portrait, also dated 1806, showing her in the same posture but with a different dress, is in the Versailles Museum (Vever, *op. cit.*, p.69 repr.). A related full-length, dated 1808, recently reappeared in a collection in Jersey, having been looted by Prussian troops from the palace at S. Cloud in 1815 (Charles de Salis, 'Marshal Blücher's Booty', *Connoisseur*, 193, 1976, p.273, fig.3).

Prov. Bought by or presented to the Duke of Wellington.

95 THE EMPRESS JOSEPHINE (1763–1814)
Signed on column left *Robert Lefèvre/ft.1806*
Canvas, oval, 25¼ × 21¼ (64 × 54)

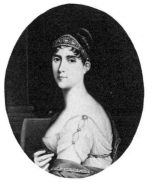

Rather less than life-size. A diamond and opal ornament, in the form of a Spartan diadem, crosses the forehead and hair in front; a small band of jewels passes over the centre of the head and behind it the hair is fastened by a diamond comb. She wears a low white linen Directoire gown, V-shaped at the back and edged with gold band.

Born Marie-Joseph-Rose de Tascher de la Pagerie in Martinique, Josephine came to Paris where she married first Alexandre de Beauharnais, who was executed, and, in 1796, General Bonaparte. She bought the château at Malmaison in 1799 and played an important part as a patron of the arts. In 1804 she was crowned Empress, but as she bore him no heir Napoleon divorced her in 1809. She retired to Malmaison and died there in 1814.

95 WM 1550–1948 Neg. P1406
Wellington *Cat.*, p.261, no.200 red

Josephine's brilliance, her position as Empress and her personal interest in the arts combined to bring into existence numerous portraits by a wide variety of painters and sculptors of which about a dozen are reproduced in *Apollo*, July 1977, special number devoted to *The Empress Josephine and The Arts*. The salient facial characteristics – the slightly clenched mouth and pursed lips, round cheeks and pointed chin – are fairly constant, though WM 1550 would appear to be a flattering portrait of a woman of 43. Portraits of her by Guillon Le Thière, 1807 (H. Vever, *La Bijouterie Française au XIX siècle*, i, 1906, repr. p.34) and Baron Gros, 1809 (Musée Massena, Nice, *Apollo*, July 1977, p.49, fig.11), for example, show that the youthful image was presented throughout the decade. In the facial features, posture and headdress, if not in dress, WM 1550 is derived from Lefèvre's full-length portrait of 1805 (Aachen, Rathaus, *Apollo*, July 1977, p.53, fig.5). There is also a closely related version of the bust portrait, dated 1805, in the collection of Lord Rosebery at Dalmeny.

Prov. Bought by the Duke of Wellington from Count Alfred d'Orsay for £100 in 1851.

96 A LADY IN COURT COSTUME, SAID TO BE THE EMPRESS JOSEPHINE (1763–1814)
Canvas, oval, 28½ × 22¾ (72·4 × 58)

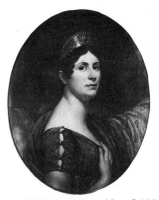

Head and shoulders, turning towards the right, wearing a Spartan diadem with a large ruby in the centre and a band of pearls round the upper edge.

Both this portrait and WM 1550 (see previous entry) were acquired by the Duke of Wellington as being of the Empress Josephine, but it is hard to believe that they represent the same person. This portrait was framed and hung as a pair with the oval portrait of Napoleon (WM 1515; see no.52) but it is quite different in execution, being unusually sketchy for Lefèvre. It is conceivable that the plump lady with the full mouth represents a later view of

96 WM 1516–1948 Neg. L388
Wellington *Cat.*, p.254 no.79 red

the slim, youthful figure of WM 1550, which, as a type, clearly originated at an earlier date than the actual portrait of 1806. WM 1516 is not very similar to any of the paintings of Josephine but a comparison can be drawn with the realistic-looking sculpture by Joseph Chinard, 1805 (Malmaison; *Apollo*, July 1977, p.43, fig.16). If WM 1516 is not a portrait of Josephine, it remains equally difficult to identify the sitter among Napoleon's sisters or sisters-in-law or any other ladies of the imperial court (see, for example, *Connoisseur*, 193, 1976, p.273f., figs.2–6, and Vever, *Bijouterie, passim*).

Condition. Damaged and retouched on forehead and nose.
Prov. Bought by or presented to the Duke of Wellington.

Charles Robert LESLIE, R.A. (1794–1859)
Born in London of American parents, he returned to the U.S. in 1799 to be educated. He came back to England in 1811, studied under West and Allston and entered the R.A. schools in 1813. Elected A.R.A. in 1821 and R.A. in 1826, he was a successful painter of genre scenes illustrating standard authors, as well as the biographer of Reynolds and Constable. There are 24 paintings by him in the V&A Museum.

97 WM 1569–1948 Neg. J1433
Wellington *Cat.,* p.280, no.391 red

97 THE DUKE OF WELLINGTON LOOKING AT A BUST OF NAPOLEON
Canvas, square, framed oval, 15⅝ × 13⅝ (39·7 × 34·5)

He is wearing evening clothes with the star of the Garter and the red ribbon of the Bath round his neck. This portrait was painted, apparently from observation, at a party given by Baroness Burdett-Coutts, the philanthropist, at her house in Piccadilly. There is a companion picture showing the Duke in identical posture, but looking at a bust of Washington, belonging to the Duke of Wellington at Stratfield Saye. Of similar size, it differs from WM 1569 in being more finished and, in particular, less sketchy in the painting of the table and bust.

There is no reason to doubt that the figure of Wellington was painted from life, at a party, although such portraits showing the sitter with a marble bust belong to a pictorial tradition of long standing. Portraits of humanists with classical busts were common in the work of Rubens and his followers, for example Rubens' portrait of Caspar Gevartius (Antwerp Museum) engraved in 1644, and in the 18th century Reynolds' *Self-portrait with a bust of Michelangelo* (1773; Royal Academy; Waterhouse, *Reynolds,* 1940, pl.150) underlines the fact that a special bond always links the living personage and the bust. The cognate tradition of the sitter actually contemplating the bust is exemplified, above all, in Rembrandt's *Aristotle contemplating the bust of Homer,* of 1653, in the Metropolitan Museum, New York (J.S. Held, *Rembrandt's Aristotle and other Rembrandt studies,* Princeton, 1969, p.21ff., where the theme is discussed at length). There can be no doubt that Leslie was aware of this tradition, and indeed he invokes it, in painting two versions with different busts.

There are two other portraits of Wellington by Leslie: an oil painting showing the Duke with his daughter-in-law (now at Stratfield Saye; Wellesley, Steegmann, pl.43), and a water-colour, showing him seen from the back, in the British Museum.

Prov. Bought by the 2nd Duke of Wellington.
Lit. Wellesley, Steegmann, *Iconography,* 1935, p.30, no.2; Elizabeth Longford, *Wellington: Pillar of State,* 1972, fig.46 (wrongly captioned as 'Wellington admiring a bust of Washington').

Johannes LINGELBACH (1622–74)
Dutch School
Born in Frankfurt, he grew up in Amsterdam and then worked in Rome

*c.*1644–50 before returning to settle in Amsterdam. His work is under the influence of Wouverman and of the Dutch school at Rome, particularly Pieter van Laer, 'Il Bamboccio'.

98 LANDSCAPE WITH TRAVELLERS RESTING
Signed lower right *LB* (monogram)
Oak panel, 8¼ × 10⅛ (21 × 25·7)

The attribution in the Le Rouge sale and the Wellington *Catalogue* was to Lingelbach and Wynants - the latter presumable being held responsible for the landscape. Apart from the inherent unlikelihood of Wynants being called in to execute the landscape of such a small picture, and one in which the figures and not the landscape predominate, the style is wholly that of Lingelbach. The sketchy, atmospheric landscape dominated by a jagged tree stump is as typical of Lingelbach as are the figures with their rugged, rustic features and outstretched, gesticulating arms. An LB monogram of this kind appears in other works by Lingelbach, for example Amsterdam Rijksmuseum no. A.227.

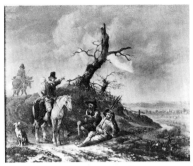

98 WM 1489–1948 Neg. J943
Wellington *Cat.* p.34, no.41 red

Condition Panel split about 3½ in. from left-hand side; flaking along this line.
Prov. Le Rouge sale, Paris, April 1818 (lot 71), bought for the Duke of Wellington by Féréol Bonnemaison for 800 fr., about £32.
Exh. Ferens Art Gallery, Hull, *Dutch Painting of the 17th century,* 1961 (63).

99 LANDSCAPE WITH TRAVELLERS RESTING, AND COUPLE ON HORSEBACK
Oak panel, 8¼ × 10⅛ (21 × 25·7)

Companion piece to WM 1489 (see previous entry)

Prov. Le Rouge sale, Paris, 27 April 1818, lot 70; bought for the Duke of Wellington by Féréol Bonnemaison for 785 fr., about £32.
Exh. Ferens Art Gallery, Hull, *Dutch Painting of the 17th Century,* 1961 (62).

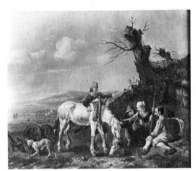

99 WM 1488–1948 Neg. J942
Wellington *Cat.,* p.35 no.37 red

Bernardino LUINI (active 1512; d.1532)
Italian (Lombard) School
At first influenced by Bramantino and Pordenone, he later worked in the manner of Leonardo, who had been in Milan *c.*1482–99. He painted mainly frescoes of religious subjects in the churches of Milan and its vicinity, and of Lugano.

Lit. A. Ottino della Chiesa, *Bernardino Luini,* Novara, 1956.

Ascribed to LUINI

100 THE VIRGIN WITH THE STANDING CHILD
Inscribed lower right with inventory no.453
Poplar panel, 29⅛ × 20¼ (74 × 51·5)

This is a replica of Luini's *Virgin of the Columbine* in the Wallace Collection (no.10; panel, 75 × 57cm.; Ottino della Chiesa, no.88, fig.96). It was held to be autograph by Beltrami (1911) and included by Berenson in the first edition of his *North Italian Painters* (1907), but Ottino della Chiesa (1956) describes it as a 'good studio copy'. There are other versions in the Hermitage, Leningrad; the Czernin Collection, Vienna (Beltrami, repr. pp.529–30); the Kunstmuseum, Basle; and the Gallaratti Scotti Collection, Milan.

The columbine (*aquilegia columbina;* the name derives from its shape which resembles four doves) first appears as a symbol of the dove of the Holy Ghost and of the Virgin in the late 14th century and is a common attribute in 15th-century painting, particularly in Germany and the Netherlands (R. Fritz, 'Aquilegia...', *Wallraf-Richartz-Jahrbuch,* 14, 1952, pp.99–110; Levi d'Ancona, 1977, pp.105–8). The plant is, typically, near to or held by the

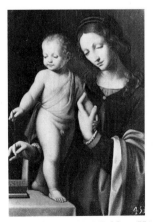

100 WM 1615–1948 Neg. H891
Wellington *Cat.,* p.156, no.84 black

Christ Child (Fritz, figs.80f.) and it appears in this context, elsewhere in Luini's paintings (Ottino della Chiesa, pl.97).

Condition. Tendency to flake down centre of panel (corresponding to worm tunnelling visible on reverse); large areas of retouching below Virgin's left wrist and on Child's drapery. Cleaned by S. Isepp in 1949.

Prov. Royal Palace, Madrid (1794 inventory no.453, in the King's dressing room, as Andrea del Sarto, but Ponz has it as 'in the style of Leonardo'). Captured at Vitoria, 1813.

Exh. Early Italian Art, New Gallery, 1893–4 (178).

Lit. Cumberland, *Catalogue*, 1787, p.86 (as Leonardo); Ponz, *Viage*, vi, p.48; G.C. Williamson, *Luini*, 1899, p.109; L. Beltrami, *Luini*, 1911, pp.524, 528 repr; B. Berenson, *North Italian Painters of the Renaissance*, 1907, p.247 (omitted in subsequent editions); A. Ottino della Chiesa, *Bernardo Luini*, 1956, p.86, no.92; Wallace Collection Catalogues: *Pictures and Drawings*, 1968 ed., p.188; M. Levi d'Ancona, *The Garden of the Renaissance*, 1977, p.107.

Follower of LUINI

101 WM 1621–1948 Neg. H893
Wellington *Cat.*, p.127, no.95 black

101 THE HOLY FAMILY WITH THE INFANT ST JOHN
Inscribed lower right with inventory no.364
Silver fir panel, $20\frac{1}{8} \times 18\frac{1}{2}$ (51 × 47) including a strip 8cm. wide added on the left.

The composition is a truncated version of the *Holy Family* by Luini in the Prado, Madrid (no.242, panel, 100 × 84cm.; Ottino della Chiesa, *Luini*, 1956, no.102, fig.114) in which the Children are shown full length. This painting is strongly under Leonardo's influence and there are several versions of the two Children embracing which are still attributed to Leonardo (H. Bodmer, *Leonardo*, K. d. K. 1931, pls 80f.; the Prado picture is repr. pl.82). WM 1621 is not strictly a truncated copy, for the composition has been altered by bringing the Children much closer to the Virgin's face in order to fit the subject into a reduced area without unduly diminishing the size of the figures. It appears to be a 16th-century work.

Condition. Cleaned by S. Isepp, 1949.
Prov. Spanish royal collection (not inv.); captured at Vitoria, 1813.

Nicolaes MAES (1634–93)
Dutch (Dordrecht) School
Born in Dordrecht, he was probably a pupil of Rembrandt in Amsterdam in about 1650. He was back at Dordrecht before 1654 and remained there until 1673 when he settled in Amsterdam. He painted genre scenes in his early years, but from 1660 he confined himself to portraiture.

Lit. W.R. Valentiner, *Nicolaes Maes*, 1924.

102 WM 1503–1948 Neg. GG4133
Wellington *Cat.*, p.27, no.60 red

102 THE EAVESDROPPER
Signed on paper hanging below shelf in inner room *N. MAES. P*
Canvas, $23\frac{5}{8} \times 26$ (57·5 × 66)

The woman is tiptoeing down the stairs, her forefinger raised to her lips to indicate silence, while she listens to a couple seen embracing in the room beyond. Maes painted several variants of this composition: one, in the royal collection (Valentiner, pl.38), is dated 1655, another in the Wallace Collection (Valentiner, pl.39) is dated 1656, a third, in the Hague (Dienst Verspreide Rijkscollecties; Valentiner, pl.42; *Tot Lering en Vermaak*, Rijksmuseum 1976, no.34), bears the date 1657, and it is likely that the Wellington picture also originated at this period. Two drawings formerly in the Earl of Dalhousie's collection (Valentiner, figs.46–7) – one of the woman, the other of the whole scene but with a man coming down the stairs – may be connected with this composition.

The motif of the index finger raised to the lips to indicate silence occurs occasionally in the Middle Ages (e.g. Psalm 141 in the 9th-century Stuttgart Psalter) and more frequently from the 16th century, when it appears, for example, in the illustration to *Silentium* in Alciati's *Emblemata* (1531) and as an attribute of Harpocrates, god of silence (see Karla Langedijk, 'Silentium', *Nederlands Kunsthistorisch Jaarboek*, 15, 1964, pp.3–18; *Tot Leering en Vermaak*, loc. cit., for further lit.). It was common especially in compositions of cupids and satyrs spying on lovers, and Nicolaes Maes has used it in the same erotic context while changing the setting from classical mythology to contemporary genre. At the same time he has used the motif to emphasize the anecdotal nature of the painting, to a much greater extent than was current among his contemporaries. Through the gesture and expression of the listening woman, he is asking his viewers to enter directly into the story in a way more reminiscent of Victorian than of 17th-century genre painting. Not suprisingly, the eavesdropper was a popular subject in the 19th century: an example of a similar scene by Hubert van Hove is in the V&A Museum (no.1540–1869; *Catalogue of Foreign Paintings*, ii, no.110).

Maes's paintings of *Eavesdroppers* of 1655–57 are among the earliest in Dutch art to show views into other rooms containing part of the narrative. Pieter de Hooch was experimenting on these lines in Delft at about the same time, but there are no dated pictures by him before 1658 and it is possible that it was Maes who pioneered this compositional device.

Condition. Paint loss at edges, old tear below servant, otherwise good. Cleaned 1977.
Prov. Burgomaster Baelemans de Steenwegen, Louvain (d.1816); 1816, Nieuwenhuys; Le Rouge sale, April 1818, lot 29, bought by Bonnemaison for 1600 fr. (£64) for the Duke of Wellington.
Exh. B.I., *Old Masters*, 1821 (97); R.A., *Old Masters*, 1888 (52); Guildhall, *Loan Collection*, 1903 (177); B.F.A.C., *Winter Exhibition*, 1928 (34); R.A., *Dutch Art*, 1929 (282); Arts Council, 1949 (4); Ferens Art Gallery, Hull, *Scholars of Nature*, 1981 (32).
Lit. Smith, *Cat. Rais*, iv, p.245, no.8; H. de G., vi, p.512, no.125; C.J. Nieuwenhuys, *A Review of the lives and works of some of the most eminent painters*, 1834, p.289; Valentiner, *Maes*, pl.40, cf.p.46f.

103 THE MILKWOMEN
Signed lower left *N. MAES*
Canvas, $24\frac{1}{8} \times 26\frac{1}{4}$ (30·8 × 66·6)

Companion to the *Woman listening* (no. WM 1503–1948, see previous entry) and dating from the same period, 1655–9. It belongs to a group of compositions with saleswomen in front of houses, painted by Maes at this time. There is a *Milkwoman* in the Beit Collection and a *Vegetable seller* in the Philadelphia Museum (Widener collection; Valentiner pls 46, 47). All have the large central figure typical of Maes's compositions at this period. The gateway in the street on the left is the St Joris Poort at Dordrecht, where Maes lived until 1673.

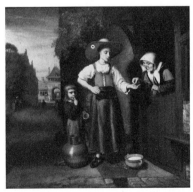

103 WM 1506–1948 Neg. GK1832
Wellington *Cat.*, p.30, no.63 red

There are several related drawings, of which the one in the Dresden Print Room (Valentiner, fig.64) is the closest. Two drawings in the Fitzwilliam Museum, Cambridge (Valentiner, figs.66, 67), differ only in showing the housewife standing in front of the door instead of behind it.

Condition. Some flaking on left edge and other local patches. Cleaned 1978.
Prov. Same as companion picture. Bought by Bonnemaison at the Le Rouge sale for 885 fr. (£36).
Exh. B.I., *Old Masters*, 1821 (116); R.A., *Old Masters*, 1888 (50); Whitechapel Art Gallery, *Dutch Exhibition*, 1904 (144); B.F.A.C., *Winter exhibition*, 1927; R.A., *Dutch Art*, 1929 (287); Arts Council, 1949 (5).
Lit. Smith, *Cat. Rais.*, iv, p.245, no.9; H. de G., vi, no.32; Nieuwenhuys, *loc. cit.*; Valentiner, *Maes*, p.55f., pl.45.

Juan Bautista del MAZO (c.1612/16–1667)
Spanish School

He was a pupil of Velazquez, whose daughter he married in 1633. After Velazquez's death in 1660, he was appointed *Pintor de cámara* in his place. Documented works by him are extremely rare.

104 THE ENTRY OF PHILIP IV INTO PAMPLONA
Canvas, 21½ × 35½ (55 × 90)

Pamplona, capital of Navarre and the principal fortress in northern Spain, is seen in the middle distance. Spectators in local Navarrese dress line the road while the two royal coaches approach the city gate. On the left, men and women perform the traditional Basque dance, the *aurresku*, holding white handkerchiefs (Trapier, 1963). The arms of Navarre are displayed in the sky.

This is a reduced version of the picture commissioned from Mazo by Philip IV when he was detained at Pamplona by the illness of Prince Baltasar Carlos in 1646. Writing in praise of this picture, Palomino (*El Parnaso Español*, iii, p.372) was enthusiastic about the treatment both of the figures and costume and of the scale and distance. The original painting, apparently no longer extant, was recorded, together with a companion *View of Saragossa* (Prado) in the Spanish royal inventories of 1686 and 1701, where the size was given as '4 vara wide, a little less high' (340cm. wide). There are also two other versions, one in the collection of the Marquis of Casa Torres (the central section only), the other in the Museo Lazaro Galdiano in Madrid. The Wellington version was listed as Velazquez by Curtis (1883), but subsequent authors have described it as either a sketch for, or a reduced replica of, the painting by Mazo formerly in the royal collection.

Trapier (1963) demonstrated the influence of Callot's etchings on the panoramic composition.

Condition. Some wearing in the sky; large area of retouching in the middle ground in the centre of the picture.
Prov. Bought by the Duke of Wellington from J.M. Brackenbury for £125 in 1844. (Pita Andrada's suggestion that this was the version listed as in the Marquis of Carpio's collection in 1651 is open to doubt because it is smaller in size than the picture listed in the inventory, i.e. 1 × 1⅓ vara or 85 × 112cm.)
Exh. Velázquez y lo Velazqueño, Madrid, 1960–61 (127).
Lit. Stirling, *Annals,* 1848, iii, p.1409 (Velazquez); E. Stowe, *Velazquez,* 1881, p.99; C.B. Curtis, *Velazquez and Murillo,* 1883, p.28, no.61; C. Justi, *Velazquez,* 3rd ed., ii, p.133; A.L. Mayer, *Velazquez,* 1936, no.152 (Mazo); E. du Gué Trapier, *Velazquez,* 1948, p.281 (Mazo); J.M. Pita Andrada, 'Los cuadros de Velazquez y Mazo que poseyo el septimo Marquez del Carpio', *Archivo Español de Arte,* 25, 1952, p.230; B. de Pantorba, *La Vida y la Obra de Velazquez,* 1955, p.165 (Mazo: sketch or reduced copy); Gaya Nuño, *Pintura Española,* no.1716; G. Kubler, M. Soria, *Art and Architecture in Spain and Portugal 1500–1800* (Pelican History of Art), 1959 ('third version at Apsley House'); J. López-Rey, *Velazquez,* 1963, no.153 (workshop replica); Trapier, 'Martínez del Mazo as a landscapist', *G.B–A.,* May 1963, p.298f., esp. p.303, fig.7 (Mazo); N. MacLaren and A. Braham, N.G. Catalogue, *The Spanish School,* 1970, p.51 (small version or copy).

Anton Raphael MENGS (1728–79)
German School

He was born in Aussig, Bohemia, the son of the painter Ismael Mengs by whom he was trained in Dresden. He was in Rome in 1741–4 and returned to Dresden in 1745 to become court painter to the Elector Augustus II of Saxony. He was in Rome again 1747–9 and 1752–61; in 1761 he was summoned to be court painter to Charles III in Madrid and he remained there until 1770 and again from 1775–6.

Mengs was greatly influenced by Raphael and by the neo-classical theories of Winckelmann.

Lit. D. Honisch, *A.R. Mengs,* Recklinghausen, 1965.

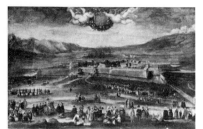

104 WM 1549–1948 Neg. F981
Wellington *Cat.,* p.191, no.195 red

105 THE HOLY FAMILY WITH THE INFANT ST JOHN
Signed and dated on footstool on right *ANTONIUS. RAPHAEL. MENGS.*
SAX. FACEB. MDCCLXV
Canvas, $70\frac{1}{8} \times 50\frac{1}{2}$ (178 × 128)

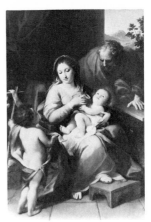

105 WM 1592–1948 Neg. P1427
Wellington *Cat.*, p.201, no.49 black

Mengs painted this picture for Charles III of Spain in 1765. D'Azara (1780)
described it as 'the first painting which Mengs painted in oil in Madrid' –
presumably as distinct from the frescoes in the Royal Palace which he began
in about 1762. There are, however, several portraits of Charles III and
members of his family which predate this painting (Honisch, esp. nos. 135ff.).

Both style and composition are derived from Raphael, the principal
influence on Mengs in his early years. The colouring is Raphaelesque; the
composition and, in particular, the facial type of St Joseph recall Raphael's
Holy Family under the oak tree, now in the Prado, which Mengs probably
knew in the Spanish royal collection. There is a pen drawing by Mengs in the
Metropolitan Museum, New York, which is clearly a study, in reverse, for the
Apsley House picture (11·5×7·5cm. squared in black chalk, exh. Yvonne
Tan Bunzl at Faerber and Maison, 1970, no.35 repr.). Another drawing, in
the same direction as WM 1592, inscribed as being preparatory for this
painting, is in the collection of the Condesa de Yebes, Madrid (14×12cm.;
Mengs exh., Madrid 1980, no.45, repr.).

It is possible that Mengs reversed his original composition under the
influence of Raphael's painting.

Condition. Small paint losses on right of child's head; retouched scratches above
Virgin's head.
Prov. Royal Palace Madrid, 1772 inventory: passage to the King's sleeping chamber,
where it was seen by the authors listed below in the 1780s; 1794 inventory: Segundo
Gabineto. Captured at Vitoria, 1813.
Exh. R.A., *Goya and his times*, 1963–4 (13); Prado, Madrid. *Antonio Raphael Mengs*,
1980 (44).
Lit. J.N. D'Azara, *The Works of Anthony Raphael Mengs*, London, 1796 (transl. from
the Italian ed. of 1780), i, list of paintings, p.68; G.L. Bianconi, *Elogio storico del
cavaliere A.R. Mengs*, Milano, 1780 (1797 ed. p.84); Ponz, *Viage*, vi, 1782, p.33;
Cumberland, *Catalogue*, 1787, p.50; Townsend, *Journey through Spain*, 1792 ed., i,
p.262; Céan Bermudez, *Diccionario Historico...*, iii, 1800; D. Honisch, *A.R. Mengs*,
1965, p.82, no.66; Gaya Nuño, *Pintura Europea*, no.207.

106 THE INFANT CHRIST APPEARING TO ST ANTHONY OF PADUA
Inscribed with inventory no.276
Canvas, $26\frac{1}{8} \times 22\frac{3}{8}$ (66·4×56·7)

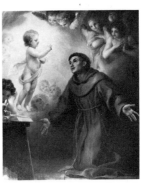

106 WM 1598–1948 Neg. P1418
Wellington *Cat.*, p.207, no.57 black

St Anthony of Padua was born at Lisbon in 1195 and entered the Franciscan
order in 1220. He became famous as a preacher in Morocco and France and
spent the last years of his life in Padua (1227–31). The popular legend of the
Infant Christ appearing to him first occurs in the 14th-century *Liber
Miraculorum*. One day when his landlord passed his room he was surprised to
see a bright light, and when he looked through a crack in the door he saw the
Infant, bathed in light, before the Saint. In the 17th-century this scene was by
far the most popular of all the depictions of St Anthony (B. Kleinschmidt,
Antonius von Padua in Leben und Kunst, 1971, pp.74ff.).

Mengs painted this picture for Charles III of Spain, probably in about
1765 (Honisch), and from 1780 it is described in published sources as one of a
pair – the other was an *Immaculate Conception* – which the King always took
with him on his travels. It is nearly monochrome in tone and derives as much
from the 17th-century Spanish school – in particular from Murillo – as from
Correggio, the principal influence on Mengs at this period. The composition
is also based on 17th-century Spanish models: there is a well-known
comparable version by Ribera in the Academia di San Fernando, Madrid

(Kleinschmidt, fig.170), while Murillo and his followers returned to the subject at least eighteen times (Kleinschmidt, p.207; some of the principal types are repr. in A.L. Mayer, *Murillo*, K.d.K., 1913, pls 40, 89, 132, 148, 189, 190). Closer than any of these, particularly for the posture of the Saint and the Child, is the composition by Valdes Leal (repr. *Apollo*, 95, 1972, p.136; *Archivo Español de Arte*, 178, 1972, p.232, pl.1) which in turn owes much to the etching by Giulio Carpioni (Bartsch, xx, 185.11). The Infant hovers over the book which had been St Anthony's earliest attribute, while the lily – originally a symbol of the chastity of the Virgin, but linked with St Anthony from the 15th-century – is held by the angel on the left.

Prov. Royal Palace, Madrid, 1794 inventory, in the King's dressing room. Captured at Vitoria, 1813.
Exh. R.A., *Goya and his times*, 1963–4 (14).
Lit. J.N. D'Azara, *The Works of Anthony Raphael Mengs*, London, 1796 (transl. from the Italian ed. of 1780), i, list of works, p.68; G.L. Bianconi, *Elogio storico del Cavaliere A.R. Mengs*, Milano, 1780 (1797 ed., p.83, wrongly described as 'mezza figura'); Céan Bermudez, *Diccionario Historico...*iii, 1800, p.131; H. Voss, *Die Malerei des Barock in Rom*, 1924, p.659; D. Honisch, *A.R. Mengs*, 1965, p.82, no.63; Gaya Nuño, *Pintura Europea*, no.206.

Adam François van der MEULEN (1632–90)
(Flemish School; worked in France)
Born in Brussels, where he was the pupil of Peeter Snayers, he became a master of the painters' guild in 1651. In 1664 he entered the service of Louis XIV of France and specialized in topographical views and battle scenes. He travelled in the company of the King during his campaigns in the Netherlands and depicted many of these battles. He became a member of the Académie Royale in 1673.

107 WM 1495–1948 Neg. P1468
Wellington *Cat.*, p.35, no.48 red

107 FRENCH GENERALS ARRIVING BEFORE A TOWN
Signed lower left *F.V. MEULEN 1678*
Canvas, $20\frac{3}{4} \times 24\frac{1}{2}$ (52·5 × 62·5)

Evelyn Wellington identified the central figure as Louis XIV. He is wearing a richly embroidered coat, but it would be unusual for the King to be shown from the back, and the way in which this rider clutches his hat suggests that he has just ridden up to the other two. The ambiguity itself makes it unlikely that the King is represented; nor is there any evidence to support the identification of Condé made in the Wellington heirloom catalogue (Wellington *Cat.*, p.36).

Condition. Paint surface considerably worn, particularly in the sky.
Prov. Bought by or presented to the Duke of Wellington.

108 LOUIS XIV AT A SIEGE
Canvas, $20\frac{3}{4} \times 24\frac{1}{2}$ (52·5 × 62·5)

Louis XIV (1638–1715), mounted on a dun charger, is in the centre of the foreground, surrounded by officers. The city under siege is not depicted with sufficient clarity to be readily identified, but it is somewhat like van der Meulen's view of Oudenarde in a comparable painting in the Alte Pinakothek, Munich (*Katalog*, 1936, no.783). The event depicted could relate either to the War of Devolution 1667–8 or to the Dutch War, 1672–8, during both of which van der Meulen accompanied the King on his campaigns in the Netherlands. It is conceivable that this picture was painted as a companion to WM 1495, in which case it could be dated *c.*1678, but nothing is known of their provenance or early history.

108 WM 1494–1948 Neg. P1467
Wellington *Cat.*, p.135, no.47 red

Condition. Five vertical strips of retouched paint loss in the middle of the picture, otherwise good.
Prov. Bought by or presented to the Duke of Wellington.

109 THE COLBERT FAMILY
Canvas, $38\frac{1}{4} \times 50\frac{3}{4}$ (97 × 129)

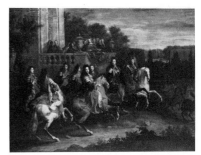

109 WM 1497–1948 Neg. L1395
Wellington *Cat.,* p.122, no.51 red

The eight riders in the foreground all wear the same uniform: a purple tunic, the upper part of the sleeves of which is striped horizontally with gold and white fur, and over the tunic a sleeveless, red, flowing silk robe, lined with white. On the left, a carved escutcheon on a pedestal displays a snake surmounted by a coronet and a cardinal's hat.

It was John Wilson Croker (1780–1857), well known both as a politician who served in Wellington's administration of 1829–30, and as an essayist, who identified the Colbert family as the subject of this painting. In a letter to the Duke dated 6 June 1835, he identified the escutcheon as that of the Colbert family and suggested that the riders were all members of the family who were Grand Treasurers of the Order of the Saint Esprit at various dates between 1680 and 1701 (quoted in Wellington *Catalogue*). Subsequently, the identification was confirmed by the Director of the Louvre in a letter to the Duchess of Wellington (1894), though he described the uniform simply as 'costume de cour'.

The central figure is clearly the 'great Colbert', Jean Baptiste Colbert (1619–83). Born, like the rest of his family, in Rheims, he entered government service in 1640, worked for the Mazarin in the 1650's and bought the barony of Seignelay in 1658. After the death of Mazarin in 1661, he became the principal minister of Louis XIV and attempted during his period in office, no less than the financial, commercial, industrial and naval modernization of France. It was Colbert also, advised by LeBrun, who nominated van der Meulen court painter in 1664. He was usually depicted with a moustache and a rather round face, particularly in the early portraits (eg. Nanteuil's engraving after Philipe de Champagne, 1662) but there are later portrayals showing him with an oval face and bushy eye brows akin to those of the central rider in this painting (eg. Pinssio's engraving after Mignard).

The prelate on the balcony is probably Colbert's second son, Jacques Nicolas (1655–1707), who became suffragan Archbishop of Rouen in 1680. But the other riders are more difficult to identify. To the right of Colbert, and shown in an almost equally prominent position, is probably his brother, Charles, Marquis de Croissy (1629–96). He was ambassador the England in 1668–74 and Secretary of State for Foreign Affairs from 1679. An engraving by J. Jones (1792) after a portrait of *c.*1680—90 (N.P.G. files) supports this tentative identification. Among the other prominent riders, the one on the far right is probably Colbert's eldest son, Jean-Baptiste-Antoine (1651–90), who assisted his father in government service. The full, high wigs indicate a date *c.*1680–90, which may be narrowed down to *c.*1680–83, the year of Colbert's death. A family tree may serve to indicate the likely and less likely candidates from which to pick the remaining riders:

Nicolas Colbert = Marie Pussort
(Conseiller d'Etat)

Jean Baptiste (1619–83)*	Charles (1626–96)*	François-Edouard (1633–93)	Nicolas (1628–76)
(Marquis de Seignelay)	(Marquis de Croissy)	(Comte de Maulévrier)	(Bishop of Auxerre)
'le Grand Colbert'		General	

Jean-Baptiste-Antoine (1651–90)*	Jacques Nicolas* (1655-1707)	Antoine Martin (1659–89)	Louis (1665–1745)
(in Government Service)	(Archbishop of Rouen)	(soldier)	(abbot)

An * indicates members of the family certainly, or almost certainly, depicted.

Condition. Blistering badly and considerably retouched in central area.
Prov. Bought by or presented to the Duke of Wellington.

Willem van MIERIS (1662–1747)
Dutch (Leyden) School
Son and pupil of Frans van Mieris the elder (1635–81), he painted mainly genre subjects (especially shop scenes) in his father's style. He lived in Leyden, where he became dean of the Painters' Guild in 1699. Towards the end of his life he became blind; there are no dated pictures after 1736.

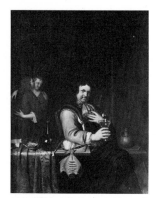

110 WM 1526–1948 Neg. Q1372
Wellington *Cat.,* p.10 no.90 red

110 INTERIOR WITH A CAVALIER DRINKING AND A COUPLE EMBRACING
Oak panel, 16 × 13⅛ (42 × 32·3)

There are many similar scenes by Willem van Mieris, and the dried fish hanging over the edge of the table is almost his hallmark. It occurs, for example, in a tavern scene formerly belonging to P. de Boer (1961; H. de G., 268) and in another at Dresden (no.261). The former is dated 1690 and WM 1526 may also be placed in the period *c.*1690–1700.

H. de Groot listed a small replica in the J. Porgès collection, Paris, 1911 (H. de G. no.248).

Prov. Choiseul-Praslin sale, Paris, 18 Feb. 1793 (Ch. Blanc, *Trésor,* ii, p.161); Lapeyrière sale, April 1817, bought for the Duke of Wellington for 2501 fr.
Exh. B.I., *Old Masters,* 1819 (23); 1829 (174).
Lit. Smith, *Cat. Rais,* i, p.82, no.82 (under 'Francis Mieris'); H. de G., x, (German ed. only), no.247.

Anthonis MOR (Antonio MORO) (*c.*1519–76/7)
Netherlandish School
Born in Utrecht, where he was a pupil of Jan van Scorel, he settled in Antwerp in 1547. Starting with the patronage of Cardinal Granvella, he became painter to the Spanish court both in Brussels and in Madrid. He was in Rome in 1550, in Portugal in 1552 and in England in 1554, returning to settle in the Netherlands in the following year. His portraits combine the realism of the Netherlandish tradition with the elegance of the Italian mannerists.

Lit. Georges Marlier, *Anthonis Mor van Dashorst,* 1934.

After MOR

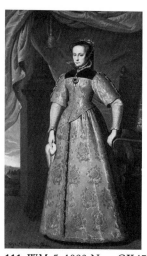

111 WM 5–1980 Neg. GK4749
Wellington *Cat.,* p.141, no.50 red

111 QUEEN MARY I OF ENGLAND (1516–58)
Inscribed lower left *La Reÿna d'inglatiera Maria* and with inventory nos. *+333 +*and *409*
Canvas, 81¾ × 48 (208 × 122)

The Queen, shown full length, standing, wears a wide hood with a high-rising open collar showing an inner frill and a white and gold brocaded gown with a tight-fitting bodice and wide sleeves.

Mary was the only surviving child of Henry VIII and Catherine of Aragon; she was separated from her mother on Catherine's divorce in 1532 and was declared illegitimate in the following year. She was, nevertheless, proclaimed Queen on the death of Edward VI in 1553 and thereafter worked for the restoration of Catholicism. She married Philip of Spain in July 1554.

According to van Mander, Mor was sent to England by Charles V in order to paint Mary for her prospective bridegroom. No date is connected with this account, but Roy Strong has suggested that the large pendant stone at her throat may be identical with that sent by Philip along with other jewels in June 1554 (Strong, 1967, p.212). Three paintings by Mor of the Queen are

accepted as autograph: (1) Prado, Madrid, dated 1554 (Hymans, 1910, repr. facing p.74), (2) Marquess of Northampton, Castle Ashby (Holbein exhibition, R.A., 1950, no.200), (3) Isabella Stewart Gardner Museum, Boston (Strong, 1967, pl.415). These all portray the Queen three-quarter length and seated, and this was also the type of the engraving by Frans Huys, 1556, and numerous versions and copies. The Apsley House picture, which appears to date from the 17th-century, is also ultimately derived from the same source, but belongs to a variant tradition in which Mary is shown full length, standing. Other examples of this type are at Schloss Ambras, Innsbruck, and St James's Palace (19th-century; see O. Millar, *Tudor, Stuart and early Georgian pictures in the collection of H.M. The Queen*, 1963, p.67, no.55).

Prov. (?) Duke of Alva; Henry Wellesley, Lord Cowley (in a letter to Seguier dated 14 Aug. 1829, the Duke of Wellington wrote 'I bought some pictures some years ago from my brother, Lord Cowley... there were among them some pretty good ones... and the original of Mary Queen of England, wife of Philip 2nd, of which the copy is at St. James'... They all came from the collection of the Duke of Alva'). It was argued in the Wellington Catalogue that this picture was in the collection of Charles I, but it has not been possible to find evidence for this hypothesis in the published inventory (*Walpole Society*, 43, 1970–72). Bought by the Duke of Wellington from Lord Cowley before 1829, and by the V. & A. from the 8th Duke of Wellington in 1980.
Lit. Stirling, *Annals*, i, p.218 (as by Mor). For the origin of the portrait see: Carel van Mander, *Livre des Peintres*, ed. H. Hymans, 1884, i, p.276; H. Hymans, *Antonio Moro*, 1910, p.76f.; G. Scharf in *Proceedings of the Society of Antiquaries*, vii, 1876, pp.49–58; Roy Strong, N.P.G., *Tudor and Jacobean Portraits*, 1969, p.212f.

Bartolomé Esteban MURILLO (1617–82)
Spanish (Seville) School
Born in Seville, where he was a pupil of Juan de Castillo (d.1640), he went to Madrid *c.*1648 to study the pictures in the royal collections. His subsequent work shows the influence of Rubens, van Dyck and Velazquez. He spent the rest of his life in Seville, where he had many assistants and followers.

Lit. Diego Angulo Iñiguez, *Murillo*, Madrid, 1981.

112 ST FRANCIS RECEIVING THE STIGMATA
Inscribed in white with fleur-de-lis and inventory no.*637*.
Canvas, 22$\frac{1}{8}$ × 19 (56·3 × 48·2)

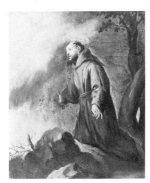

112 WM 1605–1948 Neg. H1523
Wellington *Cat.*, p.138, no.68 black

St Francis received the stigmata on Mount Alverna in 1224. A seraph appeared to him; between its wings he could see Christ on the cross and he then received the marks of wounds on his hands and feet and at his side. This is traditionally the most important event in the Saint's life and it was frequently depicted, particularly in Italian art, from the 13th century. The iconography is fairly standard from the time of the fresco cycle in the Upper Church at Assisi: St Francis kneels at the hillside, the palms of his hands upturned to receive the stigmata, in the form of rays of light emanating from the figure of Christ within the seraph (see B. Kleinschmidt, *S. Franziskus von Assisi in Kunst und Legende*, 1911, p.92–101).

This painting is a broadly executed oil sketch of a kind unusual in the oeuvre of Murillo and it has therefore not always been accepted as autograph. Acquired as Murillo by Isabella Farnese, it is recorded as hanging in her palace at La Granja in 1746. Ponz (1787) also saw it there but he described it as 'in the style of Murillo'. In the 19th-century it was published as autograph by Stirling Maxwell (1848), on whose authority it found its way into Champlin's and Bryan's dictionaries. It was then ignored by subsequent authorities such as C.B. Curtis and A.L. Mayer, but it has recently been firmly reinstated by Diego Angulo (1974 and 1981) who published a closely related drawing by Murillo in the Alcubierre Collection, Madrid, and dated the painting *c.*1650. The drawing shows the Saint in a slightly more frontal

position but is otherwise very similar – even the curious deformation of the right hand has its source in the drawing – and Angulo is in no doubt that both drawing and oil painting are autograph works. A related, though reversed, composition formerly attributed to Murillo is in the Capuchins' church in Cadiz (A.L. Mayer, *Murillo*, K.d.K., 1913, pl.239).

Condition. Paint surface much worn, but otherwise reasonably good. Cleaned in 1949–50.
Prov. Isabella Farnese collection, La Granja (fleur-de-lis mark; La Granja inventories 1746 and 1774, no.637). Captured at Vitoria, 1813.
Lit. Ponz, *Viage*, x, 1787, p.151: Stirling, *Annals*, iii, 1848, p.1436; J.D. Champlin, *Cyclopedia of Painters and Painting*, 1888, iii, p.317; Bryan's *Dictionary of Painters and Engravers*, ii, 1889, p.190; D. Angulo, 'Algunos dibujos de Murillo', *Archivo Español de Arte*, 47, 1974 p.105 (cf. fig 19); J.A. Gaya Nuño, *L'Opera completa di Munillo*, Milano, 1978, no.84; Angulo *Munullo*, 1981, ii p.250, no.302, pl.56.

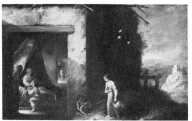

113 WM 1652–1948 Neg. J946
Wellington *Cat.* p.143, no.253 black

113 ISAAC BLESSING JACOB (Genesis xxvii, 18–29)
Canvas, $35\frac{3}{4} \times 61\frac{1}{4}$ (91 × 155)

The action takes place in the room of a humble cottage, from which a figure in a further room is visible through an open door. Half the composition consists of landscape with a women holding a laundry basket, approaching the cottage, in the centre.

Evelyn Wellington identified this picture with one of three paintings of this subject by Luca Giordano recorded in the 1772 Royal Palace inventory (no.955) but not now in the Prado. Yet it was listed as Murillo in the Wellington heirloom catalogue (1841) and there is no firm evidence for the identification with Luca Giordano. Indeed, WM 1652 is closely related to Murillo's *Isaac blessing Jacob* in the Hermitage, Leningrad (Gaya Nuño, 1978, no.204) This is one of a series of four large paintings of the life of Jacob for which, according to Palomino, Ignacio Iriarte was to have painted the landscape, but after an argument as to who should paint first, Murillo decided to do the landscape himself (this story is discussed by Gaya Nuño, *loc. cit.*). Be that as it may, such extensive landscapes are rare in Murillo's work. The Hermitage picture has a very similar composition to WM 1652, though reversed with the cottage on the right. However, WM 1562 is coarser and more sketchy in execution, and it has not always been accepted as autograph in the standard reference books (Mayer, K.d.K., 1913, not mentioned; Gaya Nuño, 1978, listed under 'other works attributed to Murillo'; Angulo, 1981, 'not completely sure that this is by Murillo'). There is a similarly treated landscape in the Prado (*Catálogo de las Pinturas*, 1972, no.3008, as Murillo) but this is not widely accepted as autograph either (Gaya Nuño, no.339). Nevertheless, in view of the close compositional relationship of WM 1652 to the Leningrad picture, the attribution to Murillo should be allowed to stand, even though there are no precise parallels to the treatment of the landscape in his work.

Isaac blessing Jacob was a popular subject in 17th-century painting in both Italy and the Netherlands, and the central group of Isaac sitting up in bed, blessing Jacob and feeling his hand while Rebecca stands to the side, is fairly standard. Murillo's composition is unusual in making the main group of figures a subsidiary part of the whole, rather than showing them in close view as was customary.

Condition. Small paint losses in upper right part of the room, on the dark wall and elsewhere; otherwise good.
Prov. Spanish royal collection (not inv.); captured at Vitoria, 1813.
Lit. Stirling, *Annals*, 1848, iii, p.1415 (Murillo); Curtis, *Velazquez and Murillo*, 1883, p.118, no.5 (Murillo); *Paintings at Apsley House*, 1965, pl.19; T. Crombie, *Apollo*, 1973, p.214, figs.11–12 (Murillo); Herder's *Lexikon der Christlichen Ikonographie*, ii,

1974, col.373; J.A. Gaya Nuño, *L'opera completa di Murillo*, 1978, no.333; Angulo, *Murillo*, iii, p.102, no.91, pl.168.

Ascribed to MURILLO

114 AN UNKNOWN MAN
Canvas, 47⅝ × 39 (121 × 99)

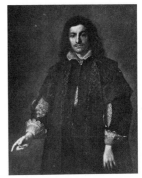

114 WM 1546–1948 Neg. L1397
Wellington *Cat.*, p.54, no.189 red

Shown three-quarter length, the sitter is wearing a sleeved waistcoat of yellow brocaded silk, a black cloth doublet partly unbottoned to show the waistcoat, and a sleeveless surcoat, black, with black brocade turned-back lining.

This is one of the few Spanish paintings at Apsley House to have been bought by the Duke of Wellington. It did not, therefore, derive from the Spanish royal collection and the attribution to Murillo has been questioned, most recently by Diego Angulo Iñiguez (1981). However, it was accepted in the catalogues of both Mayer, 1913 ('a certain work by Murillo') and Gaya Nuño, 1978 ('A splendid portrait, painted by Murillo with simplicity and elegance... the most European of 17th-century Spanish paintings'). A date in the mid 1650s, suggested by the costume, is accepted by all authorities and, in style and costume, the picture can be compared with the portrait of the Marquis of Legarda at Vitoria (Gaya Nuño, no.60).

Condition. Tear on right from sitter's hair down to his hand, ground visible round hair; otherwise good. Cleaned by J. Hell in 1951.
*Prov. c.*1800 Lord Cremorne (who was said to have bought it from 'a reduced Spanish gentleman', letter from Mrs Hicks to the Duke of Wellington, 10 Aug. 1838); Mrs Hicks (great-niece of Lord Cremorne), 1838; bought by Messrs Yates and Son for the Duke of Wellington, 1838, for £126.
Exh. B.I., *Old Masters,* 1837 (60); Grafton Galleries, *Spanish Old Masters,* 1913–14 (140).
Lit. Curtis, *Velazquez and Murillo,* p.301, no. 476u (listed only, without comment); A.L. Mayer, *Murillo,* K. d. K., 1913, p.223, repr.; *Paintings at Apsley House,* 1965, pl.18; T. Crombie, *Apollo,* 1973, p.215, fig.14; Gaya Nuño, *Murillo,* 1978, no.56; Angulo, *Murillo,* ii, p.583, no.2, 682 (not Spanish, perhaps Flemish).

François Joseph NAVEZ (1787–1869)
Belgian School

Born in Charleroi, he was a pupil of J.L. David in Paris, 1813–16, and then lived in Rome as a student of the Brussels Academy, 1817–21. In 1822 he settled in Brussels, painting mainly portraits, and became director of the Academy in 1835.

Lit. F. Maret, *François-Joseph Navez,* Brussels, 1962.

115 WILLIAM I, KING OF HOLLAND (1772–1843)
Signed lower right *F.J. NAVEZ, 1823*
Canvas, 84¾ × 63½ (215 × 161)

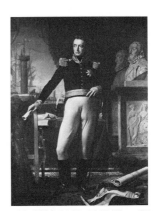

115 WM 1463–1948 Neg. P1409
Wellington *Cat.*, p.310, no.5 red

Full-length, life-size, aged about 50. He wears uniform: a dark coatee with red facings embroidered with gold, gold epaulettes, a yellow sash round his waist, white breeches and high black boots with spurs. On his chest is the star of the Military Order of William. To the right are two busts.

William Frederick, son of William IV, Prince of Orange, commanded the Dutch army during the French invasion of 1793. He served in the Prussian and Austrian armies against the French, distinguishing himself at Jena and Wagram, and, after an insurrection in his favour in 1813, was proclaimed Sovereign Prince of Holland. In 1815 he became King of the Netherlands, combining Holland and Belgium, but the union only lasted until 1830 when Belgium achieved independence. In 1840 he abdicated in favour of his son.

To identify the two busts on the right, it is logical to look among King

William's illustrious ancestors: the venerable tradition of relating sitter and bust in such portraits is discussed under Leslie's Wellington, no.97 above. In this instance the first bust can hardly represent anyone other than William the Silent (1533–84), founder of the royal Orange dynasty and hero of the Dutch war of independence. A date *c.*1580 is suggested by the costume, and the facial features may be compared, for example, with the engraving of William by William Jacobsz Delff after Adriaen van de Venne (E.A. van Beresteyn, *Iconographie van Prins Willem I van Oranje*, 1933, fig.14). The problem arises with the second bust, showing identical costume and similar features to the first. William the Silent's son and successor Maurits (1567–1625) might be a candidate (cf. the engraving by Delff after Miereveld) but the costume hardly fits his dates. It appears also that the artist has repeated the insignia of the Golden Fleece, clearly visible on the first bust, on the second, in which case Maurits can be excluded, and the likelihood remains that the second bust also represents William (opinion of Drs W.H. Vroom, Department of Dutch History, Rijksmuseum). The choice of William the Silent as a parallel for King William I is obvious, but the reason for showing two busts of him remains obscure.

Condition. Pronounced craquelure, showing pale ground beneath in places.
Prov. Presented to the Duke of Wellington by William I of Holland in 1824 (letter dated February 24, 1824, from the Baron de Nazelle in Wellington archive).
Lit. Waagen, *Treasures*, ii, p.277.

Aert van der NEER (1603/04–1677)
Dutch School
He appears to have lived in Gorkum before he moved to Amsterdam. His earliest dated picture is of 1635, by which time he was probably already in Amsterdam, where he lived until he died, in poverty, in 1677. Moonlit landscapes and winter scenes form the bulk of his production.

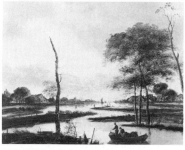

116 WM 1576–1948 Neg. H1520
Wellington *Cat.*, p.128, no.22 red

116 RIVER VIEW: EVENING
Signed left foreground *AV DN* (two monograms); inscribed in white with inventory no. lower right: *345.*
Canvas, $18\frac{3}{4} \times 24\frac{1}{4}$ (47·5×61·5)

In medieval and renaissance art such a prominent contrast between the leafless and the blooming tree could be taken as a symbol of sin and redemption (*Reallexikon zur deutschen Kunstgeschichte*, ii, 1948, col.63ff.; MR. Bennett, 'The Legend of the Green tree and the Dry', *Archaeological Journal*, 83, 1929, p.21ff.). Yet although this symbol survived in 17th-century emblem books (e.g. Nicolaus Taurellus, 1602, see A. Henkel, A. Schöne, *Emblemata, Handbuch der Sinnbildkunst des 16. und 17. Jahrhunderts*, 1967, col.176) there is no evidence to support such an interpretation in van der Neer's landscapes.

Condition. Surface very worn and damaged generally.
Prov. Spanish royal collection (not inv.); captured at Vitoria, 1813.
Lit. H. de G., vii, 1923, no.57.

Eglon Hendrik van der NEER (1634(?)–1703)
Dutch School
Son and pupil of Aert van der Neer, he was born in Amsterdam and worked mainly in Rotterdam (until 1679), Brussels (1679–89) and Düsseldorf (1690–1703) where he was court painter to the Elector Palatine, Johann Wilhelm. He painted mainy genre scenes.

117 BOYS WITH A TRAPPED BIRD

Signed on base of birdcage *E. van der Neer.* Inscribed in white with fleur-de-lis and inventory no.*20.*

Oak panel, 10×8 (25·5×20·4)

The birdcage is open; one bird is sitting on top of it, another has been caught by one of the boys below. Such pictures prominently figuring birds are to be interpreted on two levels: as the genre scenes they depict, and for their more hidden meaning in which the bird is a symbol of love in one or other of its manifestations (E. de Jongh, 'Erotica in Vogelperspectief', *Simiolus,* 3, 1968-9, pp.22-74). Birds in cages can symbolize either love as imprisoning men and women, or as maidenhood which is shown as lost when the bird has flown. There are examples of both interpretations in the 17th-century Dutch paintings by Jan Steen (Leiden), Willem van Mieris (Hamburg), Pieter van Noort (Zwolle) and Pieter de Hooch (Cologne) (De Jongh, figs.19, 21, 23-4). This particular example is closest to representations of Cupid as a birdcatcher in 17th-century emblem books. In Daniel Heinsius, *Emblemata Amatoria,* 1608, no.21, under the Petrarchan heading *Perch'io stesso mi strinsi,* (Because I bound myself), Cupid watches while the bird he had helped to bind flies into its cage (reprint, Scolar Press, 1973, no.21; de Jongh, fig.20; A. Henkel and A. Schöne, *Emblemata, Handbuch zur Sinnbildkunst des XVI und XVII Jahrhunderts,* Stuttgart, 1967, 756, repr. a slightly different version from Heinsius, *Het Ambacht van Cupido,* 1615, no.46). The birdcage hanging from the tree reappears in identical form in Van der Neer's painting and the composition as a whole is clearly linked with the emblem. Cupid as a birdcatcher also occurs in another emblem book, Crispyn de Passe, *Thronus Cupidus,* Amsterdam 1620, no.2 (Henkel-Schöne, 757).

Eglon van der Neer usually painted scenes of elegant genre and only rarely pictures of children (H. de G., nos. 111–19). Comparable paintings of boys with a cat and/or birds are in the museums of Karlsruhe, Leningrad, Stockholm, (dated 1664) and Schwerin (dated 1679).

The composition of WM 1587 must have proved popular; there are two versions, one in the Earl of Portland's collection (H. de G., no.119; Goulding, 1936, no.524), the other in the Castle Museum, Nottingham, both without the cage. The central figures were engraved in reverse in 1768 by William Walker (Boydell's *Catalogue of Historical Prints,* 1787, ii, no.32, as by Netscher).

Prov. Isabella Farnese collection, La Granja (fleur-de-lis mark); La Granja inventories 1746 and 1774, no.20. Captured at Vitoria, 1813.

Lit. H. de G., v, no.114; R.W. Goulding, *Catalogue of the Pictures belonging to... the Duke of Portland,* 1936, p.211; Gaya Nuño, *Pintura Europea,* no.198.

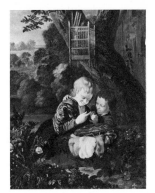

117 WM 1587–1948 Neg. K716
Wellington *Cat.,* p.150, no.40 black

NETHERLANDISH School, 1596

118 SELF-PORTRAIT OF AN UNKNOWN PAINTER

Dated above sitter's ear on right *1596;* inscribed in white with inventory no.*359*

Canvas, 21¼×16¼ (54×41·3)

The sitter, who appears to be in his thirties, holds a palette and brushes. He was identified as 'T.H. Zucchero' in Seguier's list and as the Dutchman Cornelis Ketel (1548-1609) in the Wellington *Catalogue.* The attribution to Taddeo Zuccaro can be excluded as he died in 1566, thirty years before this picture was painted, but it is of interest in showing that this was thought to be an Italian work. The attribution to Ketel was not accepted by Stechow (1927) and it does not bear close examination. The portrait is not similar to the engraving of Ketel in van Mander's *Schilderboek* (reprint of 1617 ed. with German translation, 1906, ii, p.171; for a list of other portraits of Ketel see H.

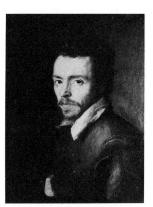

118 WM 1628–1948 Neg. HA3466
Wellington *Cat.,* p.62, no.117 black

van Hall, *Portretten van Nederlands Beeldende Kunstenaars,* 1963, p.166), and in any case the dates do not fit. WM 1628 is dated 1596, at which date Ketel was 48, but the sitter looks appreciably younger. The engraving of Ketel in van Mander shows a much older looking man in the costume of the 1590s than the one appearing in the Wellington picture, which has most recently been described as 'Anonymous, Flemish(?)', with the proviso that 'the possibility that it is Italian cannot... be excluded' (Delft-Antwerp exhibition, 1964). Comparable Italian self-portraits are reproduced by M. Masciotta, *Autoritratti,* Milano, 1955 (pls 41ff., esp. pl.66), but a Netherlandish origin remains most likely.

As a result of the improved status of the artist, there was a rapid increase in numbers of self-portraits produced for collectors in the second half of the 16th century. WM 1628 is typical of them in showing the artist with his palette and brushes, the insignia of his craft (for recent discussions and bibliographies, see the catalogues of the exhibition at the Hamburg Kunsthalle, *Das Bild des Künstlers,* 1978, and at the Herzog Anton Ulrich-Museum, Brunswick, *Selbstbildnisse und Künstlerporträts,* 1980).

Prov. Spanish royal collection (not inv.); captured at Vitoria, 1813.
Exh. Delft, Stedelijk Museum, and Antwerp Museum, *De Schilder in Zijn Wereld,* 1964–5 (2).
Lit. W. Stechow in Thieme, Becker, 20, 1927, p.219.

Caspar NETSCHER (1635/6–84)
Dutch School
Born in Prague, he was a pupil of Gerard ter Borch at Deventer in 1655 and settled at the Hague in 1662. He specialized in portraits of the aristocracy and, until the later 1660s, also painted genre scenes of upper-class life somewhat in the manner of ter Borch and Metsu.

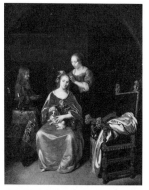

119 WM 1523–1948 Neg. K717
Wellington *Cat.,* p.44 no.87 red

119 A LADY AT HER TOILET
Signed lower right *G Netscher f*
Oak panel, $17\frac{1}{2} \times 14$ ($44 \cdot 5 \times 35 \cdot 5$)

A maid is arranging the ribbons in the lady's hair, while a page is bringing a salver on which are a round silver vessel and a spoon.

This is a version of a composition by Netscher at Dresden, dated 1665, and it was probably painted at about the same time. The Dresden picture is identical in composition and size and differs only in the expression of the lady. H. de Groot records another replica in the sale of Ch. Meigh, 20 June 1850, bought by Nieuwenhuys.

Condition. Generally good apart from a few slight abrasions; cleaned by Vallance in 1951.
Prov. Lapeyrière sale, April 1817 (lot 36), bought by Bonnemaison for the Duke of Wellington for 901 fr. (£36).
Exh. B.I., *Old Masters,* 1819 (28).
Lit. Smith, *Cat. Rais.,* iv, p.164, no.67; Waagen, *Treasures,* ii, p.277 ('an excellent picture... of his earlier period'); H. de G. v, p.179, no.90 (a replica by the artist).

Adriaen van OSTADE (1610–85)
Dutch (Haarlem) School
Adriaen van Ostade, the elder brother of Isack, was born in 1610 in Haarlem, where he spent most of his life. According to Houbraken he was a pupil of Hals at the same time as Adriaen Brouwer (*c.*1626–27), but there is no other evidence for this. He entered the Haarlem guild in 1634, and became its dean in 1662. Influenced by Brouwer, and from 1640 by Rembrandt's chiaroscuro, he painted mainly peasant genre scenes, of which he also made some fifty etchings.

120 THE COURTYARD OF AN INN WITH A GAME OF SHUFFLEBOARD
Signed in bowling alley on left *A v Ostade 1677*
Oak panel, 13¼ × 18½ (33·7 × 47)

Shuffleboard, or more correctly shovelboard, is a game known since the early 16th-century, in which a coin or other disk is driven by a blow from the hand along a highly polished floor or table. The table at which the two men are playing appears to have been about 5m. long, placed under a specially constructed shelter in the courtyard. Adriaen van Ostade frequently included board games, bowls and skittles in scenes of this kind, but this detailed representation of shuffleboard is unusual.

There are four closely related drawings: (1) British Museum, water-colour, dated 1677 (no.1847–3–26–6; 25·8 × 38); (2) Rijksmuseum, Amsterdam, pen and ink and wash (25 × 37·6cm.; exh. *La Vie en Hollande au XVIIe siecle*, Musée des Arts Decoratifs, Paris, 1967, no.105, pl.34); (3) Teylers Museum, Haarlem, pen and ink and wash (25·5 × 37·5cm.). These three drawings are identical in composition, but the water-colour is closest to the oil painting in its more detailed delineation, particularly of faces and costume, and it presumably represents the final preparatory stage. The painting differs in composition only in very minor details; the dog, for example, standing near the bench on the left in all three drawings has been omitted in the finished painting. The fourth drawing, more doubtfully autograph but including the dog and therefore linked with the drawings rather than with the painting, is also in the British Museum (pen and wash; 1895–9–15–1235, 'attributed to A.v.O.', 25 × 37·5cm.).

Prov. Duc de Choiseul (engraved in the Choiseul Gallery, no.17) sale, Paris, April 1772; Prince de Conti sale, Paris, 8 April 1777; Chevalier Lambert sale, Paris, 27 March 1787; Coclers sale, Paris, Feb. 1789; Smeth van Alphen sale, Amsterdam, 1–2 Aug. 1810, lot 72; H. Croese sale, Amsterdam, 18 Sept. 1811, lot 61; Lapeyrière sale, 14 April 1817, lot 38, bought for 5450 fr. (£218) by Bonnemaison for the Duke of Wellington.
Exh. B.I., *Old Masters*, 1818 (68); 1845 (41); R.A., Winter Exhibition, 1886 (101); Whitechapel Art Gallery, 1904 (352); R.A., *Dutch Art*, 1929 (214); V. & A., 1947 (10); Arts Council, 1949 (6).
Lit. Charles Blanc, *Le Trésor de la Curiosité tiré des catalogues de vente*, Paris, 1857–8, i, pp.194, 379, ii, pp.112, 332; Smith, *Cat. Rais.*, i, p.124, par.62; Waagen, *Treasures*, ii, p.274; H. de G., iii, no.856; *Paintings at Apsley House*, 1965, pl.28.

Alessandro Varotari, Il PADOVANINO (1588–1648)
Venetian School
Born in Padua, he settled in Venice in 1614 and received many commissions for frescoes in Venetian churches. His style is based on early Titian, something of an anachronism in 17th century Venice, but he helped to pass on the colouristic tradition of the 'great period' to Venetian artists of the 17th century.

Ascribed to PADOVANINO

121 ORPHEUS ENCHANTING THE ANIMALS (Ovid, *Metamorphoses*, Book XI, Chapter I)
Canvas, 59 × 45 (143 × 111)

In its colours – in particular the deep red of the cloth and the pale reddish sky – its soft handling and coarse herring-bone canvas, this is a Titianesque picture; indeed, it was attributed to Titian in the Wellington collection in the 19th-century. Its history is complicated by the fact that there is another, almost identical, version in the Prado (no.266; 165 × 108cm.) which was in the collection of Isabella Farnese, Queen of Spain. The Prado picture has fewer animals – it does not contain the dog on the left, which is very like the

one in Titian's *Venus of Urbino* (Uffizi, Florence, *c.*1538. Tietze, *Titian,* fig.107) – or the birds which appear at the top of the Apsley painting. A third version, closer to the latter in that it contains the dog and the birds, was formerly in the Horny collection, Vienna, where it was attributed to Titian (W. Suida, *Tiziano,* 1938, p.158, pl.118; 153×104cm.). However, the Prado picture has long been catalogued as by Padovanino and already in 1877 Crowe and Cavalcaselle recognized that this is a reasonable attribution for the Apsley House painting. Apart from general stylistic similarities, a close comparison can be made with the *Three Graces* attributed to Padovanino in the Bucharest Museum (Kauffmann, 1973, fig.3) which contains a bird similar to those in the Apsley *Orpheus* and, like them, probably derived from Netherlandish naturalism of the Jan Brueghel period, *c.*1600. Padovanino has remained a somewhat shadowy figure and the attribution to him has not found universal acceptance (Wethey, 1975) but it remains plausible.

The figure of Orpheus himself is derived not from Titian but from a figure of Apollo playing the lyre in a musical contest with Marsyas in a North Italian painting of *c.*1530 in the Hermitage (Tietze and Tietze-Conrat, 1936). The artist's immediate source was probably an engraving dated 1562 by the Venetian Giulio Sanuto after the Hermitage painting (Kauffmann, figs.4, 5). A.E. Popham suggested that the ultimate source of the figure lies in one of the *Ignudi* in Michelangelo's Sistine chapel ceiling (A.E. Popham, *Correggio's Drawings,* 1957, pp.21–7).

Orpheus enchanting the animals was frequently depicted in the time of the Roman empire, when Orphism was a popular religion (Kauffmann, fig.6) and it remained common in the Early Christian period when Orpheus, with his power of ending discord with music and eloquence, became the principal model for the representation of Christ. Relatively rare between the 6th and 14th-centuries, the scene owed its revival in the pictorial arts to the writings of Christian commentators who interpreted pagan myths in Christian terms. In the *Ovide Moralisé* (*c.*1300) Orpheus is again interpreted as Christ and his song represents the preaching of the divine word by which the souls of men are drawn away from damnation. The modern tradition of representing the scene began with the illustrated *Ovide Moralisé* manuscripts of the 14th-century, and it is at this period that the animals and birds to be found in the Wellington picture – including the lion and the unicorn – first appear (Kauffmann, fig.7). The unicorn has no textual basis in the Orpheus story, but it was known as the traditional enemy of the lion. The appearance of the two animals side by side in the context of Orpheus is due to the traditional hostility between them and strikingly illustrates the power of Orpheus to enchant the wildest animals and to reconcile the deepest foes. For the same reason, the two are often shown together in scenes of Paradise or of the Creation of the animals.

Condition. The canvas appears to have been cut at the bottom, which may account for the fact that the painting is shorter than the Prado version. There is some general wearing, especially in the dark areas, and an old tear in the canvas 20cm. from the top edge downwards, near the top right corner.

Prov. Spanish royal collection, perhaps to be identified with the painting attributed to Titian (2×1½ vara, equivalent to 168×126cm.) in the early inventories: Royal Palace, Madrid (Alcazar) 1666 inventory, no.692; 1686 inventory, no.865; 1701 inventory, no.487 (the Wellington *Catalogue* attribution to Bassano is due to a confusion with a picture of the same subject by Bassano listed in this inventory and elsewhere). 1734 inventory, pictures saved from the fire in the Alcazar, no.24. (The Prado version is listed in the 1746 La Granja inventory, and was probably acquired by Isabella Farnese.) Captured at Vitoria, 1813.

Lit. J.A. Crowe and G.B. Cavalcaselle, *Titian, his life and times,* ii, 1877, p.461 (Padovanino); Perez Sanchez, *Pintura Italiana,* p.561 (Padovanino); C.M. Kauffmann, 'Orpheus: the Lion and the Unicorn', *Apollo,* 98, 1973, pp.34–8; H.E. Wethey, *The Paintings of Titian,* iii, 1975, p.218, no.X–31 (version 1), pl.232

(Venetian School, *c*.1575). For the composition and the Prado picture see also: A. Venturi, *Studi dal Vero*, 1927, p.281ff. (Titian); H. Tietze and E. Tietze-Conrat, 'Tizian Studien', *Jahrbuch der Kunsthistorischen Sammlungen in Wien*, x, 1936, p.144f.; Thieme, Becker, 34, p.116 (Padovanino); C. Donzelli and G.M. Pilo, *I Pittori del Seicento Veneto*, 1967, p.308 (Padovanino).

Giovanni Paolo PANINI (or Pannini) (1691/2–1765?)
Italian School
Born in Piacenza, from 1711 he worked under Luti in Rome. He did much decorative painting of Roman villas and palaces, and many commissions for the Cardinal de Polignac. He is one of the best-known painters of classical ruins.

Lit. F. Arisi, *Gian Paolo Panini*, 1961.

122 A FESTIVAL IN THE PIAZZA DI SPAGNA, ROME, 1727
Signed on enclosure of wine fountain *I.P. Panini Placentus Romae 1727*
Canvas, $18\frac{1}{8} \times 39\frac{3}{8}$ (46 × 100)

122 WM 1641–1948 Neg. GD1226
Wellington *Cat.*, p.217, no.145 black

This painting was commissioned by Cardinal Cornelio Bentivoglio, Spanish ambassador in Rome, to record the festivities celebrating the birth of the Infanta on 23 September 1727, which took place outside the embassy in the Piazza di Spagna (Arisi, 1961). The Spanish embassy on the far side of the square is decorated with two coats of arms, presumably those of Spain and of the Cardinal ambassador, Cornelio Bentivoglio, though they are insufficiently clear to be firmly identified. On the left, the artificially constructed rock may be identified from the inscription on a print by Filippo Vasconi (*Settecento a Roma*, exh., 1959, no.1814) as the 'macchina per fuoco artificiato' (artificial fire machine) designed by the painter Sebastiano Conca. On it, Thetis is consigning her infant son Achilles to the centaur Chiron to instruct him and to direct him to the Temple of Glory above. The allegory is clearly of the Kingdom of Spain and the youngest member of its royal family.

In the left foreground of the picture, a small crowd is gathering round the wine fountain. This was a common feature on such occasions; an infallible method of persuading large numbers of citizens to join in the festivities of the great (Arisi, 1961). The procession of carriages is headed by a gilt one with a cardinal, presumably Cardinal Bentivoglio himself.

This is the earliest dated painting by Panini. The precise and detailed delineation of the architecture contrasts with the broad, sketchy treatment of the figures. Influenced by Vanvitelli (1653–1736), this early work by Panini may be seen as a precursor of Canaletto's (1697–1768) town views.

Condition. Some wearing in sky, otherwise good. Cleaned by S. Isepp in 1950.
Prov. Spanish royal collection (not inv.); captured at Vitoria, 1813.
Exh. First Magnasco Society exh., Agnews, Nov. 1924 (19) (see O. Sitwell, *Apollo*, 79, 1964, p.381); Rome, *Il Settecento a Roma*, 1959 (408).
Lit. H. Voss, *Malerei des Barock in Rom*, 1924, p.633; W. Gaunt, *Rome past and present*, 1926, pl.66; M. Labo, in Thieme, Becker, 26, 1932, p.201; F. Arisi, *Gian Paolo Panini*, 1961, pp.92, 133, no.66, fig.112-3; Mario Praz, 'Piazza di Spagna', *L'Oeil*, Jan. 1963, p.37 (repr.).

123 ST PAUL AT MALTA, GRASPING THE VIPER
Signed on top stone of the base of the pedestal, right, *I.P.P. 1735*
Canvas, 30 × 25 (76·2 × 63·5)

Companion piece to WM 1505: *St Paul at Athens*.

After suffering shipwreck on the way to Rome, St Paul landed on the Island of Melita (Malta) and on lighting a fire 'there came a viper out of the heat, and fastened on his hand... And he shook off the beast into the fire and felt no harm' (Acts xxviii, 3-6). This subject, though commonly depicted in

123 WM 1502–1948 Neg. HA161
Wellington *Cat.*, p.178, no.59 red

the 17th-century, is relatively rare in the 18th. Panini uses it to people a typical composition of classical ruins. This is a replica with variations, including the addition of the statue of Hercules on the right, of a painting in the possession of Carlo Sestieri (73×61, dated 1731, Arisi, no.88, fig.140) and there are two preparatory drawings for figures in the foreground in the Berlin Kupferstichkabinett (no.17542, figure leaning against pillar, centre foreground: no.17556, young man right foreground).

Condition. Pronounced craquelure; tear with attendant paint loss on plinth of column on right, repaired 1981.
Prov. Le Rouge sale, Paris, April 1818, lot 41, bought for the Duke of Wellington by Féréol Bonnemaison for 701 fr. (£28) the pair.
Lit. H. Voss, *Malerei des Barock in Rom*, 1924, p.633 (Panini); M. Labo in Thieme, Becker, 26, 1932, p.201; Arisi, *Panini*, 1961, p.149, no.103.

124 WM 1505–1948 Neg. G1224
Wellington *Cat.*, p.179, no.62 red

124 St Paul preaching at Athens
Signed on fragment of column, centre foreground *I.P.P. 1737*
Canvas, 29⅞×25⅛ (76×63·7)

Companion piece to WM 1502: *St Paul at Malta.*
 'Then Paul stood in the midst of Mars' hill, and said, Ye men of Athens, I perceive that in all things you are too superstitious...' (Acts xvii, 22–31). Nearly all compositions of this theme were influenced by the Raphael Cartoon (V&A), though Panini's is a more independent rendering than most. For example, a comparable near-contemporary painting, Sebastiano Ricci's at Toledo, Ohio (J. Daniels, *Sebastiano Ricci*, 1976, no.420, fig.133, dated 1713) is much closer to the Raphael Cartoon.
 This is a replica, with variations, of a painting in the collection of Carlo Sestieri (73×61, dated 1731, Arisi, no.87, fig.143). It is curious that it was painted in 1737 whereas its pendant is clearly dated 1735.

Prov. Same as WM 1502.
Lit. Same as WM 1502; Arisi, *Panini*, p.150, no.104.

PARMIGIANINO (1503–40)
Italian School
His name was Girolamo Francesco Maria Mazzola, called 'Il Parmigianino' from his place of birth, Parma. He was in Rome from about 1524 to 1527, and then in Bologna and from 1531 in Parma. Influenced by Correggio, Raphael and Michelangelo, he was one of the most brilliant exponents of Italian Mannerism.

Lit. S.J. Freedberg, *Parmigianino*, Harvard, 1950.

After PARMIGIANINO

125 WM 1601–1948 Neg. H890
Wellington *Cat.*, p.182, no.62 black

125 The mystic marriage of St Catherine
Inscribed in white with inventory no. 450
Canvas, 29¾×22½ (75·5×57)

Although this painting was in the Spanish royal collection as by Parmigianino, it is now generally accepted to be one of several early copies of what was clearly a very popular composition. The original (panel, 74×57cm.), which was in the Borghese Gallery, where it was engraved by Camillo Tinti in 1771 (Freedberg, fig.54), came to England before 1814 when it was engraved by J.S. Agar in the collection of W. Morland M.P., and was in the collection of successive earls of Normanton from 1832 until 1974 when it was acquired by the National Gallery (Christie's, 29 Nov. 1974, lot 40). It has been dated by Freedberg *c.*1525–6 in Parmigianino's Roman period, between the more Raphaelesque *Madonna* in the Galleria Doria Pamphili,

Rome and the more fully mannerist *Vision of St Jerome* in the National Gallery (1525–7).

WM 1601 is all but identical with the National Gallery *Mystic Marriage of St Catherine* in size and composition. However, it is slightly less free and fluid in treatment and there are points of difference in detail, for example St Catherine's dress is more firmly painted over the bosom, and Joseph's eye is more prominently shown. It remains close to the original in quality and feeling and is doubtless a 16th-century work: 'Una bella copia antica', in the words of Giovanni Copertini (1932).

Three other early copies were recorded in inventories of the 16th-17th centuries: (1) Parma, S. Giovanni Evangelista: a copy bequeathed in 1586; (2) Parma, Farnese collection, recorded in 1708 as a copy; (3) Palais Royale, Paris 1786, later Westminster collection until 1924. The latter, like the Wellington picture, laid claim to the status of original, but is generally considered inferior both to it and to the National Gallery painting (Freedberg, p.172–3). Freedberg lists a total of ten copies and the popularity of the composition is further attested by the numerous engravings, of which those by Bonasone (Freedberg, fig.53), Marcantonio school (Bartsch, xv, 511, Master of the Name of Jesus) and Camillo Tinti are the best known.

The Mystic Marriage of St Catherine is not based on an incident in the Saint's life and is not recorded in the early texts of the Golden Legend. The theme of St Catherine (martyred in 307) as the bride of Christ is first found in hymns of the 13th and 14th-centuries:

Sponsae Christi eximiae
Repraesentantur nuptiae
Katherinae

(quoted, with numerous other examples, by J. Sauer, 'Das Sposalizio der heiligen Katherina von Alexandrien', *Friedrich Schneider Festschrift*, Freiburg, 1906, p.343).

By this period Catherine was one of the most popular of female saints and also one of the principal representatives of the *Vita Contemplativa*, and the event symbolizes the mystical marriage of the Christian soul to the Saviour. It is represented in the arts occasionally in the 14th-century (Verona Museum, van Marle, *Italian Schools*, iv, fig.100) derived from the *sacra conversazione* (Virgin and Saints) type, and frequently in the 15th and 16th-century, particularly in Italy. Parmigianino follows the standard iconography for the main group but the dramatic juxtaposition of St Joseph and the wheel, upon which the Saint was tortured, in the foreground, is his own innovation. The popularity of his composition is shown not only by the numerous copies and engravings, but also from its impact on other artists. An etching by Schiavone, for example, is very closely based on the Parmigianino composition.

Condition. Some retouching on St Catherine's yellow robe above left hand; otherwise good.

Prov. Spanish royal coll., *c.*1755, Buen Retiro, Madrid (Ponz, vi, p.122, hanging in a corridor leading from the Oratory to the King's study); Royal Palace Madrid, 1794 inventory: hanging in the King's dressing room. Captured at Vitoria, 1813.

Exh. Birmingham Society of Arts, 1831.

Lit. Ponz, *Viage*, vi, 1782, p.122; G. Copertini, *Il Parmigianino*, Parma, 1932, i, p.78–9, pl.39; S.J. Freedberg, *Parmigianino*, Harvard, 1950, p.172–3; M. Fagiolo Dell'Arco, *Il Parmigianino*, Rome, 1970, p.262. C. Gould, N.G. *Sixteenth-century Italian Schools*, Addendum 1975.

Jean François-Pierre PEYRON (1744–1814)
French School

Born in Aix-en-Provence, he was a pupil of L.-J.-F. Lagrenée and settled in Rome 1775–82. He painted classical subjects much influenced by Poussin

and enjoyed considerable success in his early years. At the Salon of 1787 his *Death of Socrates* suffered in comparison with David's treatment of the same subject, and his career remained marred by the unequal rivalry with David.

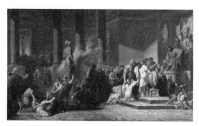

126 WM 1625–1948 Neg. Q1385
Wellington *Cat.*, p.380, no.108 red

126 ATHENIAN GIRLS DRAWING LOTS TO DETERMINE WHICH SEVEN AMONG THEM SHALL BE SENT TO CRETE FOR SACRIFICE TO THE MINOTAUR
Paper on Canvas, 22×39 (56×99)

According to Plutarch, Minos, King of Crete, exacted a tribute from the Athenians every nine years of seven youths and seven maidens to be devoured by the Minotaur, a monster, half man, half bull. Theseus eventually delivered his country from this tribute by destroying the monster. The picture represents the Athenian girls drawing lots as to who should be sent to Crete. In the centre, in front of the statue of Athena, Theseus stands and watches.

This is typical of the themes taken by neoclassical artists from Greco-Roman legend and history, though Peyron was one of the few to have painted this particular subject. According to the Wellington *Catalogue*, this painting was signed *J. Peyron 1778* on the lower step beneath the urn, but this signature is no longer visible, nor did it reappear when the picture was cleaned in 1951. However, the date 1778 is plausible, for one of the preparatory drawings is dated 1777 and according to Jacques Vilain (1974–5) the painting was exhibited at the Salon in 1783, though not listed in the *livret*. There are several ink drawings for this composition: (1) Sotheby's, 19 Nov. 1963, lot 35 (16·9×27cm.), showing the whole composition and very similar to the painting except that there are fewer figures in the background; (2) Musée Granet, Aix-en-Provence (48×62cm.; exh. *Le Néo-Classicisme Français*, Grand Palais, Paris, 1974–5, no.111 repr.) of the right half of the composition, showing only the group round the urn; (3) Montpellier Museum (no.837-1-1148, 26×40cm.) showing the left half of the composition; (4) Charles Le Blanc sale, 3–6 December 1866, lot 509, signed and dated *Roma 1777*.

After his return from Rome to Paris in 1783 Peyron received the prestigious commission from the Direction des Bâtiments du Roi to paint a large version of this picture for Versailles, but the scheme was subsequently abandoned. Peyron returned to the subject later in his career and exhibited a drawing of it at the Salon in 1798 (335). This drawing is apparently no longer extant, but it was engraved by Etienne Beison and shows an Egyptian rather than a Roman architectural background (Rosenblum, 1967, p.17, fig.13).

Condition. Areas of retouched damage along upper edge, otherwise good. Cleaned by S. Isepp in 1951.
Prov. Spanish royal collection (not inv.); captured at Vitoria, 1813.
Exh. R.A., *France in the 18th Century,* 1968 (557, repr.).
Lit. Gaya Nuño, *Pintura Europea...,* 1964, no.224; R. Rosenblum, *Transformations in late 18th century art,* 1967, p.17; J. Vilain in *Le Néo-Classicisme Français. Dessins des Musées de Provence,* Grand Palais, Paris, 1974–5, under no.111.

Jan Willem PIENEMAN (1779–1853)
Dutch School
Self-taught, he became a well-known portrait, history and landscape-painter. In 1820 he was director of the Amsterdam academy, and subsequently Josef Israels became his pupil. His *Battle of Waterloo,* now in the Rijksmuseum, for which the Apsley House portraits are preparatory sketches, is perhaps his best-known work.

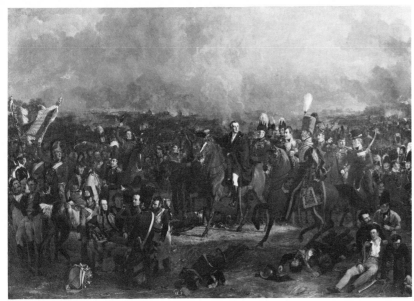

J.W. Pieneman, *The Battle of Waterloo* (57·6×83·6cm.), Courtesy of Rijksmuseum, Amsterdam.

127 MAJOR-GENERAL SIR FREDERICK CAVENDISH PONSONBY, K.C.B. (1783–1837) AND MAJOR-GENERAL SIR COLIN CAMPBELL, K.C.B., K.C.H. (1776–1847) (on the left)
Signed lower left *JWP/Apsly (sic) House/London/1821*
Paper on canvas, $20\frac{1}{4} \times 16\frac{1}{4}$ (51·4×41·2)

127 WM 1468–1948 Neg. P1469
Wellington *Cat.*, p.270, no.10 red

Sketches of heads only, on grey background.

Sir Frederick Ponsonby, son of the Earl of Bessborough, entered the army in 1800, went with his regiment to Spain as a major in 1809, and distinguished himself at Talavera. From 1811 he commanded the 12th Light Dragoons and took a leading part in the battles of Salamanca, Vitoria and Waterloo, where he lay wounded on the field all night. He was Governor of Malta 1825–35.

Sir Colin Cambell was engaged in Wellington's campaigns in India, 1801–5, and served with him in Hanover and Denmark in 1808 and thoughout the Peninsular campaign. He was on Wellington's staff at Waterloo, was promoted major-general in 1825 and governor of Ceylon 1839–47.

This is one of thirteen portrait sketches painted by Pieneman from life in 1821 in preparation for his large composition of the *Battle of Waterloo* (1824) now on permanent loan at the Rijksmuseum from the Dutch royal collection (for the other sketches see nos. 128–39).

In the finished painting, Campbell and Ponsonby are in the group to the right of the Duke of Wellington – Campbell third from the Duke and Ponsonby fifth – their heads in more or less the same positions as in the sketch.

The origin of this group of sketches is elucidated in correspondence between Pieneman, Lord Clancarty, the British Minister at Brussels and the Duke of Wellington in 1820 (Wellington archives). Pieneman planned to paint the Battle of Waterloo after the success of his picture of the Battle of Quatre Bras at the Brussels Exhibition and, taking the advice of Colonel F.E. Hervey in Brussels, wrote to Lord Clancarty with a view to showing his sketch to the Duke of Wellington. Clancarty suggested to the Duke that Pieneman should obtain sittings in London and the result of the

correspondence was his visit to London and the sketches in the collection, all dated 1821.

Other portraits of Ponsonby include a water-colour sketch by Thomas Heaphy in the N.P.G. (1914/10) and a full-length ascribed to the same artist, *c.*1819, in the Royal Lancers Officers' Mess, Market Harborough (Christie's, 29 July 1948, lot 2). There is also a marble bust, artist unknown, in the Wellington Museum.

Of Campbell, there is a profile caricature by Robert Dighton in the Scottish N.P.G. (2178) and a portrait as an older man by William Salter in the N.P.G. (3702) which is a sketch for Salter's *Waterloo Banquet*, 1836, Wellington coll., (Stratfield Saye).

Condition. Some buckling of the paper surface.
Prov. Bought by the Duke of Wellington, with twelve other sketches, from the artist in 1825 (a counterfoil in one of the Duke's chequebooks is inscribed: '1825, July 21. Mons. Pieneman £417, 18s. Payment for the pictures of the officers.').
Lit. Dictionary of British Portraiture, 2, pp.36, 173.

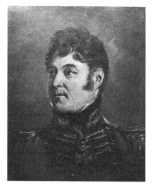

128 WM 1470–1948 Neg. P1471
Wellington *Cat.*, p.297, no.12 red

128 GENERAL SIR COLIN HALKETT, G.C.B., G.C.H. (1774–1856)
Signed on left *JWP/Apsly House/London/1821*
Paper on canvas, 21×9½ (30·4×24)

Sketch of head and shoulders on a dark background. He wears the Peninsular gold cross. Sir Colin Halkett was appointed lieut.-colonel of the King's German legion in 1803, having served in the Dutch foot-guards from 1792. He took part in campaigns in Denmark and Sweden in 1807–8 and in the Peninsular War, 1808–13, becoming a major-general in 1814. At Waterloo he commanded a British brigade and was severely wounded. He became a lieut.-general in 1830 and a general in 1841, having been commander-in-chief at Bombay, 1831–2.

This is one of thirteen portrait sketches painted by Pieneman from life for his large *Battle of Waterloo* (1824) now in the Rijksmuseum (see no.127 for the origin of the group). In the event, Halkett was not included in the finished picture.

Halkett is also depicted in William Salter's *Waterloo Banquet*, 1836, and there is a sketch of him for this painting in the N.P.G. (no.3720).

Prov. Bought by the Duke of Wellington, with twelve other sketches, from the artist in 1825 (see no.127).
Lit. Dictionary of British Portraiture, 2, p.97.

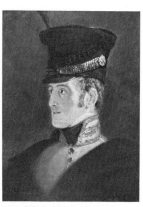

129 WM 1475–1948 Neg. H1514
Wellington *Cat.*, p.282, no.17 red

129 FIELD MARSHAL SIR JOHN COLBORNE, IST BARON SEATON G.C.B., G.C.H. (1778–1863)
Signed on left *JWP/Apsly House/London/1821*
Canvas, 25¼×20½ (64×52)

Sketch of head and shoulders on dark background. He wears a black shako with silver chin-strap resting on the peak, and the uniform of the 52nd Regiment.

Sir John Colborne, joined the army in 1794, served in Egypt in 1801, was military secretary to Sir John Moore in Sweden and Portugal in 1808–9 and then joined Wellington as a lieutenant-colonel in Spain. After Albuera he took command of the 52nd, one of the three famous regiments which formed the Light Brigade. At Waterloo, his charge played a major part in the defeat of Napoleon's Old Guard. Promoted major-general in 1825, he was lieutenant-governor of Upper Canada 1828–38. He was elevated to the peerage in 1839, commanded the forces in Ireland 1855–60 and was created field marshal on his retirement in 1860.

This is one of thirteen portrait sketches painted by Pieneman from life for his large *Battle of Waterloo* (1824) now in the Rijksmuseum (see no.127). In

the finished painting Seaton, with sword drawn, is at the far end of the group on the right of the Duke of Wellington. There are portraits of him as an older man by George Jones, 1860–3 (N.P.G., no.982b) and by W. Fisher 1862 (formerly United Services Club).

Prov. Bought by the Duke of Wellington, with twelve other sketches, from the artist in 1825 (see no.127).
Exh. National Portrait Exh., South Kensington, 1868 (201); *Victorian Exh.,* New Gallery, 1891–2 (91) – in both cases erroneously attributed to H.W. Pickersgill; *Pageant of Canada,* Ottawa, 1967–8 (258, repr.).
Lit. R. Ormond, N.P.G., *Early Victorian Portraits,* 1973, i, p.413; *Dictionary of British Portraiture,* 2, p.191.

130 LIEUT.-GENERAL SIR JOHN ELLEY K.C.B., K.C.H. (d.1839)
Signed on right *JWP/Apsly House/London/1821.*
Paper on canvas, 18¼ × 14¼ (46·3 × 36)

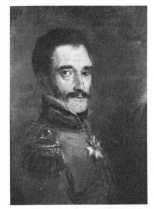

130 WM 1476–1948 Neg. Q1364
Wellington *Cat.,* p.269, no.18 red

Sketch of head and shoulders on dark background. He wears the scarlet uniform of a general, with blue collar and gold epaulettes and the cross of the Order of the Bath.

Sir John Elley joined the Royal Horse Guards in 1789, rose from the ranks to become acting adjutant during the campaign in Flanders in 1793–5 and purchased a lieutenancy in 1796. As assistant adjutant-general of cavalry, he served with distinction throughout the Peninsular War, 1808–13, and he was adjutant-general of cavalry at Waterloo. In 1835 he was returned to Parliament for Windsor as a supporter of Peel and became a lieut.-general in 1837.

This is one of thirteen portrait sketches painted by Pieneman from life for his *Battle of Waterloo* (1824) now in the Rijksmuseum (see no.127). In the finished painting, Elley is third in the row at the far right of the picture. He is wearing a hat and facing left instead of right as in the sketch.

Other portraits include a water-colour, showing him full length and in battle, by Thomas Heaphy, 1818 (private collection). He is also depicted in William Salter's *Waterloo Banquet,* 1836, and there is a sketch of him for this painting in the N.P.G. (no.3713).

Prov. Bought by the Duke of Wellington, with twelve other sketches, from the artist in 1825 (see no.127).
Lit. Dictionary of British Portraiture, 2, p.72.

131 GENERAL SIR GEORGE COOKE, K.C.B. (1768–1837)
Signed lower left *JWP/Apsly House/London/1821*
Paper on canvas, 26½ × 21 (42 × 53·3)

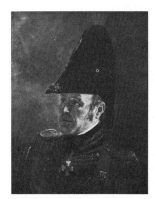

131 WM 1478–1948 Neg. P1399
Wellington *Cat.,* p.286, no.21 red

Sketch of head and shoulders on a light brown background. He wears the scarlet uniform with gold epaulettes and aiguillettes of a general, the star of the Bath and, from his neck, the cross of the same order.

Sir George Cooke entered the 1st Foot Guards in 1784, served in Flanders in 1794, in the Helder campaign in 1799 and in the Scheldt expedition 1809. He served in the Peninsular War 1811–13, was made major-general and commanded a division in the Netherlands in 1813–14. He was present at Quatre Bras and Waterloo, where he lost an arm.

This is one of thirteen portrait sketches painted by Pieneman from life for his large *Battle of Waterloo* (1824) now in the Rijksmuseum (see no.127). In the finished picture Cooke is shown next to Wellington, on the right.

Prov. Bought by the Duke of Wellington, with twelve other sketches, from the artist in 1825 (see no.127).
Lit. Dictionary of British Portraiture, 2, p.50.

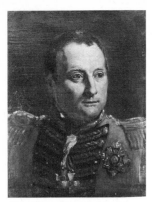

132 WM 1479–1948 Neg. Q1382
Wellington *Cat.*, p.275, no.22 red

132 GENERAL ROWLAND HILL, VISCOUNT HILL, G.C.B., G.C.H. (1772–1842)
Signed on left *JWP/Apsly House/London/1821*
Canvas, 19×15 (48·4×38)

Sketch of head and shoulders, nearly life-size, on a dark brown background. He wears the uniform of a general with gold epaulettes. On his breast is the star of the Grand Cross of the Bath and from his neck hang the badges of the Orders of Marie Theresa of Austria and St George of Russia.

Rowland Hill joined the 38th Foot in 1790, took leave to study at the military school in Strasbourg and took part in the expedition to Toulon as a captain in 1793. He served at Gibraltar and Minorca, 1796–9, Egypt, 1801–2, Ireland, 1803–5 and Hanover, 1805; and throughout the Peninsular campaign 1808–13 as a divisional commander. M.P. for Shrewsbury 1812–14, he was raised to the peerage after the war and took part at Waterloo where his horse was shot from under him. When Wellington became Prime Minister in 1828 Hill was appointed Commander-in-Chief of the army.

This is one of thirteen portrait sketches painted by Pieneman from life in 1821 for his large *Battle of Waterloo* (1824) now in the Rijksmuseum (see no.127 for the origin of the group). In the finished painting, Hill is shown mounted and wearing a hat, on the right, next to Seaton.

There are portraits of Hill by George Dawe (National Army Museum) and George Richmond (N.P.G., 1055), engraved in the Rev. Edwin Sidney's *Life of Lord Hill*, 1845. He is also shown in William Salter's *Waterloo Banquet*, 1836, for which there is a sketch in the N.P.G. (3724).

Condition. Additional strips at all four edges; canvas bulging.
Prov. Bought by the Duke of Wellington, with twelve other sketches, from the artist in 1825 (see no.127).
Lit. Dictionary of British Portraiture, 2, p.108.

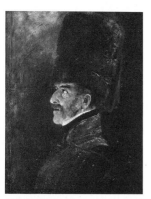

133 WM 1481–1948 Neg. P1398
Wellington *Cat.*, p.405, no.24 red.

133 FIELD MARSHAL HENRY WILLIAM PAGET, 1ST MARQUESS OF ANGLESEY, K.G. (1768–1854)
Signed on left *JWP/Apsly House/London/1821* (only partially legible)
Paper on canvas, 30×24½ (76·2×62·2)

Sketch of head and shoulders, life-size. He wears a busby and the uniform and slung jacket of the 11th Hussars. For Anglesey, see under Lawrence, no.87.

This is one of thirteen portrait sketches painted by Pieneman from life in 1821 for his large *Battle of Waterloo* (1824) now in the Rijksmuseum (see no.127 for the origin of the group). Befitting his position as commander of the cavalry, Anglesey appears in a prominent place mounted, in the right foreground of the finished picture receiving almost as much emphasis as the Duke of Wellington himself. The details of the features and the position of the head are identical to those in the sketch, though in the finished picture the sitter is shown full-length.

Condition. Blisters caused by paper detachment from canvas.
Prov. Bought by the Duke of Wellington, with twelve other sketches, from the artist in 1825 (see no.127).
Lit. Dictionary of British Portraiture, 2, p.6.

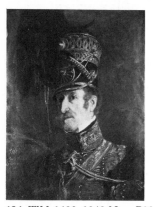

134 WM 1482–1948 Neg. P1397
Wellington *Cat.*, p.287, no.25 red

134 LIEUT.-COLONEL WILLIAM THORNHILL (*d.*1850)
Signed lower left *JWP/Apsly House/London/1821*
Paper on canvas, 28½×21½ (72·3×54·6)

Sketch of head and shoulders, life-size, dark background. He wears a high, black, gold-embroidered shako, with feathers, and the gold-embroidered uniform of the 7th Hussars.

Thornhill entered the 23rd Foot in 1799 and joined the 7th Light

Dragoons as a captain in 1806. He served in the Peninsula and was A.D.C. to Lord Uxbridge (later Marquess of Anglesey) at Waterloo, where he was severely wounded.

This is one of thirteen portrait sketches painted by Pieneman from life in 1821 for his large *Battle of Waterloo* (1824) now in the Rijksmuseum (see no.127 for the origin of the group). In the finished picture Thornhill is shown in a position identical to the sketch, on the right, behind Anglesey.

Condition. Tear in paper lower right corner; otherwise good.
Prov. Bought by the Duke of Wellington, with twelve other sketches, from the artist in 1825 (see no.127).

135 MAJOR-GENERAL JOHN FREMANTLE, C.B. (*d.*1845)
Signed on left above shoulder *JWP/Apsly House/London/1821*
Paper on canvas, 20½ × 16 (52 × 40·2)

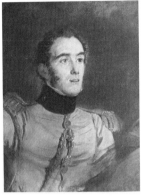

135 WM 1483–1948 Neg. H1515
Wellington *Cat.*, p.298, no.26 red

Sketch of head and shoulders, life-size, on a dark brown background. He wears the scarlet uniform of a staff officer.

Fremantle entered the Coldstream Guards in 1805 and served in Germany in 1806, South America in 1807 and afterwards throughout the Peninsular War. He was A.D.C. to Wellington at Waterloo.

This is one of thirteen portrait sketches painted by Pieneman from life in 1821 for his large *Battle of Waterloo* (1824) now in the Rijksmuseum (see no.127 for the origin of this group). In the painting Fremantle is shown mounted on the left wearing his cocked hat.

Condition. Slight abrasions lower edge; otherwise good.
Prov. Bought by the Duke of Wellington, with twelve other sketches, from the artist in 1825 (see no.127).

136 GENERAL LORD EDWARD SOMERSET, K.C.B. (1776–1842)
Signed at left above shoulder *JWP/Apsly House/London/1821*
Paper on canvas, 21 × 16½ (53·3 × 42)

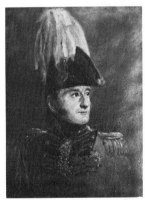

136 WM 1484–1948 Neg. P1400
Wellington *Cat.*, p.278, no.27 red

Sketch, head and shoulders, body facing front, head inclined to the right, light brown background. He wears a cocked hat and feathers and the scarlet uniform of a general, turned back with blue and embroidered with gold, and gold epaulettes and aiguillettes. He wears the star of the Bath on his breast and the badge at his neck together with the Peninsular gold cross and the badge of the Tower and Sword of Portugal.

Lord Robert Edward Henry Somerset, third son of the Duke of Beaufort and elder brother of Lord Raglan, was commissioned in the 10th Light Dragoons in 1793. He was aide-de-camp to the Duke of York in Holland in 1799 and was promoted to lieut.-colonel in 1800. From 1799 to 1802 he was M.P. for Monmouth and from 1803 to 1829 for Gloucestershire. He served with distinction throughout the Peninsular War, 1809–13, and was promoted major-general in 1813. At Waterloo he commanded the household brigade of cavalry. He became a general in 1841.

This is one of thirteen portrait sketches painted by Pieneman from life for his large *Battle of Waterloo* (1824) now in the Rijksmuseum (see no.127). In the finished picture Somerset is shown mounted, with drawn sword, on the left.

Somerset also appears in William Salter's *Waterloo Banquet*, 1836, and there is a sketch of him for this painting in the N.P.G. (3754). There is also a water-colour of him by Thomas Heaphy (N.P.G. 1914·15).

Condition. Small areas of paper separation from canvas.
Prov. Bought by the Duke of Wellington, with twelve other sketches, from the artist in 1825 (see no.127).
Lit. Dictionary of British Portraiture, 2, p.198.

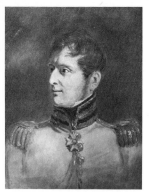

137 WM 1486–1948 Neg. H1516
Wellington *Cat.*, p.299, no.31 red

137 FIELD MARSHAL LORD FITZROY JAMES HENRY SOMERSET, 1ST BARON
RAGLAN, G.C.B. (1788–1855)
Signed at left *JWP/Apsly House/London/1821*
Paper on canvas, 19¾×15¾ (50×40)

Sketch, head and shoulders, life-size on dark brown background. He wears the
scarlet uniform of a staff officer and the badge of the Dutch royal military
order of William.

Lord Fitzroy James Henry Somerset, youngest son of the Duke of
Beaufort, was commissioned in the 4th Light Dragoons in 1804. He served on
Wellington's staff in the Peninsular War from 1808, becoming Wellington's
Military Secretary in 1811 and a lieut.-colonel in 1812, and at Waterloo,
where he lost an arm. After the war he remained Wellington's secretary and
accompanied him on a variety of diplomatic missions. He was M.P. for Truro
1818–20 and 1826–29. In 1852 he was made Master General of the Ordnance
and raised to the peerage as Lord Raglan. He commanded the British troops
in the Crimea 1854–5, taking part in the battles of Alma, Balaclava and
Inkerman. He was criticized for shortcomings in the organization of supplies
in the winter of 1854–5 and died in June 1855 outside Sebastopol.

This is one of thirteen portrait sketches painted by Pieneman from life for
his large *Battle of Waterloo* (1824) now in the Rijksmuseum (see no.127). In
the finished picture Fitzroy Somerset is shown standing by his horse, next to
Wellington. He wears a cocked hat, but the features and posture are the same
as in the sketch.

Raglan also appears in William Salter's *Waterloo Banquet*, 1836, and
there is a sketch of him for this painting in the N.P.G. (3743). He is portrayed
as an older man, in 1853, by Sir Francis Grant (formerly United Services
Club) and in a famous photograph by Roger Fenton showing him shortly
before his death, together with Omar Pasha and Marshal Pelissier (print in
V&A).

Prov. Bought by the Duke of Wellington, with twelve other sketches, from the artist,
in 1825 (see no.127).
Exh. South Kensington, *National Portraits Exhibition*, 1868 (188, erroneously as
Pickersgill); New Gallery, *Victorian Exhibition*, 1891–2 (88).
Lit. Dictionary of British Portraiture, 2, p.178.

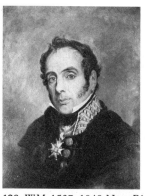

138 WM 1527–1948 Neg. P1470
Wellington *Cat.*, p.276, no.92 red

138 GENERAL MIGUEL RICARDO DE ALAVA (1771–1843)
Signed at left *JWP/Apsly House/London/1821*
Paper on canvas, 19¼×15¼ (48·8×38·7)

Sketch of head and shoulders on light brown ground. He wears the uniform of
a Spanish officer with open, gold-embroidered collar and gold buttons, the
cross of the Bath and the red cross of St James of Compostella of Spain.

This is one of thirteen portrait sketches painted by Pieneman from life for
his large *Battle of Waterloo* (1824) now in the Rijksmuseum (see no.127). In
the finished picture Alava is shown wearing a cocked hat with feathers, in the
group on the right of the Duke of Wellington, between Campbell and
Ponsonby.

There is another portrait of Alava at Apsley House – painted by George
Dawe in 1818 (see no.34 for biographical note).

Condition. Some blistering owing to paper separation from canvas.
Prov. Bought by the Duke of Wellington, with twelve other sketches, from the artist
in 1825 (see no.127).

139 WM 1540–1948 Neg. M1968
Wellington *Cat.*, p.295, no.181 red

139 GENERAL SIR JAMES SHAW KENNEDY, K.C.B. (1788–1865)
Signed at right *JWP/Apsly House/London/1821*
Paper on canvas, 11½×9¼ (29·2×23·4)

Sketch of head and shoulders on dark background. He wears the scarlet uniform of a staff officer.

James Shaw (he took the name of Kennedy, his wife's family name, in about 1834) joined the 43rd Light Infantry in 1805, was at Copenhagen in 1807 and fought with distinction in the Peninsular War, 1808–12. In spite of illness, he was recalled to fight at Quatre Bras and Waterloo in 1815 and was promoted major and made commandant of the garrison at Calais soon after the battle. From 1826 until 1835 he was stationed at Manchester to deal with outbreaks of violence against the combination laws and in 1836–8 he was inspector-general of the Irish constabulary.

This is one of thirteen portrait sketches painted by Pieneman from life for his large *Battle of Waterloo* (1824) now in the Rijksmuseum (see no.127). In the event, Shaw Kennedy does not appear to have been included in the finished picture.

Prov. Bought by the Duke of Wellington, with twelve other sketches, from the artist in 1825 (see no.127).
Lit. Dictionary of British Portraiture, 2, p.125 (the only portrait listed).

Johann Georg PLATZER (1704–61)
Austrian School
Born in St Michael Eppan, in the Tyrol, he was a pupil of his stepfather Jos. Anton Kessler at Innsbruck and of his uncle Johann Christoph Platzer in Passau. From 1728, when he entered the Vienna Academy, he worked mainly in Vienna. He painted genre, historical and mythological subjects, influenced by the Antwerp school of the 17th-century, in particular the Francken family and Jan Brueghel. There are six paintings by him in the V&A.

Lit. G. Agath, *Johann Georg Platzer, ein Gesellschaftsmaler des Wiener Rococo,* Dresden, 1955.

140 ANTHONY AND CLEOPATRA AT THE BATTLE OF ACTIUM
Copper, $20\frac{1}{2} \times 31\frac{1}{2}$ (52×80)

140 WM 1496–1948 Neg. Q1360
Wellington *Cat.*, p.256, no.49 red

The Battle of Actium, 30 B.C., marked the defeat of Mark Anthony at the hands of Augustus and led to the suicide of Cleopatra (see no.141). Mark Anthony is shown in the central galley commanding his men while Cleopatra is enthroned on a splendid ship on the right. Platzer used a very similar composition – a mêlée of ships of the ancient world as he saw it – for his depiction of *The Rape of Helen* (Wallace Collection, no.634).

This painting and its companion were bought by the Duke of Wellington from the Chevalier Gaspard Thierry, who ascribed them to 'François Georges Platzer'. No such artist exists, and it is clearly an error for Johann Georg Platzer, but the confusion was compounded when Evelyn Wellington gave them to Johann Victor, the father of Johann Georg, while supplying him with the dates of his son. In any case the style of the two paintings leaves no room for doubt that they are by Johann Georg Platzer.

Prov. Bought together with its companion by the Duke of Wellington in Paris in 1817, for 3000 fr. from the Chevalier Gaspard Thierry. According to him these two paintings 'ont été donnés en récompense de services éminents par le roi de Bavière à un Prince Hohenzollern, d'après ce que le Prince Charles d'Issenbourg, qui les a vus, en a dit au propriétaire actuel' (letter of 17 Jan. 1817 in Wellington archive).
Exh. B.I., *Old Masters,* 1819 (128, 137).

141 THE DEATH OF CLEOPATRA
Copper, $20\frac{1}{2} \times 31\frac{1}{2}$ (52×80)

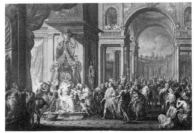

141 WM 1493–1948 Neg. P1466
Wellington *Cat.*, p.265, no.46 red

After Mark Anthony's defeat by Augustus at the Battle of Actium, Cleopatra resolved not to become the prisoner of Augustus and killed herself by applying an asp to her arm. The picture shows a magnificent hall, with rococo

decoration, in which Cleopatra, dying on her throne, is attended by a physician. Augustus, accompanied by a retinue of soldiers, is approaching the dying queen.

Cleopatra's death is traditionally depicted either by a single figure (for example, Guido Reni, Palazzo Pitti, Florence; Guercino, Denis Mahon Coll.) or with the queen and a small group of attendants (e.g. Jordaens, Cassell, Staatliche Kunstsammlung). The huge throng of figures in this painting appears to be Platzer's own variation on the theme.

Prov. See previous entry.
Exh. See previous entry.

Cornelis van POELENBURGH (*c.*1595–1667)
Dutch (Utrecht) School
Born in Utrecht, where he studied under Bloemaert, he was in Rome and Florence from 1617 until about 1627 when he returned to settle in Utrecht. Under the influence of Bril and Elsheimer, he specialized in Italianate landscapes peopled with mythological figures.

Lit. L. Salerno, *Pittori di paesaggio del Seicento a Roma*, i, Rome, 1977–8, pp.224–37.

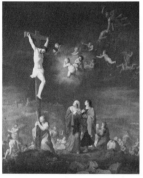

142 WM 1610–1948 Neg. HA3467
Wellington *Cat.*, p.132, no.78 black

142 THE CRUCIFIXION, WITH THE FALL OF THE REBEL ANGELS
Signed on stone centre foreground *CP*, inscribed in white with a St Andrew's cross, lower right, and inventory no.*447*, lower left.
Oak panel, $22\frac{3}{4} \times 19\frac{3}{4}$ ($57 \cdot 5 \times 50 \cdot 7$)

Mary Magdalen hugs the Cross while John and Mary stand together on the right. There are numerous figures on the hillside including, on the left, a group casting lots for the garments. Jerusalem is outlined in the distance on the left. Balancing the Crucifixion, on the right, is the fall of the Rebel Angels, with the good angel, probably to be identified with St Michael, flogging a sinner beneath whom is a snake and skull.

The diagonally placed Cross occurs occasionally in the 16th-century, but it was with the compositional experiments of Rubens in the second decade of the 17th-century that it became popular (Munich, Alte Pinakothek; Antwerp Museum; R. Oldenbourg, *Rubens*, K.d.K., pls 96, 216). It is Rubens, also, who returned to the late Gothic type of Christ with the body low on the Cross, arms tautly stretched and the head sunk down on the chest. Of the numerous Crucifixions derived from Rubens, it is perhaps with those of van Dyck that WM 1610 can be most closely compared, (e.g. Lille Museum, *c.*1630; G. Glueck, *van Dyck*, K. d. K., 1931, pl.224). It is worth noting that Poelenburgh was personally acquainted with both Rubens and van Dyck.

There are depictions of the *Fall of the Rebel Angels* – the expulsion from paradise of the sons of God who had lusted after earthly women – as early as the 10th-century, but the theme's popularity in the Counter Reformation was due to the interpretation of Michael's victory as a symbol of the Church's triumph over heresy. As in this instance, the composition is similar to both the *Last Judgment* and to *St Michael and the dragon*. What is so unusual here is the combination of the *Fall of the Rebel Angels* with the *Crucifixion*. One may presume an intended contrast between the Fall and Salvation, and, indeed, whenever the *Fall of the Rebel Angels* is shown with other scenes, it is used as an antithesis to the subject that is being glorified (K.A. Wirth, 'Engelsturz', *Reallexikon zur Deutschen Kunstgeschichte*, v, 1967, col.654ff., esp.671). The fact that it is painted on oak panel indicates that this picture originated in the Netherlands after Poelenburgh's return from Rome in 1627. Such devotional images, painted at Utrecht, provide further evidence for the existence of a considerable Catholic minority in the northern Netherlands at this period. Indeed, although the painters of Utrecht were the principal exponents of the Dutch religious painting in the 17th-century, they were by no means the only

ones (S. Slive, 'Notes on the relationship of Protestantism to 17th-century Dutch Painting', *Art Quarterly*, 19, 1956, p.3ff.).

Condition. Scratches in right background, otherwise good.
Prov. Spanish royal collection; acquired by Philip V (1731–46) as indicated by the white cross, La Granja inventory, 1746, no.447; Aranjuez inventory, 1794, no.447; captured at Vitoria, 1813.
Lit. Valdivieso, *Pintura Holandesa*, p.340.

143 THE ANGELS GUIDING THE SHEPHERDS TO THE NATIVITY
Signed on stone, left foreground *C.P.*
Copper, $16\frac{1}{4} \times 13\frac{1}{8}$ ($41 \cdot 2 \times 33 \cdot 3$)

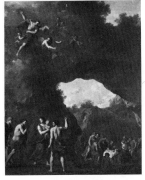

143 WM 1588–1948 Neg. L1404
Wellington *Cat.*, p.42, no.41 black

The half-draped, gesturing classical figures and the baroque arrangement of the angels are derived from Italian painting and indicate a date after Poelenburgh's return from Italy in *c.*1627. This is a fine example of his religious compositions; comparable works with similar groups of angels include an *Annunciation to the Shepherds* (Gray, Musée Baron Martin; no.162 in the Petit Palais exh. listed below), an *Annunciation* (Vienna, Kunsthistorisches Museum), an *Adoration of the Shepherds* (Rutland sale, Christie's, 16 April 1926, lot 31, now Bernard Houthakker gallery, Amsterdam, exh. 1968) and an *Adoration of the Magi* (Geneva Museum). There was a version of the Wellington picture in the Gerhardt sale, Lepke, Berlin, November 1911 (lot 22, repr.),and another with Messrs Speelman, London, in 1982 (panel, $47 \cdot 5 \times 36 \cdot 5$).

Condition. Small areas of flaking and retouching, *passim.*
Prov. Spanish royal collection; Aranjuez 1794 (perhaps identifiable with a *Nativity* by Poelenburgh in the 1794 inventory, size given as $1\frac{1}{4}$ *pie* by 1 *pie y seis* (i.e. 15×18in.). Captured at Vitoria, 1813.
Lit. Gaya Nuño, *Pintura Europea*, no.170; *Le Siècle de Rembrandt* exh. catalogue, Paris, Petit Palais, 1970–71, mentioned under no.162; Valdivieso, *Pintura Holandesa*, p.339.

See also Breenbergh (no.14).

PORTUGUESE School, *c.*1822

144 KING JOHN VI OF PORTUGAL (1769–1826)
Canvas, $82 \times 53\frac{1}{2}$ (208×136), including 5cm. strip at bottom, a later addition

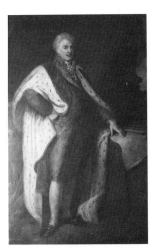

144 WM 1466–1948 Neg. P1404
Wellington *Cat.*, p.331, no.8 red

He wears an ermine cloak with purple border over a yellow silk coat and knee-breeches. On his chest is the red and blue sash of the order of Christ, St James and Aviz. The royal arms of Portugal are embroidered on the tablecloth on the right.

John VI was the son of Peter III of Portugal. He became regent in 1799 and fled to Brazil at the time of the French invasion in 1807. In 1816 he became king but refused to leave Brazil and it was not until 1822 that he returned to Portugal, promising to uphold the Constitution drawn up after the revolution of 1820. However, he abolished it in the following year, with the result that he was faced with renewed revolt.

The best portraits of John VI are by Domingos Antonio de Sequeira (1768–1837), court painter and designer of the famous Portuguese silver table service at Aspley House (see D. Lord, 'Siqueira...', *Burl. Mag.*, 74, 1939, p.153ff.; Bruges Museum, *La Toison d'Or*, 1962, nos.300f.). However, WM 1466 does not approach Siqueira's portraits in quality and no artist's name was connected with the picture when it was presented by the sitter to the Duke of Wellington, presumably not long after his return to Portugal in 1822.

Condition. Marked discoloration, otherwise good.
Prov. Presented to the Duke of Wellington by King John VI of Portugal.

RAPHAEL (1483–1520)
Italian (Roman) School

Son of Giovanni Santi (d.1494) of Urbino and, by tradition, the pupil of Pietro Perugino, he settled in Rome *c.*1508, at about which time he probably visited Florence. In Rome he worked for the banker Agostino Chigi but above all for the Vatican. He succeeded Bramante in 1514 as architect of St Peter's, and later held responsibility for all papal enterprises in the arts. His influence in the revival of a classical art was immense.

After RAPHAEL

145 THE VIRGIN AND CHILD

Copy, with variations, of Raphael's *Madonna della Sedia* in the Palazzo Pitti, Florence

Panel, $20\frac{1}{8} \times 14\frac{1}{2}$ (51×37)

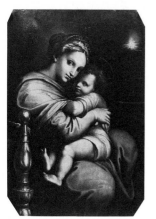

145 WM 1618–1948 Neg. P1465
Wellington *Cat.,* p.225, no.88 black

Although this painting is patently based on the Madonna della Sedia it differs from it in several respects. The original is round, indeed it is the quintessential tondo. In WM 1618, St John has been omitted on the right and a lit candle placed there instead. Both faces have been changed; the Virgin, with her piercing dark eyes, has been beautified, and her costume has been changed; she no longer wears a turban as in the original.

The early authorities were full of praise for this picture. Mengs (1782) thought that the head of the Madonna 'is his (Raphael's) and has equal merit to any of his works, being full of life and spirit', and Ponz wrote 'The head of the Virgin and that of the Child in this picture are evidently finished by Raphael himself.' By the time it reached England it had attracted the attribution to Giulio Romano and in a letter to the Duke of Wellington dated 9 Feb. 1814, Lord Maryborough wrote: 'West said the Correggio and the Julio Romano ought to be framed in diamonds, and that it was worth fighting the battle for them.' This attribution was noted by Waagen *(Treasures),* maintained by Evelyn Wellington and defended by Adolfo Venturi (1926), who enumerated the Virgin's beauty and strong chiaroscuro as specifically typical of Giulio Romano. Yet the attribution has not survived modern scrutiny and WM 1618 is now listed simply as an old copy of the *Madonna della Sedia* (Dussler, 1971). Indeed it may well date from the early 17th century, when the experimentation with single light sources was at its height.

Prov. Spanish royal collection, The Palace, Madrid 1794 (Ponz: Princess's room); captured at Vitoria, 1813.
Exh. B.I., *Old Masters,* 1828, (40, *as Giulio Romano);* Birmingham Society of Arts, 1831.
Lit. Mengs, *Letter to Ponz,* trans. J. T. Dillon, 1782, p.87; Ponz, *Viage,* vi, 1782, p.43; Cumberland, *Catalogue,* 1787, p.88 (Raphael); Passavant, *Tour,* 1836, i, p.174 (an old copy of the Madonna della Sedia); Waagen, *Treasures,* ii, p.274 (an old and excellent copy of the Madonna della Sedia is ascribed to Giulio Romano); A. Venturi, *Storia dell'Arte Italiana,* ix, 2, 1926, p.369f., fig.302 (by Giulio Romano); L. Dussler, *Raphael, a critical catalogue,* 1971, p.36 (one of many copies of the Madonna della Sedia).

See also under Bonnemaison.

Guido RENI (1575–1642)
Italian (Bolognese) School

Born in Bologna, he studied under Denys Calvaert *c.*1584–93 and then in the Carracci Academy from 1594/5. He worked in Rome as much as in Bologna in the early part of his career, but the later part of his life, from *c.*1630, was spent largely in Bologna. He was one of the principal exponents of early baroque art in Italy.

Lit. C. Gnudi, G. C. Cavalli, *Guido Reni,* 1955.

146 HEAD OF ST JOSEPH
Inscribed in white with crosses and inventory no. + *109* + .
Canvas, oval $27\frac{3}{4} \times 22\frac{1}{8}$ ($70 \cdot 5 \times 56 \cdot 2$)

Although this picture is not included in C. Gnudi and G. C. Cavallis' catalogue or in C. Garboli, E. Bacceschi, *L'Opera Completa di Guido Reni*, 1971, it remains possible to accept the attribution to Guido under which it entered the Spanish royal collection in the early 18th century. It is very similar in style and posture to the St Matthew in the Vatican Pinacoteca (Gnudi, Cavalli, p.17, pl.180; *c*.1635–40) and also to the St Joseph in the Galleria Nazionale, Rome (Gnudi, Cavalli, p.99, pl.192), though this, a very late work, is even freer in treatment. Of the many drawings of such heads by Guido perhaps the closest is the one in the Museum at Lille (Gernsheim photo no.18211). The white St Andrew's cross usually indicates a painting acquired by Philip V, though in the La Granja (San Ildefonso) inventory of 1746 this picture is listed with those of his wife Isabella Farnese, which formed a separate collection. It remained at La Granja until 1812 when it was one of a group of twelve pictures (only two have been identified) presented to the Duke of Wellington by the Intendant of Segovia, on behalf of the Spanish nation:

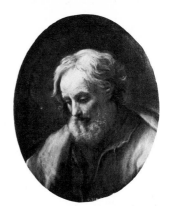

146 WM 1513–1948 Neg. P1425
Wellington *Cat.*, p.67, no.72 red

> Your Excellency, – If a feeling of delicacy on your part will not admit of your accepting the offer I made you, on behalf of the nation, of such trifles in the Royal Palace of San Ildefonso as might have been most agreeable to you, I cannot overlook the deep obligation of my country to the hero of Great Britain, and the Regent would justly resent any indifference on my part in showing the gratitude due to the Liberator of Spain. As I believe that you take a particular interest in pictures, I take the liberty of presenting to you the twelve best and most artistic pictures which I have been able to find.
>
> In the name of the Spanish Nation and the Government I beg that you will deign to accept this very small offering – the chief object of which is to show the gratitude and recognition of the Nation.
>
> I pray the God of Armies to keep you in perfect health, and beg that you will favour me with the expression of your wishes on the subject.
>
> SEGOVIA, August 15, 1812 (Signed) The Intendant of the Province,
> Ramon Luis Escovedo

Condition. Paint surface considerably worn, especially on right side of face and neck; cleaned by S. Isepp in 1950.
Prov. Philip V and Isabella Farnese Collections, La Granja inventories 1746, 1774, 1794, no.905, 'una pintura original en lienzo de Guido Reni una caveza de san Joseph su forma ovalado'... Presented to the Duke of Wellington by the Intendant of Segovia in 1812.
Lit. Perez Sanchez, *Pintura italiana*, p.176 (as Guido Reni); Gaya Nuño, *Pintura Europea*, p.86, no.281, pl.95.

Sir Joshua REYNOLDS P.R.A. (1723–92)
Born in Devonshire, the son of a clergyman, Reynolds went to Italy in 1749 and returned in 1752 determined to bring the influence of Italian baroque painting to English portraiture. He was, with Gainsborough, the leading portrait painter in London and this, together with his importance as a theorist, led to his appointment as first president of the Royal Academy in 1768.

Lit. E. K. Waterhouse, *Reynolds,* 1941.

Traditionally ascribed to REYNOLDS

147 LANDSCAPE WITH THE FLIGHT INTO EGYPT
Canvas, $24\frac{1}{4} \times 20\frac{1}{4}$ ($61 \cdot 5 \times 51 \cdot 3$)

From its appearance alone, it is hard to imagine why this painting was ever

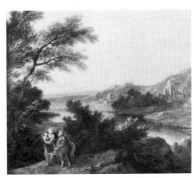

147 WM 1545–1948 Neg. H1513
Wellington *Cat.*, p.97, no.188 red

attributed to Reynolds. The few religious scenes he painted, for example the *Holy Family* of 1788 in the Tate Gallery, are quite different, primarily figure subjects with the landscape kept firmly in the background. We know from C.R. Leslie that Reynolds 'did not neglect the study of landscape' during his early years in Devon, 1746–9 (Leslie, *Life and Times of Sir Joshua Reynolds*, I, 1865, p.34), and Northcote lists two or three landscapes in his catalogue of Reynolds' paintings (James Northcote, *Life of Sir Joshua Reynolds*, 2nd ed., 1818, ii, p.350). On this slender basis, over thirty landscapes were attributed to Reynolds in the course of the 19th century. They are listed by Graves and Cronin (1899, p.1233ff.) but they have not been included in any more recent survey of his work.

WM 1545 is based on a Claudian type of composition; indeed a close comparison can be made with Claude's *Pastoral landscape with Flight into Egypt* at Dresden (M. Röthlisberger, *Claude*, 1961, no.110, fig.191). There is nothing inherently unlikely about Reynolds painting such a subject in his early years, but in this instance the crudity of the execution makes this a very doubtful hypothesis.

Condition. Severe bitumen craquelure in dark areas; tendency to blister.
Prov. Lord Northwick, sold Phillips, 24 Aug. 1859, lot 1835; bought by the second Duke of Wellington for £35.14s.
Lit. A. Graves and W. V. Cronin, *A History of the Works of Sir Joshua Reynolds P.R.A.*, iii, 1899, p.1153; *Paintings at Apsley House*, 1965, pl.49.

After REYNOLDS

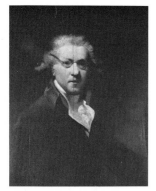

148 WM 1533–1948 Neg. HA3471
Wellington *Cat.* p.73, no.170 red

148 SELF-PORTRAIT, WEARING GLASSES
Panel, 30 × 24½ (71 × 62)

This is a studio or contemporary copy of the self-portrait in the royal collection at Windsor Castle (panel, 29⅝ × 24⅞; Millar, 1969, p.98, no.1008, pl.105). The original, painted in 1788, was Reynolds's last portrait of himself. Among other replicas and old copies are those at Petworth, Dulwich and Kenwood.

Condition. Cleaned by H. Rogers in 1950.
Prov. W. B. Beaumont, Christie's, July 1881, lot 239, bought by Martin Colnaghi for £17.17s; Messrs. Henry Graves and Co., from whom the 2nd Duke of Wellington bought it in 1882 for £262.10s.
Lit. Oliver Millar, *Later Georgian Pictures in the Royal Collection*, 1969, p.98; Peter Murray, *Dulwich Picture Gallery, a catalogue*, 1980, p.103.

Jusepe de RIBERA *Lo Spagnoletto* (1591–1652)
Spanish School
Born in Játiva, he was a pupil of Francisco Ribalta in nearby Valencia but went to Italy at an early age and remained there for the rest of his life. Documented in Rome in 1615–16, he settled in Naples in 1616 and enjoyed the patronage of the Spanish Viceroys. He painted mainly religious subjects in a Caravaggesque style.

Lit. A. E. Perez Sanchez and N. Spinosa, *L'Opera Completa del Ribera*, Milano, 1978.

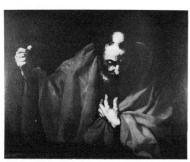

149 WM 1619–1948 Neg. M1971
Wellington *Cat.*, p.229, no.91 black

149 ST JAMES THE GREAT
Inscribed in white with inventory no.412.
Canvas, 29¾ × 39¾ (45 × 101)

St James is identified by his pilgrim's staff. He is shown reading the inscription on the parapet ASCE(N)DIT AD C(A)ELOS SEDET AD DEXTERA(M) (he ascends to heaven and sits at the right side). This presumably refers to Mark x, 35–45, where James and his brother John ask

Christ: 'grant unto us that we may sit one on thy right hand the other on thy left hand in thy glory.'

This painting was engraved as by Ribera by Josef Vazquez in 1792 when it was in the Royal Palace, Madrid (inscribed *Santiago el Menor (sic) cuyo se halla en el Real Palacio de Madrid;* published in *Cuadros en el Real Palacio y en el Museo de Madrid,* Madrid 1787–1858) and it was catalogued as such in the Wellington Collection. However, it was not listed by A. L. Mayer (*Ribera,* 1923), and it has recently been described as a studio production made to the master's instructions by C. M. Felton (dissertation, 1971). No other version of the composition is known, though the type of the half-length figure enveloped by a cloak recurs frequently in his work and the foreshortening of the head is paralleled in the St Paul hermit in the Prado (Mayer, *Ribera,* 1923, pl.46) It is, on the whole, finely painted, but there are weak passages — for example the hand in the centre — and the possibility that it is a studio work cannot be excluded.

Condition. Retouched areas on cloak; vertical line of damage down the centre. Cleaned by S. Isepp in 1950.
Prov. Royal Palace Madrid, 1792 (date of engraving); captured at Vitoria, 1813.
Exh. Third Magnasco Society exhibition, Agnew's, 1926, no.6 (see Osbert Sitwell, *Apollo,* 1964, p.383).
Lit. Gaya Nuño, *Pintura Española,* no.2277 (as Ribera); *Paintings at Apsley House,* 1965, pl.14; C. M. Felton, *Jusepe de Ribera* MS dissertation, Univ. of Pittsburgh), 1971, no.S.22 (studio); A. E. Perez Sanchez and N. Spinosa, *L'Opera Completa del Ribera,* 1978, no.79 (uncertain).

150 ST JOHN THE BAPTIST
Inscribed above lamb's head on left *Jusepe de Ribera/espanol/F.1650*
Canvas, 40¾ × 30 (103 × 76)

Ribera painted many compositions of the Baptist but none is very close to the Wellington picture. It was accepted as autograph by Mayer (1923), but the outlines are unusually hard and the authority of the inscription is called into question by the date *1650.* This was the period of Ribera's late, most expressionist style, at which period emaciated saints dominate his work. Nevertheless this is an original composition of a Riberesque type and, if it is not autograph, it could well be a studio replica of a lost original.

Condition. Somewhat worn in sky and flesh. Retouched paint loss on chest and face, at left eye and nose, and on sheep. Cleaned by S. Isepp, 1950.
Prov. Royal Palace, Madrid; 1794 inventory, in the Palace oratory. Captured at Vitoria, 1813.
Exh. 2nd Magnasco Society Exh., Agnew's, 1925, (4) (see Osbert Sitwell, 'The Magnasco Society', *Apollo,* 79,1964, p.382).
Lit. J. Townsend, *A Journey through Spain in the years 1786 and 1787. . .,* 2nd ed., 1792, I, p.261; Ponz, *Viage,* vi, p.41 ('formerly in the Queen's bedchamber', but this could refer to the full size St John by Ribera now in the Prado); A. L. Mayer, *Jusepe de Ribera, Lo Spagnoletto,* 1923, p.198, Gaya Nuño, *Pintura Española,* no.2400; *Paintings at Apsley House,* 1965 pl.12; C. M. Felton, *Jusepe de Ribera* (MS diss., Univ. of Pittsburgh), 1971, p.351, no.S.23 (studio attribution); Perez Sanchez and Spinosa, *Ribera,* no.164 (uncertain).

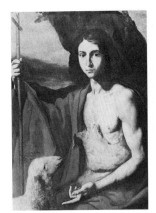
150 WM 1627–1948 Neg. 894
Wellington *Cat.,* p.108, no.115 black

Traditionally ascribed to RIBERA

151 LA CARCASSE: A WITCH BEING DRAWN ON THE SKELETON OF A MONSTER
Inscribed lower left *R.V. inventor/Yosephf de Ribera pingit/16--;* inventory no. in red, lower left *90*
Copper, 13½ × 25⅝ (34·3 × 65·5)

This is an exact copy, with only minor variants, of an engraving of *c.*1520–25

151 WM 1580–1948 Neg. J945
Wellington *Cat.,* p.98, no.33 black

ascribed to Agostino dei Musi, called Agostino Veneziano, 36.1x63.8 cm.; Bartsch, xiv, p.426. Only the group of tiny figures round a fire, representing a witches' Sabbath, and the crescent moon are not in the engraving. The inscription *R. V. inventor* may be read as *Raphael Urbinas inventor*, which suggests that the original design for the engraving was Raphael's. Although there is no corroborating evidence, this is not an implausible tradition and it has been accepted by several authorities (Bartsch; Pittaluga, 1930).

Only the inscription connects this painting with Ribera and it is in a form which does not appear elsewhere. In style the picture is not typical of Ribera's work; the greenish-blue and reddish flesh tones suggest a Flemish origin, possibly under the influence of Rubens. The copper support also indicates a Netherlandish rather than a Spanish origin. Certainly, if the attribution to Ribera in the inscription is taken at face value, this can only be a student work. It is hardly conceivable that it is a painting by the mature Ribera after *c*.1620.

The subject has been variously interpreted. Its components are the skeleton of a huge monster ridden by a witch and accompanied by heroic figures. E. Tietze-Conrat (1936) identified the witch as Hecate, goddess of magic, whose retinue included the souls of those who died before their time, particularly children, or were killed by force. Hence she is here shown picking up children and putting them into a brazier, while the heroic figures in her train also represent those who died before their time. This is a plausible interpretation, based on classical descriptions of Hecate combined with the evidence of 15th-century witchcraft trials, but there are no pictorial parallels to this composition.

Condition. A few small areas retouched; good on the whole. Cleaned in 1950.
Prov. Spanish royal collection: 1734 inventory of pictures saved from the fire in the Alcazar, no.219; 1772 inventory of the Royal Palace, Madrid, no.90, King's withdrawing room; 1794 inventory no.90, first room in new wing; captured at Vitoria, 1813.
Exh. B.I., *Old Masters,* 1828 (59); Birmingham Society of Arts, 1831; B.I., *Old Masters,* 1854 (reviewed *Times,* 5 June 1854).
Lit. Cumberland, *Catalogue,* p.78 (in Prince's dining room in Royal Palace); Ponz, *Viage,* vi, p.51 (Prince's principal saloon in Royal Palace); Céan Bermudez, *Diccionario,* iv, p.191; Passavant, *Tour,* i, p.171 (read date as 1641); Waagen, *Treasures,* ii, p.276 (read date as 1641); Elizabeth du Gué Trapier, *Ribera,* 1952, p.246 f; Gaya Nuño, *Pintura española,* no.2278 (inscription false but painting worthy of Ribera); C. M. Felton, *Jusepe de Ribera* MS diss. Univ. of Pittsburgh), 1971, p.459, no.x-103 (unaccepted attribution); Perez Sanchez and Spinosa, *Ribera,* no.410 (not by Ribera). For the print, see: Mary Pittaluga, *L'Incisione italiana nel Cinquecento,* n.d. (1930), p.163, fig.99; E. Tietze-Conrat, 'Der "Stregozzo"', *Die graphischen Künste,* i, 1936, pp.57–9.

Philipp Peter ROOS, called Rosa da Tivoli (1655/7–1706)
German School; worked in Italy
Born in Frankfurt, he was the son and pupil of Johann Heinrich Roos. He travelled in 1677 to Rome where he married and settled. Without exception, his paintings are of horned cattle, goats and sheep among the ruins of the Roman Campagna.

Lit. Luigi Salerno, *Pittori di paesaggio del Seicento a Roma,* ii, Rome, 1977–8, pp.626–31.

152 SHEPHERD AND CATTLE
Canvas, $34\frac{5}{8} \times 52\frac{1}{2}$ ($87 \cdot 7 \times 133 \cdot 6$)

Until its recent relining, the back of the canvas bore the inscription *Pe. Nro .Sor.* (Principe Nuestro Señor), indicating that it belonged to Charles IV when he was still Prince of Asturias. This inscription should be accepted at its face

152 WM 1648–1948 Neg. HA3469
Wellington *Cat.,* p.317, no.212 black

value even though the picture is not recorded in the inventory of *c.*1782 of Charles IV's collection in the Casa de Campo of the Escorial, published by J. Zarco Cuevas (for other paintings from this collection see under d'Arpino, Sassoferrato and Vernet).

In style and subject WM 1648 is typical of Roos. The execution is cruder than in his best work, but even so the attribution should clearly be allowed to stand.

Condition. lined in 1974 when a long horizontal tear was repaired.
Prov. Charles IV when Prince of Asturias in the Casa de Campo de El Escorial. Captured at Vitoria, 1813.

Salvator ROSA (1615–73)
Italian School
Born in Naples, he studied under his uncle Domenico Greco, but was strongly influenced by Ribera and Aniello Falcone. He left Naples for Rome in 1635, then moved to Tuscany before finally settling in Rome after 1649. He painted a wide variety of subjects but has remained best known for his landscapes with craggy rocks and broken trees which provided the inspiration for the Picturesque landscape in 18th-century England.

Lit. L. Salerno, *L'Opera Completa di Salvator Rosa*, Milano, 1975.

153 BATTLE SCENE WITH CLASSICAL COLONNADE
Signed on plank lower left *SR* (monogram)
Inscribed in white with inventory no.159
Canvas, 33×60¼ (84×153)

153 WM 1591–1948 Neg. HA3468
Wellington *Cat.*, p.216, no.48 black

Under the influence of Aniello Falcone, Salvator Rosa painted battle scenes from the beginning of his career. Indeed, his earliest known dated picture is a *Battle* of 1637 (W. Mostyn-Owen coll.; Salerno, 1975, no.7). The majority of these were painted while he was living in Tuscany (Florence, Siena, Pisa) in 1640–49 (Salerno, 1975, nos.88–94) and WM 1591 can be placed in the same period, for it is very close to them in both style and composition. Even the motif of the Corinthian columns — setting the scene in the classical period — is a recurrent feature (e.g. Palazzo Pitti, Florence; Kunsthistorisches Museum, Vienna, dated 1645; Salerno, 1975, nos.89,94). The Wellington picture belongs to the smaller members of the group (Palazzo Pitti (89); Lord Spencer, Althorp (90); Salerno, 1975 nos. in brackets); the large ones average 230×350 cm. (Palazzo Pitti (88), Vienna (94), Louvre (111)).

Although they form only a minor aspect of his total output, Salvator Rosa's battle pieces exerted a considerable influence on specialists in this field throughout the 17th century, such as Jacques Courtois, Il Borgognone.

Condition. generally rather rubbed, especially in the sky and dark areas; retouched region of irregular width down left edge.
Prov. Spanish royal collection (not inv.); captured at Vitoria, 1813.
Exh. Second Magnasco Society Exhibition, Agnew's, 1925 (14) (see Osbert Sitwell, *Apollo*, 1964, p.382).
Lit. L. Ozzola, 'Works of Salvator Rosa in England', *Burl. Mag.*, 16, 1909–10, p.149 (an imitation); H. Voss, *Die Malerei des Barock in Rom*, 1924, pp.289 (repr.), 567 (autograph, as in all subsequent authorities); L. Salerno, *Salvator Rosa*, 1963, p.119, no.24b (repr.) (Tuscan period, 1640s); Gaya Nuño, *Pintura Europea*, p.87, no.292; Perez Sanchez, *Pintura Italiana*, p.436; L. Salerno *L'Opera Completa di Salvator Rosa*, 1975 p.91, no.93 (repr.).

Sir Peter Paul RUBENS (1577–1640)
Flemish (Antwerp) School
Born in Siegen, Westphalia, of an Antwerp family, Rubens moved in 1587 to Antwerp where, after leaving school, he became a pupil of Adam van Noort

and Otto van Veen. From 1600–08 he lived in Italy, entering the service of Vincenzo Gonzaga, Duke of Mantua, on whose behalf he visited Spain in 1603. He returned to Antwerp in 1608 and was appointed painter to the Brussels Court of the Archduke Albert in the following year. He was commissioned by Marie de Médicis to execute a series of paintings for the Luxembourg and accordingly visited Paris in 1622 and 1625. His activities as a diplomat took him to Spain in 1628 and to London in 1629–30, when he was knighted by Charles I. Having returned to Antwerp in 1630, he carried out the paintings for the ceiling of the Whitehall Banqueting House in the succeeding year. He died in 1640, renowned as a courtier and diplomat as well as a painter.

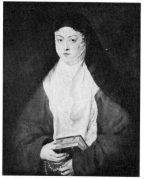

154 WM 1626–1948 Neg. F958
Wellington *Cat.*, p.394, no.109 black

154 Ana Dorotea, daughter of Rudolph II, a nun at the Convent of the Descalzas Reales, Madrid
Canvas, $28\frac{3}{4} \times 25\frac{3}{4}$ $(73 \times 65 \cdot 4)$

The sitter is in the habit of the Barefooted Carmelites as worn by members of the Spanish royal family and other noble families who, on retiring to this Madrid cloister, were called the Descalzas Reales (royal barefooted nuns). In style and subject this painting fits well into a series of portraits of members of the Spanish royal family carried out by Rubens during his visit to Madrid in 1628. The painter Pacheco recorded: 'During the nine months which he spent in Madrid, he painted a great deal as we shall see (so great is his skill and facility). First he made half-length portraits of the King and Queen and the Infanta in order to take them back to Flanders with him. He made five likenesses of His Majesty. . . He made a portrait of the Infanta at the Descalzas larger than half-length and produced replicas of it. . .' (For others in the series and a discussion of the group see Wildenstein exh., 1950, nos.33–4).

There has been considerable discussion concerning the identity of WM 1626. Catalogued simply as 'portrait of a nun' by Evelyn Wellington, the picture was recognized as a version of a painting in the cloister of the Descalzas Reales at Madrid by Ellis Waterhouse (1949 exhibition). This painting was inscribed with the name Sor Margarita de la Cruz, daughter of Maximilian II, and Waterhouse accepted this identification for the Wellington picture also. Subsequently, it was pointed out by Ludwig Burchard (Wildenstein exh., 1950) that Sor Margarita de la Cruz was 61 in 1628 and totally blind and hence that the identification was hardly acceptable. Burchard suggested that the name Margarita on the inscription nevertheless provided the clue and identified the sitter as the Infanta Margarita, sister of Philip IV.

A decade later, the Descalzas Reales portrait was cleaned and the inscription disappeared, together with a considerable amount of 19th century repaint, and thus the name Margarita was finally dissociated from the sitter. The convincing identification of the Infanta Ana Dorotea was made by Maria Teresa Ruiz Alcón (1963) on the basis of a comparison with a portrait of her by Andres Lopéz. Ana Dorotea was the daughter of Rudolph II (see above no.1) by his mistress Catherine de Strada. She came from Austria to Spain in 1623, entered the monastery of the Descalzas and took her vow in 1628 aged 17. She may be identified with the Infanta at the Descalzas discussed by Pacheco and the replica is also mentioned by him. Both WM 1626 and the Descalzas version were in the royal collection in 1794; they are described in the inventory as 'two portraits of nuns. . . holding rosaries. . . by Rubens' (nos. 58 and 59). Whether the copy in the Descalzas is in fact by Rubens remains an open question.

Condition. Some wearing in dark areas; otherwise good.

Prov. Spanish royal collection, 1794 Royal Palace inventory nos.58–9, passage to the library; captured at Vitoria, 1813.
Exh. Grafton Gallery, *Second National Loan Exhibition,* 1913–14, no.45, pl.45; V. & A. 1947 (11); Arts Council, 1949 (7), pl.2 (Ellis Waterhouse); Wildenstein, London, *Peter Paul Rubens,* 1950 (35), repr. (Ludwig Burchard).
Lit. Francisco Pacheco, *Arte de la Pintura,* 1638, ed. F. J. Sanchez Canton, 1956, i, p.153; Elias Tormo, *En las Descalzas Reales,* 1915–17, pp.229f., notes 43–4; Maria Teresa Ruiz Alcón, 'Otro Rubens en las Descalzas', *Goya,* 56–7, 1963, p.250f., fig.4 (Descalzas version fig.3); F. Huemer, *Portraits, i, Corpus Rubenianum Ludwig Burchard,* xix, 1977, p.101, no.1 fig.41. For a reproduction of the Descalzas version before cleaning see *Catalogo de la Exposicion Franciscana,* Madrid, Sociedad Española de Amigos de Arte, 1927, no.22, pl.27.

155 HEAD OF AN OLD MAN
Oak Panel, oval 19½ × 14⅛ (49·5 × 35·8)

The costume suggests a date *c.*1620; a comparable portrait of the same period, though not with a sketchy background, is reproduced by Oldenbourg (*Rubens, K. d. K.,* 1921, pl.128, then van Diemen Gallery, Berlin). On the picture's status no fuller judgement has been published since that of Rooses (1890): 'bon tableau, probablement authentique'. Its high quality supports this judgement.

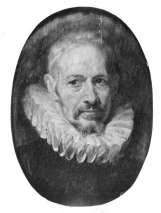

155 WM 1570–1948 Neg. F977
Wellington *Cat.,* p.114, no.5 black

Condition. Panel split vertically and the line of the join running down the forehead and the right eye has been retouched.
Prov. Spanish royal collection, Royal Palace, Madrid (1794 inventory, no.13612, one of a pair in the King's dressing room). Captured at Vitoria, 1813.
Exh. Dowdeswell Galleries, *Sketches and Studies by P. P. Rubens,* 1912 (8).
Lit. Max Rooses, *Rubens,* iv, 1890, p.297, no.1101.

After RUBENS

156 THE HOLY FAMILY WITH ST ELIZABETH AND ST JOHN
Inscribed in white with inventory no.*806* and fleur-de-lis
Copper, octagonal, 9¾ × 9¾ (24.8 × 24.8)

This is a much-reduced copy of a painting by Rubens in the Wallace Collection (133 × 97cm.; *Catalogue,* 1968, no. P.81; R. Oldenbourg, *Rubens, K. d. K.* 1921, pl.69). The original was painted *c.*1614 (Oldenbourg) for the Archduke Albert, co-Regent of the Netherlands, to whom Rubens was appointed court painter in 1609. WM 1586 differs from the original in the addition of a vase of flowers on the left which were ascribed to Jan Brueghel and the picture itself to Teniers (Wellington *Cat.*; Wallace Collection *Cat.*), but these attributions have not been generally accepted. Nevertheless, it is clearly a good 17th-century copy, and until an acceptable attribution is forthcoming Max Rooses' description should be allowed to stand: 'charmante réduction peinte d'un pinceau délicat par une main habile'.

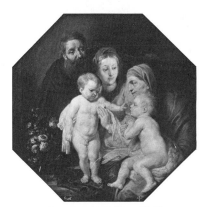

156 WM 1586–1948 Neg. J931
Wellington *Cat.,* p.101, no.39 black

Condition. Slight wearing of flesh paint especially on Elizabeth, otherwise good.
Prov. Isabella Farnese, Queen of Spain (fleur-de-lis), La Granja inventory, 1746, no.806, as Rubens; La Granja inventory, 1774; Aranjuez inventory, 1794; captured at Vitoria, 1813.
Exh. R.A., *Old Masters,* 1887 (104), as Rubens; Dowdeswell Galleries, *P. P. Rubens,* 1912 (17), with list of attributions.
Lit. Max Rooses, *L'Oeuvre de P. P. Rubens,* i, 1886, p.308; Wallace Collection Catalogues, *Pictures and Drawings,* 1968, under no.P.81 (a small contemporary copy, ? Teniers).

157 HERCULES AND THE NEMEAN LION
Canvas, 27½ × 19¼ (70 × 49)

This was the first of the twelve labours Hercules performed in the service of

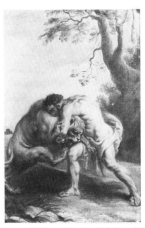

157 WM 1608–1948 Neg. N1407
Wellington *Cat.,* p.199, no.75 black

Eurystheus. The Nemean lion was brought on the scene by Juno, stepmother of Hercules, in order to endanger him. But in spite of its supposed invulnerability, Hercules was able to choke it in his arms.

WM 1608 is a copy, probably of the 18th century, of a composition by Rubens which was itself derived from a popular classical motif. In about 1606, during his stay in Rome, Rubens made a pen and ink drawing of the Roman relief of *Hercules and the Nemean lion* in the Villa Medici, depicting it in its damaged state with detailed accuracy (private collection, Dorset; M. Jaffé, *Rubens in Italy*, 1977, p.83, pls.285–6). Some years later he made several drawings in which the classical relief was converted into a rounder, more flowing composition showing Hercules and the lion almost as a single unit. These are, respectively, in the Louvre (Jaffé, pl.287), in the Plantin-Moretus Museum, Antwerp (Delen, 1938, no.192, pl.36) and in the British Museum (Hind, 23). The original oil painting, showing Hercules with his left foot on a tiger, is now identified as the one in the collection of R. van de Broek, Brussels (Jaffé, pl.288, where it is dated 'about 1615') and there is an oil sketch showing Hercules in a somewhat different posture without the tiger, in the Charles Kuhn Collection, St Louis, Missouri (S. Alpers, *The Decoration of the Torre de la Parada, Corpus Rubenianum Ludwig Burchard*, ix, 1977, p.277, fig.198, dated 'in the early 1630s').

There are also numerous copies, including:
1. Formerly Sanssouci, Berlin, life-size (R. Oldenbourg in *Jahrbuch der Königl. Preuss. Kunstsamml.*, 37, 1916, p.270 f., fig.2).
2. Art Museum, Bucharest, 56·5x93·5cm., with additional landscape (Muzeul de Arta al R.P.R., Galeria Universala, *Catalog*, 1957, no.269, pl.53).
3. Christie's, 9 Feb. 1979, lot.12; 104x149cm.
4. V&A Museum, no.308–1864, 44·5x39cm., 18th/19th-century copy (*Catalogue of Foreign Paintings*, I, 1973, p.251, no.310).

The composition was engraved by N. Rhein, and by R. Freidhof, 1801.

It has been suggested, in connection with some of the above versions, that the composition was originally painted as part of a Hercules series for the Torre de la Parada, near Madrid, which Rubens decorated for Philip IV in 1636–8. Recently, however, S. Alpers *(loc. cit.)* has found that there is insufficient evidence for such a cycle ever having been in the Torre de la Parada and she argues that the composition of *Hercules and the Nemean lion* clearly predates Rubens's work on the Torre. Nevertheless, there must have been a Rubensian Hercules cycle available for the artist of WM 1608 to copy, presumably, though not certainly, in Spain. It is recorded as one of four such works in the style of Rubens in the Royal Palace inventory of 1794. One of these is the companion at Apsley House, *Hercules wrestling with the bull* (see next entry); the other two were described as *Hercules killing the Centaur* (presumably Nessus); and the last, apparently not connected with Hercules, as 'a huntress removing an arrow from a deer'.

Prov. Spanish royal collection; Royal Palace inventory, 1794 (no. 14247), one of four paintings in the manner of Rubens measuring $\frac{3}{4}$ by more than one $\frac{1}{2}$ vara (i.e. 63×42cm.) (see above). Captured at Vitoria, 1813.
Lit. Rooses, *Rubens*, iii, 1890, p.102, under no.619 ('The Duke of Wellington possesses a small picture representing the same subject'); A. J. J. Delen, *Cabinet des Estampes de la Ville d'Anvers, Catalogue des dessins anciens, école flamande et hollandaise*, Brussels, 1938, p.64 (listed as one of several versions).

158 HERCULES WRESTLING WITH ACHELOUS IN THE FORM OF A BULL
Canvas, $27\frac{1}{2}$ × 19 (70×48)

Companion piece to WM 1608 (see previous entry).

To obtain the hand of Deianeira, Hercules had to fight the river-god Achelous, who had the power of taking on various shapes. Hercules mastered

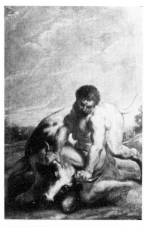

158 WM 1597–1948 Neg. P1417
Wellington *Cat.*, p.220, no.55 black

him when he was in the form of a bull and broke off one of his horns. This is presumably the picture's subject, but it could almost equally well illustrate the *Capture of the Cretan bull,* which is the seventh labour.

As opposed to the composition of the companion piece, *Hercules and the Nemean lion,* of which there are numerous drawings, versions and copies, this theme is extremely rare in extant Rubensian works. Apart from WM 1597, there are only two drawings to denote the existence of the original composition by Rubens:
1. A slight preparatory drawing by Rubens in the corner of a sheet of studies for the *Lapiths and Centaurs* (W. Burchard collection, Farnham; Alpers, 1977, p.278, fig.137) which differs in showing Hercules in profile.
2. A more finished drawing in the Seilern collection, catalogued there as by Rubens (A. S., *Flemish Paintings and Drawings at 56 Princes Gate, v, Addenda,* 1969, p.62, no.326, pl.41) but not accepted as autograph by Alpers (p.278, fig.200).

The Seilern drawing has a companion, *Hercules killing the Hydra,* which reinforces the view that these compositions derived from a fuller Hercules cycle by Rubens, though not that this was necessarily connected with the Torre de la Parada.

Prov. See previous entry.

Jacob van RUISDAEL (1628/29–82)
Dutch School
Born in Haarlem, he was the son of a frame-maker and dealer who was also a painter, and may have studied under his uncle, Salomon van Ruysdael; he was also influenced by Cornelis Vroom (*c.*1590/91–1661). A member of the Haarlem guild in 1648, he settled in Amsterdam by 1657. He later became a doctor of medicine in 1676, at Caen. Hobbema was among his pupils.

Lit. Jakob Rosenberg, *Jacob van Ruisdael,* 1928.

Follower of RUISDAEL

159 LANDSCAPE WITH BLEACHING GROUNDS
Indistinctly signed lower left, (?) *Gi. . . or Ri. . .;* inscribed lower right with inventory no.147.
Canvas, $21\frac{1}{4} \times 25\frac{1}{2}$ (54 × 65)

While the woman is spreading out the sheets on the grass, a man is bringing a further load in a wheelbarrow. Another woman, carrying linen, is entering an outhouse.

Both the style and the subject matter derive from Jacob van Ruisdael. He painted bleaching grounds near Haarlem on several occasions (e.g. Rosenberg, *Ruisdael,* fig.119; *c.*1660) and the closed-in type of composition is typical of Ruisdael in the 1650s.

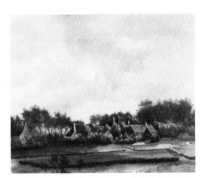

159 WM 1594–1948 Neg. Q1374
Wellington *Cat.,* p.101, no.57 black

The picture's poor condition generally, in particular the thinness of the paint surface in the foreground and on the trees, makes it difficult to speak with confidence on details of style and quality, yet it is clear that on neither count can it be attributed to Jacob Ruisdael himself. Jean Vermeer van Haarlem (1628–91) has been the traditional attribution accepted in the Wellington Catalogue, but it is difficult to support from his secure work. He was much influenced by Ruisdael and comparable views of bleaching grounds have been attributed to him (e.g. Senff sale, Anderson, New York, 28–9 March, 1928, lot 12, repr.) but the comparison is insufficiently close to warrant the attribution. Another follower of Ruisdael for whom bleaching grounds were a favourite subject was Jan van Kessel III (1641/2–1680), but his work differs in composition, being derived from Ruisdael's later, open

vista landscapes (examples at Kassel Museum; Brussels Museum; Ketton Cremer collection, Felbrigg). Until a convincing attribution is found, therefore, the picture can best be described as by an immediate follower of Jacob van Ruisdael.

Condition. Paint surface much worn, particularly in the foreground and on the tree; much retouched.
Prov. Spanish royal collection (not inv.); captured at Vitoria, 1813.

Giovanni Battista Salvi, called SASSOFERRATO (1609–1685)
Italian School
Born in Sassoferrato, he was influenced by Raphael's and Annibale Carracci's work in Rome, where he was also influenced by Domenichino. He was active mainly in Perugia, Urbino and Rome and was famous for his Madonnas, which he repeated in endless series of replicas. His paintings are so close to those of Raphael that he was at one time thought to be a 16th-century artist.

Lit. Francis Russell, 'Sassoferrato and his sources', *Burl. Mag.,* 119, 1977, p.694.

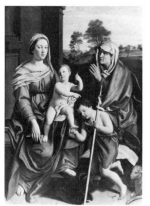
160 WM 1606–1948 Neg. P1419
Wellington *Cat.,* p.222, no.70 black

160 THE VIRGIN AND CHILD WITH ST ELIZABETH AND THE INFANT ST JOHN
Canvas, 62×47 (157×120)

The style is reminiscent of Raphael, though there is no closely comparable composition by him or by Guido Reni who, between them, provided the source of so many of Sassoferrato's works. Hermann Voss (1924) linked this painting with the artist's depictions of the *Holy Family* in Chantilly and Berlin, but these show St Joseph as well as St John and Elizabeth and are not very similar. The same figures (without St Joseph) appear on a painting by Sassoferrato in the Glasgow Art Gallery (*Italian Paintings, Illustrations,* 1970, p.92) but here also the composition is quite different.

For a similar Raphaelesque composition at Apsley House, painted a century later, see Mengs' *Holy Family.*

Condition. On coarse canvas which gives the surface a rough texture under smooth handling. There are large areas of repaint, e.g. the Baptist's left arm, the lamb and the lower part of the Virgin's dress.
Prov. Spanish royal collection (not inv.); captured at Vitoria, 1813.
Exh. Royal Manchester Institution, 1834, (118); 2nd Magnasco Society Exhibition, Agnew's, 1925 (7) (See Osbert Sitwell, 'The Magnasco Society', *Apollo,* 79, 1964, p.382).
Lit. Waagen, *Treasures,* p.277; H. Voss, *Die Malerei des Barock in Rom,* 1924, p.516; Gaya Nuño, *Pintura Europea,* p.87, no.290; Perez Sanchez, *Pintura Italiana. . .* p.332.

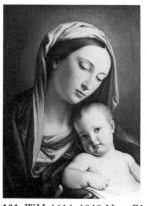
161 WM 1614–1948 Neg. P1420
Wellington *Cat.,* p.92, no.83 black

161 VIRGIN AND CHILD
Canvas, $19\frac{3}{8} \times 15\frac{1}{2}$ (49·2×39·3)

This may be identified with the painting of the Virgin and Child by Sassoferrato recorded in the collection of Charles IV, when he was Prince of Asturias, in his summer palace, the Casa de Campo at the Escorial: 'Otra pintura de *Nuestra Señora con el Niño,* de dos tercios de alta y media vara de ancho; su autor Sasso Ferrato' (i.e. about 56x42cm. See Zarco Cuevas, 1934). It should be distinguished from the Virgin and Sleeping Child in the Prado (no.342) with which it has been confused (Zarco Cuevas; Perez Sanchez).

There are several versions of this composition by Sassoferrato or his workshop, including those in the Corsini Gallery, Rome; with Brian Koetser, London, exh. 1968; and formerly in the F. O. Blundell collection.

Condition. Damaged and retouched lower right, especially on the Child's arm and on the Child's head and right eye; otherwise quite good.

Prov. Charles IV, when Prince of Asturias, in the Casa de Campo de El Escorial, *c.*1782–88; captured at Vitoria, 1813.
Exh. Royal Manchester Institution, 1834, (118).
Lit. J. Zarco Cuevas, *Cuadros reunidos por Carlos IV, siende principe, en su Casa de Campo de El Escorial,* extract from 'Religion y Cultura', 1934, p.32; Gaya Nuño, *Pintura Europea,* p.87, no.288; Perez Sanchez, *Pintura Italiana,* p.331 (as 'Virgin and sleeping Child').

John SIMPSON (1782–1847)
British School
Student at the R. A. School and then assistant to Lawrence, he left London for Lisbon in 1834 and became court painter to the Queen of Portugal.

See also Wilkie, no.195.

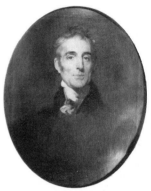

162 WM 1561–1948 Neg. HA3470
Wellington *Cat.,* p.386, no.235 red

162 Arthur Wellesley, First Duke of Wellington, k.g. (1769–1852)
Canvas, rectangular, framed in oval, 28×23

Head and shoulders, *c.*1835, wearing dark coat and white neckcloth. An inscription on the stretcher at the back: *Sir John Beckett, 11 Stratford Place,* has linked this portrait with a correspondence between Sir John Beckett and the Duke of Wellington in which Beckett asks the Duke to sit for him to Mr Simpson. The Duke refused in a letter of July 1834:

> I have not promised to sit for less than a score of portraits. No Portrait Painter will copy the picture of another nor paint an original under from 15 to 20 sittings, and thus I am expected to give not less than 400 sittings to a Portrait Painter in addition to all the other matters I must attend to, and in addition to the reception of and answers to such applications. 'À l'impossible personne n'est tenu,' and I must plead the truth of that Proverb. . .

It is possible that the Duke relented and sat to Simpson after all, but, as Wellesley, Steegmann point out, the portrait is very close to Lawrence's of *c.*1829 in the collection of the Earl of Jersey (Wellesley, Steegmann, pl.28) and may have been inspired by it. In any case Simpson painted a full-length of Wellington in 1835, which was exhibited at the R.A. in the following year, and there is evidence that he sat to Simpson in 1837 for a head and shoulders portrait in the Earl of Normanton collection (Wellesley, Steegmann, p.46, nos.2 and 3).

Prov. Sir John Beckett; bought by or presented to the 1st or 2nd Duke of Wellington.
Lit. Wellesley, Steegmann, *Iconography,* 1935, p.46.

Jan STEEN (1625/6–79)
Dutch School
Born in Leyden, he was a pupil of Jan van Goyen, whose daughter he married. He subsequently lived at the Hague, Delft (where he leased a brewery from his father), Haarlem and Leyden, where he received permission to keep an inn in 1672. He is well known for his lively genre scenes.

Lit. W. Martin, *Jan Steen,* 1954.

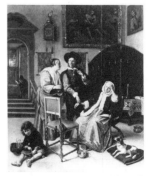

163 WM 1525–1948 Neg. F965
Wellington *Cat.,* p.39, no.81 red

163 The physician's visit
Signed on lower step leading to inner room *J Steen*
Oak panel, 19¼×16½ (49×42)

In this painting, as in the many other variations on this theme by Jan Steen, the girl is not ill but lovesick. To underline the point, there is a picture of Venus and Adonis on the wall and the boy in the foreground is Cupid in 17th-century costume, putting an arrow in his bow. The doctor looks knowingly at the girl's mother, who is holding a urine bottle. The second picture is Frans Hals' *The laughing mulatto,* now at Cassel, which also appears in the *Christening* at Berlin-Dahlem. A curious dish at the girl's feet contains a length of ribbon which was used to burn and to revive the patient by its smell

— a popular remedy of the time (J. B. F. van Gils, 'Een detail op de Doktorsschildereijen van Jan Steen', *Oud Holland,* 38, 1920, p.200f.).

It has been suggested that Jan Steen rendered the doctor's costume in the style of the actors of the Commedia dell'Arte. (S. J. Gudlaugsson, *De Komedianten van Jan Steen en zijn tijdgenoten,* 1945, English ed. 1975; Martin, 1954, p.64.) Such influence undoubtedly occurs in the artist's work, but in this instance it must be said that the wide hat and slashed sleeves were part of the rather conservative professional dress of the 17th century (oral opinion of Mrs M. Ginsburg; c.f. the music master in Jan Steen's *Harpsichord lesson,* Wallace collection).

Jan Steen painted this subject many times: over forty variants are listed by Hofstede de Groot. The paintings in the Alte Pinakothek, Munich, the Hermitage, Leningrad, and the Mauritshuis, The Hague, are all similar in various ways. An identical version was in the collection of P.H. Ford (Christie's, 24 Oct. 1958, lot 102, panel, $18\frac{1}{2} \times 16\frac{1}{2}$in., H. de G. no.167; R.A. Winter Exhibition, 1885, no.75). The Wellington picture may be dated in the 1660s from the costume (Martin, 1954).

No other artist treated this subject so often or in such variety, but among contemporaries Gerard Dou, Gabriel Metsu, and Frans van Mieris painted comparable scenes of lovesick women (J. A. van Dongen, *De Zieke Mens in de Beeldende Kunst,* Amsterdam, 1968, p.11; *Tot Lering en Vermaak,* p.242). This, also, was the period of Molière's *Le Malade Imaginaire.*

Condition. Panel split one-third from right hand edge; repaired in 1950.
Prov. Either this or the identical version was in the J. P. Wierman sale, Amsterdam, 18 Aug. 1762, lot 40; sale Amsterdam, 4 July 1798, lot 90; Jan Gildemeester Jansz, Amsterdam, 11 June 1800, lot 203; the dowager Boreel, Amsterdam, 23 Sept. 1814, lot 19. Bought by the Duke of Wellington at the Lapeyrière sale, Paris, April 1817, lot 55.
Exh. B.I., *(Old Masters),* 1818 (19); Guildhall, *Loan Exhibition,* 1892 (87); *Jan Steen,* Dowdeswell Galleries, 1909 (30); B.F.A.C., *Winter Exhibition,* 1927–8 (33); R.A. *Dutch Art,* 1929 (188); Arts Council, 1949, cat. 9 pl.1 (but not actually exhibited).
Lit. Smith, *Cat. Rais.,* iv, p.24, no.75; Waagen *Art and Artists,* 1838, p.298; Waagen *Treasures* ii, p.273; T. van Westrheene, *Jan Steen,* 1856, no.72; Hofstede de Groot, i, no.137; A. Bredius, *Jan Steen,* 1927, p.49, pl.33; W. Martin, *Jan Steen,* 1954, p.64, pl.70; *Tot Lering en Vermaak,* Rijksmuseum, Amsterdam, 1976, p.234 f, fig.61b.

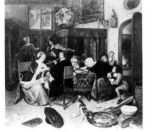

164 WM 1541–1948 Neg. F967
Wellington *Cat.,* p.20, no.73 red

164 THE DISSOLUTE HOUSEHOLD
Signed *J. Steen* (J and S monogram) on board on floor and inscribed *Bedurfve huishow* (dissolute household)
Canvas, $31\frac{3}{4} \times 35$ ($80 \cdot 5 \times 89$)

As the inscription indicates, the picture expounds the effects of intemperance, and these are made clearly visible in every detail. The master of the house is too busy love-making to care about the chaos that will soon engulf him, the mother is having her pocket picked, the dog is eating the meat in the foreground and the maid, who has stolen a necklace, is entertaining a fiddler. Less obviously, an unwatched roast has fallen into the fire in the next room, a monkey — a symbol of 'everything sub-human in man, of lust, greed, gluttony and shamelessness in the widest possible sense' (E. Panofsky, *Studies in Iconology,* 1967, Harper Torchbook ed., p.195) — has stopped the clock, and even the oyster shells in the foreground are unduly large. Suspended from the ceiling is a tub containing the punishments awaiting the dissolute household, including a birch, a sword, an empty purse and a clapper, used to give warning of contagious diseases.

Jan Steen painted this subject several times. There is a similar scene, dated 1663, in the Vienna Museum, and another *Effects of Intemperance* (33x34 in.) was sold at Christie's 16 March 1956, lot 161 (exh. Slatter, 1950,

no.1; Bredius, 1927, pl.16; Hofstede de Groot, no.110). A date in the 1660s is likely for the Wellington picture also.

Condition. Cleaned by Horace Buttery *c.*1947.
Prov. According to Hofstede de Groot, this was the picture in the sales of P. de Smeth van Alphen, Amsterdam, 1 Aug. 1810, lot 96 (bought Rijers) and W. Rijers, Amsterdam, 21 Sept. 1814, lot 143 (bought Eversdijk), but the descriptions in the catalogues are imprecise and do not allow a conclusive identification. Bought for the Duke of Wellington by Féréol Bonnemaison in 1818.
Exh. B.I., *Old Masters*, 1821 (44), 1831 (150), 1845 (48) (as 'Jan Steen's family'); R.A. *Old Masters*, 1886 (90) (reviewed, *Athenaeum*, 30 Jan. 1886); Dowdeswell Galleries, *Jan Steen*, 1909 (11); R.A., *Dutch Art*, 1929 (177); Arts Council, 1949 (10); Bordeaux Museum, *La Femme et l'Artiste*, 1964 (63); Ferens Art Gallery, Hull, *Scholars of Nature*, 1981 (33).
Lit. Smith, *Cat. Rais.,* iv, p.25, no.78; Waagen, *Treasures*, ii, p.273; Passavant, *Tour*, p.172; T. van Westrheene, *Jan Steen*, 1856, no.74; H. de G., i, no.109; A. Bredius, *Jan Steen*, 1927, p.41, pl.17; W. Martin, *Jan Steen*, 1954, p.51, pl.49.

165 A WEDDING PARTY
Signed and dated lower centre, *J. Steen 1667*
Canvas, 39½ × 61½ (101 × 156)

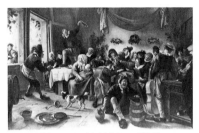

165 WM 1510–1948 Neg. F961
Wellington *Cat.*, p.40, no.47 red

The bride and groom sitting under the middle wreath are dwarfed by the guests in their revelry. In front of the couple is a woman with a saucepan on her head, holding a large spoon: attributes of Gluttony that appear, for example, on the monster in the lower right-hand corner of Brueghel's *Gula* (Gluttony; drawing of 1556–7, subsequently engraved; for a discussion of the subject matter see C. G. Stridbeck, *Bruegelstudien*, Stockholm, 1956, p.113, fig.14). The use of the wedding feast as a theme to highlight human debauchery also occurs in the work of Pieter Brueghel, whose *Wedding Banquet* (Vienna, Kunsthistorisches Museum) and *Wedding Dance* (Detroit, Institute of Arts) may be seen as the forerunners of Jan Steen's composition (F. Grossmann, *Pieter Brueghel, The complete paintings*, 3rd ed., 1973, pp.199–201; for a recent discussion see also S. Alpers 'Bruegel's festive peasants', *Simiolus*, 6, 1972–3, p.163).

Several of the figures — in particular the musicians on the left — are in the actors' costumes of the *Commedia dell'Arte*. The man in the high hat on the left is the innkeeper, whose costume is reminiscent of Pulcinello's (Gudlaugsson, 1945).

Here, as elsewhere in his work, Jan Steen can be appreciated for the meticulous painting of the still life in the foreground as much as for his moralizing portrayal of peasant life. The figure seated in the foreground is possibly intended as a self-portrait; the type is ubiquitous in Jan Steen's paintings (cf. the self-portrait, formerly in the Ten Cate collection, reproduced by de Jonge, 1946, p.47).

Condition. Crack in paint surface running down centre and damaging the last letter of the signature, otherwise good. Cleaned by Horace Buttery, 1950–51.
Prov. Auctioned at the Hague, 24 April 1737, lot 7; Burgomaster Hogguer, sale 18 Aug. 1817, bt. by Woodburn and Buchanan; Le Rouge sale, Paris, 27 etc. April 1818, lot 53, bt. by Féréol Bonnemaison for 11,810 fr. (£472) for the Duke of Wellington.
Exh. B.I., *Old Masters*, 1821 (82); 1848 (15) (reviewed, *Athenaeum*, 24 June, 1848); 1856; R.A., *Old Masters*, 1888 (59) (reviewed, *Athenaeum*, 7 Jan. 1888), Dowdeswell Galleries, *Jan Steen*, 1909 (8); R.A., *Dutch Art*, 1929, (204); Arts Council, 1949 (8); Mauritshuis, The Hague, *Jan Steen*, 1958–9, (43), pl.41.
Lit. W. Buchanan, *Memoirs of Painting. . .*, ii, 1824, p.354 (Buchanan bought a half share); Smith, *Cat. Rais.,* iv, p.36, no.111; Waagen, *Art and Artists*, ii, 1838, p.299; H. de G., i, no.462; A. Bredius, *Jan Steen*, 1927, p.54, pl.43; S. J. Gudlaugsson, *De Komedianten van Jan Steen en zijn tijdgenoten*, The Hague, 1945, p.51, fig.51, Eng. ed. 1975; C. H. de Jonge, *Jan Steen* (Palet Serie) Amsterdam, 1946, p.47, repr. p.45; W. Martin, *Jan Steen*, 1954, p.53, pl.86 (apparently confused with the *Egg Dance*).

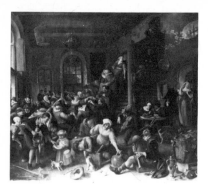

166 WM 1507–1948 Neg. F970
Wellington *Cat.*, p.318, no.64 red

166 THE EGG DANCE: PEASANTS MERRYMAKING IN AN INN
Canvas, $43\frac{5}{8} \times 53$ (110×135)

The 'Egg Dance' is being performed by the group in the centre, the idea being for the participants to work the eggs out of the circle without breaking any of them. It was a popular pastime in Holland in the 16th and 17th centuries; among earlier representations is Pieter Aertsen's *Egg Dance* in the Rijksmuseum, Amsterdam (see N. G. exhibition catalogue, 1976). The majority of the revellers are engaged in eating, drinking and amorous pursuits. The bird in the cage, symbol of chastity, has flown. Ellis Waterhouse (Arts Council exhibition catalogue, 1949) suggested that the lady standing in the doorway on the right between the two men may be an illustration of the choice between virtue and vice. The fashionable man could be encouraging her to enter the inn while his soberly dressed companion stands behind, but the more usual representation of this scene is of a man choosing between two women, as in the *Choice of Hercules*. The theme of the well-dressed lady accosted or attacked as she enters a rowdy tavern is a recurrent one in Jan Steen's work and may be seen, for example, in the merrymaking scenes in the Vienna Museum and the Hermitage, Leningrad.

This is one of Jan Steen's most elaborate and ambitious compositions in terms of the large number of figures and activities portrayed. Like the other paintings of this kind, it is a late work. It is closely comparable with the *Merrymaking in an Inn* in the Louvre, which is dated 1674, and the similar scene in the royal collection.

Condition. Good; cleaned by Horace Buttery, 1950–51.
Prov. Le Rouge sale, Paris, April 1818, lot 54, bought by Féréol Bonnemaison for the Duke of Wellington for 3,000 fr. (£120).
Exh. B.I., *Old Masters,* 1821, (136); 1848 (21) (review in *Athenaeum,* 24 June 1848) 1856; Dowdeswell Galleries, *Jan Steen,* 1909 (18); Arts Council, 1949 (11); *Art in Seventeenth Century Holland,* N.G., 1976 (108).
Lit. Smith, *Cat. Rais.,* iv, p.36, no.110; Waagen, *Art and Artists,* ii, p.299; H. de G., i, no.600; W. Martin, *Jan Steen,* 1954, p.53, pl.53 (apparently confused with the *Wedding Feast*).

Abraham STORCK (1644–after 1704)
Dutch School
He was born in Amsterdam and lived there most of his life. His seascapes and Dutch harbour scenes are in the style of Willem van Velde and Bakhuizen.

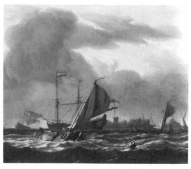

167 WM 1642–1948 Neg. J935
Wellington *Cat.*, p.25, no.148 black

167 DUTCH SHIPPING IN A RIVER
Signed on lowest bar of fence on right *A. STORCK:* inscribed in white with inventory no., lower right, *328.*
Canvas, $13\frac{1}{2} \times 18$ (34×46)

Prov. Spanish royal collection (not inv.); captured at Vitoria, 1813.
Lit. Gaya Nuño, *Pintura Europea,* no.197; Valdivieso, *Pintura Holandesa,* p.374.

Jacques François Joseph SWEBACH called Fontaine (or Swebach-Desfontaines) (1769–1823)
French School
Born in Metz, the son of a painter, he was a pupil of Michel Duplessis in Paris and began to exhibit camp and battle scenes regularly from 1788. In 1800 he was commissioned to paint a picture for the Empress Josephine's house at Malmaison and from 1802–13 he was the first painter at the Sèvres porcelain factory.

Lit. Edouard André, *Swebach-Desfontaines,* Paris, 1905.

168 An encampment
Signed on fountain lower left *Swebach dit font*(aine) *1796*. Inscribed with
inventory no. lower left corner: *103*.
Canvas, 26 × 33¾ (67 × 85·7)

In the centre four mounted officers are conversing, with the one on the left
riding away. Behind them are various tents; the one on the right with a
signboard is apparently a canteen, with soldiers drinking outside. There is
another tent in the right foreground, with barrel hoops at the side.

Although the composition is derived from Dutch 17th-century camp
scenes, in particular those of Wouverman (compare no.197), the tonality is
very much lighter, as befits a painting of this period.

Condition. Good, cleaned in 1980.
Prov. Spanish royal collection (not inv.); captured at Vitoria, 1813.

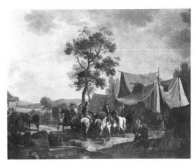

168 WM 1643–1948 Neg. Q1386
Wellington *Cat.*, p.252, no.174 black

169 Passage of the Danube by Napoleon before the Battle of Wagram
Signed on hut on left *Swebach dit fontaines. 1810*
Canvas, 31¾ × 50½ (80·5 × 128·5)

In the foreground the French army is shown on the right bank of the Danube,
crossing on a pile bridge to a small island and beyond that to the island of
Lobau. On the right a mounted groom in imperial livery, facing the river, is
talking to Rustam, the Emperor's famous Mameluke. A little to the left is the
Emperor's grey charger Marengo, held by another groom on foot. Napoleon
himself stands in the right centre foreground accompanied by a general and a
marshal, talking to an officer of the ordnance. In the centre foreground, seen
from the back, are a general and an officer of the Bavarian army. On a second
bridge — of boats — troops are returning to the right bank with wagons,
presumably to fetch ammunition and supplies.

169 WM 1560–1948 Neg. P1464
Wellington *Cat.*, p.262, no.224 red

This is the painting for which Swebach was awarded the *grande medaille*
at the Salon of 1810. It bore the double title: *Passage du Danube avant la
bataille de Wagram* and *Napoleon traversant le Danube pendant la matinée du 5
Juillet 1809*. The Duchess of Wellington, unaware that this was the artist's
own title, argued that the painting depicts the crossing of the Danube before
the battle of Essling, six weeks before Wagram. Recently the original title has
been supported by M. Jean Brunon, specialist in Napoleonic studies, who has
confirmed that the scene represents the early morning of Wednesday, 5th
July, the first day of the battle of Wagram, also known as the battle of
Enzersdorf (written opinion, 1964).

The construction of this pile bridge was a matter of great pride to the
French engineers. It had been built during June with supplies brought from
Vienna and it enabled Napoleon to make his claim that 'the Danube no longer
exists' (Rauchensteiner, 1977). A comparable depiction of this scene,
apparently showing the second lap of the crossing to Lobau with two pile
bridges next to each other, is given in a drawing by A. Delaborde (repr.
Quennerat, 1966, p.117, fig.23). After the crossing, Napoleon's first attack on
the Austrian army under Archduke Charles was beaten back, but he inflicted
a heavy defeat on the Austrians on the following day. The victory at Wagram
led to the Treaty of Schönbrunn which ended Austria's war of 1809 against
the French control of Germany.

Swebach exhibited battle scenes of Napoleon's victories from 1802,
including those at Mount Thabor, Marengo, Rivoli and Austerlitz. In each of
these he succeeded in incorporating lively anecdotal scenes in large, carefully
controlled formal set-pieces. WM 1560 has a more naturalistic appearance.
The first owner of the picture, B. B. Williams, maintained that Swebach was
actually an eyewitness of the crossing, claiming that it was 'taken on the spot
by Swebach' (Wellington *Cat.*). We do know that he visited the banks of the
Danube in 1809 and made sketches there (André, p.20). In any case, the

painting was recognized as outstanding in Swebach's *oeuvre*; it won him a gold medal at the Salon and a glowing review by the anonymous author of the *Entretiens sur les ouvrages de peinture, sculpture et gravure exposés au Musée Napoléon en 1810*. He listed its qualities — masterly perspective, realism of landscape, freshness of atmosphere, composition and movement — and pronounced it one of the most beautiful pictures in the exhibition.

Condition. Diagonal scratch lower right; otherwise very good.
Prov. 1814, B. B. Williams; bought from him by the Duke of Wellington in 1843 for £600 (the original price had been £1200, but after consulting Seguier the Duke offered £500 and Williams ultimately settled for £600).
Lit. Entretiens sur les ouvrages de peinture, sculpture et gravure exposés au Musée Napoléon en 1810, Paris, 1811, p.109f. (quoted by André); André, *Swebach*, 1905, p.20f.; The Duke of Wellington, 'Two war artists under Napoleon and the Tsar', *Connoisseur*, 193, 1976, p.305ff. On the crossing of the Danube and the battle of Wagram see: J. C. Quennerat, *Atlas de la Grande Armée*, 1966, p.117; V. J. Esposito, *A Military History and Atlas of the Napoleonic Wars*, 1964, map 104 (the clearest map); M. Rauchensteiner, *Die Schlacht bei Deutsch Wagram*, Vienna 1977, pp.11–14.

David TENIERS the younger (1610–90)
Flemish school

Born in Antwerp, where he was a pupil of his father David Teniers I, he moved to Brussels in 1651 and became court painter and curator of the picture collection to the Archduke Leopold William, governor of the Netherlands. His earliest works are peasant interiors in the manner of Brouwer; from about 1640 he combined landscapes with scenes of peasant life.

The Duke of Wellington owned fifteen paintings by Teniers — most of them from the Spanish royal collection. Ten are now in the Wellington Museum (see below) and five remain in the present Duke's collection (Wellington *Cat.*, nos.13,14,16,31,237).

170 WM 1499–1948 Neg. H1517
Wellington *Cat.*, p.32, no.55 black

171 WM 1579–1948 Neg. GF1206
Wellington *Cat.*, p.11, no.32 black

170 A VILLAGE MERRYMAKING AT A COUNTRY INN
Signed and dated lower right *D. TENIERS. FIC.1655*
Copper, $6\frac{3}{4} \times 8\frac{1}{8}$ (17 × 20·6)

Village festivals with dancers and bagpipers are very common in Teniers' work; there is a similar composition, for example, in the Metropolitan Museum, New York (no.25.110.64).

In contrast to the large canvases by Teniers from the Spanish royal collection, this small panel on copper was acquired by the Duke at the Lapeyrière sale. One similar composition of comparable size was among the paintings captured at Vitoria (Wellington *Cat.*, p.23, no.16); it is now in the Duke of Wellington's collection at Stratfield Saye.

Condition. Good. Cleaned in 1949.
Prov. Sales: Randon de Boisset, Paris, Feb. 1777 (lot 62; 2011 fr.); Destouches, Paris, March 1794; Wautier of Brussels, Paris, June 1797, (4000 fr.); Solirène, Paris, March 1812 (2501 fr.); Lapeyrière, April 1817 (lot 58; 5,500 fr., £222). Bought by Bonnemaison for the Duke of Wellington.
Exh. B.I., *Old Masters*, 1818 (21); R.A., *Old Masters*, 1890 (109) (reviewed, *Athenaeum*, 8 Feb. 1890).
Lit. Smith, *Cat. Rais.*, iii, p.314, no.199; Waagen, *Treasures*, ii, p.274.

171 PEASANTS PLAYING BOWLS IN FRONT OF AN INN BY A RIVER
Signed on the stone on the right *D. TENIERS F*
Canvas, $23\frac{7}{8} \times 31\frac{1}{4}$ (60·6 × 79·4)

This is a recurrent theme in the work of Teniers. There are similar compositions, for example, in the National Gallery of Scotland, Edinburgh,

and, on a larger scale, in the National Gallery (no.951, dated about 1660; Gregory Martin, *The Flemish School*, 1970, p.267).

Prov. Isabella Farnese collection, La Granja inventory 1746, no.329; Royal Palace, Madrid, inventory 1772, no.329, in the King's retiring room. Captured at Vitoria, 1813.
Lit. Gaya Nuño, *Pintura Europea*, no.144.

172 A FLEMISH VILLAGE FESTIVAL
Signed right foreground below cloth *DAVID TENIERS FC* (1639 on Magpie board)
Inscribed in pink with inventory no.894
Canvas, $33\frac{1}{2} \times 46\frac{7}{8}$ (85 × 119)

172 WM 1581–1948 Neg. Q1362
Wellington *Cat.*, p.29, no.34 black

In the centre a man with an apron is apparently drinking the health of the winner of the game, who is holding the prize in his hand. On the right some girls are playing a game, watched by an audience of men. The inn on the left has the sign of the Magpie.

Condition. Flaking paint laid, and cleaned 1981.
Prov. Possibly from the Spanish royal collection (the inscription 894 is presumably the inventory number, but it does not tally with the principal royal inventories. According to Nieuwenhuys, in a letter to Lady Burghersh, 12 October 1840: 'Le tableau. . . fit autrefois de la Galerie des Rois d'Espagne, où il resta jusqu'à la première invasion française de ce pays').
 Thomas Emmerson, sale 1829 (370 gns); bought for the Duke of Wellington in 1840 by Lord Burghersh at Brussels for 25,000 fr. (£1,000).
Exh. B.I., *Old Masters*, 1841 (58); R.A., *Old Masters*, 1886 (reviewed, *Athenaeum*, 30 Jan. 1886).
Lit. Smith, *Cat. Rais.*, iii, p.395, no.510; ix, p.468, no.198.

173 A LIME-KILN WITH FIGURES
Signed on stone in right foreground *D. TENIERS F*
Canvas, $23 \times 34\frac{5}{8}$ (58·5 × 88)

This is one of the rare examples of paintings of industrial scenery in the 17th century. It shows the preparation of limestone for the kiln in which lime — the chief constituent of mortar — is produced by calcining the limestone.

173 WM 1583–1948 Neg. H883
Wellington *Cat.*, p.27 no.36 black

 With the coming of the industrial revolution in the 18th century, industrial landscape became a feature of picturesque and of romantic painting in England, (F. D. Klingender, *Art and the Industrial Revolution*, p.72ff.), but it appears only occasionally in the art of 17th-century Europe. Rural industries like bleaching and sand quarries were depicted by Netherlandish artists, including Teniers (Kunsthalle, Hamburg; Petworth, respectively), but scenes with lime-kilns are exceedingly rare and Teniers appears to have been the only painter of his time to depict this subject on several occasions. Comparable scenes by him are the *Lime-Kiln near an inn* (Christie's, 23 June 1967 and again 29 June 1973, lot 101 repr.) and the *Brick making* at the Dulwich Gallery (P. Murray, *The Dulwich Picture Gallery*, 1980, no.57 repr.) The Wellington picture has points of similarity with both these compositions.

Condition. Cleaned in 1949.
Prov. Spanish royal collection (not inv.); captured at Vitoria, 1813.
Lit. Gaya Nuño, *Pintura Europea*, no.152.

174 LANDSCAPE WITH TWO SHEPHERDS, CATTLE AND DUCKS
Signed on stone lower left *D. TENIERS F.*
Inscribed in white with inventory no.791
Canvas, $18\frac{3}{8} \times 37\frac{3}{4}$ (46·7 × 96)

The large foreground figures are very similar to those in the Harvest scene,

174 WM 1589–1948 Neg. H884
Wellington *Cat.*, p.15, no.46 black

WM 1602, and the Landscape with shepherds and cattle, WM 1613 (nos.176, 179). An analogous composition is the *Coloquio pastoril* in the Prado (no.1814; M. Diaz Padrón, *Catalogo de Pinturas*, i, *Escuela Flamenca siglo XVII*, 1975, p.407, pl.273).

Condition. Vertical tear in centre. Cleaned in 1949.
Prov. Spanish royal collection: 1734 inventory of pictures saved from the fire of the Alcázar, no.791; 1772 inventory of the Royal Palace, Madrid, no.791, Green Cabinet room; captured at Vitoria, 1813.
Lit. Gaya Nuño, *Pintura Europea*, no.146.

175 WM 1595–1948 Neg. H1522
Wellington *Cat.*, p.12, no.52 black

175 INTERIOR OF A COWSHED
Canvas, 21¼ × 36 (54 × 91·4)

Stylistic factors, including the careful execution and the monumental quality of the figures, suggest that this picture was painted in *c.*1640–50, when Teniers was at the peak of his career. Such compositions are not very frequent in Teniers' *oeuvre*, but the woman and the boy with the calf reappear in identical postures in an *Interior* in Budapest (Exh. of *Old Masters in Hungarian private collections*, Museum of Fine Art, Budapest, 1946, no.93, pl.27) and there are comparable scenes of cowsheds in the Kiev Museum, the Vienna Museum (Adolf Rosenberg, *Teniers der Jüngere*, 1895, fig.42) and the Sedelmeyer sale (Paris, 1907, no.55). These three pictures also include the owl perched on rafters or on the stalls. Owls are usually symbols of gluttony in 17th-century Dutch scenes of feasting and revelry *(Reallexikon zur deutschen Kunstgeschichte,* vi, 267ff.) but in this case the reference is presumably to the owl as a night bird, perched in the darkness of the shed.

Condition. Cleaned 1950; small area of damage lower right.
Prov. Spanish royal collection (not inv.); captured at Vitoria, 1813.
Lit. Gaya Nuño, *Pintura Europea*, no.145.

176 WM 1602–1948 Neg. H885
Wellington *Cat.*, p.18, no.63 black

176 A HARVEST SCENE
Signed lower centre *D. Teniers F*
Inscribed in white with inventory no.108
Canvas, 19¼ × 24¼ (50 × 61·6)

Numerous figures are at work cutting and binding in a cornfield. Such scenes of harvesting are rare in Teniers' *oeuvre*; a comparable painting is in the Liechtenstein Collection. The subject is the traditional one chosen to illustrate the month of July or August in calendars.

Condition. Good. Cleaned in 1950.
Prov. Spanish royal collection: 1734 inventory of pictures saved from the fire in the Alcázar, no.108; 1772 inventory of the Royal Palace, Madrid, no.108, passage to the King's pew; captured at Vitoria, 1813.
Exh. B.I., *Old Masters*, 1824 (44).
Lit. Gaya Nuño *Pintura Europea*, no.147.

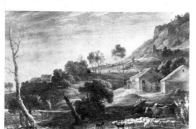

177 WM 1609–1948 Neg. H886
Wellington *Cat.*, p.97, no.77 black

177 LANDSCAPE WITH PEASANTS DRIVING CATTLE: EVENING
Signed on stone lower right *D. TENIERS FEC.*
Canvas, 18¼ × 29¼ (46·3 × 74·3)

Similar in subject to WM 1589 and 1613, the scale of the figures is smaller and the execution more perfunctory, probably indicating a later date.

Condition. Cleaned in 1949.
Prov. Spanish royal collection: 1734 inventory of pictures saved from the fire in the Alcázar, no.864; 1772 inventory of the Royal Palace, Madrid, no.864, apartment of the Infante Don Xavier, 'a landscape with a cottage, a shepherd and shepherdess'. Captured at Vitoria, 1813.
Lit. Gaya Nuño, *Pintura Europea*, no.154.

178 VIEW OF THE ARTIST'S HOUSE '*DE DRY TOREN*' NEAR PERCK
Signed on stone lower right *DT.F* (DT in monogram)
Canvas, $32\frac{3}{4} \times 67$ (83×170)

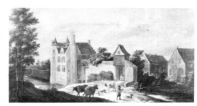
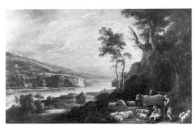

178 WM 1611–1948 Neg. GD591
Wellington *Cat.*, p.26, no.79 black

The building was identified with Teniers' own house, De Dry Toren near Perck, by Gregory Martin (1968) upon comparisons with a line illustration in *Les Belges Illustres, Panthéon Nationale*, 1844 (ii, p.32). Of its three towers, the third is an observation tower characterized by its open-work top. Views of this house recur frequently in Teniers' work (e.g. (1) Duke of Buccleuch coll., exh. *Flemish Art*, R.A., 1927, no.300; (2) Sale, Fischer, Lucerne, 12 June 1970, lot 521). Teniers bought the Dry Toren from J. B. von Broeckhoven and Helene Fourment, Rubens' widow, in 1662, which provides a terminus post for this painting. Perck is not far from Rubens' own Château de Steen.

Condition. Cleaned in 1949.
Prov. Spanish royal collection (not inv.); captured at Vitoria, 1813.
Lit. Gaya Nuño, *Pintura Europea*, no.151, pl.59. Gregory Martin, 'A view of Het Sterckshof by David Teniers the younger,' *Burl. Mag.*, 110, 1968, p.577, fig.57.

179 LANDSCAPE WITH SHEPHERDS AND A DISTANT VIEW OF A CASTLE
Inscribed in white with inventory no. 893
Canvas, $21\frac{1}{2} \times 35\frac{1}{8}$ ($54 \cdot 6 \times 89$)

The large foreground figures are very similar to those in the *Landscape with two shepherds* (WM 1589, no.174) and the theme is analogous to the pastoral landscapes in the Prado (see no.174) and to one in a private collection in Denmark, which is dated 1668 (Bruegel exh. 1980, no.226).

179 WM 1613–1948 Neg. H888
Wellington *Cat.*, p.25, no.81 black

Condition. Cleaned in 1949.
Prov. Spanish royal collection: 1734 inventory of pictures saved from the fire in the Alcázar, no.893; 1772 inventory of the Royal Palace, Madrid, no.893, apartment of the Infante Don Xavier; captured at Vitoria, 1813.
Exh. Brussels, Palais des Beaux-Arts, *Bruegel*, 1980, no.228.
Lit. Gaya Nuño, *Pintura Europea*, no.150, pl.60.

TITIAN (Tiziano Vercellio) (*c.*1482–1576)
Italian (Venetian) School
Titian came from Cadore in the Dolomites to Venice to learn painting and became a pupil of Gentile and Giovanni Bellini and Giorgione. From the time of his *Assumption*, 1516–18 (Frari, Venice) until his death, he was widely recognized as the greatest Venetian painter. He was spectacularly successful as a painter of portraits and mythological and religious subjects.

Lit. Harold E. Wethey, *The Paintings of Titian*.

Follower of TITIAN

180 AN UNKNOWN LADY, CALLED 'TITIAN'S MISTRESS'
Inscribed in red, centre foreground, with inventory no.49
Canvas, $38\frac{3}{8} \times 28$ ($97 \cdot 5 \times 71$)

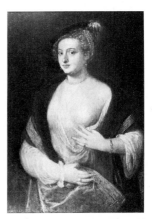

180 WM 1620–1948 Neg. H892
Wellington *Cat.*, p.222, no.92 black

The nude breast was at one time painted over with a pale grey veil, the remains of which are still visible. According to the 1772 inventory of the Royal Palace, Madrid, this was one of eight portraits, more than half length, by Titian; one a portrait of himself, another of his wife and the others of unknown sitters. The size given is $1\frac{1}{4} \times 1$ vara (106x85cm.) and a marginal note indicates that all these pictures were originally oval but were made square. The outlines of the original oval shape are still visible on the canvas.

Harold Wethey (1971) describes WM 1620 as School of Titian, about 1550, 'the quality. . . is moderately high, little if any inferior to the well-known picture of the *Girl in a Fur Coat and Hat* in Leningrad' (Titian workshop, Wethey, pl.265). The type of portrait is similar to Titian's *Girl in*

a Fur Coat in the Kunsthistorisches Museum, Vienna (Wethey, pl.73). For another comparable portrait from Titian's workshop in the Dortmund Gallery see M. Roy Fisher, *Titian's Assistants during his later years* (outstanding dissertation), 1977, p.36., pl.25.

Condition. See above.
Prov. Royal Palace, Madrid, King's antechamber (1772 inventory, one of a group of eight portraits by Titian, nos.42,45,85,39,46,118,39,39); captured at Vitoria, 1813.
Lit. Ponz, *Viage*, vi, 1782, p.26; H. E. Wethey, *The Paintings of Titian, ii, The Portraits*, 1971, p.179, no.X–91, pl.266.

Francesco TREVISANI (1656–1746)

Born in Capodistria, Trevisani studied in Venice until about 1678 when he settled in Rome. His paintings combine the expressiveness and chiaroscuro of the Roman followers of Caravaggio with the strong colours of the Venetian tradition.

Lit. F. R. Di Federico, *Francesco Trevisani*, Washington, 1977.

Ascribed to TREVISANI

181 THE VIRGIN AND CHILD WITH ST CARLO BORROMEO
Inscribed in white, lower right, with inventory no.396
Canvas, $18\frac{5}{8} \times 11\frac{1}{8}$ (47·3×28·3)

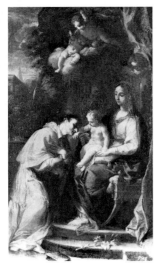

181 WM 1624–1948 Neg. Q1381
Wellington *Cat.*, p.119, no.104 black

The attribution to Trevisani is the traditional one, enshrined in the Wellington *Catalogue,* but the picture has not been identified in the royal Spanish inventories. Although there are generic similarities with Trevisani in style and composition (e.g. Di Federico, pl.74), the attribution is not really convincing in the light of recent appraisals of Trevisani's *oeuvre*. There are areas very crudely painted, for example, the saint's hand, but the surface is so rubbed, in many places down to the canvas, that it is difficult to assess the picture's original quality. Yet the pentimenti, for example at the saint's ear, indicate that it is probably an original work and not merely a copy. It seems reasonable to propose a date in the late 17th century.

Carlo Borromeo (1538–84) was the nephew of Pius IV, whose close collaborator he became. Created cardinal in 1560, he took a leading part in the Council of Trent, 1562–3, and as Archbishop of Milan from 1564 became one of the outstanding figures in the Counter-Reformation Church. He was canonized in 1610. Eight years later, Cardinal Federico Borromeo cited the portrait by Ambrogio Figini (1548–1600) in the Biblioteca Ambrosiana, Milan, as 'the best head done of him in a painting'. This authoritative evidence, together with the death-mask in the Capuchin monastery at Milan, have fixed Carlo Barromeo's physiognomy for future generations, though the multitude of subsequent portraits tend to exaggerate its most characteristic feature: the prominent nose (Angelo Maria Raggi, in *Bibliotheca Sanctorum,* Pontificia Università Lateranense, iii, 1963, col.846ff., with illustrations and bibliography).

Condition. Surface badly rubbed, particularly on the Christ Child and on the Virgin's face.
Prov. Spanish royal collection (not inv.); captured at Vitoria, 1813.

Diego VELAZQUEZ (1599–1660)
Spanish School
Born in Seville, he was a pupil of Francisco Pacheco 1613–18. He visited Madrid in 1622 and was recalled there in the following year by the Conde-Duque Alvarez, minister of Philip IV. He enjoyed immediate success, was appointed court painter and thereafter remained attached to the royal court, painting mainly portraits of the royal family and members of the court. He

was in Italy 1629–31, studying the painters of Venice, Rome and Naples, and again in 1649–51.

Lit. J. Lopez-Rey, *Velazquez, a catalogue raisonné,* 1963; new ed., 1979.

182 TWO YOUNG MEN EATING AT A HUMBLE TABLE
Canvas, 25¾ × 41 (65·3 × 104)

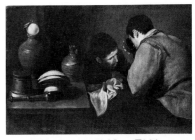

182 WM 1593–1948 Neg. F983
Wellington *Cat.,* p.210, no.50 black

In his early years, from 1617, when he entered the Guild of St Luke at Seville, until his final departure for Madrid in 1623, Velazquez painted several such scenes of everyday life. Related to the picaresque novels which had originated in Spain with Lazarillo de Tormes, they show ordinary people eating and drinking or preparing food and are characterized by an uncompromising realism and an ochre tonality with strong contrasts of light and shade. In these respects they owe much to the influence of Caravaggio, though in subject matter they are also related to the genre paintings of the 16th-century Flemish school. Several of these *bodegones* are oblong in shape, with half-length figures and prominent still life. In particular, the *Negro Servant* (Sir Alfred Beit collection), *Kitchen Scene with Christ in the house of Mary and Martha* (N.G.) and the Wellington picture form a closely knit group. The precise dating of these early paintings has hitherto been largely conjectural (see lit. below) as only one of them was known to be dated; the *Adoration of the Magi* (Prado) of 1619. More recently, however, cleaning has revealed the date 1618 on both the *Old Woman frying eggs* (N.G., Edinburgh) and the *Kitchen scene with Christ in the house of Mary and Martha* (N.G.). The two paintings are very similar in style to the Wellington picture, while the pestle and mortar and the green glazed oil jug appear in all three of them. This bears out a date *c.*1618–20 for the Wellington picture, even though it is painted on a finer canvas than the N.G. and Edinburgh pictures (see next entry).

The painting was first described by Palomino in 1724: 'He painted another picture of two poor men eating at a humble little table where there are different earthenware vessels, oranges, bread and other things, everything observed with rare thoroughness'. Subsequently it was in the collection of the Marquis of Ensenada, as 'two poor persons eating at a humble table': it was one of 29 pictures bought from the Ensenada collection by Charles III in 1769 and it has been fully recorded ever since (see below). There are versions or copies in a collection in Seville (Lopez-Rey, 106) and in a collection in Rome (Lopez-Rey, 107; A. di Stefano, *Archivo Español de Arte,* 27, 1954, pp.257–9).

Condition. A number of scattered retouched losses, particularly in background and on tunic of figure on right. Cleaned by Horace Buttery, 1958.
Prov. Marquis of Ensenada; bought by Charles III in 1769. Royal Palace, Madrid (1772 inventory, King's retiring room). Captured at Vitoria, 1813.
Exh. R.A., *Old Masters,* 1888 (125); New Gallery, *Spanish Art,* 1895–6 (73); Guildhall, *Spanish Painters,* 1901 (103); Grafton Galleries, *Spanish Old Masters,* 1913–14 (45); Arts Council/National Gallery, *Spanish Paintings,* 1947 (39); Arts Council, 1949 (14); N.G., *El Greco to Goya,* 1981 (14).
Lit. (N.B. The early sources are gathered together in *Velázquez, Homenaje en el Tercer Centenario,* Instituto Diego Velázquez, Madrid 1960.) Palomino, *Museo Pitorico,* iii, p.480 (1960 ed., p.32); Cumberland, *Catalogue,* 1787, p.54 (King's retiring room); Ponz, *Viage,* vi, p.34 (King's retiring room); Céan Bermudez, *Diccionario,* V, p.178; Stirling, *Annals,* ii, p.581; Stirling, *Velazquez and his works,* 1855, p.36; French ed. with catalogue by W. Bürger, 1865, p.270; C. B. Curtis, *Velazquez and Murillo,* 1883, p.37, no.85; G. Cruzada Villaamil, *Anales de la vida y de las obras de Velázquez,* 1885, p.326, no.166; Karl Justi, *Velazquez,* English ed., 1889, p.72.; M. Mesonero Romanos, *Velásquez fuera del Museo del Prado,* 1889, p.195; A. de Beruete, *Velasquez,* English ed., 1906 pp.7,151,157 (1617–23); F. J. Sanchez Canton, *Pintores de Camara,* Madrid, 1916, p.83; J. Allende-Salazar, *Velazquez,* K. d. K., 1925, pl.5 (*c.*1618); A. L. Mayer, *Velazquez,* 1936, no.109 (*c.*1619–20); E. Lafuente, *Velazquez,* Phaidon, 1943, no.7; E. du Gué Trapier, *Velasquez,* New York, 1948, pp.57,69; B. de Pantorba, *La*

Vida y la obra de Velázquez, 1955, no.13 (1618–20); J. Lopez-Rey, *Velazquez, a catalogue raisonné*, 1963, no.105 (c.1622); 1979 ed., no.24; M. A. Asturias, P. M. Brandi, *L'Opera completa di Velazquez*, Milan, 1969, no.4 (1618?); N. Maclaren, National Gallery, *Spanish School*, revised A. Braham, 1970, pp.122,124.

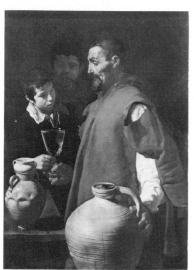

183 WM 1600–1948 Neg. S1275
Wellington *Cat.*, p.184, no.59 black

183 THE WATERSELLER OF SEVILLE

Canvas, 42x31⅞ (106·7x81); original size, without the addition of the 4 cm. strip added at top, 40½ × 31⅞ (103×81)

This is the most famous of all the *bodegones* painted by Velazquez before he left Seville for Madrid in 1623 (see previous entry). The nickname el Corzo, the Corsican, for the waterseller was recorded in the Buen Retiro inventory of 1701, and Palomino (1724, quoted by Lopez-Rey) described him somewhat fancifully: 'The painting called the Waterseller, who is an old man very shabbily dressed in a sordid ragged smock, which would discover his chest and abdomen covered with scabs and hard, strong callouses. And beside him there is a boy to whom he is giving a drink. This work has been so talked of that it has been kept to this day at the Palace of Buen Retiro.' The fig at the bottom of the glass which the waterseller is handing to the boy was commonly used to freshen the water (Lopez-Rey, p.163).

In style, this painting is very similar to the *Two men at a humble table* and to the other genre scenes of Velazquez's early period, 1617–23 (see previous entry). It has been variously dated within that period (see lit. below) but there is no firm evidence for precise dating. The handling of the chiaroscuro is very close to the *Adoration of the Magi* (Prado) which is dated 1619; the posture and lighting of the boy's head on the left is the same on both pictures. MacLaren/Braham (N.G. cat. 1970) pointed out that the open-weave canvas is of the same kind as that used for the *Kitchen Scene* (N.G.) and the *Old Woman frying eggs* (N.G. Edinburgh), both dated 1618. However, as these are the only three dated pictures of Velazquez's early period, there is insufficient evidence for a precise chronology and c.1620 would seem to be the most reasonable rendering of the date of the *Waterseller*.

It was probably one of the paintings Velazquez brought with him in 1623 to Madrid, where it was acquired by his early admirer and friend Don Juan Fonseca y Figueroa, chaplain to Philip IV (d.1627). When Velazquez appraised the paintings left by Fonseca he valued the *Waterseller* at 400 reales, higher than any other work in the collection. Yet the valuation in the 1701 inventory was, at 600 reales, surprisingly low in comparison with other works (Fernandez Bayton, *Inventorios*, II, p.316).

There are three copies, in each of which the waterseller is shown wearing a cap: Contini-Bonacossi collection, Florence; Walters Art Gallery, Baltimore, and ex-New York art market (Lopez-Rey, nos.125–7, pls.189–90,194). The painting was etched by Goya and frequently engraved (Blas Amettler, Madrid 1792–4; Bart. Vazquez, 1793 etc.).

Velazquez's *bodegones* were usually accepted at their face value as realistic genre scenes, the visual counterpart of the picaresque novel, until recently, when scholars took to analysing them for symbolic or allegorical content (see especially Julian Gallego, *Vision et Symboles dans la Peinture Espagnole du Siècle d'Or*, 1968. For interpretations of Dutch genre paintings see above under Nicolaes Maes and Jan Steen). The *Waterseller* has been variously interpreted. Moffitt (1978), following Gallego (1974), argued in detail that the three figures represent the three ages of man and can be interpreted by comparison with Titian's famous painting in the N.G., as an allegory of Prudence. These are interesting comparisons, but the clinching evidence for such interpretations is lacking. On the other hand, we do know that the waterseller was a feature of picaresque novels (ed. Angel Valbuena Prat, *La Novela picaresca española*, Antwerp, 1646, new ed. Madrid, 1968, p.1756) and

it may well be that there is no need to look further for his appearance in Velazquez' painting.

Condition. Good; cleaned in 1959. There are pentimenti at the collar of the waterseller's jacket, his right sleeve and the fingers of both hands.

Prov. Juan Fonseca y Figueroa, Madrid (d.1627); see J. Lopez Navio, 'Velazquez tas los cuadros de D. Juan de Fonseca', *Archivo Español de Arte*, 34,1961, p.64; Gaspar de Bracamonte, Madrid, traditionally, Cardinal Infante Don Fernando (d.1641); royal collection, Madrid: Buen Retiro Palace (1701 inventory no.496); Royal Palace (1772 inventory, no.497, hanging in the passage to the King's pew; 1794 inventory, King's dining room). Captured at Vitoria, 1813.

Exh. B.I., *Old Masters*, 1828 (46); 1847 (121); Royal Manchester Institution, 1834 (121); R.A., *Old Masters*, 1886 (119); New Gallery, 1895-6 (134); Guildhall, 1901 (100); Grafton Galleries, *National loan exhibition*, 1909-10 (31); id., 1913-14 (49); B.F.A.C., *Spanish Art*, 1928 (3); R.A., *17th century*, 1938 (219); Arts Council/N.G., *Spanish Paintings*, 1947, (37); Arts Council, 1949 (13); Madrid, *Velázquez y lo Velazqueño*, 1960 (40); Montreal, *Man and his world*, 1967 (35); N.G., *El Greco to Goya*, 1981 (15).

Lit. (for full titles see previous entry. Several of the early sources are reprinted in *Velázquez: Homenaje. . .* Madrid, 1960); Palomino, 1724 (1960 ed., p.32); D. D'Argenville, *Abregé de la vie des plus fameux peintres*, ii, Paris, 1745, p.331; N. Caimo, *Lettere d'un vago Italiano ad un suo amico*, Pittburgo, 1768, p.152; Cumberland, *Anecdotes*, ii, 1783, p.6 (1960 ed., p.111); *id., Catalogue*, 1787, p.39 (Royal Palace, King's dressing room); Ponz, *Viage*, vi, pp.31,198; J. N. D'Azara, *The Works of Anthony Raphael Mengs*, ii, 1796, p.83; Céan Bermudez, *Diccionario*, v, 1800, pp.158.178 (1960 ed., pp.125,137); J. D. Fiorillo, *Geschichte der Malherey in Spanien*, 1806, p.235, (1960 ed., p.146); Passavant, *Tour*, i, p.170; Waagen, *Art and Artists*, ii, p.298; *id., Treasures*, ii, p.276; Stirling, *Annals*, 1848, ii, p.580; *id., Velazquez*, 1855, p.35; French ed. by W. Bürger, p.270; Curtis, no.86 (*c.*1620); Justi, pp.69,71; W. Armstrong, 'Velazquez', *The Portfolio*, 28, July 1896, p.72, Oct. 1896, pp.18,26; Beruete, pp.10, 151,157 (1617-23); Mesonero Romanos, p.193; Allende-Salazar, pl.17(*c.*1620); Mayer, no.118 (*c.*1618); Lafuente, no.4; Trapier, pp.59, 68ff. (1619-20); Pantorba, no.21 (*c.*1621); J. Lopez Navio, *Archivo español de Arte*, 1961, p.64 (Fonseca collection); Lopez-Rey, no.124 (*c.*1619-20), 1979 ed., no.16; José Camon Aznar, *Velázquez*, Madrid, 1964, p.208ff.; MacLaren/Braham, p.124; Asturias and Bardi, no.20 (*c.*1620); J. Gallego, *Velázquez en Sevilla*, 1974, pp.99f., pl.3; J. F. Moffitt, 'Image and meaning in Velazquez's Water Carrier of Seville'. *Traza y Braza, Cuadernos Hispanos de Simbologia arte y literatura* (Barcelona) 7,1978, pp.5-23.

184 A SPANISH GENTLEMAN, PROBABLY JOSÉ NIETO, CHAMBERLAIN TO QUEEN MARIANA OF AUSTRIA, WIFE OF PHILIP IV
Canvas, 30×25 (76·3×65·3), including strips 2·5cm. added on left and 4cm. on right.

The earliest record (1772 inventory) describes this picture simply as 'portrait with a golilla' — a reference to the sitter's white collar. Cumberland's (1787) description of a half-length Velazquez portrait of Antonio Perez, secretary to Philip II (died in 1611!) hanging in the Prince's dining room in the Royal Palace may refer to this picture, and subsequently the sitter was identified as Alonso Cano (Mayer) the playwright Calderon de la Barca and Velazquez himself (Waagen; César Pemán, 1960) but none of these are remotely acceptable. At one point a fictitious inscription *AC* was invented to support the Alonso Cano identification (J. Ortega y Gasset, *Velázquez*, pl.40). Enriqueta Harris has convincingly identified the sitter as José Nieto, the Queen's chamberlain in the 1650s. It is he who appears in the background of the Meninas (Prado) and although this image is sketchy and indistinct it is sufficiently similar to the Apsley House portrait to warrant a tentative identification (Harris, figs.65–6). Nieto was probably an early acquaintance of Velazquez at court and certainly he had been his opposite number in the royal

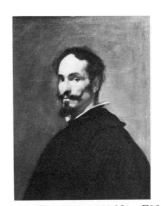

184 WM 1596–1948 Neg. F989
Wellington *Cat.*, p.172, no.53 black

household as chamberlain to the Queen, for several years before the Meninas was painted in 1656.

It is likely that the picture is unfinished: at least the hair and ear have an unfinished rather than a merely sketchy appearance. Trapier has pointed to the three strokes of the brush in the upper right-hand corner where the artist wiped it. This unfinished appearance has led Neil MacLaren (1947 exhibition catalogue) to suggest a date in the 1650s, after the second Italian visit, but most other authorities agree on a date in the 1630s (see *lit.* below). It is similar in style to the portrait of the sculptor Martinez Monanez in the Prado (Lopez-Rey, no.503, pl.102) which may be dated 1635-6, when Martinez was at court in Madrid. However, Enriqueta Harris has suggested a date in the mid-1640s as fitting both the style and the approximate age of the sitter; 'Joseph Nieto, some dozen years younger than when he appears, his hair now receding, as the Queen's Chamberlain in the doorway of the Meninas (1656)'.

There are four early copies, three of which were apparently made when the picture was narrower:
1. Mexico, Museum of Art (called Mazo; Lopez-Rey, 552)
2. Madrid, Mayorga collection
3. Somerset de Chair collection, St Osyth's Priory, Essex
4. St Bonaventura University, New York, Friedsham Memorial Library (Lopez-Rey 551), head and shoulders only.

Finally, a copy labelled 'Goya' in the Lazaro Galdiano collection, Madrid, is 19th century. These copies are fully discussed by Harris (1978, p.308).

Condition. Somewhat rubbed on hair and cloak; generally good. Pentimenti visible on hair. Strips added to canvas on left (4cm.) and right (2·5cm.).
Prov. Duquese del Arco; Royal Palace, Madrid (1772 inventory, probably identical with the 'man said to be Antonio Perez' hanging with the Innocent X portrait in the Prince's apartment (Pieza del Oratorio), though Velazquez's name is not mentioned; Cumberland, *Catalogue,* 1787, p.75f., (lists a half-length portrait of Antonio Perez by Velazquez in the Prince's dining room in the Royal Palace, where Ponz, vi, p.49 had described the man with the golilla). Captured at Vitoria, 1813.
Exh. B.I., *Old Masters,* 1828 (9) (Spanish gentleman); no.11, 1855, (self-portrait); New Gallery, 1895-6 (107); Guildhall, 1901 (125); Grafton Galleries, 1913-14 (62); R.A., *Spanish Paintings,* 1920-21 (67); R.A., *17th century,* 1938 (220); B.F.A.C., *Spanish Art,* 1928 (4); Arts Council/N.G., *Spanish painting,* 1947 (36); Arts Council, 1949 (12); National Museum, Stockholm, *Exhibition of Spanish Masters,* 1959-60 (102).
Lit. (For full titles see no.182.) Cumberland, *Catalogue,* 1787, p.75; Ponz, *Viage,* vi, p.49; Passavant, *Tour,* i, p.170; Waagen, *Art and Artists,* ii, p.298 (said to be of himself); Stirling, *Annals,* iii, p.1401; id., *Velazquez,* 1855, French ed. by W. Bürger, 1865, p.271, no.116; Curtis, no.209; Justi, pp.300, 426 (not a self-portrait); Beruete, pp.48,151,157 (1638-44); Mesonero Romanos, p.197; Allende-Salazar, pl.51 (*c.*1632); Mayer, no.378 (*c.*1632-4); Lafuente, no.52; Trapier, p.187 (early 1630s); Pantorba, no.81 (*c.*1640); César Pemán, 'Sobre autorretratos de juventud de Velazquez' *Varia Velazqueña,* i, 1960, pp.696-704; Lopez-Rey (late 1630s), 1979 ed. no.91; Asturias and Bardi, no.57 (1632-4); J. Gudiol, *Velazquez,* Eng. ed., 1974, p.211; Enriqueta Harris, 'Velazquez's Apsley House Portrait: an Identification', *Burl. Mag.,* 120, 1978, pp.304-08.

Ascribed to VELAZQUEZ

185 POPE INNOCENT X
Canvas, $32\frac{1}{4} \times 28\frac{1}{4}$ (82 × 71·5)

Early in 1649 Velazquez travelled to Italy at the command of Philip IV to buy pictures and sculptures for the royal collection. It was his second visit and it resulted in the appearance of a strong Italian, particularly Venetian, influence in his work. He bought paintings by Titian, Tintoretto and Veronese and then went on to Naples and Rome. The portrait of Innocent X (Giambattista

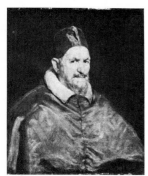

185 WM 1590-1948 Neg. F976
Wellington *Cat.,* p.158, no.47 black

Pamphili, 1574–1655), now in the Galleria Doria Pamphili, is the most famous of the paintings he produced in Rome. It differs from the Wellington picture in showing the Pope three-quarter length, seated and holding a piece of paper inscribed *Alla Santa di NroSigre / Innocencio X / Per / Diego di Silva y Velazquez de la Ca/mera di S. M$^{ta.}$ Catt$^{ca.}$* with the addition of a date, now illegible, which has been read as 1650. This was Jubilee year, the high-water mark of Innocent's papacy, when 700,000 pilgrims converged on Rome. He is considered to have been a reforming Pope, active in sending out missions and reforming religious orders, but indecisive and too much under the influence of his sister-in-law Olimpia Maidalchini. The masterpiece in the Galleria Doria Pamphili has always belonged to the sitter's family and there has never been any doubt that it is the original painting commissioned by the Pope, who gave Velazquez a golden medallion with his portrait as a sign of his appreciation. With its red tonality and fluid brush strokes it has been considered, since the 17th century (Boschini, *Carta del Navigar pitoresco*, 1660), as the most Titianesque of Velazquez's paintings.

Several contemporary witnesses, and subsequently Palomino (1724), record that Velazquez brought a copy of his portrait of Innocent X back with him when he returned to Madrid in June 1651. The fullest comment appears in a letter dated 8 July 1651 from the papal nuncio in Madrid, Giulio Rospigliosi, to Cardinal Pamphili in Rome, in which he says that Velazquez has returned from Italy 'and brought with him a good many originals by the best painters as well as a very like portrait of our Lord (Innocent X) which His Majesty has shown to enjoy very much.' (É ritornata quà d'Italia D. Diego de Velasco Aiutante di Camera e Pittore di S. M. e ha condotto molta quantità di pitture originali de migliori autori come parimte un ritratto molto simile di N. Sre de quale la M.A. ha mostrato dicompiacersi molto. . .'. See E. Harris, 'Velázquez en Roma', *Archivo Espanol de Arte*, xxxi, 1958, p.186).

Velazquez himself owned a portrait of Innocent which is recorded in the inventory made at his death (*Velazquez-Homenaje*, 1960, p.312, no.374) but who painted it is not mentioned. Rospigliosi's comment that the picture pleased the king suggests that it was given to him, and this is confirmed in a marginal note in a manuscript of Velazquez's friend Lazaro Diaz del Valle of 1656: 'he had a portrait of His Holiness to bring to His Majesty in Spain' (hizo un retrato de Su Santidad para traerle a Su Mg$^{d.}$ a España'. See F. J. Sanchez Canton, *Fuentes literarias*, iii, 1933, p.348, discussed by Harris, *loc. cit.*).

It used to be assumed that the Apsley House picture was the one recorded by Palomino as brought back to Spain by Velazquez (Wellington *Cat.*). It is first listed in the inventories of the royal collection in 1772 when it was in the passage to the King's pew in the Royal Palace at Madrid: 'Un retrato del Papa Innocencio 10 de medio cuerpo de vara de alto, y poco menos de ancho, original de Velázquez.' The size fits well (1 vara = 33·36in. or 84·7cm.) and it is reasonable to suppose that this is indeed the Wellington picture, which remained in the royal collection until 1813.[1] However, in the 1772 inventory it is marked as coming from the Marquis of Ensenada's collection, bought by Charles III in 1769, which makes it doubtful whether this was the picture given to Philip IV by Velazquez in 1651 — if, indeed, the gift was ever made.

There are many copies of the portrait of Innocent X; unfortunately none has a provenance extending further back than the 18th century. This makes it impossible to identify the copy or copies described by the artist's contemporaries with extant paintings. The fact that the Wellington picture was accepted as by Velazquez in the Spanish royal collection in the

1. The fact that a painting of identical description and size reappears in the royal inventory of 1814 is more probably due to an error than to the existence of another version unrecorded in the royal palace before or since.

inventories of 1772 and 1794 enhances its status, but it does not prove that it was the copy brought back by the artist himself in 1651.

On grounds of style and quality the picture has been the subject of dispute among authorities for the last hundred years. It was accepted as autograph by Curtis (1883) and Armstrong (1896), while Justi (1889) argued that the head was by Velazquez himself, the robe and background perhaps by another hand. Beruete (1898), on the other hand, considered that the execution was less fresh than Velazquez's own, and this doubt was echoed by Allende-Salazar (1925), who rejected the picture from the Velazquez canon and listed it without any evidence as probably a copy by the artist's Moorish assistant Juan de Pareja. This view was in turn rejected by Mayer (1936), according to whom 'the quality is entirely that of Velazquez' own work'. More recently Camón (1964) has argued that it is by Velazquez himself and Lopez-Rey (1963) has echoed Justi's view that the head 'reveals the master's hand', while much of the costume and background is by an assistant. This is certainly a reasonable hypothesis, but until further evidence comes to light the question remains open. It is a splendid picture, but there is a softness in the handling, even on the head, which cannot be fully explained by the influence of the great Venetians.

Of the copies, there are relatively few showing the three-quarter length composition of the Doria-Pamphili picture; the majority are, like the Wellington version, bust size (Lopez-Rey, nos.446–57). Nearly all of them are considered to be copies by other hands. Apart from the one in the National Gallery, Washington (Lopez-Rey, no.448; formerly Horace Walpole and Catherine the Great, Hermitage, and Mellon Collections) only the Wellington picture has any claim to be considered autograph. Subsequently it was copied by Goya (Lopez-Rey, no.456, pl.358) and others[1], and more recently the original version inspired a series of compositions by Francis Bacon.

Condition. Thinly painted and some wearing, particularly in the background.
Prov. Marquis of Ensenada, bought by Charles III, 1769; Royal Palace, Madrid, 1772 inventory: passage to the royal pew; 1794 inventory: Prince's apartment (Pieza del Oratorio). Captured at Vitoria, 1813.
Exh. B.I., *Old Masters*, 1828 (5); R.A., *Old Masters*, 1887 (160); New Gallery, 1895–6 (54); Guildhall, 1901 (122); Grafton Galleries, 1913–14 (59); Arts Council, 1949 (15); Madrid, *Velázquez y lo Velazqueño*, 1960 (71).
Lit. (For full titles see no.182.) Palomino, 1724, iii, p.501 (1960 ed., p.59); Cumberland, *Anecdotes*, ii, p.34 (1960 ed., p.118); Ponz, *Viage*, vi, p.49; (Prince of Asturias saloon in the Royal Palace, hanging next to Velazquez's Man wearing a golilla, see previous entry); Passavant, *Tour*, i, p.170 (sketch for the Doria-Pamphili portrait); Waagen, *Art and Artists*, ii, p.298 (a chef d'oeuvre); Stirling, *Annals*, ii, p.642 (fine repetition); iii, p.1502; Waagen, *Treasures*, ii, p.277; Stirling, *Velazquez*, 1855, p.158; French ed. by W. Bürger, no.115 (replica of the Doria-Pamphili portrait); Curtis, no.187 (with wrong history); Justi, p.359 (head by Velazquez; robes and background perhaps by another hand); W. Armstrong, 'Velazquez', *The Portfolio*, 29 Oct. 1896, p.66 (replica by Velazquez); Beruete, p.88 (the last of the copies); Mesonero Romanos, p.205; Allende-Salazar, pl.203 (copy by Pareja); Mayer, no.412 (original by Velazquez); Pantorba, p.179 (replica); Lopez-Rey, no.446 (head by Velazquez; most of costume and background by another hand; 1979 ed., no.115); Camon, p.730f. (by Velazquez); Asturias and Bardi, no.107B (copy).

Studio of VELAZQUEZ

186 Francisco Gomez de Quevedo y Villegas (1580–1645)
Canvas, $24\frac{1}{4} \times 22\frac{1}{4}$ (61 × 56)

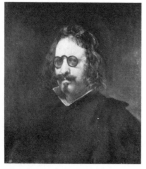

186 WM 1548–1948 Neg. HA3463
Wellington *Cat.*, p.203, no.192 red

1. For example Max Liebermann, who kept his copy in his studio (*Max Liebermann,* exh. Nationalgalerie Berlin, 1979, p.297 repr.).

Quevedo was a brilliant classical scholar, a satirist and lyric poet whose work probed the moral aspect of the Spanish decline in the 17th century. His life was punctuated by a series of duals, vendettas and periods of exile caused both by his satirical exposure of corruption and by his own fiery temperament. He fled to Italy after a duel in 1611 and subsequently entered the service of the Duke of Osuna, Viceroy of Naples and Sicily, who was his protector until his own fall in 1620. After a period of banishment, Quevedo obtained a position at the court of Philip IV and became secretary to the King in 1632. Meanwhile, his reputation was assured with the publication in 1626 of the *Vida del Buscon*, a picaresque romance, and of the series of *Suenos* (visions of hell) in which he provided a satirical analysis of the human condition. His attacks on the Duke of Olivares led to his imprisonment in 1639–42 and he died three years later. He much admired Velazquez and celebrated his fame in two of his poems *(Varia Velazqueña, 1960, ii, p.19)*.

Both this portrait and another in the Instituto de Valencia de Don Juan in Madrid (Lopez-Rey, no.532), which is inscribed with the name of the sitter, are widely considered to be studio copies of a lost original by Velazquez. Palomino *(El Museo. . . iii, p.333)* described the original: 'Another portrait was done by Velazquez of Don Francisco de Quevedo Villegas. . . He painted him with his spectacles on, as he was in the habit of wearing them.' Indeed the word *quevedos* has come to mean eyeglasses (Nottingham exhibition catalogue, 1980). There are three further copies (Madrid: X. de Salas collection and Biblioteca Nacional, Lopez-Rey 533–4, and J. Lafuente collection, repr. J. Camón Aznar, 1964, p.357) and an engraving of one by Noort was used to illustrate the posthumous edition of Quevedo's poems, *El Parnaso espanol*, Madrid, 1648 (Camón, repr. p.358).

Velazquez must have painted the original before 1639 when Quevedo was imprisoned. A date in the 1630s when the poet was in his fifties, is inherently likely and Trapier (1948) has argued that as he is depicted in secular costume it must have been painted after 1634, when he gave up his church benefices to marry.

Prov. Possibly Don Francisco de Brune, Cadiz (see R. Twiss, *Travels through Portugal and Spain in 1772 and 1773*, 1775, p.308; but this could have been one of the other versions). Lady Stuart, London, sale 15 May 1841, lot 44 (£49-7s); bought by the Duke of Wellington from Messrs Smith in 1841 for 100 guineas.
Exh. B.I., *Old Masters*, 1885; R.A., *Old Masters*, 1887 (111); New Gallery, 1896 (68); Guildhall, 1901 (98); Grafton Galleries, 1913-14 (42); Arts Council, 1949 (16); Nottingham University Art Gallery, *The Golden Age of Spanish Painting*, 1980 (39).
Lit. (for full titles see no.182.) Stirling, *Annals*, ii, p.635; iii, p.1403; Stirling, *Velazquez*, 1855, p.150; French ed. by W. Bürger, 1865, p.271, no.117; Curtis, no.191 (original by Velazquez); Justi, p.278; Armstrong, *The Portfolio*, 28 July 1896, p.60; Beruete, p.62 (probably a copy of the lost original); Mesonero Romanos, 1899, p.199; Allende-Salazar, pl.169, p.284 (studio replica); Mayer, no.362 (studio replica by same hand as the 'Young Man' in the Metropolitan Museum); Lafuente, p.34 (studio copy); Trapier, p.197; Pantorba, p.227 (copy); Lopez-Rey, no.531 (perhaps but not surely a workshop copy of Velazquez's lost original); Camón, p.355f.; Asturias and Bardi, no.30 (copy).

Willem van de VELDE the younger (1633–1707)

Dutch School

Elder brother of Adriaen van de Velde, both sons of Willem van de Velde the elder, he was born in Leyden, the family afterwards settling at Amsterdam. He studied with his father and probably also with Simon de Vlieger. By 1672 he had followed his father to England where, from 1674, they worked for Charles II, remaining for the rest of their lives. He is known for seascapes with shipping.

Lit. M. S. Robinson, *Van de Velde drawings. . . in the National Maritime Museum*, 1958.

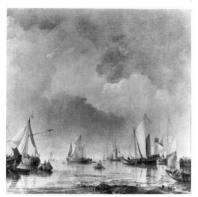

187 WM 1644–1948 Neg. J941
Wellington *Cat.*, p.8, no.201 black

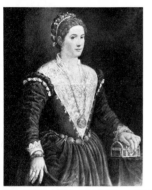

188 WM 1543–1948 Neg. H879
Wellington *Cat.*, p.151, no.184 red

189 WM 1616–1948 Neg. Q1387
Wellington *Cat.*, p.175, no.85 black

187 LARGE SHIPS AND BOATS IN A CALM
Signed in white, right of centre, *W V V*
Oak panel, $16 \times 16\frac{1}{2}$ $(40 \cdot 7 \times 42)$

The ships fly the Dutch flag. M.S. Robinson has detected traces of Dubbels' signature underneath that of van de Velde (see his *Van de Velde Paintings*, forthcoming).

Condition. Lines of grain showing through paint; otherwise good.
Prov. Spanish royal collection (not inv.); captured at Vitoria, 1813.
Lit. H. de G., vii, 1923, no.118a; Gaya Nuño, *Pintura Europea*, no.194; Valdivieso, *Pintura Holandesa*, p.383.

VENETIAN School, 16th century

188 AN UNKNOWN LADY
Inscribed on the back *Catherine Cornaro*
Canvas, $44\frac{1}{2} \times 36$ $(113 \times 91 \cdot 5)$

She is wearing a red velvet gown with a V-shaped white lace front. Round her wrist is a gold shell-pattern belt; a gold pendant, showing two putti flanking a central object, perhaps an armorial shield, hangs from a long necklace.

In the Beckford catalogue of 1823 this painting — if indeed it can be so identified — was described as 'P. Veronese. A finely coloured portrait of Catherine Cornaro', and this description was retained in the Wellington *Catalogue*. Yet it is a curious one, for Caterina Cornaro, Queen of Cyprus (1454–1510), died several years before Veronese (1528–88) was born and there was no suggestion that he was copying an earlier portrait. Indeed the identification was utterly fanciful: we know from contemporary portraits that Caterino Cornaro's appearance was quite different (e.g. Gentile Bellini, *c.*1500, in the Museum of Fine Art, Budapest, see E. Schaeffer, 'Bildnisse. . . der Caterina Cornaro', *Monatshefte für Kunstwissenschaft*, iv, 1911, p.12ff., pl.8), and in any case this picture was painted nearly half a century after her death. Nor is the attribution to Veronese tenable. To judge from the costume and from comparable portraits by Titian, Paris Bordone and other members of the Venetian school, a date in the middle or third quarter of the 16th century is likely, but it is difficult to suggest a convincing attribution.

The pendant with the two putti is typical of the roundels used as hat badges in the first half of the 16th century and then adapted for use as pendants from the 1540s (e.g. Y. Hackenbroch, *Renaissance Jewellery*, 1979, pl.140 A and B. I am grateful to Michael Snodin for this information).

Condition. Paint surface considerably worn and retouched. Cleaned by S. Isepp in 1949.
Prov. Perhaps to be identified with a portrait in the Beckford sale, 10 Oct. 1823, lot 43 (see above); bought by Mr King for 19 gns (not 16 as in Wellington *Cat.*); Peter Norton, Soho Square; Messrs Henry Graves & Co., who sold it to the Duke of Wellington for £105 in 1845.

Marcello VENUSTI (1512/15–79)
Italian (Roman) School
Born in Como, Venusti began his career under Giulio Romano at Mantua and then became a pupil of Perino del Vaga in Florence, but most of his career was spent in Rome. His early work is reminiscent of Correggio, but he subsequently became a friend and close follower of Michelangelo.

189 THE ANNUNCIATION
Poplar panel, 15×11 (38×28)

The original of this picture is in the sacristy of San Giovanni in Laterano, Rome, attributed to Marcello Venusti (panel, 320×210cm.; Parroni, 1937,

fig.6). The attribution is due to Vasari, according to whom Marcello Venusti painted the panel from Michelangelo's design (Vasari, ed. Milanesi, vii, 1881, p.575). Most authorities have accepted Vasari's account; only Giuseppe Parroni has put forward a dissenting view and attributed the San Giovanni in Laterano panel to Michelangelo himself.

It is not difficult to detect Michelangelo's ideas behind the composition; as Tolnay pointed out, the angel's gesture is analogous to that of God in the Creation of Adam on the Sistine ceiling. There is indeed a drawing in the Uffizi, Florence, which is directly preparatory for the San Giovanni in Laterano painting and which used to be considered the Michelangelo design described by Vasari (Parroni, 1937, fig.5; Wilde, 1959, fig.7). However, this drawing is, by common consent, now attributed to Venusti, working from a lost Michelangelo original (Tolany, 1960; Barocchi, 1962).

There are several other recorded copies of the composition. Parroni reproduces two panels which were, in 1937, in the collections of Mgr Steinmann, Palazzo Brancaccio, Rome (210x160, Parroni, fig.8) and of Prof. Canali, Rome (86x66). Another, closer in size to WM 1616, is at Castle Howard and there is a version in landscape format in the Museum at Chambéry (Inv. 719; 43·5×59). The Wellington picture is a miniature version of the original which it follows closely, differing only in the patterning of the floor and in not having an arched top. It is convincing as a 16-century work but has usually been considered as after rather than by Marcello Venusti. However, Wilde (1959) described it as a reduced replica painted by Venusti himself and suggested that 'it was perhaps the success of these replicas that led him to specialize in the *piccola maniera*'. Vasari himself wrote of '. . .Marcello who continues to produce small things executed with incredible patience', and WM 1616 fits well with this description. Infra-red examination reveals the presence of underdrawing in the Virgin's dress, and in other opaque areas, as well as pentimenti on the ambo, which supports the view that this is by Venusti himself rather than a copyist. There is an engraving of the composition by Nicholas Beatrizet (Tolnay, 1960, fig.316).

Condition. The panel has tended to split along the grain and the paint surface has flaked considerably and been retouched *passim*.
Prov. Spanish royal collection (not inv.); captured at Vitoria, 1813.
Lit. Passavant, *Tour*, i, p.170; Waagen, *Treasures*. ii, p.276; J. Wilde, 'Cartonetti by Michelangelo', *Burl. Mag.*, 101, 1959, pp.370–81, esp. p.378, n.39. On the composition and the drawings, see also: G. Parroni, 'Michelange ou Venusti?', *G. B-A.*, 17, 1937, pp.283–98; Charles de Tolnay *Michelangelo*, v, 1960, p.82, figs.314–6; Paola Barocchi, *Michelangelo e la sua scuola. . .*, 1962, i, p.245, no.197, ii, pl.308.

Claude-Joseph VERNET (1714–89)
French School
Born in Avignon, where he studied under his father Antoine, it was during his residence in Rome from 1734 to 1753 that he established his international reputation. Influenced in Rome by Adrian Manglard and Panini, he specialized in Arcadian coastal views in the tradition of Claude, Gaspard Dughet and Salvator Rosa. He became a member of the French Académie in 1753 and thereafter lived in Paris.

Lit. F. Ingersoll-Smouse, *Joseph Vernet*, Paris, 1926.

190 SUNSET: VIEW OVER A BAY WITH FIGURES
Inscribed at back *Fait par M. Vernet 1742 et appartient a M.D-* (illegible) and *Pe NroSor* (Principe Nuestro Señor)
Canvas, $22\frac{3}{8} \times 41\frac{1}{2}$ (57×105)

The coast is reminiscent of the area north of Naples, near Posillipo or further

190 WM 1645–1948 Neg. P1424
Wellington *Cat.*, p.382, no.205 black

round the Golfo di Pozzuoli; elegant visitors examine some fish proffered by two fishermen.

The French inscription on the back is no longer clearly legible, but there is no doubt that the date is 1742. This was during Vernet's most inventive period, when he was living in Rome and visiting the coast of southern Italy, before his work became repetitive in the second half of his career. A replica dated 1759, larger in size (134x178cm.) and taller in format, is in a private collection in Madrid (Juan J. Luna, verbal communication, 1974). A late 18th-century copy was sold at Christie's, 31 Oct. 1975 (lot 177; 59·7x110·5 cm.) and there is a copy in the collection of one of Vernet's descendants in Paris. The inscription *PeNroSor* indicates the ownership of the Prince of Asturias, before he became Charles IV in 1788. Among the paintings hanging in his newly built country house, the Casita del Principe at the Escorial, were no less than twelve by Joseph Vernet, who must have been one of his favourite artists. Two of these were given to Charles by Louis XVI in February 1781 (Ingersoll-Smouse, nos.895 and 1013; Zarco Cuevas, nos.329–30). A further six were commissioned by Charles from Vernet himself in May 1781 for 40,000 livres (Ingersoll-Smouse, nos.1082–87; Zarco Cuevas, nos.335–40). They arrived in Madrid in December 1782. Of these, three are now in the Prado (nos.2347–9) and one *(View of a port during a fire)* is in the private collection of the Duke of Wellington. Finally, four more canvases by Vernet are listed in the Casita del Principe inventory (*c.*1782–88): 'Cuatro iguales tambien Paises, Marinas y un incendio del mar' (landscapes, seascapes and a fire at sea; Zarco Cuevas, nos.331–4). The size given for these — less than two-thirds vara by one vara, or about 60×80cm. — fits reasonably well with WM 1645–1948 and also with its pendant, the *Italian Gondola* (view of Sorrento) in the Prado (no.2350; Ingersoll-Smouse, no.456). It is, therefore, likely that these are two of the four paintings listed under this heading.

Condition. Still on the original canvas; never relined.
*Prov.*Louis-Auguste de Tonnelier, Baron de Breteuil (1733–1807), French ambassador in Naples, 1771–5, sale 16–25 Jan. 1786, no.52; Charles IV, when Prince of Asturias; Casita del Principe, Escorial, *c.*1786. Captured at Vitoria, 1813.
Exh. Iveagh Bequest, Kenwood (and Musée de la Marine, Paris), *Claude Joseph Vernet*, 1976 (9) (repr.).
Lit. F. Ingersoll-Smouse, *Joseph Vernet*, 1926, p.43, no.78 bis; J. Zarco Cuevas, *Cuadros reunidos por Carlos IV, siende Principe, en su Casa de Campo de El Escorial*, 1934 (extract from *Religion y Cultura*), p.37, nos.331–4; Gaya Nuño, *Pintura Europea*, no.221.

After VERNET

191 A SHIPWRECK
Canvas, 13×19¼ (34×49)

This is probably a studio replica or contemporary copy of the *Shipwreck* in the collection of the Earl of Elgin (Ingersoll-Smouse, no.747, fig.185, as *c.*1760–65; exh., *Landscape in French Art*, R.A., 1949–50, no.135, together with its companion, *Calm*, no.136). The Wellington version differs in omitting the birds in the sky and a figure clinging to a piece of wood in the foreground, but it is otherwise identical in composition. However, it is considerably weaker in execution than the Elgin picture and it no longer appears possible to uphold the old attribution to Vernet's hand. Ingersoll-Smouse did not list it, but she did catalogue a third version, in the Aschaffenburg Gallery, as a copy of the Elgin picture.

WM 1575 cannot be identified with any of the twelve Vernets obtained by Charles IV when Prince of Asturias for the Casita del Principe del Escorial (see previous entry).

191 WM 1575–1948 Neg. Q1373
Wellington *Cat.*, p.70, no.21 black

Prov. Spanish royal collection (not inv.); captured at Vitoria, 1813.
Lit. Gaya Nuño, *Pintura Europea*, 219, pl.73.

Jan VICTORS (1620–*c*.1676)
Dutch (Amsterdam) School

A native of Amsterdam, he was probably a pupil of Rembrandt before 1640. He painted mainly religious pictures under Rembrandt's influence until the 1650s, when he increasingly produced peasant genre scenes in a more individual style.

192 A VILLAGE SCENE
Signed and dated on wooden trough *Jan Victors Fect 1654*
Canvas, 29×37 (73·7×94)

192 WM 1512–1948 Neg. Q1361
Wellington *Cat.,* p.55, no.69 red

The man tending his horse on the right is balanced on the left by a group of figures including courting couples and two fish pedlars, one of whom is extracting eels from an eel basket suspended in water. There are several similar scenes by Jan Victors; the closest was in the Max Wassermann collection (sold Galliera, Paris, 26 Nov. 1967, lot 41, repr., 78×92cm.). Individual figures also reappear in his work: the man on the right is identical with the standing figure in the Rijksmuseum *Greengrocer* (no.A2345, Rijksmuseum, *All the paintings,* p.579), which is also dated 1654.

Condition. Scattered minor paint losses. Cleaned by S. Isepp, 1951.
Prov. Le Rouge sale, Paris, April 1818 (lot 68), bought for the Duke of Wellington by Féréol Bonnemaison for 1400 fr. (£56).
Exh. B.I., *Old Masters,* 1821 (128).

Edward Matthew WARD, R.A. (1816–79)
British School

A pupil of John Cawse, he completed his education in Rome, 1836–8, and with Peter Cornelius in Munich, 1839. An accurate illustrator, he concentrated on history pieces of the English 17th century and the period of the French Revolution and on illustrations to Dr Johnson and Goldsmith.

193 NAPOLEON IN THE PRISON OF NICE IN 1794
Signed lower left centre *EMW 1841;* inscribed on label on back *No.2/EMWard/13 Russell Place/Fitzroy Square*
Canvas, 30×25 (76×63·5)

193 WM 1518–1948 Neg. Q1363
Wellington *Cat.,* p.242, no.81 red

Napoleon was given command of the artillery of the army in Italy in February 1794 at the age of 24, but his relations with the Jacobins became strained during the height of the Terror later in the year. The picture is described in detail in the British Institution catalogue of 1841: 'He incurred the suspicion of Laporte and the other "representatives" attached to the "army of Italy" in consequence of a journey to the Gulf of Genoa, which he performed in obedience to secret orders from Paris; and, as soon as his absence from headquarters was thus explained, he regained his freedom. The officer who came to release him was surprised to find him busy in his dungeon over the map of Lombardy. — *Lockhart.'* Various inscriptions, including *Vive la Nation* and *Napoleon,* are clearly visible on the wall behind Napoleon.

This is one of the earliest of several history pieces relating to the period of the French Revolution painted by Ward throughout his career. Others include *The French royal family in the prison of the Temple* (*c.*1854, Preston Art Gallery, exh. R.A. *Bicentenary,* 1968, 224), *Marie Antoinette listening to the Act of Accusation,* 1859, and *The last toilet of Charlotte Corday,* 1862 (both engraved by Lumb Stocks; Dafforne, pls 10,13).

According to a tradition enshrined in the Wellington Catalogue, the artist

was highly pleased at the Duke's purchase of this picture and said that it was 'his first success'.

Prov. Bought by the Duke of Wellington from the artist in 1841 for £21.
Exh. B.I., 1841 (341).
Lit. James Dafforne, *The Life and Works of E. M. Ward,* 1879, pl.2 (engraved by J. Outrim).

Sir David WILKIE R.A. (1785–1841)
Scottish School

Born in Cults, near Edinburgh, he studied at the Trustees' Academy, Edinburgh, under John Graham. In 1805 he came to London to study at the R.A. schools and from the beginning of his career Teniers was his guiding star and Sir George Beaumont his principal patron. His early genre scenes brought him considerable popularity and he was elected A.R.A. in 1809 and R.A. in 1811. His development towards a broader style, confirmed by his travels in Italy and Spain in 1825, led to a decline in his popularity, though he continued to enjoy royal patronage.

194 WM 1469–1948 Neg. L259
Wellington *Cat.,* p.78, no.11 red

194 CHELSEA PENSIONERS READING THE WATERLOO DESPATCH
Signed lower left *David Wilkie, 1822*
Panel, 62¼ × 38¼ (158 × 97)

The picture's setting is the King's Road, Chelsea, with the Chelsea Hospital on the left.

A full description of the scene is given by Wilkie's contemporary, Allan Cunningham:

There are fifteen prominent characters who perform leading parts in this martial drama, besides a number of subordinate personages, who contribute to the general joy by supplying the tables with drink, the feet with music, and the mouth with savory food: 1, an orderly of the Marquis of Anglesey's Lancers, who brings the Gazette of the battle; 2, an artilleryman, who throws down his knapsack, and is speaking to the lancer, to whom several hands are offering liquor in exchange for his intelligence; 3, a sergeant of the gallant forty-second, a Macgregor from Glengarry, who fought at Barossa, stands listening to the comments of the lancer, as well as the words of the Gazette, and seems ready to exclaim, 'Bravo, the brave forty-second!' 4, a soldier of the Hanoverian Legion, a corps distinguished at Waterloo; 5, a Life Guardsman, whose regiment united with the Greys, the Blues and the Enniskillens in repelling the desperate charges of the French Cuirassiers; 6, an old Pensioner who was with Wolfe at Quebec, and who reads aloud, but without emotion, the Gazette of Waterloo: this, as well as many others, is a portrait; 7, a soldier's wife, pressing eagerly forward to see if her husband's regiment has many slain; her face, from which the colour has fled, and her agonised look, intimate that much blood has been shed, and that she fears the babe she carries is fatherless and herself a widow; 8, a veteran whose appetite has survived all the vicissitudes of war, and whose love of good cheer is only suspended for a moment by the great news: his mouth seems to open naturally for the oyster which he has lifted on his fork; 9, a negro of the Band of Foot Guards, who was once a servant of the celebrated Moreau, and accompanied him in his retreat through the Black Forest; 10, a soldier from India, who fought in the battle of Assaye, and served too under the Marquis of Granby; 11 and 12, an Irishman of the 12th Dragoons telling the news to the veteran who seems hard of hearing; his pipe dropping insensibly from his hand; both are touched with liquor, and the younger seems saying to the elder, 'Bunker's Hill was but a cock-fight to this'; 13, a sergeant of the Oxford Blues who shared in the battle of Vittoria; at his feet is a black dog, known to the officers and men by the name of 'The Old Duke,' which followed the regiment all over Spain; the sergeant holds up his little son, and his looks, as well as those of his wife, seem to say, 'An if ye live to be a man'; 14, a soldier of the Foot Guards, stretching himself anxiously out from one of the windows of the 'Duke of York' public-house, anxious to hear what the Gazette says; 15, an out-door Pensioner, who, on his way to have his keg and can

replenished, halts to hear the news; his wounded hand and the wooden leg denote that he has been where blows are abundant. To this barren roll-call of names I may add, that the joy is great, the drink plentiful, and the whole scene animated and picturesque. (Cunningham, ii, p.76ff.).

Thanks to Wilkie's own letters and diaries, it is possible to trace the development of the composition from the original commission in August 1816 to the exhibition at the R.A. in May 1822. Wilkie wrote to Benjamin Robert Haydon on 18 August 1816, full of excitement, to tell him of the Duke of Wellington's commission. The introduction was effected by Lord Lynedoch (see under Lawrence, no.86 above) and the Duke gave Wilkie the commission after looking through his work in the studio. Wilkie reported the conversation:

> The Duke. . . said that the subject should be a parcel of old soldiers assembled together on their seats at the door of a public-house chewing tobacco and talking over their old stories. He thought they might be in any uniform, and that it should be at some public-house in the King's road, Chelsea. I said this would make a most beautiful picture, and that it only wanted some story or a principal incident to connect the figures together: he said perhaps playing at skittles would do or any other game. When I proposed that one might be reading a newspaper aloud to the rest, and that in making a sketch of it many other incidents would occur, in this he perfectly agreed, and said I might send the sketch to him when he was abroad. . . (Haydon, p.324).

At the time, Wilkie estimated that the project would take him two years. In 1817 he is recorded as busy preparing studies for the Wellington picture (Cunningham, i, p.459) but it was only in December of the following year that he was ready to show the Duke some of his sketches (Cunningham, ii, p.13f.). This meeting did not take place until 7 March, 1819, when the Duke told Wilkie to 'picture more of the soldiers of the present day, instead of those I had put of half a century ago'. (Cunningham, ii, p.17). Finally, at a meeting on 12 July, at which the Tory politician Charles Long (later Baron Farnborough) advised the Duke, Wilkie submitted the sketches of which the Duke 'preferred the one with the young figures; but as Mr Long remonstrated against the old fellows being taken out, the Duke agreed that the man reading aloud should be a pensioner. . .' and that the man with the wooden leg should be retained. It was agreed that Wilkie should begin the picture *immediately* (Cunningham, ii, p.18). Yet it was not until the end of the following year that he immersed himself in the subject and he then devoted sixteen months of uninterrupted work to it before it was finished to his satisfaction. Several witnesses reported on his obsessive sketching of figures and buildings in Chelsea throughout 1821 (Cunningham, ii, p.50, 53ff.). As well as sketching from life, it appears that Wilkie made use of coloured clay models of groups of figures in the construction of his composition (letter to Perry Nursey, 20 July 1820, *The Academy*, 1878). But what remains unclear is the precise stage at which Wilkie made the change from an anecdotal genre scene with old soldiers and a man reading, as agreed in 1816, into a dramatic subject of contemporary history of the reading of the Waterloo despatch, nor even whether it was before or after the meeting with the Duke in July 1819. All Wilkie tells us in 1822 is that 'the introduction of the Gazette was a subsequent idea of my own to unite the interest and give importance to the business of the picture'. (Cunningham, ii, p.72). The fact remains that it was this change which makes the Chelsea Pensioners such a central work in Wilkie's career, marking his transition from genre to history painter (Campbell, 1971; Gear, 1977).

As late as February—March 1822, the Duke was still calling on Wilkie and changes were made to the last minute. By this time the picture's fame was assured: 'I find that the picture of the Chelsea Pensioners has produced an

interest that is quite new to me in my professional progress,' wrote Wilkie in April 1822 (Cunningham, ii, p.68), and at the Academy it was hung in the centre, over the fireplace, next to Lawrence's portrait of the Duke. Such was the picture's popularity that a rail had to be erected to protect it from the crowds. Wilkie received 1200 guineas from the Duke, paid in cash on the spot, and the same amount from Messrs Moon, Boys and Graves for copyright of the print engraved by John Burnet (Raimbach, 1843; *Art Journal*, 1850, p.276: £1100 plus the presentation proof).

There are some 80 extant drawings which confirm the literary evidence of Wilkie's conscientious approach to the subject. The majority are studies of figures or groups (especially British Museum; Ashmolean; R.A.) and it is clear that the picture grew in terms of loosely linked groups. There are, for example, numerous studies of the girl on the right doing her hair; many of them showing her frontal, but Wilkie must have decided that this pose was too much of a distraction from the main theme (Campbell, p.418, figs.4–6). There are also drawings of the whole composition, for example in the Duke of Wellington's collection; at Amherst College Museum, U.S.A.; in the National Gallery of Scotland, Edinburgh (no.D.4935; squared for transfer); at Sotheby's sale, 25 March 1920, lot 114 (formerly J. P. Heseltine coll.) and at Christie's, 5 March 1974, lot 196 (watermark 1819). These link with the surviving oil sketches, which fall into two groups: (1) with fewer figures than the finished composition, with the father and child in profile on the extreme right, subsequently abandoned (e.g. Mellon Center, Yale, dated 1822, repr. *Burl. Mag.*, Dec. 1969, Supplement, pl.76; and Christie's, 22 March 1974, lot 134, from the collection of Dr John Gott, Bishop of Truro) and (2) with a multitude of figures, as in the final version (e.g. Christie's, 25 Nov. 1974, lot 140). There is a drawing relating to the group of the seated soldier holding up the baby in the V&A (E. 1097–1963).

In 1822 there was no hint of adverse criticism to mar the picture's triumph, though it was pointed out that eating oysters in June — the Gazette announcing the battle is date June 22 — was forbidden by Act of Parliament. More serious doubts were only voiced much later; the *Athenaeum*, 2 July 1842, for example, commented upon the artificial nature of the picture, pronouned it 'composed rather than inspired' and, more surprisingly, criticized its brilliant tonality (quoted in Wellington *Cat.*, p.82). However, the *Chelsea Pensioners* has remained one of the most popular pictures at Apsley House and has been called upon to grace a dozen exhibitions, more than any other painting in the collection.

Condition. Paint surface in excellent condition; reverse of panel sealed with wax to prevent rapid change of moisture content, 1955.
Prov. Bought by the Duke of Wellington from the artist for £1260 in 1822.
Exh. R.A., 1822 (126); B.I., *Works of Sir David Wilkie*, 1842 (14) (reviewed *Athenaeum*, 2 July 1842); Scottish Academy, Edinburgh, 1837; *Royal Military Exhibition*, Chelsea Barracks, 1840; R.A., *Old Masters*, 1886 (37); R.A., *Old Masters*, 1907 (131); *Japan-British Exhibition*, 1910; R.A., *Scottish Exhibition*, 1939 (151); R.A., *Sir David Wilkie*, 1958 (11); Petit Palais, Paris, *British Romantic Painting*, 1972 (329).
Lit. Géricault, letter to Horace Vernet, 1 May 1821 ('Combien aussi seraient utiles a voir les expressions touchantes de Wilky (sic)!', *Gericault raconté par lui-même et par ses amis*, 1947, p.105; discussed by S. Lodge, *Burl. Mag.*, 107, 1965, p.625); *Autobiography of B. R. Haydon*, 1853, i, p.323f.; Cunningham, *Wilkie*, 1843, i, pp.453,459; ii, pp.13, 17ff., 50,53ff.; 68–78; M. T. S. Raimbach (ed.), *Memoirs of the late Abraham Raimbach, including a memoir of Sir David Wilkie*, 1843, p.173; Waagen, *Treasures*, ii, p.273; *Quarterly*, 92, 1853, p.454; 'Wilkie's letters to Perry Nursey', *The Academy*, 14, 1878, p.324; Lord Ronald Gower, *Sir David Wilkie*, 1902, p.45ff., repr.; W. T. Whitley, *Art in England 1821-37*, 1930, p.30ff.; Patsy Campbell, 'Pictures of the Waterloo Era; Wilkie and Burnet at Apsley House', *Country Life*, 25 Feb. 1971, p.416ff.; Josephine Gear, *Masters or Servants? A study of selected English*

painters and their patrons of the late 18th and early 19th centuries (outstanding dissertations), New York 1977, p.359ff.

195 KING GEORGE IV (1762–1830)
Signed lower right *DAVID WILKIE 1830*
Canvas, 110×70 (279×178)

The King is wearing full Highland dress, consisting of a bonnet with three eagles' feathers, the royal Stuart tartan jacket and kilt, green tartan plaid and the usual Highland accoutrements: pistols, broadsword, dirk, powderhorn and sporran. The order of the Golden Fleece hangs from his neck and he wears the sash and star of the Order of the Thistle and the star of the Order of the Garter.

George IV, eldest son of George III, was appointed Regent in 1811 and ascended to the throne in 1820. He was an active and discerning patron and connoisseur of the visual arts.

This is a replica of the portrait in the royal collection at Holyrood House, dated 1829 (Millar, 1969, p.141, no.1183, pl.273). The Highland dress dates from the King's visit of 1822 to Edinburgh, but the full-length portrait was only commissioned in 1829. The progress of the original painting is fully recorded in Wilkie's letters to Sir William Knighton, keeper of the privy purse to George IV. The King sat to Wilkie in April 1829 and after seven sittings the study of the head and hands was sufficiently advanced to allow the project to be completed in the studio. This was done in February 1830: 'I am now working upon the whole-length for which I have a fine-looking Highlander for a model', and the picture was one of three sent by Wilkie to the R.A. in April of that year. He himself singled out its rich dark colouring ('I have made this the most glazed, and deepest toned picture I have ever tried or seen tried in these times') and the low perspective ('the low perspective is thought new and successful') as its salient characteristics. Wilkie's letters are published in full in Cunningham, *Wilkie,* iii, pp.10, 21f., 42-4, and summarized by Millar.

There is a pen and wash sketch in the National Gallery of Scotland (Millar, fig.47) and another was sold at Christie's, 16 July 1974 (lot 85 repr.). Wilkie received £525 for the original portrait and £420 from the Duke of Wellington for the replica.

It has always been accepted that WM 1459 is a replica signed and painted by Wilkie himself for the Duke. Wilkie's bill, dated 4 August 1831, simply states: 'To extra whole length portrait of his late majesty George IV, including gilt frame, £420.0.0' (Wellington archives). However, Hamish Miles has discovered from Wilkie's letters that John Simpson, a known portrait painter and one-time assistant to Lawrence (see above, no.162) painted a copy of the Holyrood picture for Wilkie and has tentatively identified WM 1459 with Simpson's copy. The crucial letter is the one written by Wilkie to Sir William Knighton on 4 November 1830: 'The portrait of his late Majesty has been copied in excellent style by Mr. Simpson. I am much pleased with it. The drawing of the head, hands, and figure is capitally understood, and the general hue very like the picture. What it wants is a *skin* all over. I have these two days begun upon the head and hands, and mean to go all over it to make it as nearly my own as possible' (Glasgow, Mitchell Library).

This could possibly refer to a different copy, but the identification with the Wellington portrait is supported by another letter from Wilkie to Knighton, 9 February 1831: 'The portrait of his late Majesty for the Duke of Wellington — the frame being now ready — I hope shortly to get delivered to his Grace'.

We are on the whole ill-informed about early 19th-century studio

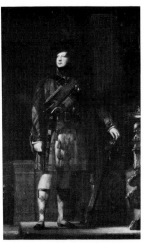

195 WM 1459–1948 Neg. P1410
Wellington *Cat.*, p.308, no.1 red

practice, but it seems plausible that by the time Wilkie had 'gone all over' an assistant's copy it could be sold as his own work, at a price one-fifth below that of the original portrait.

The King also paid £210 for a half-length replica which he presented to the Duke of Buccleuch, with whom he had stayed at Dalkeith Palace in 1822 (Buccleuch Coll.). Wilkie's other major portrayal of the King is in *The Entrance of George IV at Holyroodhouse*, which was also exhibited at the R.A. in 1830 (Millar, no.1184, pl.282).

Condition. pronounced bitumen craquelure.
Prov. Bought by the Duke of Wellington from Wilkie for £420 including the frame.
Exh. B.I., *Works of Sir David Wilkie*, 1842 (45); South Kensington, *National Portraits Exhibition*, 1868.
Lit. Passavant, *Tour*, i, p.173; Waagen, *Treasures*, ii, p.277 ('a very stately figure of astonishing force and effect of colour'); Cunningham, *Wilkie*, iii, p.528; Oliver Millar, *The later Georgian Pictures in the Collection of H.M. The Queen*, 1969, p.141; Hamish Miles, *David Wilkie* (forthcoming).

196 KING WILLIAM IV (1765–1837)
Signed lower right *David Wilkie f. Brighton 1833*
Canvas, 105 × 69 (267 × 173)

The King wears the coatee and epaulettes of the Colonel-in-Chief of the Grenadier Guards and the waist belt and cocked hat of a Field Marshal. He wears the sash and star of the Order of the Garter; the sovereign's badge of the Order of the Bath from his neck and the star of the Grand Cross of the Bath on his chest.

William IV was the third son of George III. At the age of 13 he went to sea and became Lord High Admiral in 1827. He succeeded his brother to the throne in 1830. Wilkie recorded that the King sat for him at Brighton in November 1831 (Cunningham, *Wilkie*, iii, p.50) and the first result of these sittings was the full-length portrait of William in the robes of the Garter exhibited at the R.A. in 1832 (71) and now at Windsor (Millar, 1969, p.143, no.1185, pl.276). The head in WM 1460, exhibited at the R.A. in the following year, is very similar to that in the Windsor portrait and it is likely that both pictures derive from the same sittings. Various sketches for the Windsor portrait are recorded by Millar; the only ones specifically for the Apsley picture, showing the King standing in military uniform, being a sheet containing five pen-and-ink studies sold at Sotheby's 30 November 1978 (lot 29, repr), and one in the volume sold at Sotheby's 18 March 1982 (lot 37, repr.). There are several other oil paintings of William IV by Wilkie (e.g. Scottish N.P.G., no.806) but the Apsley House portrait is the only one showing him in military uniform. It has been described as 'perhaps Wilkie's finest portrait' (R.A. exhibition, 1958).

Condition. Retouched scratch to right of hilt of sword; otherwise good.
Prov. Presented to the Duke of Wellington by William IV in 1833.
Exh. R.A., 1833 (140); B.I., *Works of Sir David Wilkie*, 1842 (41); R.A., *Sir David Wilkie*, 1958 (35, pl.22).
Lit. Waagen, *Treasures*, ii, p.277 ('very animated and vigorous'); Cunningham, *Wilkie*, iii, p.529; J. Woodward, *Connoisseur Period Guides 1830-60*, p.53, pl.33; *Paintings at Apsley House*, 1965, pl.51; Millar, *Later Georgian Pictures*, 1969, p.143.

Philips WOUVERMAN (1619–68)
Dutch (Haarlem) school
A painter, mainly of landscapes with battles, camps or hunts, he was born in Haarlem and lived there throughout his life. He was influenced by Pieter van Laer ('Bamboccio', 1592/5–1642), one of the leading Dutch painters of figure subjects in Rome.

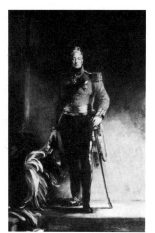

196 WM 1460–1948 Neg. P1403
Wellington *Cat.*, p.238, no.2 red

197 Camp scene with bugler and farrier's booth

Signed lower left *PHLS* (monogram) *W,* inscribed in white with fleur-de-lis (right) and inventory no.*314* (left)
Canvas, 22½ × 31 (57·5 × 79)

The drunk soldier on the right, and the tankard suspended over the awning, indicate that the tent in the foreground is a canteen; the one behind it is a farrier's booth where a horse is being shod. Next to the bugler on the left are two bound prisoners, guarded by a soldier. This composition is typical of Wouvermans' camp scenes; there is a replica on wood, sold at Fischer, Lucerne (8.9.1924, lot 101, repr.).

Condition. Good.
Prov. Spanish royal collection: Queen Isabella Farnese (fleur-de-lis), La Granja inventories 1746, no.314, and 1774. Captured at Vitoria, 1813.
Exh. B.I., *Old Masters,* 1828 (156); 1852 (81).
Lit. Smith, *Cat. Rais.,* i, 1829, p.334, no.459; Waagen, *Treasures,* ii, p.274; Gaya Nuño, *Pintura Europea,* no.186; Valdivieso, *Pintura Holandesa,* p.412.

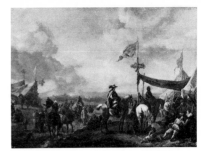
197 WM 1584–1948 Neg. P1426
Wellington *Cat.,* p.58, no.37 black

198 The departure of a hawking party

Signed lower right *P.H.* (monogram) *W.*
Canvas, 30 × 41¾ (76·2 × 106)

Companion to WM 1617 (see next entry).

These two paintings are particularly fine examples of the hunting scenes with mansions, ruins and fountains which Wouverman produced from about 1650. A very similar composition, for example, was in the collection of Baroness Bentinck (H.de G., 533; Sotheby's, 28 Nov. 1975, lot 73). They are characterized by their cool, grey tonality, and in both of them Wouverman has used his device of placing a white horse in the foreground as a focal point of the composition. He is not known to have visited Italy, and the Mediterranean aspect of these scenes is probably derived from the work of Pieter van Laer, who was also a native of Haarlem. Wouverman's compositions of this kind were enormously popular in the 18th century, and exercised a considerable influence on French rococo painting.

Condition. Areas of wearing and damage in mountains and sky, particularly upper right.
Prov. Spanish royal collection (together with WM 1617); Royal Palace, Madrid, 1772 inventory (Infante Don Xavier's quarters), 1794 inventory (King's dressing room, though according to Cumberland, 1787, p.78, they were hanging in the Prince's dining room). Captured at Vitoria, 1813.
Exh. (together with WM 1617): B.I., *Old Masters,* 1844 (15,19; review in *Ahenaeum,* 22 June 1844), 1855; Birmingham Society of Arts, 1831; R.A., *Old Masters,* 1887 (73,79) (review in *Times,* 14 Jan. 1887); Arts Council, 1949 (17,18).
Lit. Cumberland, *Catalogue,* 1787, p.78; Smith, *Cat. Rais.* i), 1829, p.255, no.188; H.de G., ii), no.538 (with incorrect provenance); H. Gerson, *Het Tijdperk van Rembrandt en Vermeer* (De Nederlandse Schilderkunst deel ii), 1952, p.49, pl.145; *Paintings at Apsley House,* 1965, pl.32; Gaya Nuño, *Pintura Europea,* no.188; Valdivieso, *Pintura Holandesa,* p.412.

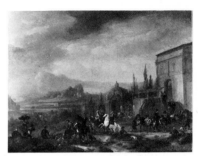
198 WM 1650–1948 Neg. S1277
Wellington *Cat.,* p.116, no.245 black

199 The return from the chase

Signed on stone lower left *PH* (monogram) *W*
Canvas, 30½ × 42 (77·5 × 107)

Companion to WM 1650 (see previous entry).

Prov. see previous entry.
Exh. B.I., *Old Masters,* 1828 (120); 1841 (72); and as in previous entry.
Lit. Cumberland, *Catalogue,* 1787, p.78; Smith, *Cat. Rais.* i, 1829, p.284, no.306; Waagen, *Treasures,* ii, p.274 (the companion was at Stratfield Saye); H.de G., ii,

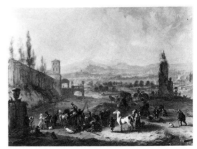
199 WM 1617–1948 Neg. S1276
Wellington *Cat.,* p.103, no.86 black

no.766; *Paintings at Apsley House,* 1965, pl.33; Gaya Nuño, *Pintura Europea,* no.187; Valdivieso, *Pintura Holandesa,* p.412.

Henry WYATT (1794–1840)
British School
Born near Lichfield, he was a pupil at the R.A. schools from 1812 and assistant to Thomas Lawrence 1815–17. He worked in Birmingham (1817–19), Manchester (1819–25, 1838) and Leamington (1834–37), as well as in London (1825–34), painting portraits in the manner of Lawrence and also genre and landscape.

200 FREDERICK AUGUSTUS DUKE OF YORK AND ALBANY, K.G (1763–1827)
Inscribed on the back *Painted by H. Wyatt, 78 Newman St.*
Millboard, $11 \times 9\frac{1}{2}$ (28 × 24)

The sitter faces left and is wearing a dark frock coat with a black stock and the star of the Garter.

Frederick, Duke of York, second son of George III, was trained as a soldier. He commanded the British forces in Flanders in 1793–5, became commander-in-chief of the army in 1798 and again fought the French in Holland in 1799. Both campaigns ended in failure, but he subsequently achieved some distinction as a reformer of army organization.

Wyatt lived at 78 Newman Street from *c.*1825 until 1834 (Graves, *R.A. Exhibitors*). WM 1472 appears to be a copy of Lawrence's portrait exhibited at the R.A. in 1822 (K. Garlick, *Walpole Society,* 1964, p.205, no.4). It corresponds very closely, even in size, with G. T. Doo's engraving after Lawrence of 1824 (proof in VAM: no.18936).

Prov. Probably bought by the Duke of Wellington from Lord Canterbury in 1843.

200 WM 1472-1948 Neg. M242
Wellington *Cat.,* p.296, no.14 red

Catalogue of the principal pictures found in the baggage of Joseph Bonaparte

Made by Mr. Seguier on their arrival in London.

			NO. IN 1901 CATALOGUE	NO. IN THIS CATALOGUE
1. *Portrait of a Lady*	. Titian	. .	72	—
2. *Christ in the Garden*	. Coreggio	. . .	38	32
3. *Virgin and Child*	. Jul. Romano	. .	88	145
4. *Virgin and Child*	. Leo. da Vinci (School of)	.	73	—
5. *Battle Piece*	. Vandermeulen	. .	.219	—
6. *Battle Piece*	. Vandermeulen	—
7. *The Ball*	. Watteau	. .	82	—
8. *Dead Game*	. Fyt217	—
9. *Female Head*	. Murillo	. .	.110	—
10. *Mountebanks*	. Vandermeulen	. .	.112	—
11. *Farriers*	. Wouwermans (School of)	.	.128	—
12. *Madonna*	. Sasso Ferrata	. .	.151	—
13. Titian's Brother	. .	66	—
14. *Dead Christ*	. Unknown	. .	.213	—
15. *Landscape*	. Unknown	—
16. *Infant Christ and Saint*	Unknown	. .	27	—
17. *Landscape*	. Teniers	. . .	81	179
18. *Christ*	. Unknown	. .	.114	—
19. *St. Peter*	. Spagnoletto	. .	93	
20. *Portrait*	. Velasquez	. .	53	184
21. *Card Players*	. G. Hondthorst	.	.131	59
22. *Water Seller*	M. A. Caravaggio	. .	59	183
23. *Battle Piece*	. Bourgognone	. .	28	—
24. *Battle Piece*	. Bourgognone	. .	98	—
25. *Dressing a Wound*	. Teniers	. .	.147	—
26. *A Female Saint*	. Spanish Painter	.	.111	—
27. *St. John in the Wilderness*	. Spagnoletto	. .	.115	150
28. *Portrait of Innocent X*	Velasquez	. . .	47	185
29. *Lime Kiln*	. Teniers	. . .	36	173
30. *Landscape*	. Artois	. .	45	—
31. *Landscape*	. Moucheron	. .	4	—
32. *Sketch of the Plague*	. Nic. Poussin	. .	3	—
33. *Interior: Gaming*	. Teniers	. .	.223	—
34. *Smoking*	Teniers	. .	.237	—
35. *Landscape*	. Elsheimer	—
36. *Landscape*	. Vanderneer	. .	22	116
37. *Portrait*	. Maas	. .	.161	—
38. *Landscape*	. Van der Heyde	. .	.183	—
39. *St. Francis*	. Murillo	. .	68	112
40. *Cattle*	. Van-Bergen	. .	.208	—
41. *Storm*	. Vernet	. .	21	191
42. *Landscape*	. Paul Bril; A. Caracci	.	97	—
43. *Adoration*	. Sebastian Conca	—
44. *Man Tying his Shoe*	. Teniers	. .	.107	—
45. *Embarkation of St. Paul*	Claude Lorraine	.	87	—
46. *Landscape*	. Claude Lorraine	. .	89	—
47. *Soldiers at Cards*	. Hondt122	71

48. *Landscape*	. Teniers	.	. 79	178
49. *Playing at Bowls*	. Teniers	.	. 32	171
50. *Landscape and Figures*	An. Caricci	.	.102	—
51. *Landscape*	. Vanderneer	.	. 51	—
52. *Halt of an Army*	. Wouwermans	.	. 37	—
53. *Hawking*	. Wouwermans	.	.245	—
54. *Hawking*	. Wouwermans	.	. 86	—
55. *Battle Piece.*	. Paracel	—
56. *Battle Piece*	. Uncertain	—
57. *Virgin and Child*	. Sasso Ferrata	.	. 83	161
58. *Portrait of Murillo*	. Murillo	.	.106	—
59. *Old Man's Head*	. Spagnoletto	.	. 91	149
60. *Portrait of Th. Zucchero*	. Th. Zucchero	.	.117	118
61. *Reaping*	. Teniers	.	. 63	176
62. *St. Catherine*	. Claud Coel	.	. 30	29
63. *Orpheus*	. Titian	.	. 35	172
64. *Holy Family*	. Mengs	.	. 49	105
65. *Venus and Adonis*	. Domenichino	.	. 80	27
66. *Danæ*	. Titian	.	.256	—
67. *Ismael and Hagar*	. Luca Giordano	.	.135	55
68. *Portrait of a Lady*	. Titian	.	. 92	180
69. *Jacob Stealing the Blessing*	. Murillo	.	.253	113
70. *Magdalen*	. Mengs	.	.121	—
71. *Concert*	. Flemish Painter Uncertain		94	—
72. *Holy Family*	. Carletto Cagliari	.	. 25	—
73. *Annunciation*	. MichelAngelo	.	. 85	189
74. *The Miraculous Draught*	. Rafaelle	.	.124	—
75. *Virgin and Child*	. Guido	.	.216	—
76. *Portrait*	. Murillo	.	.116	—
77. *The Arts*	. Old Franks and Breughel		. 1	—
78. *Ignatius Loyola*	. Mengs	—
79. *Landscape*	. Zuccarelli	.	.202	—
80. *Hercules and Lion*	. Rubens (School of)	.	. 75	157
81. *Landscape*	. Gysels	.	.207	62
82. *Battle Piece*	. Salv. Rosa	.	. 48	153
83. *Diana and Acteon*	. Uncertain	.	235	—
84. *Pan and Syrinx*	. Uncertain	.	.255	—
85. *Conflagration*	. Vernet	.	.130	—
86. *Holy Family*	. Leo. Da Vinci	.	. 95	101
87. *Virgin and Child*	. Leo. Da Vinci	.	. 84	100
88. *The Scourging*	. Velasquez	.	.123	—
89. *Our Saviour on the Mount*	. Carlo Olorada Flamenco		61	—
90. *Adam and Eve*	. Uncertain	.	.125	3
91. *Diana Hunting*	. Kerinx	.	. 96	—
92. *Child*	. Coreggio	.	.169	—
93. *Taking down from the Cross*	. Lud. Caracci	.	.192	—
94. *Crucifixion*	. Polemberg	.	. 78	142
95. *St. John*	. Mengs	.	.129	—
96. *Landscape*	. Breughel	.	. 64	—
97. *Playing at Cards*	. Uncertain	.	.232	—
98. *Annunciation*	. Ancient Master	.	.238	30
99. *Ruins and Figures*	. Spanish Painter	.	.133	—

100. *Madonna and Flowers*	. M. Fioro144	—
101. *Judith and Holofernes*	. Elsheimer 67	45
102. *Taking down from the Cross* Alonzo di Arco		.126	—
103. *Magdalen* . .	. Painter's name not legible		.180	—
104. *Last Supper* . .	. Albert Durer	. .	. 65	81
105. *Sea Piece* Peters 7	—
106. *Holy Family* . .	. Rubens 39	156
107. *A Head* Spanish Painter	. .	. 6	—
108. *Landscape* . .	. Uncertain	—
109. *Landscape* . .	. Paul Potter	. .	23	82
110. *Landscape* . .	. Painter's name not legible		.140	—
111. *Boys with Birds' Nest*	. Vanderneer 40	117
112. *Smoking* . .	. Teniers 14	—
113. *Virgin and Child*	. Uncertain100	78
114. *Marriage of St. Catherine* . .	. D'Arpino 74	4
115. *Landscape* . .	. Bremberg209	14
116. *Landscape and Figures*	. Polemberg	. .	. 41	143
117. *Incantation* . .	. Spagnoletto, from a design of Rafaelle	. .	. 33	151
118. *Merry-making* .	. Teniers 16	—
119. *Marketing* . .	. Dankertz	—
120. *Portrait of a Lady*	. Mirevelt149	—
121. *Landscape* . .	. Brueghel 10	64
123. *Landscape* . .	. Brueghel 18	19
123. *Landscape* . .	. Brueghel127	22
124. *Landscape* . .	. Brueghel134	21
125. *Landscape* . .	. Brueghel136	20
126. *Landscape* . .	. Brueghel138	23
127. *Landscape* . .	. Gysels132	63
128. *Sea Piece* . .	. De Vlieger148	167
129. *Adoration* . .	. Pietro Perugino	.	. 56	—
130. *Adoration of the Virgin* .	. Ancient Master	.	. 69	—
131. *Nymphs and Satyrs*	. Annibal Caracci	.	.113	—
132. *St Cecilia* . .	. G. Hondthorst	.	.288	—
133. *Offering to Flora*	. Brueghel	. .	.248	—
134. *Virgin and Child*	. Barocci 29	—
135. *Landscape* . .	. Mouchercon	.	.200	—
136. *Portrait of A Cardinal* .	. Uncertain	. .	. 99	—
137. *Boys Drinking*	. M. A. Caravaggio	.	. 50	182
138. *A Head* . .	. Murillo	. .	. 94	—
139. *St. Apollonia*	. Uncertain	. .	.236	—
140. *Old Man's Head*	. Uncertain	. .	. 5	155
141. *A Nun's Head*	. Rubens	. .	.109	154
142. *Landscape* .	. Both	. .	. 71	—
143. *Head of a Saint*	. Spangoletto	.	. 44	—
144. *Magdalen* .	. Vandyke	. .	.246	42
145. *Samson and Delilah*	. L. Giordano	.	.139	56
146. *Landscape* .	. F. Bolognese	.	.139	—
147. *Ruins and Figures*	. Uncertain	.	.241	—
148. *Cattle* . .	. Klomp	.	11	—
149. *Army Marching*	. Uncertain	. .	.103	—
150. *Landscape* . .	. Teniers	. .	. 77	117
151. *Market* . .	. Uncertain	. .	. 60	—

152. *Ruins and Figures*	.	. Vivian and J. Miel	.158	—
153. *Landscape* .	.	. *B. (sic)* Bril and A. Carraci	.101	15
154. *Landscape*	.	. Claude Lorraine .	. 58	28
155. *Landscape*	.	. Uncertain	—
156. *Sea View*	.	. Vernet226	—
157. *Historical Piece*		. P. Battoni108	—
158. *Entrance of the*				
Nuncio into Madrid .		. P. Panini145	122
159. *Landscape*	.	. Dietrich 17	—
160. *Hercules and Achelous*		*From* Rubens 55	158
161. *Marriage of St.*				
Catherine .	.	. *From* Parmegiano .	. 62	125
162. *Element of Fire*	.	. Breughel247	—
163. *Laboratory*	.	. Teniers 31	—
164. *Landscape and Cattle*		Teniers 46	174
165. *Cowhouse* .	.	. Teniers 52	175

A Drawing in Water-Colours of *The Massacre of St. Bartholomew,* by Callot

A Fine Drawing of *The Last Supper.*

In addition to the above Pictures, there are fifty or sixty more — some of which are good Pictures by Modern Masters—worth preserving, the remainder of no value.

Index to the 1901 Catalogue

Present (1981) locations:
WM = Wellington Museum
PC = Private collection of the Duke of Wellington
PC(S) = Private collection (sold)

(2) *Battle Scene*	28	245	PC
(3) *Battle Scene*	98	247	PC
(4) *Battle Scene*	240	366	PC
(5) *Battle Scene*	241	367	PC
(6) *Battle Scene*	239	367	PC
(7) *Battle Scene*	238	368	PC
BOTH A. and J.			
Landscape, with Figures	71	45	PC
BOUQUET, M.			
Landsape: Moonlight	228	373	PC (s)
BREENBERGH, B			
Landscape, with Ruins and Figures . .	209	24	WM
BRUEGHEL, J.			
(1) *A Road Scene with Figures* . .	138	123	WM
(2) *Landscape, with a Windmill* . .	64	144	PC
and ROTTENHAMMER, J.			
(3) *Diana Returned from the Chase* . .	96	190	PC
(4) *Road Scene, with Figures* . .	136	212	WM
(5) *Travellers, in a Landscape* . .	127	228	WM
and VAN KESSEL, J.			
(6) *Going into the Ark* . . .	134	236	WM
(7) *River Scene, with Boats and Figures* .	18	241	WM
BRIL, P.			
(1) *A Hunting Scene* . . .	97	37	PC
(2) *Landsape, with St. Hubert* . . .	101	37	WM
BROCKY, C			
Arthur, First Duke of Wellington, K.G. .	395	363	PC (s)
BROUWER, A			
Boers Smoking	86	7	WM
BURNET, J			
The Greenwich Pensioners . . .	217	75	WM
CALIARI, See P. VERONESE.			
CANOVA, A.			
(1) *Napoleon I.* (Statue)	1	443	
(2) *Sappho* (Bust)	37	459	
(after) (3) *Napoleon I.* (Bust) . . .	XIII	441	
CARAVAGGIO (M. A. AMERIGE)			
(1) *The Conjuror*	190	181	WM
(2) *Gamblers*	131	325	WM
CARACCI, A.			
(1) *Landscape, with Pan, Cupid and Nymphs* .	113	62	PC
(2) *Landscape, with Nymphs* . . .	102	69	PC
CESARE, G. (IL CAVALIERE D'ARPINO)			
(1) *The Expulsion from Paradise* . .	125	129	WM
(2) *The Marriage of St. Catherine* . .	74	136	WM
CHANTREY, SIR F., R.A.			
(1) *Arthur, First Duke of Wellington*, K.G.			
(Bust). . .	I	429	
(2) *Robert, Marquis of Londonderry*, K.G.			
(Bust) . .	VIII	435	
(3) *William, Second Earl of Lonsdale* (Bust) .	15	447	
(4) *Thomas, Eleventh Earl of Lauderdale,*			
G.C.B. (Bust)	16	448	
CIGNANI, C. (CHINIANI)			
Venus and Adonis	80	96	WM
CLAUDE DE LORRAIN (CLAUDE GELLÉE)			
(1) *Landscape*	58	95	WM

GRIMALDI, G. F. *See* BOLOGNESE,
GUERCINO (G. F. BARBIERI)

(1) *Mars*	65	200	WM
(2) *Venus and Cupid*	68	224	WM

GYSELS, P.

(1) *River View*	132	124	WM
(2) *A River View with Figures*	207	145	WM
(3) *Landscape, with Figures Crossing a Brook* .	10	146	WM

HALL, J.

Colonel Gurwood, C.B.	9	291	WM

HAYDON, B. R.

Arthur, First Duke of Wellington, K.G. . .	251	375	PC

HAYTER, SIR G.

Nicholas I., Emperor of Russia . . .	164	416	PC

HAYTER, H.

Frederick William, Duke of Brunswick	213	383	WM

HAYTER, J.

Viscount Combermere, G.C.B. . . .	103	292	WM

HEALY, G. P.

Marshal Soult	215	247	WM

HERBIG, W.

Frederick William III., King of Prussia . .	3	306	WM

HOPPNER, J., R.A

(1) *The Right Hon. William Pitt* . .	214	71	WM
(2) *Lady Charlotte Greville*	33	345	PC

(attributed to)

(3) *Edward, Second Baron Longford* . .	141	354	PC
(4) *Lady Anne Culling Smith and her Daughters*	173	354	PC
(5) *William, First Baron Maryborough* . .	144	357	PC
(6) *Henry, First Baron Cowely, G.C.B.* . .	145	358	PC
(7) *Arthur, First Duke of Wellington, K.G.* .	167	361	PC

HUDSON, THOMAS (attributed to)

Richard Colley, Baron of Mornington . .	168	358	PC

JANET (F. CLOUET)

Andrea Doria	35	51	PC

JOSEPH, G. F.

The Right Hon. Spencer Percival . . .	220	85	WM

JOSEPH. S.

Colonel Gurwood, C.B. (Bust) . . .	VI	433	.

KETEL, C.

Portrait of Himself	117	62	WM

KNIBERGGEN, F.

Landscape with Deer	23	24	WM

KNIGHT, J. P.

Sir George Murray, G.C.B.	179	289	WM

LANDSEER, SIR E., R.A

(1) *The Illicit Still*	104	243	WM
(2) *The White Horse 'Moscow'* . . .	390	250	PC
(3) *Van Amburgh and his Animals* . . .	199	335	PC (s)

LAWRENCE, SIR T., P.R.A.

(1) *Henry, First Marquess of Anglesea, K.G.* .	16A	272	WM
(2) *William, Viscount Beresford, G.C.B.* . .	23	280	WM
(3) *Thomas, Lord Lynedoch, G.C.B.* . .	15	288	WM
(4) *Henry, Third Earl Bathurst, K.G.* .	16	242	PC
(5) *Marianne Caton, Marchioness Wellesley* .	29	353	PC

MENGS, A.
(1) *Magdalen*	121	148	PC
(2) *St. John the Baptist*	129	174	PC
(3) *The Holy Family*	49	201	WM
(4) *The Infant Christ appearing to St. Anthony of Padua.*	57	207	WM

MIEL, J., AND A. VIVIANI (CODAGORA)
Ruins, with Figures	158	120	PC

MOLINAER, K.
Dutch Frost Scene, with Figures	45	14	PC

MONOT, M. C.
Hercules (Bronze Statuette).	38	456	

MORE, SIR A.
Mary I,. Queen of England.	50	141	WM

MOUCHERON, F.
(1) *Landscape, with Figures*	200	3	PC
(2) *Landscape, with Figures.*	4	38	PC

MURILLO, B. E.
(1) *Portrait of a Gentleman.*	189	54	WM
(2) *Old Woman Eating Porridge.*	222	90	PC
(3) *St. Francis of Assisi receiving the Stigmata.*	68	138	WM
(4) *Isaac Blessing Jacob*	253	143	WM
(5) *Portrait of Himself*	106	162	PC
(6) *St. Catherine.*	111	226	PC
(7) *Head of the Virgin.*	105	235	PC
(8) *Portrait of a Spanish Gentleman.*	116	236	PC
(9) *St. Anthony of Padua*	6	240	PC

(School of)
Head of a Woman	110	174	PC

NAVEZ, F. J.
William I., King of Holland	5	310	WM

NETSCHER, C.
The Toilet	87	44	WM

NOEL, A. J.
Waterloo Church.	341	300	PC

NOLLEKENS, J.
(1) *The Right Hon. Spencer Percival* (Bust)	10	431	
(2) *The Right Hon. George Canning,* (Bust)	IV	432	
(3) *Arthur, First Duke of Wellington,* K.G. (Bust)	11	435	
(4) *The Right Hon. William Pitt* (Bust)	12	438	

NUZZI, M. *See* MARIO D'A FIORI.

OCHTERVELT, J. (attributed to)
A Musical Party	94	126	PC

PALKIRK
Two Horses (Bronze Group)	XX	452	

PANNINI, G. P.
(1) *St. Paul at Melita.*	59	178	WM
(2) *St. Paul at Athens.*	62	179	WM
(3) *The Spanish Embassy in Rome, 1727.*	145	217	WM

PARMEGIANO (F. MAZZUOLA)
Marriage of St. Catherine	62	182	WM

PEETERS, B.
A Sea-piece	7	20	PC

PEYRON, J. F. P.
Sacrifice of Maidens	108	380	WM

PIENEMAN, J. W.
(1) *Lieut.-General Sir John Elley,* K.C.B.	18	269	WM

TENIERS, D.
 (1) *Interior, with a Man Smoking* . . . 14 10 PC
 (2) *Peasants Playing at Bowls* . . . 32 11 WM
 (3) *Interior of a Cowhouse* . . . 52 12 WM
 (4) *Landscape, with Figures and Animals* . 46 15 WM
 (5) *A Harvest Scene* 63 18 WM
 (6) *Boers Smoking* 237 22 PC
 (7) *A Village Scene* 16 23 PC
 (8) *Landscape, with Shepherds* . . . 81 25 WM
 (9) *View of a Chateau* 79 26 WM
 (10) *A Limekiln, with Figures* . . . 36 27 WM
 (11) *A Flemish Village Festival* . . . 34 29 WM
 (12) *A Village Merry-making at a*
 Country Ale-house 55 32 WM
 (13) *A Surgeon's Shop* 147 43 PC
 (14) *Landscape, with Cattle* . . . 77 97 WM
 (15) *The Alchymist* 31 139 PC
TER–BORCH, G.
 Theatricals in a Flemish Town . . . 112 128 PC
TINTORETTO (J. ROBUSTI)
 Cicogna, Doge of Venice . . . 185 155 WM
TITIAN (T. VECELLI)
 (1) *Danae* 256 198 PC
 (2) *Caterina Cornaro* 72 202 PC
 (3) *Titian's Mistress* 92 222 WM
(School of)
 Figures Worshipping an Idol . . . 66 177 PC
(after)
 Sleeping Venus 201 220
TREVISANI, F. C.
 The Holy Family, with St. Carlo Borromeo . 104 119 WM
TURCHI, A. *See* A. VERONESE.
TURNERELLI, P.
 George III, (Bust) 14 451
VAN ARTOIS, J.
 Landscape, with Figures . . . 45 183 PC
VAN DER DOIS, J.
 Landscape, with Figures and Animals . . 137 55 PC
VAN DER HEYDEN, J., and
 VAN DE VELDE, A.
 (1) *View of a Town in Holland* . . . 56 13 WM
 (2) *View on the Vecht, near Maarsen* . . 58 16 WM
VAN DER MEULEN, A. F.
 (1) *Louis XIV and Generals arriving before a*
 town 48 35 WM
 (2) *The Colbert Family* 51 122 WM
 (3) *Louis XIV at Siege* 47 135 WM
VAN DER NEER, A.
 River View: Evening 22 128 WM
VAN DER NEER, E. H.
 Boys with a Trapped Bird . . . 40 150 WM
VAN DE VELDE, A., and
 Van der Heyden, J.
 (1) *View of a Town in Holland* . . . 56 13 WM
 (2) *View on the Vecht, near Maarsen* . . 58 16 WM
VAN DE VELDE, W.
 Vessels in a Calm 201 8 WM

WILKIE, SIR D., R.A.

(1) *Lady Lyndhurst* 32 73 PC

(2) *Chelsea Pensioners reading the Waterloo*
 Despatch 11 78 WM

(3) *William IV* 2 238 WM

(4) *George IV* 1 308 WM

WILSON, R., R.A.

Landscape 196 42 PC

WINTERHALTER, F. (after)

H.R.H. Prince Arthur, Duke of Connaught . 291 349 PC

WOOTTON, J. (?)

John, Duke of Marlborough, K.G. (equestrian). 91 383 PC (s)

WOUWERMAN, PHILIPS

(1) *Camp Scene* 37 58 WM

(2) *The Return from the Chase* 86 109 WM

(3) *The Departure of a Hawking Party* . . 245 116 WM

(School of)

A Farrier Shoeing a White Horse . . . 128 67 PC

WOUWERMAN, PIETER

Landscape 226 389

WRIGHT, J. M.

(I) *Battle of the Pyrenees* 397 344 PC

(2) *Battle of Vitoria* 398 346 PC

WYATT, H.

H.R.H. Frederick, Duke of York and Albany
 (after Lawrence) 14 296 WM

ZURBARAN, F.

Joseph Visiting Elizabeth 57 394 PC

Concordance of numbers

Wellington Museum (WM) number	Catalogue number	Wellington Museum (WM) number	Catalogue number
1459	195	1508	60
1460	196	1509	1
1461	68	1510	165
1462	49	1511	61
1463	115	1512	192
1464	50	1513	146
1465	51	1514	164
1466	144	1515	52
1467	65	1516	96
1468	127	1517	33
1469	194	1518	193
1470	128	1519	94
1471	74	1520	93
1472	200	1521	120
1473	86	1522	18
1474	87	1523	119
1475	129	1524	41
1476	130	1525	163
1477	34	1526	110
1478	131	1527	138
1479	132	1528	35
1480	88	1529	77
1481	133	1530	9
1482	134	1531	66
1483	135	1532	84
1484	136	1533	148
1485	8	1534	47
1486	137	1535	36
1487	73	1536	37
1488	99	1537	38
1489	98	1538	83
1490	25	1539	2
1491	91	1540	139
1492	76	1541	44
1493	141	1542	31
1494	108	1543	180
1495	107	1544	7
1496	140	1545	147
1497	109	1546	114
1498	43	1547	26
1499	170	1548	186
1500	69	1549	104
1501	70	1550	95
1502	123	1551	79
1503	102	1552	16
1504	5	1553	53
1505	124	1554	75
1506	103	1555	67
1507	166	1556	24

Wellington Museum (WM) number	Catalogue number	Wellington Museum (WM) number	Catalogue number
1557	40	1609	177
1558	80	1610	142
1559	6	1611	178
1560	168	1612	27
1561	162	1613	179
1562	57	1614	161
1563	17	1615	100
1564	89	1616	189
1565	54	1617	199
1566	58	1618	145
1567	85	1619	149
1568	90	1620	180
1569	97	1621	101
1570	155	1622	78
1571	72	1623	15
1572	64	1624	181
1573	39	1625	126
1574	19	1626	154
1575	191	1627	150
1576	116	1628	118
1577	82	1629	92
1578	29	1630	48
1579	171	1631	56
1580	151	1632	71
1581	172	1633	3
1582	121	1634	22
1583	173	1635	59
1584	197	1636	63
1585	32	1637	21
1586	156	1638	55
1587	117	1639	20
1588	143	1640	23
1589	174	1641	122
1590	185	1642	167
1591	153	1643	169
1592	105	1644	187
1593	182	1645	190
1594	159	1646	62
1595	175	1647	14
1596	184	1648	152
1597	158	1649	30
1598	106	1650	198
1599	28	1651	42
1600	183	1652	113
1601	125		
1602	176		
1603	81	1–1971	46
1604	45	1–1980	12
1605	112	2–1980	13
1606	160	3–1980	10
1607	4	4–1980	11
1608	157	5–1980	111

Changes in attribution since the 1901 Catalogue

PREVIOUS ATTRIBUTION	INVENTORY NUMBER (WM)	PRESENT ATTRIBUTION
Cavaliere d'ARPINO	1607	Follower of Cavaliere d'ARPINO
BEECHEY	1530	After BEECHEY
Jan BRUEGHEL	1586	After RUBENS
Follower of CARAVAGGIO	1547	Cecco del CARAVAGGIO
Follower of CARAVAGGIO	1635	Ascribed to Antiveduto GRAMMATICA
CIGNANI	1612	Ascribed to CIGNANI
CLAUDE	1599	Ascribed to CLAUDE
CUYP	1490	CALRAET
Lavinia FONTANA	1622	ITALIAN School, c.1600
Henry HAYTER (?)	1553	GERMAN School, c. 1810–15
Cornelis KETEL	1628	NETHERLANDISH School, 1596
LEFÈVRE	1515	After GÉRARD
LUINI	1615	Ascribed to LUINI
LUINI	1621	Follower of LUINI
MOR	5–1980	After MOR
MURILLO	1546	Ascribed to MURILLO
PARMIGIANINO	1601	After PARMIGIANINO
Johann Victor PLATZER	1496	Johann Georg PLATZER
REYNOLDS	1545	Traditionally ascribed to REYNOLDS
RIBERA	1580	Traditionally ascribed to RIBERA
Giulio ROMANO	1618	After RAPHAEL
Andrea del SARTO	1529	ITALIAN School, 16th Century
TINTORETTO	1544	After Leandro BASSANO
TITIAN	1582	Ascribed to PADOVANINO
TITIAN	1620	Follower of TITIAN
TREVISANI	1624	Ascribed to TREVISANI
VELAZQUEZ	1590	Ascribed to VELAZQUEZ
VELAZQUEZ	1548	Studio of VELAZQUEZ
VERKOLJE and HUYSUM	1492	Jan Van HUYSUM
Jan VERMEER VAN HAARLEM	1594	Follower of Jacob van RUISDAEL
VERNET	1575	After VERNET
VERONESE	1543	VENETIAN School, 16th Century
Unknown	1509	Ascribed to Hans von AACHEN
Unknown	1565	GERMAN School, c.1830
Unknown	1471	HOPPNER
Unknown	1551	ITALIAN School
Unknown	1466	PORTUGESE School c.1822

Subject Index

References are to Catalogue numbers